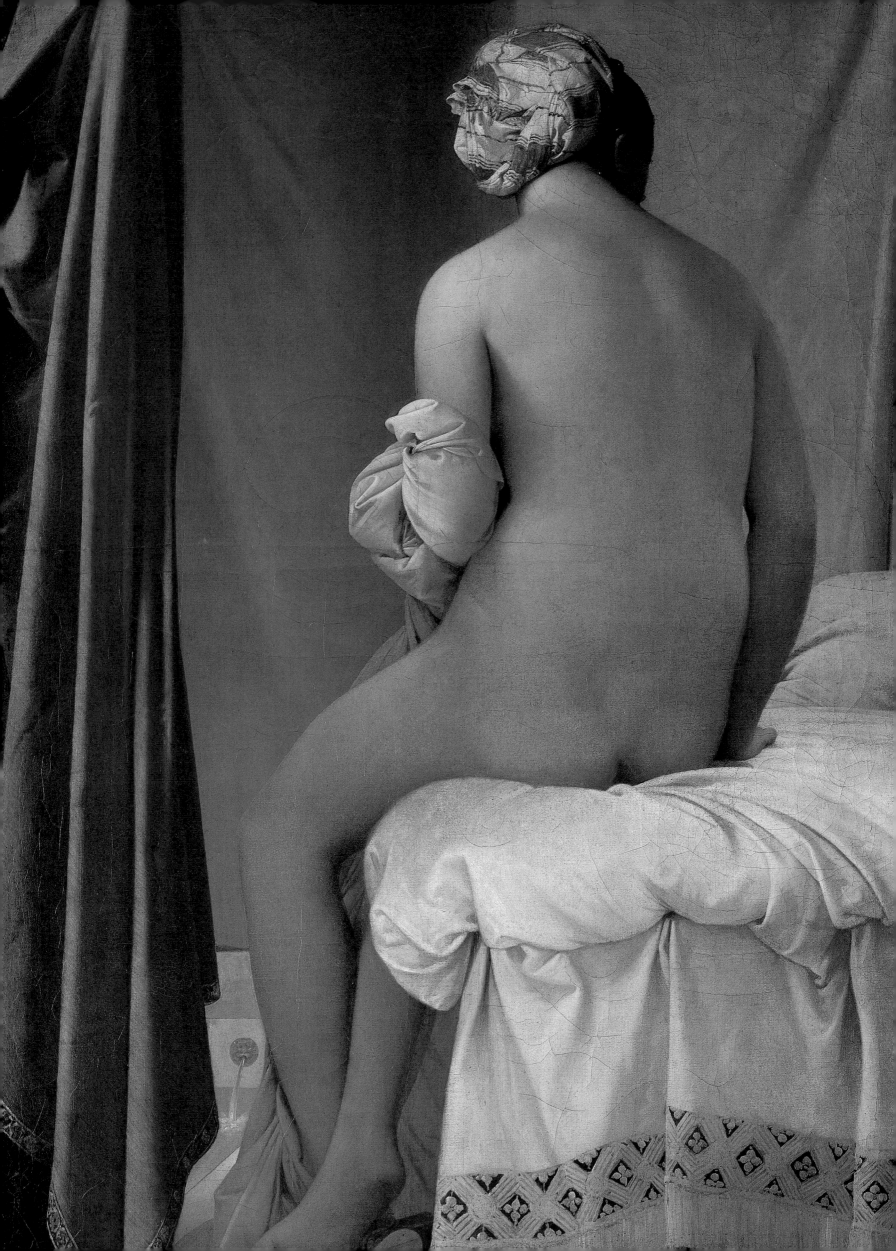

THE LOUVRE

Alexandra Bonfante-Warren

METRO BOOKS
NEW YORK

P. 1 & 7
François Gérard. *Psyche Receiving the First Kiss of Love.* 1798.
Oil on canvas. 73 1/4 x 52 in. (186 x 132 cm).

P. 2
Jean-Auguste-Dominique Ingres. *The Valpinçon Bather.* 1808.
Oil on canvas. 56 1/2 x 38 1/4 in. (143.5 x 97.1 cm).

Copyright © 2000 Universe Publishing
A Division of Rizzoli International Publications, Inc.
300 Park Avenue South
New York, NY 10010
www.rizzoliusa.com

This 2008 edition published by Metro Books,
by arrangement with Rizzoli International Publications, Inc.

 All illustrations courtesy of Art Resource, New York.

Design by: Charles Ziga, Ziga Design

Metro Books
122 Fifth Avenue
New York, NY 10011

ISBN-13: 978-0-7607-3490-2

Printed and bound in China

10 9 8 7 6

CONTENTS

ACKNOWLEDGMENTS

I would like to thank, first, Hugh Lauter Levin for thinking of me for this thrilling project, which has allowed me to time-travel in the company of great artists, writers, saints, queens, kings, and politicians, but also with unnamed children, peasants, revolutionaries, and reactionaries.

In the present, I wish to thank Jeanne-Marie P. Hudson of Hugh Lauter Levin Associates, a writer's dream of an editor, a tactful shepherdess with a gift for flexible organization, a great eye, and, it would seem, unfailing good humor. I am grateful, too, to Debbie Zindell, also of Hugh Lauter Levin Associates, for her discerning and trustworthy eye. Charles Ziga's handsome design would make any text read well. At Art Resource, Gerhard Gruitrooy, Director of Research, not only understood what I was trying to do but at times helped me understand as well. I appreciate his taste, imagination, and enthusiasm. Also at Art Resource, my thanks to Jenny McComas for her ready assistance.

In Paris, my thanks to Ms. Patricia Mounier and Agnès Jourdaine, in the Department of Communications at the Musée du Louvre, for answering my queries with promptness and generosity. I am also grateful to the heroes at the Louvre's Information Desk, who field thousands of questions a day, many of them mine.

This is for my friends and family, in particular for *mon général*, who first showed me Paris.

THE LOUVRE

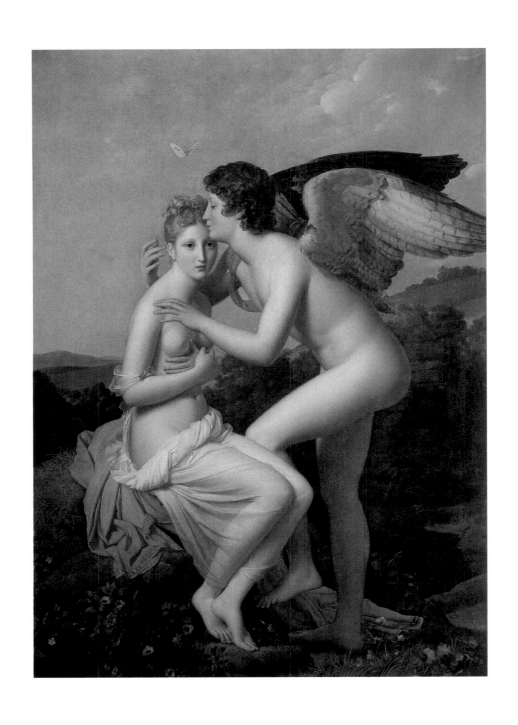

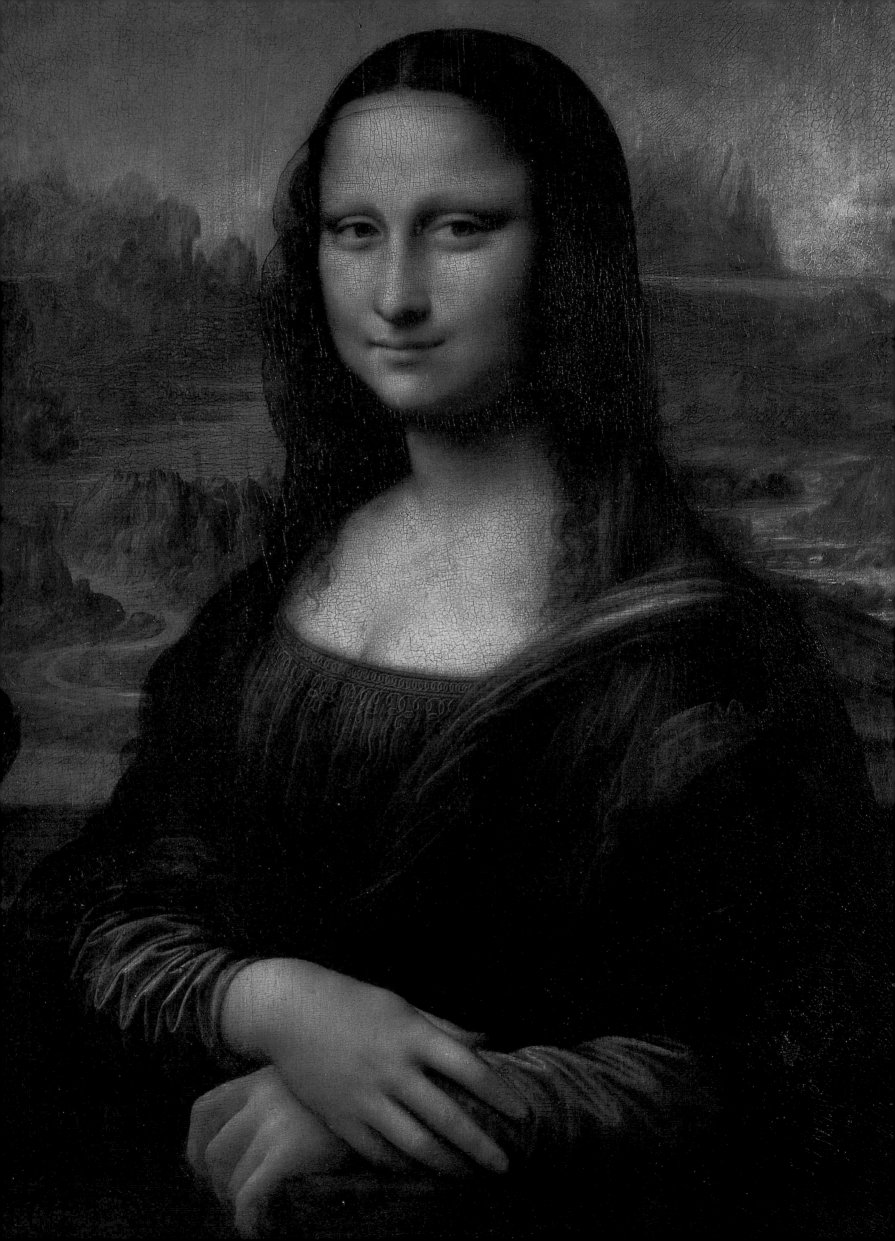

The Musée du Louvre

The Musée du Louvre—that is, the museum that inhabits the Louvre Palace—has existed for over two hundred years, though it has occupied the palace exclusively for a fraction of that time. During the long aristocratic centuries, the great collections of fine and decorative art housed in the Louvre were the property of its royal residents, the concept of a museum where the public might view such treasures not even dreamed of. The story of the museum is a complex one, which embraces the story of the palace: of the kings, queens, and commoners who built it; were conceived, lived, conspired, and died in it; fled it and decorated it. The story of the Louvre is also the story of Paris, and of France itself.

The world's largest museum, the Musée du Louvre is also one of the world's most exciting places, its buildings offering a journey through time, while its galleries display works that arouse the full range of human responses, from admiration and wonder, to curiosity, lust, and anger. The profusion and variety of objects tell us about the times, about social, class, sexual, and religious feelings and beliefs. But there is more than history within this space, represented perhaps most perfectly by the ubiquitously imitated but never replicated *Mona Lisa*. Leonardo's portrait (thought by some to be a self-portrait) transcendentally transforms paint on canvas into an impression of deep stillness as elemental as the enigmatic landscape behind the sitter, her hand on an equally mysterious sill. This painting, which has evoked every human and artistic emotion from frustration, envy, and contempt to violent rage, has come to stand for the enduring force of art.

Since its beginnings, the Louvre has conferred legitimacy on those who claimed it—for the brief period of a human lifetime—and as such it has been central to the history of its city and nation, even before there was a nation. It has been a wartime castle, and, rarely, a peacetime palace; it has witnessed faith, bloodshed, grandeur, and spectacle, despair, terror, and resolve that we in our time can only imagine—or reconstruct from the gilded traces left to us. The Louvre drew on the greatest talents of Europe, and was built at the cost of the misery of anonymous millions. Its construction vied with wars, revolutions, and the fall of kings, the rise of republics, and the loss of empires.

The museum's story is also the history of all museums and embraces the very notion of what we call art: the process by which the guardian lion of a Mesopotamian temple ends up in a glass cage bathed in French sunlight—or the picture of a self-possessed Florentine lady hangs behind a vertical, glass-fronted bunker.

"A Romanesque crucifix was not originally a sculpture, Cimabue's *Madonna* was not originally a painting, even Phidias' *Athena* was not originally a statue." So begins *Le Musée Imaginaire*, by André Malraux, novelist and, as French minister of cultural affairs, overseer of the Louvre from 1958 to 1969. We become curators of the Imaginary Museum when we restore something of the artwork's original qualities, evoking them in situ, in masonry museums. For example, the Louvre's palatial halls, literally teeming with visionary manifestations of talent, and of faith, fear, and the hope of Heaven, elicit curiosity, admiration, and the awe of viewers. Such profound feelings can overshadow the recollection that each of these works was made for specific surroundings, a context that endowed it with significance, whether church or throne room.

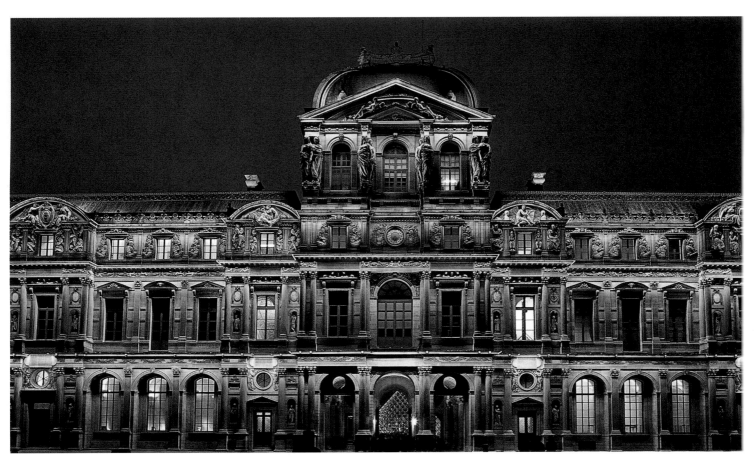

The Louvre at night with a view of the Pyramid through the Lescot-facade of the Cour Carrée.

Our imaginations are stirred by the sea-green patina of ancient bronzes, the ethereal whiteness of ancient marbles, European and Asian, and the romantic signs on *The Victory of Samothrace* and *The Venus de Milo* of the passage of time, as another French writer, and great sculptor, Marguerite Yourcenar, wrote. If we free our imaginations, we can see in those bronzes once more the warm browns of human skin, see those marbles painted in colors that, bleached by the centuries, the statues themselves have taught us to perceive as garish (it was Michelangelo and the Renaissance that mistook, then perpetuated the absence of color). These, and their Christian successors in incense-scented chapel and church, contained divinity or grace, and if we look for these works in museums and galleries today, it is because they still contain their antique power.

Space and time alter artworks, and so does photography, by taking an object out of all context except for the frame of the single picture—or of the book that contains the photographs. In a book, photography can have a leveling effect, making all objects of similar size, simply because they are on pages of the same size. Here, too, viewers become curators when they reimagine the work not only in its original surroundings, but also in its original dimensions. There is more: like people, some artworks are more photogenic than others. Photographs can lighten varnish-darkened paintings, and drawings too light-sensitive to be exhibited can be viewed at leisure. By the same token, however, the magic of some works does not survive the translation into a photograph. The delicate, tender delight that glows from medieval teenage Madonnas and their babies fades in the flattening light of photography. (Paradoxically, the bad black-and-white photographs of scholarly illustrations can do these sculptures more justice, because more imagination is required of the viewer.)

We can somewhat restore works to the Imaginary Museum because the receiving of art, like the making of it, is a process of pursuing what is true, of surrendering to the object's mystery. We can label that mystery "art" or "talent" or "genius"—or necessity: the masons who cut and laid the blocks of Paris limestone for Philip Augustus's Great Tower were certainly placing beauty second, after the security of a firmly planted structure. (Eight centuries later, stability would be one of Pei Ieoh Ming's guiding architectural values as well, leading him to raise pyramids within the Louvre's grounds.)

∽ ∽ ∽

At the turn of the thirteenth century, the Capetian warrior king Philip Augustus was trying both to wrest several northern French provinces from King John Plantagenet of England, the treacherous brother of Richard the Lionhearted, and to safeguard the Île-de-France, the region of which Paris was the capital. On the western side of the city's fortifications, facing the Plantagenet holdings, the French king erected a moated castle with towers on a site called the Louvre; the castle walls surrounded a moated circular keep, the Great Tower, one hundred feet (31 m) high, one of the architectural wonders of the age. Within the stone enclosure, buildings lined the west wall and the Seine wall on the south. This arrangement effectively protected Philip Augustus from foreign enemies to the west and disgruntled subjects to the east; it became the model for military defenses throughout the gradually unified kingdom, and the subject of ballads and popular tales.

The answer to the riddle of the name of the site of Philip Augustus's castle is lost in the remote past—or, it may not be mysterious at all. The proposed etymologies are more imaginative than likely, expressing a desire to extend France even farther back in time, to a fortress inhabited by Charlemagne, or a Saxon tower defending against the invading Northmen. Some suggestions for the origin of *lovre* or *louvre* in French (*lupara* or *lupera* in Latin) are *rubra*, "red place," a reference to the color of the local sand, and *rouvre*, "oak tree." Both these possibilities, though, are based on a nonexistent consonant shift. More colorful, but equally unsubstantiated, are references to a leprosarium or to a *luperia*, a kennel dedicated to the wolf hunt. In the end, the most probable—and not the least evocative—origin is simply *loup*, "wolf," a reminder of the wild woods of early Europe. Today, not oak trees, but orderly rows of chestnuts line the Seine along the Quai des Tuileries, and radiate west from the Carrousel.

Philip's tower, like the Tower of London, was multipurpose. The archives and treasury of the Crown were kept there, as were the king's enemies. Philip, however, lived elsewhere, in his presumably more comfortable palace on the nearby Île de la Cité. Man of war though he was, Philip Augustus, also known as Philip II, granted its charter to the University of Paris, the first such institution the world had ever seen.

RIGHT
The Winged Victory of Samothrace, set on her prow at the top of the Grand Staircase, commands an imperial presence.

P. 8
Leonardo da Vinci. *Mona Lisa*. 1503. Tempera on wood. 23 ⅝ x 18 ½ in. (60 x 47 cm).

OVERLEAF
Florentine School. 15th century. *Masters of Renaissance Painting: Giotto, Uccello, Donatello, Manetti, and Brunelleschi*. Oil on wood. 25 ¾ x 83 ⅞ in. (65.5 x 213 cm).

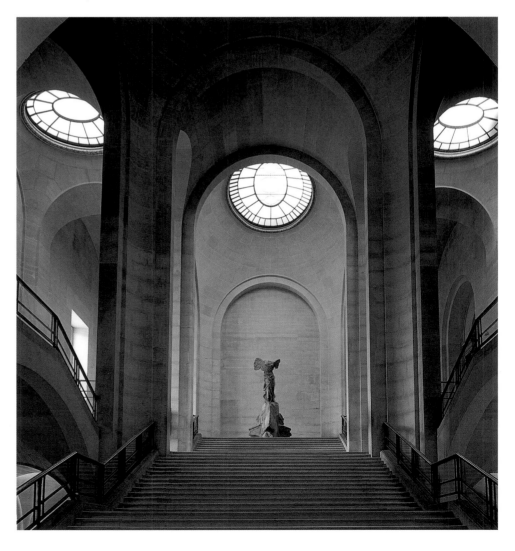

And, in the tradition of monarchs the world over, he was a patron of the arts and of architecture, principally through the many churches he built.

Philip Augustus's grandson, Louis IX—the future Saint Louis—a Crusader like his ancestor, gained by treaty the Plantagenet lands for which his grandfather had battled. Louis also collected manuscripts in a modest way, creating the foundation for the great library of Charles V a century later. The war at home largely over, Louis converted the west wing of the Louvre into a formal audience hall, where justice was dispensed and important personages received. Solemn state receptions came to be held at the castle, as well as the colorful and fatal tournaments that the Church condemned.

Under the pious Louis IX and his visionary and merciless grandson Philip the Fair, Paris mushroomed; in 1328, when the first Valois king, Philip VI, ascended the throne, the city, with about one hundred thousand residents, was the most populous in Europe; the plague that swept westward out of central Asia twenty years later would halve the city's number. In the countryside, the diminished population was somewhat better off after the pestilence passed, but the French monarchs would increasingly need to maintain a presence in Paris, lest one of the frequent urban uprisings, coupled with the constant threat from England, topple a reigning sovereign.

In 1356, when King John the Good was taken prisoner by the English at Poitiers, the dauphin, Charles V, later called "the Learnèd," became regent. Two years later, when Étienne Marcel, provost of the merchants of Paris, led a rebellion in the name of the people, Charles found the Louvre as useful as his forebears had. With a substantial force of men-at-arms garrisoned there, at his back, as it were, Charles addressed the people and swayed the heated crowd. Despite the swing in popular opinion, Marcel and his men broke into the Louvre and slaughtered two of the royal advisers before Charles's very eyes. Although regicide would become a violent fact of French royal life, at the time even the possibility amounted to sacrilege. After Charles's partisans murdered Marcel, Charles pressed his advantage with a grimly effective armed repression of a peasant rebellion.

The dauphin's victory affirmed the king's absolute authority—at least for the time being. Upon his accession, Charles began to turn the fortress of the Louvre into a regal, yet pretty palace, an aesthetic statement bespeaking the king's serene self-assurance. At the same time, he extended the city walls westward, and had a moat dug alongside, so that the Louvre was now within the city.

The poet, priest, and diplomat Petrarch described the dauphin Charles as "a young man of ardent intelligence." As a grown man, Charles was also known for his great piety, the orderliness of his private as well as public life, and the luxurious tastes he satisfied with splendid reliquaries and other religious objects that he commissioned. He was studious: his rich library of 973 manuscripts, on subjects from classical literature to magic and botany, would form the core of the future Bibliothèque de France. He was also one

of the new breed of monarchs; a statesman as much as a soldier, Charles knew very well that he must impress his peers with his majesty, and that meant splendor and pomp. And not only his fellow monarchs. Having repressed his subjects by force, he was as aware as his imperial Roman predecessors that, even more than fed, the people must be awed.

Charles, who also built the Bastille, transformed much of Philip Augustus's Louvre into a splendid royal residence. The king's architect, Raymond du Temple, remembered in the name of a nearby street, renovated the original buildings and constructed wings on the north and east, so that there were now halls against all four walls. The new wings were reached by a spiral staircase that was much admired in its day, and decorated with statues of the royal family. The term "fairy-tale" recurs in descriptions of this late-medieval fancy, a snow-white confection iced with shining ceramic tiles, spiky with graceful round turrets, and open to the world with a few actual windows, as well as Philip Augustus's narrow defensive fissures.

On a page of the Book of Hours of the duke of Berry—Charles's art-patron brother—the Louvre rises, courtly and bright, spanking new, benignly overlooking the plowing and sowing taking place across the Seine. The new Louvre, however, was still a walled castle, and it retained some of the functions of the old fortress, including the prison; the weapons room, where women fletched arrows; and, like a mailed fist in a silken glove, Philip Augustus's tower, grim and blind, at its center.

It was also a magnificent guest house for visiting dignitaries, such as the Holy Roman Emperor Charles IV and his retinue, who came to Paris in 1377. The emperor and his suite arrived at the Louvre by boat— an inadequate word for the floating palace that transported him to Charles's breathtaking new construction. Even the emperor was impressed to see the neatly laid-out gardens, Raymond du Temple's grand staircase, the frescoes, and the chapels, including the French king's private oratory, and the many windows. Gargoyles guarded the castle's turrets, while chimneys atop the high roofs told of fireplaces and residential comfort within. The royal menagerie brought the animals of the illuminated bestiaries to life. Although the territory of France was in the throes of almost constant warfare, Charles's Louvre stood for the ideal of a kingdom that was united and at peace.

∾ ∾ ∾

The embodiment of the French Renaissance, and one of the first European collectors in the modern sense, was Francis I of the house of Valois, whose paintings, many by the celebrated Clouets, father and son, would form one of the core holdings of the Louvre museum. Born in 1494, Francis ascended the throne against all odds as a confident twenty-one-year-old in 1515. Niccolò Machiavelli, who visited France on several diplomatic missions during the reign of Louis XII, just before Francis's ascension, marveled at the country's great wealth (the Florentine also remarked, a shade wistfully, that the people were so meek they barely required governance). Much of the country's riches were consumed, however, in almost constant

warfare, often in forays against the Holy Roman Empire, and in purchasing art objects. Francis was what would be later called a *connoisseur* and an *amateur*—an expert and passionate lover and patron of literature, painting, sculpture, decorative domestic objects, and architecture, though he was notorious for his lack of tact. He was also fond of lavish display—it would be ten years before the royal treasury recovered from the 1520 three-week celebrations at the Field of the Cloth of Gold in honor of Henry VIII, who should have been the host, since he held the region at the time.

In the fifteenth century, the fertile exchanges of technique and conceptual approach between the northern European schools of painting, especially the Flemish and German, and the central Italian, had concluded with the triumph of the Italians. The year after Francis became king, he called Leonardo da Vinci to his court at Amboise, on the Loire. Granted the former royal manor at Cloux, near the current royal residence, Leonardo was given the titles "first painter" and "engineer and architect of the king." Most everyone (including, in a matter-of-fact way, Leonardo himself) agreed that Leonardo was one of the geniuses of his day. At Amboise, Leonardo designed marvels such as a mechanical lion for the entertainment of the court, but also painted *The Virgin of the Rocks* and *Saint Anne and the Virgin,* two of his greatest works. So great was the king's love for his "first painter" that tradition has put Francis at Leonardo's side when the artist died in 1519. Following Leonardo's death, Francis bought several of the artist's Italian paintings.

Leonardo was the most famous of Francis's artists, but close behind him were Andrea del Sarto, Titian, and Primaticcio, as well as the brilliant and excitable goldsmith, sculptor, and two-time murderer Benvenuto Cellini, who was in the king's service twice, between criminal escapades. The king collected works by Sebastiano del Piombo and by Raphael, setting a precedent for subsequent Valois monarchs who collected drawings as well, especially illuminated manuscripts and portraits. (These would be kept in the Bibliothèque Royale until 1671, when Louis XIV absorbed drawings into the royal collections.)

As Machiavelli had noted, France was still in some ways feudal, with the barons wielding much power. Though the kings, their courts, and households no longer traveled around the country consuming their vassals' tribute, usually in kind, on site, a royal circuit allowed the reigning sovereign to keep an eye on possible sources of rebellion, and to impress his subjects firsthand with his armed authority. Francis and his magnificent entourage journeyed from palace to palace; at first Francis favored the Loire Valley: besides Amboise, he enjoyed Blois and Chambord, where he built a château.

Later, he would spend more time closer to Paris, at Villers-Cotterets and at the legendary château of Fontainebleau, once a royal retreat, today the summer residence of France's presidents. There, Francis not only kept his own *cabinet* of paintings but also encouraged a school of easel painting; three hundred years later, another school, the Barbizon painters, would take *their* easels to the region. The first recorded use of the word "cabinet" dates to 1525. Originally describing a small room apart, the cabinet—a cousin of the *studioli* of such erudite members of the Italian nobility as Federico di Montefeltro and Isabella d'Este— came to be a room in which a collection of similar objects, or artistic or scientific interest, were housed. As such, it was one of the forerunners of today's museums.

In 1528, when Francis determined to have a proper palace in Paris, Charles V's fairy-tale castle, which had been virtually abandoned for one hundred fifty years, was in a sorry state. Where Charles had buttressed his show of assurance by retaining Philip Augustus's keep, Francis saw the Grosse Tour as an outmoded excrescence, and perhaps an unhappy reminder as well: Francis himself had been a prisoner in Pavia just two years earlier. The razing of the tower marked the passage of the Louvre into its second stage of existence, as a royal residence, no longer a defensive castle. Yet the keep did not go unmourned—an observer commented that it was "a pity" to raze the tower, "for it was very beautiful, high, and strong, and well suited to imprison men of great renown."

The decision to make the long-disregarded royal house a regal home was largely political: as the leaders of France have always either known or had to learn, no head of state can afford to neglect Paris. After tearing down Philip Augustus's keep, Francis had the royal apartments redecorated. One of the king's great talents was for recognizing it in others, and his taste in architecture was in no way inferior to

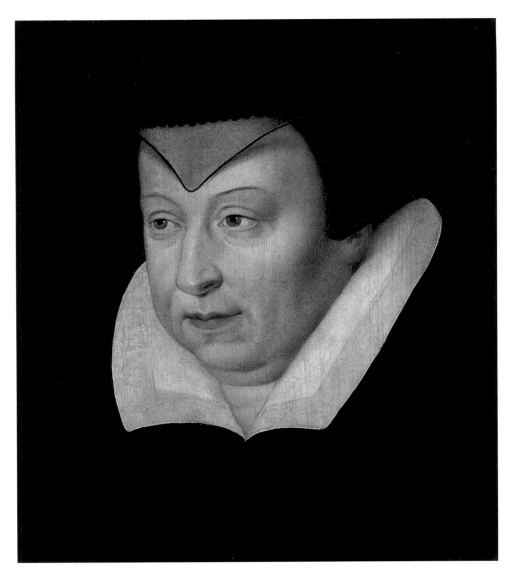

his eye for painting, sculpture, and household *objets*. In 1546, the monarch, now in his early fifties, selected the painter and architect Pierre Lescot to undertake the design of the new palace, in conjunction with Jean Goujon, a remarkable sculptor who had studied with Michelangelo. Francis died the following year, but Lescot continued his work through three more reigns, until his own death in 1578.

Lescot's graceful, almost playful façades set the tone for the palace for the next four centuries, with some intriguing exceptions. In the Italian fashion, female figures—nymphs and goddesses, nude or inadequately draped—cavort, consult, and reflect but clearly dominate the decoration of the court, albeit idealized and abstracted into allegories and classical divinities. In the Cour Napoléon, though female allegorical sculptures adorn the pediments, the figures that line the upper stories are sternly vertical historical males, all, whether in toga or breeches, resolutely dressed.

Prophecy, sorcery, and the Wars of Religion haunted the reigns of the last Valois kings. Henry II, Francis's second son, who rebuilt the south wing of the Louvre and commissioned the stately, stylish grandeur of the Salle des Caryatides, was married to Catherine de Médicis, a daughter of the powerful Florentine merchant and banking family, when they were both scarcely more than children. Within a few years of his marriage, Henry fell in love with Diane de Poitiers, twenty years his senior; she would openly be his mistress and political adviser for the rest of his life. Diane's sway over the king and her legendary beauty, unmarred by the passing decades, were naturally ascribed to sorcery. Gossip, however, credited the king and queen's ten children, three of whom succeeded to the throne, to Diane's practical-minded promptings.

The king and his lover shared a passion for hunting, and any references, however oblique, in any medium, to the sport or to Diana, the Roman goddess of the hunt, are a tribute to Diane de Poitiers. The royal palaces, including the court façade of Henry's rebuilt west wing of the Louvre, display a curious example of the Renaissance love for codes. The vertical bars of the king's initials are entwined with the

queen's own initials, backward on the left, forward on the right; however, the letter C is the shape of the crescent moon, sacred to the goddess Diana, and the crossed royal ciphers form the letter D. In 1559, when the point of a lance crashed through the visor of Henry's golden helmet and into his eye during a tournament, the despairing queen abruptly recalled two predictions of the tragic event, one of them a rhymed quatrain by Michael de Notre-Dame, better known as Nostradamus, foretelling the cruel death of a lion, his eyes gouged out in a "golden cage."

With the Reformation, religion became the sword that divided the nations of Europe bitterly and bloodily. The Huguenots, as the French Calvinists were called, included important families of the nobility. In 1560, the year after Catherine became regent for her eldest son, the short-lived Francis II, the Huguenots rallied to overthrow the Catholic royal faction; the Crown's repression was instantaneous and brutal. In 1562–63 and 1567–68, now regent for her second son, Charles IX, the Queen Mother passed edicts intended to end the fratricidal Wars of Religion. Despite Catherine's every effort, civil war became the plague of the age—in 1562, Jean Goujon, a Protestant, left the country.

In the meantime, the royal renovations proceeded apace. In 1563, desiring a château of her own, a retreat far, but not too far, from court, the Queen Mother commissioned a palace to be built on the site of the tile factories—in French, *les tuileries*—just outside the city walls; the gardens in the Italian manner would set the style for French landscaping. In addition, in 1566, Catherine directed that a hall, the Petite Galerie, be built closing off the garden between the southern wing of the Louvre, which now housed her apartments, and the river wall.

Seeking to negotiate peace between the religious factions, in 1572 Catherine married her daughter Margaret of Valois to a young leader of the Huguenots, Henry, king of Navarre. Five days after the wedding, in the night between August 23 and 24—the eve of Saint Bartholomew's Day—the bells of Saint-Germain-l'Auxerrois, the royal parish church, gave the signal to begin the massacre of the Huguenots. The carnage raged for five days, with the bridegroom held prisoner in the Louvre. (He would remain a virtual prisoner for the next four years.) Members of the royal court, including a close adviser of the king himself, were herded into the Cour du Louvre and mowed down with crossbows and harquebuses. Some escaped into the Louvre, only to be so butchered that "the walls were purple with blood . . . and the stairs ran red till nightfall." Blood was said to have spattered the new bride's bedroom.

Pope Gregory XIII and the Catholic sovereigns of Europe openly congratulated Catherine for ordering the slaughter, its timing apparently precipitated by the king's growing sympathy for the Protestants. As hideous as the massacre was, it was clearly the exasperated recourse of an imperious temperament. But it was more: Catherine, a daughter of the great Medici dynasty, was bred to do her duty to family and country—at all costs. And the costs were gruesome. Estimates of the number dead in Paris and throughout France reach as high as fifty thousand, but the near-annihilation of the opposition did not eliminate the problem. The Wars of Religion continued for another quarter-century, taking the lives of the next two kings of France.

Charles's successor in 1574 was Henry III, a tormented soul whose tenure at the Louvre was interrupted by civil war. Sexually ambiguous and deeply devoted to his wife, the "little queen" Louise de Lorraine, the king was given to nightmares. One morning, waking terrified from a dream in which he was being savaged by wild beasts, he ordered the palace's crossbowmen to kill the royal lions who lived in the Louvre's moat. In 1588, forced to flee Paris, Henry III left the Louvre to the Paris League, who hanged sixteen men in Henry II's great hall, one of a seemingly endless series of executions and reprisals in that century of carnage. The following January, Catherine died at Blois; Henry III was murdered by a monk six months later.

Henry, king of Navarre, also known as Henry de Bourbon, saved himself during the week of Saint Bartholomew's by embracing Catholicism; as King Henry IV, he would do so again to claim the Paris he had won on the battlefield, his pragmatism embodied in his remark "Paris is well worth a mass." By 1600, when he married his second wife, Marie de Médicis, Henry IV had brought a hard-won peace and with it the chance for prosperity to a realm devastated by the cruel war at home. Henry's road to the throne and

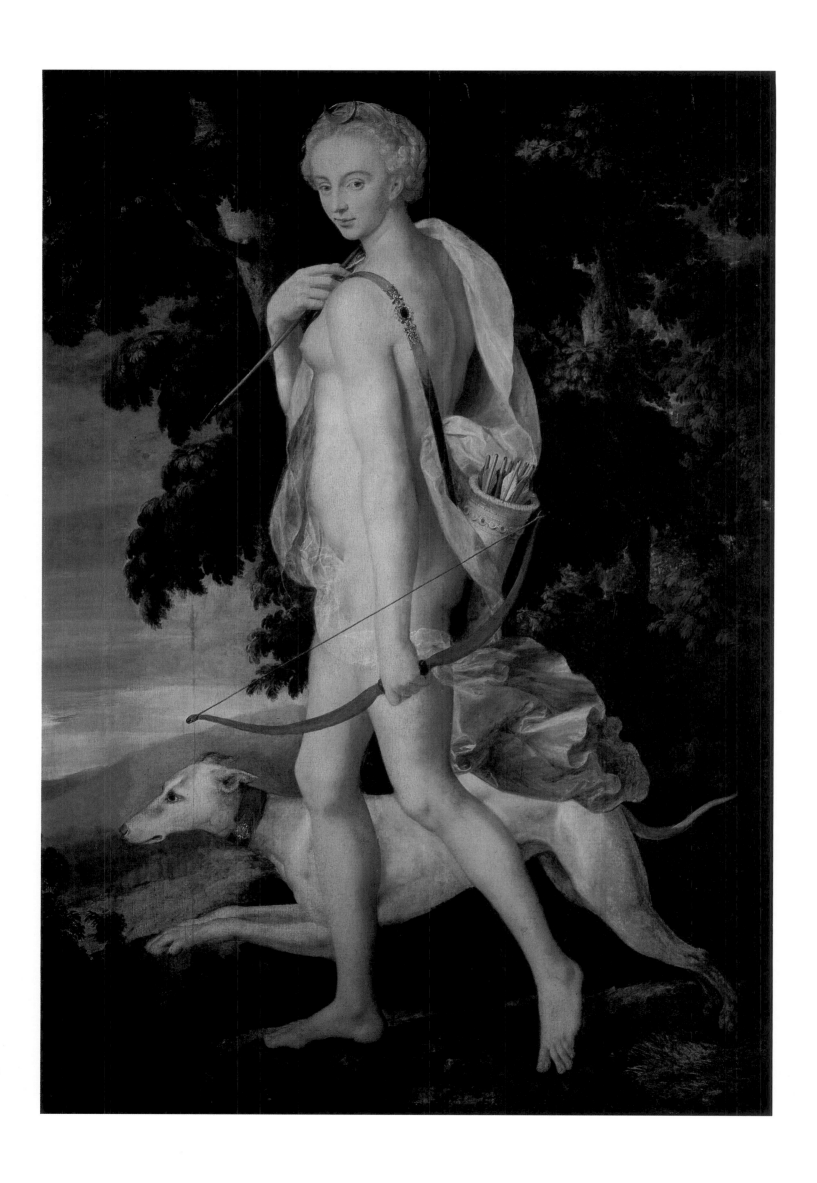

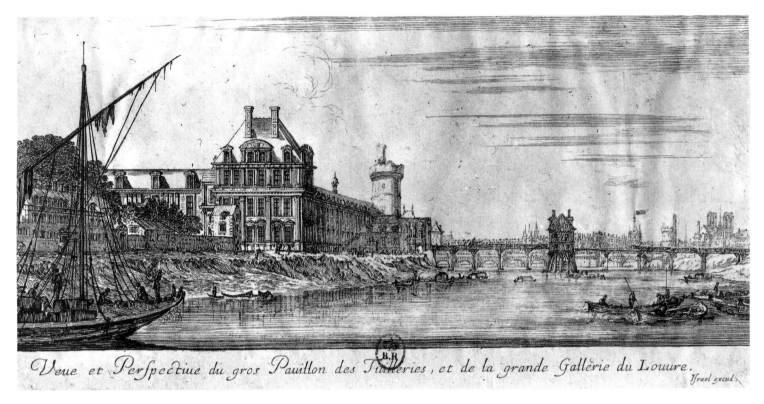

Veue et Perspectiue du gros Pauillon des Tuileries, et de la grande Gallerie du Louure.

his expedition of explorers to the New World proved him a man of vision. With the aid of the remarkable duc de Sully, for whom the Louvre's central pavilion is named, the Bourbon king designed programs for the economic restructuring of the nation and the urban restructuring of its capital. Similarly, Henry had a Grand Plan for the royal palace—at the time of his accession, neither Francis's Louvre nor Catherine's Tuileries Palace nor her Petite Galerie was finished. He genuinely loved his capital, and his architectural program for the Louvre was also a tribute to the city he had won at great sacrifice.

Henry's plan called for quadrupling the areas of both the Cour Carrée and the palace itself, and creating a series of quadrangles that would unify the Louvre and the Tuileries. In his lifetime, he achieved Charles IX's vision of a gallery along the Seine that would join the two palaces—the Grande Galerie. Henry also had Lescot's façade completed and a second floor added to the Petite Galerie; this second floor was dedicated to a gallery of royal portraits beginning with that of Saint Louis. (In addition, the ever practical Henry planted groves of mulberry trees outside the north wall. These fed the silkworms that in turn nourished France's flourishing textile industry.)

The king was equally down-to-earth in assigning space in the new areas of the palace. In traditional urban architecture, the ground floors of buildings and the mezzanines below were often given over to shops and workshops, and the Grande Galerie, in a royal kind of way, followed convention. Sponsored by the Crown, a crowd of artists and artisans—still, despite Leonardo, a relatively hazy distinction—lived and worked in the tunnel-like halls below the *grand étage*. "Painters, sculptors, printmakers, . . . goldsmiths, furnituremakers, clockmakers," tapestry makers, and the Mint inhabited the Grande Galerie below stairs.

Henry was an *amateur;* like Francis I, he was particularly fond of Classical sculpture, and his collection would join that of the Valois king in the Louvre's museum. The tradition of a royal menagerie in the palace continued too, after Henry III's panicked slaughter: the dauphin, the future Louis XIII, liked to walk his camel up and down the quarter mile of the riverside gallery. The young prince also loved his more modest zoo, made up, not of exotic gifts from distant potentates, but of woodland creatures from the surrounding countryside.

For the rest, the royal palace was the scene of boisterous entertainments for the court, which included the ballet of the time—these might feature not only members of the nobility, but sometimes even Henry himself—as well as spectacles carried over from the time of Francis I and Leonardo, and earlier still. Pageants and tableaux, elephants and a din of musicians, began at midnight and crashed on until dawn. The larger-than-life Henry was nothing if not energetic: known to have had fifty-four official mistresses, in his fifties he was dubbed *le Vert Galant*—roughly, "the sexy old dog."

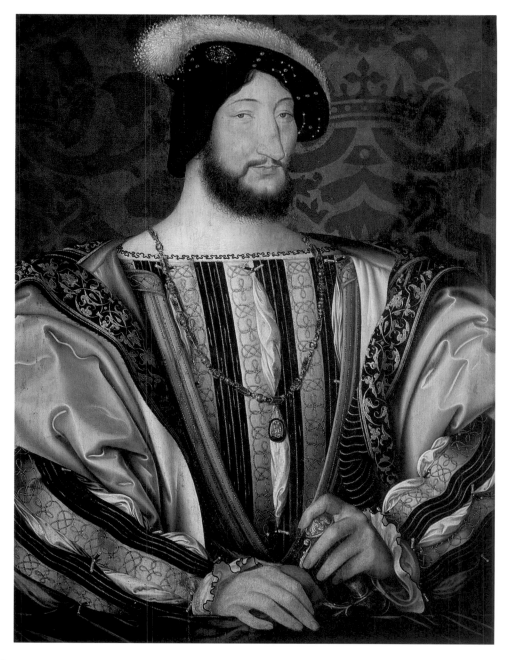

The festival was suddenly stilled on May 14, 1610. Henry IV, who in 1598 had passed the Edict of Nantes permitting some measure of freedom of religion, was assassinated by a religious fanatic. The courtyard of the Louvre was draped in black velvet, and a wax effigy of the late king lay in state in the Salle des Caryatides for eleven days, during which his meals continued to be brought to him in the mourning hall, where silk-clad courtiers now speculated in worried whispers about the next king's reign. Five years later, Henry's first wife, the good-natured and cultivated Margaret of Valois, would die, financially ruined; the Musée d'Orsay stands on what was once her estate.

The old king was dead; the young king was nine years old, and his mother, the forceful Marie de Médicis, like Catherine, a daughter of the powerful Florentine dynasty, would rule France as regent for seven years. Beginning in 1612, she undertook construction of a country domain: the Luxembourg palace and gardens, across the Seine from the Louvre. Apparently, that was not remote enough; one of Louis XIII's first acts upon reaching his majority in 1617 was to send his mother into polite exile at Blois. Marie had no intention of going quietly, and by 1622 she was on the king's council.

To mark the occasion, the Queen Mother commissioned Peter Paul Rubens to paint for the Luxembourg Palace a cycle of paintings between 1622 and 1625. The contract called for all twenty-four paintings—over three hundred square yards of canvas—to be entirely and exclusively by the master's hand. This staggering, hallucinatory Baroque extravaganza, today in the Louvre's Galerie Médicis, begins with portraits of her parents and goes on to detail episodes from Marie's life, including her coronation (Margaret had been merely queen consort) and her political, military, and maternal achievements.

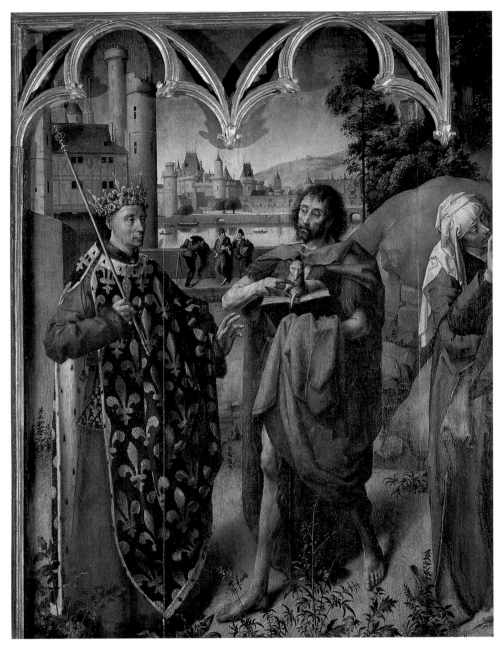

Throughout, the queen is accompanied by Jupiter and an uncharacteristically clinging Juno, angels, putti, the Three Graces, and various other classical figures. Baroque excess had met its match in a Medici queen.

War, royal circuits, and the charms of hunting, the countryside, and lovers had long taken the French monarchs away from the Louvre. In 1627, however, Louis XIII began construction on the Paris palace's greatest rival. The king's architect, Jacques Lemercier, who three years earlier had taken over the project of expanding the Cour Carrée and the building of the Pavilion de L'Horloge (the Clock Pavilion, which still displays its tiny dial), was now given the assignment of designing a royal hunting lodge some ten miles from Paris, an easy day's journey from the capital. Within a few years, work on the Louvre would be virtually at a standstill.

Versailles became the king's home, although the Louvre remained unequivocally the royal palace: the queen, Anne of Austria, lived there, and Louis had his apartments there, including an aviary and a series of workrooms for the earnest artisan-king, who found sober satisfaction in his "forge, gun room, printing press, and carpenter's shop." Like his father, Louis supported the ballet, but even more enthusiastically, going so far as to write music for one. The spectacles, which might last all night, were performed on the second floor of the Grande Galerie—twice as long then as it is today—for invited audiences of sometimes four thousand. The crush was at times life-threatening, at times life-engendering, providing as it did on occasion for great, if discreet, familiarity.

This same hall, where today the Louvre's Italian masterpieces hang, was the scene of an archaic royal ritual revived by Louis XIII: the *cérémonie des écrouelles*. Scrofula—tuberculosis of the lymph glands of the neck—an illness that produces particularly unattractive abcesses, was traditionally known as the

King's Evil, because on certain occasions the reigning monarch was believed to be able to cure this ugly affliction. In part a ritualized gesture of humility, similar to the medieval saints' penchant for treating repugnant diseases of the skin, it was also a clear affirmation of the king's divine right to rule.

In the late 1630s, work on the Louvre resumed with international fanfare when Louis XIII summoned Nicolas Poussin to Paris. Poussin, one of France's and the century's great painters, had been working for high-ranking prelates in Rome, where he had executed paintings for Saint Peter's Basilica. In addition, he had done a series of four paintings, the *Bacchanalia*, for Cardinal Richelieu, an advisor to Marie de Médicis, and the most powerful man in France—not excluding the king. Like his successor, Cardinal Mazarin, Richelieu was a collector; his testament expressed the curious desire that his collection be open to the public. His unprecedently democratic dictates went unheeded, but many of his artworks eventually reached the Louvre, so that in time his wish came true.

Now, in the early 1640s, Poussin was to be superintendent of the royal residences, no less a title than he felt he deserved. For the great ceiling of the Grande Galerie, a massive undertaking, Poussin began, but did not complete, an epic program, *The Labors of Hercules*, in the Classical style for which he was celebrated. No political naif—he had, after all, been working in the highest ecclesiastical circles in Rome—Nicolas Poussin nevertheless was no match for the situation he encountered in Paris. All his life he had focused on his art, often at the expense of public honors; whatever the origins of his attitude may have been, he neither worked nor played well with others at the French court. His open disdain for his colleagues merely added fuel to the chronic intrigues around the king, and in the end, exhausted, frustrated, and disgusted, Poussin soon returned to the relative peace of the Vatican.

∾ ∾ ∾

Unlike his father and grandfather, Louis XIII died a natural death. Tradition has it that France owes the very existence of his heir, Louis XIV, the Sun King, to the Louvre: when a sudden rainstorm kept the king from returning to Versailles one night, Louis and his virtually estranged queen renewed relations, and the dauphin was the result.

Louis XIV was born in 1638 into a home racked by political tensions, primarily between his father and his father's mother. Having ascended the throne in 1643, while still a child, he was caught amid the armed upheavals of the Fronde, a popular uprising, which in 1648 flared into a parliamentary rebellion similar to England's. The court was forced to leave Paris more than once, and when Charles I of England was beheaded, in 1649, the boy Louis became well aware of what could be the fate of kings. In the end, it was not the nobility, and certainly not the semi-starving common people, but the Paris bourgeoisie who turned the tide, allowing Louis and his mother, the regent, to return to the capital.

One of Anne of Austria's first domestic actions upon returning home to the Louvre was to have her summer apartments in the Petite Galerie decorated. Calling on popular Italian and French artists for the stuccowork and frescoes, she entrusted her bathroom, an affair of gold, gilded bronze, and marble columns, to the court painter Simon Vouet and to Eustache Le Sueur. In typically aristocratic style, Anne left the carpenters' bills "unpaid for forty years," a later observer noted.

When he came to rule in his own right, Louis XIV proved himself far more his mother's than his father's son, both in his assumption of absolute authority and in his sumptuary politics. The king appreciated spectacle not only as policy but as participant: in 1662, dressed as an ancient Roman, he led a two-day "Carrousel," or tilting-match, that left its name in the complex of today's Louvre. A procession of quadrilles defiled, costumed—besides as Romans—as Persians, Indians, and Americans. More than a thousand members of the nobility paraded as dancers and acrobats where today the smaller of Napoleon's arches rises.

The nobility had provided the muscle behind the Frondists, and Louis was aware that he must keep them in sight and dependent, preferably deep in debt. Soon, the country aristocracy was moving to Paris to protect their position and seek wealth by currying the king's favor. To achieve the daily opulence that attendance at court required, the aristocracy called on armies of servants, artisans, and merchants: the capital, with well over half a million inhabitants, was once more the largest city in Europe. Meanwhile, outside the city, the neglected estates became the scene of ever-deepening misery.

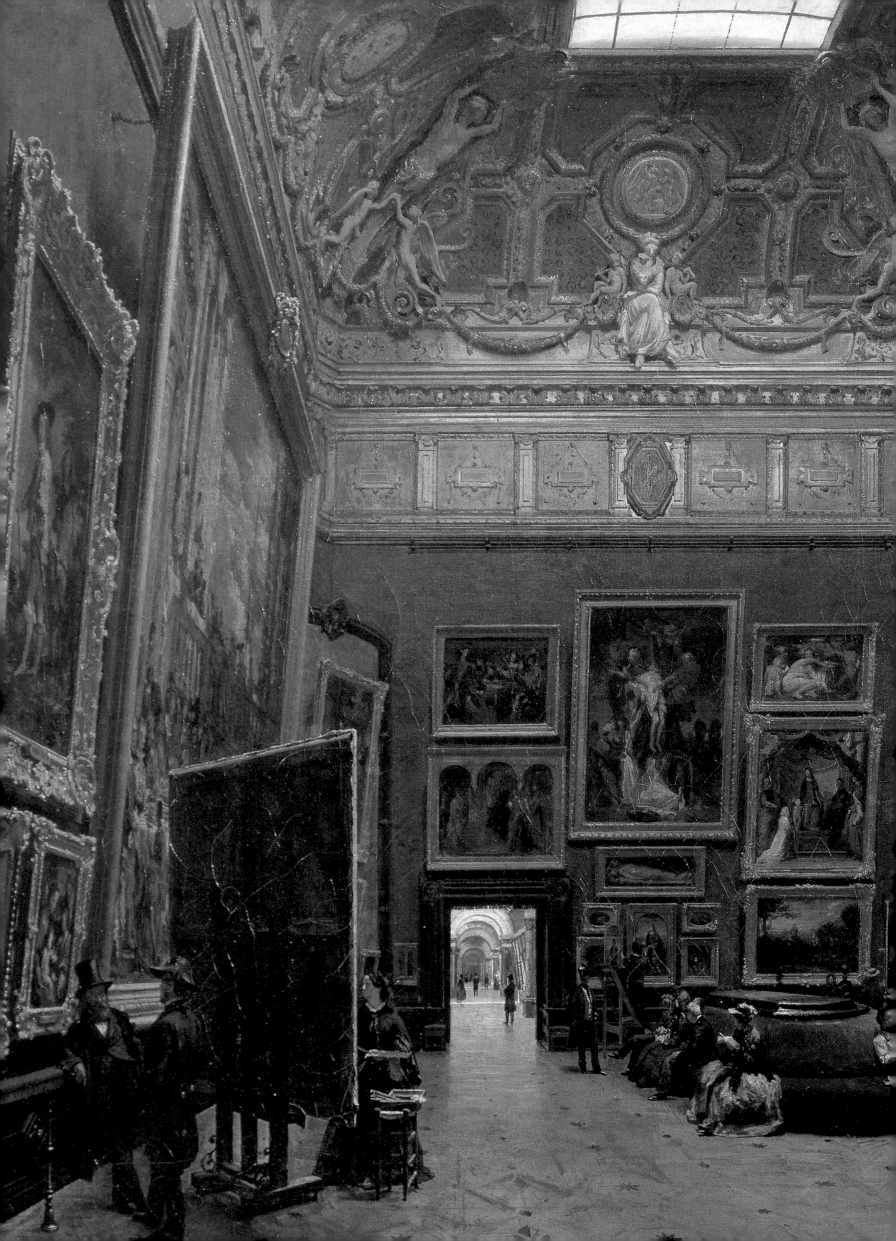

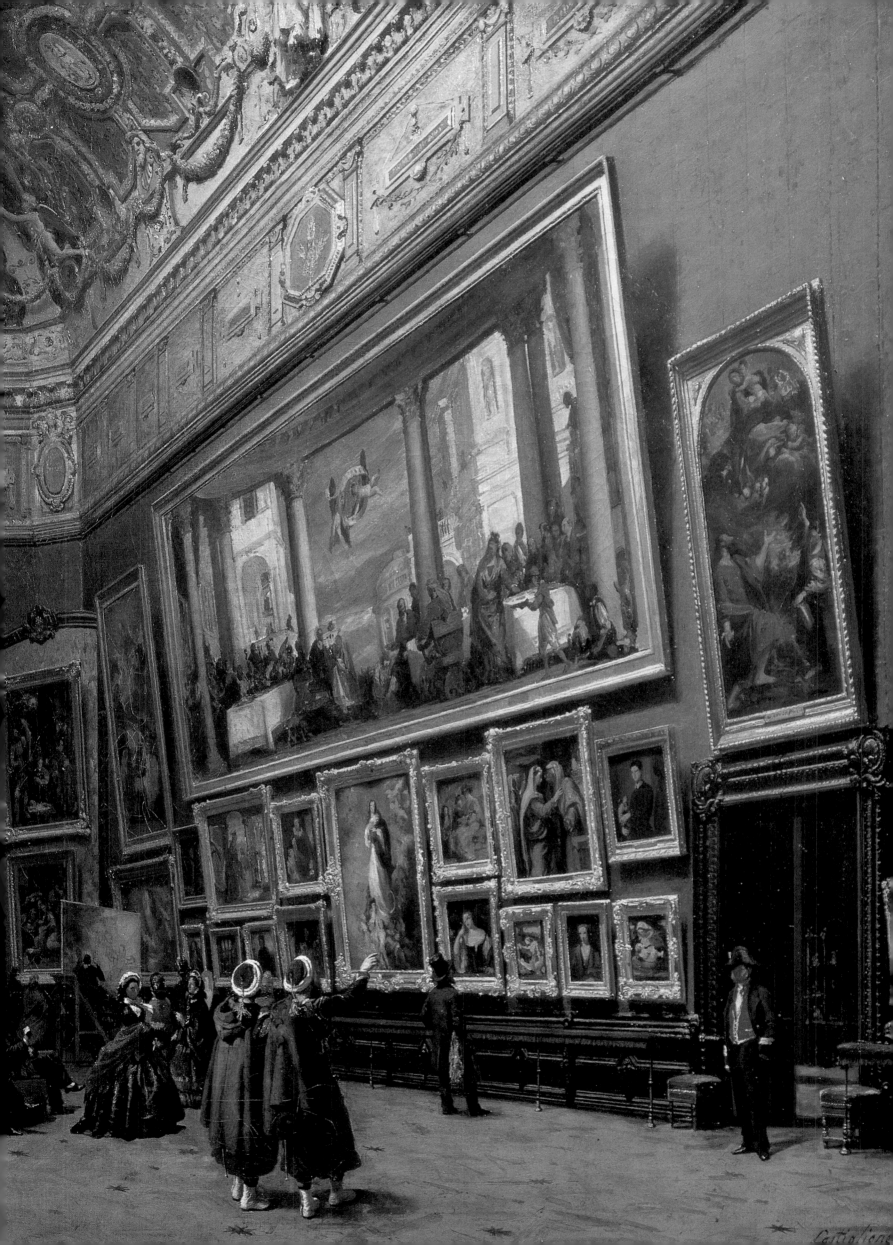

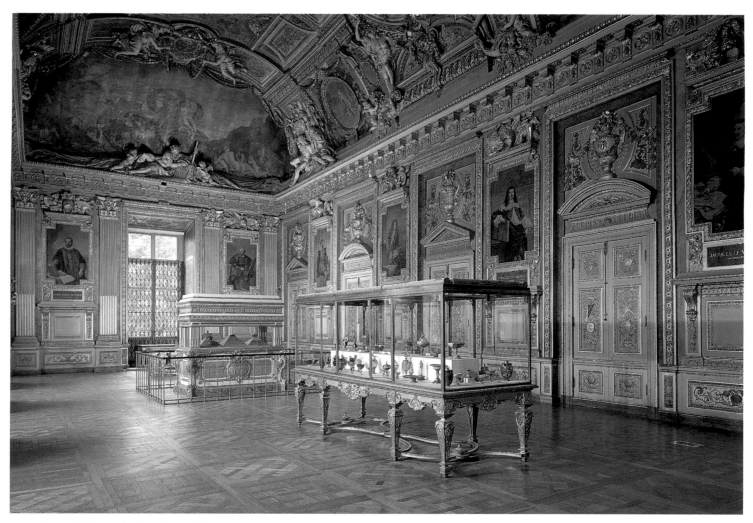

Interior of the Galerie d'Apollon.

It was clear before very long that the old Louvre was hopelessly inadequate to its new burden, and in 1659, the king's architect, Louis Le Vau, took on Henry IV's Grand Plan. The Cour Carrée was quadrupled, and following a devastating fire in 1661, Le Vau restored the Petite Galerie and created the second-story Galerie d'Apollon. The reference to the Greek and Roman god of the sun and of the arts was an obvious tribute to the Sun King, the monarch who is said to have declared to Parliament during the tumult of the Fronde, "*L'état c'est moi*"—"*I* am the state."

Louis's reign—the longest of any European ruler—made France the most prestigious nation in the world. The king's missionaries and merchants established a French presence in Africa, India, and the Americas, including the Louisiana Territory and Saint-Domingue, or Haiti, which soon became a source of fabulous wealth. France itself exported grain, and Louis developed manufacturing and commerce, going so far as to have Venetian lace-makers kidnapped when his industrial spies were unable to discover their trade secrets. At the same time, the nation was at war, on sea and land, for all of Louis XIV's reign, which created a hemorrhaging of the country's great wealth. The taxes levied to support the wars, the export of grain, and regulations that prohibited the flow of food from one French region to another, all converged to keep the French peasants on the edge of famine. One bad winter could produce widespread starvation, and there was more than one bad winter during the king's long reign.

The largely urban bourgeoise that had supported his regime when he was a child profited from the king's economic policies, many of which were formulated and pursued by his minister, the fascinating and complex Jean-Baptiste Colbert. Colbert, formerly in the employ of Cardinal Mazarin (hence of the Queen Mother's coterie), was made controller general of finance in 1665 and secretary of state for the king's household in 1669; as pragmatic as his patrons, he was breathtakingly effective. It was he, under the king's aegis, who in the 1660s founded the academies of letters, sciences, and architecture, all of which were housed in the Louvre.

Louis was indeed the sun where the arts were concerned. Racine, Corneille, and Molière wrote plays that were produced in the Salle des Machines, the theater Louis built in the Tuileries. Beginning in 1672 the Royal Academy of Painting and Sculpture held exhibitions of works by its members in Richelieu's Palais Royal, one of his bequests to the Crown. In 1699, the exhibitions moved to the Grande Galerie, and after 1725 to the Salon Carrée (which is not, in fact, square), which gave its name to the influential, often controversial shows that would be held until 1914.

The last of the medieval Louvre was torn down, leaving only the (unsanitary) moat where a crazed Henry III had sought to cut down his demons. Louis planned a colonnade, a grand entrance to dignify the east wing of the palace, and who better to design such an architectural expression than Gian Lorenzo Bernini, the sculptor who at midcentury had ideated and built the colonnade of Saint Peter's Basilica in Rome? In fact, Bernini was only one of the contestants, albeit the most famous, but the king rejected his proposal for a sinuous and imposing façade, because, in the end, it was not French enough. During his brief, embattled sojourn in Paris, Bernini also suggested that the king present a permanent public exhibition of art from the royal collections. Claude Perrault, a physician and founding member of the Academy of Sciences, won the plum architectural commission. (His brother Charles, a member of the Académie Française, was famous for his *Contes de ma mère l'oye*, or *Tales of Mother Goose*.)

In 1678, all work on the Louvre ceased, and all resources were diverted to Versailles, where his father's retreat would become the king's palace. Louis built his own hunting lodge nearby, at Marly-le-Roi; a number of the park's sculptures today disport themselves in the court of that name, part of the Grand Louvre renovation. By the time the king and his court moved there in 1682, Versailles had consumed more than two hundred lives and the equivalent of more than $300 million dollars. In Paris, the roof of Perrault's handsome Colonnade was left unfinished.

Versailles is celebrated for its interior decoration and *objets d'art*, but it also became home to the royal art collection, while the Louvre served as storage space: Henry II's Salle des Caryatides had served as a Salle des Antiques under Henry IV; now it did so again, with André Félibien as its first curator. The Louvre still sheltered the academicians as well as the academies. The academies were active and engaged: their classicism in art, and an equivalent rigor in intellectual matters, created a French style of thought that endures today. The scholars and their scientific collections attracted foreign guests, in the flux of intellectual exchanges that would give rise to the Enlightenment, and in the end, ironically, the endeavors of the Crown-sponsored academicians would eventually nurture the Revolution itself.

Under the guidance of Colbert and Charles Lebrun, first painter to the king, history became the most prestigious artistic content of the day, reflecting the time-honored view of the human tale as being determined by the actions of great men. History painting, at which the French Academy artists excelled, reinforced Louis's deliberate cult of personality. The king, however, had a soft, if shallow, spot for his more humble subjects, and a sort of pendant to history painting soon emerged. So-called genre painting captured portraits of the usually rural, nameless poor, such as farmers and blacksmiths, and spotlighted their homes and work. Other popular if less noble topics, inspired by Caravaggio, included the people of the urban streets, such as fortune tellers, often shorthand for rogues and prostitutes. Art was no longer solely devotional, decorative, or hagiographic.

These complementary subjects—the epochal and the transitory, not to say disposable—mirrored a shift in the existential understanding of time and history, including art history. No longer were ancient scenes presented in contemporary dress to make the narratives more immediate to the viewer; time was no longer a visually continuous present, but an evolving dimension. Francis I and Henry IV had acquired the classical statuary admired by contemporary painters and sculptors; Louis XIV, advised by Colbert and Lebrun, purchased classical and contemporary art for Versailles as well, but also works from what we call the Renaissance on. The inventory made of the king's Cabinet of Paintings toward the end of his reign gave a total of 1,478 pictures, making it one of the most ample collections of the time. (French works numbered 930, Italian 369, and northern European, 179.)

The Royal Academy of Painting and Sculpture drew on the royal collection for its *conférences*, the regular lectures at which senior academicians analyzed a single painting, most often by an Old Master, pointing out to students its strengths and weaknesses in the specific formal areas of color, composition, and drawing. Portions of the collections of the Crown were on display in one or another *salle* of the Louvre or Tuileries palace, where paintings were exhibited in the fashion of the cabinets, crowding the room's walls. In the high-ceilinged rooms of the royal palaces, larger paintings were hung from dadoes, the moldings just below the ceiling, at an angle that facilitated viewing by the privileged visitors, while smaller works filled the spaces below. Similarly, sculptures were warehoused, but on view, in the Louvre's Salle des Antiques, where distinctions were not always drawn between ancient works and statuary in the ancient manner.

The conventional exhibition of museum collections that we are accustomed to today, ordered by geography and chronology, is only one of a number of approaches. In an eighteenth-century amateur's cabinet, pictures might be organized on either side of a suggested central vertical axis, for example, to produce a harmoniously arranged wall, rather than to show the individual paintings to their best advantage.

Meanwhile, the Louvre was lively with far more than the life of the mind. The artisans still occupied the bottom floors; with the king away, the palace became a sort of grand lodging house, soon taking in courtiers, squatters, and, in time, a stable of ducal horses—and their hayloft.

Louis XIV, who died in 1715, was a tough act to follow, in several respects. He had undoubtedly created a great nation and the most brilliant court in Europe, but his achievements had been at the expense of that same nation, especially the long-suffering poor, represented with such dignity and cleanliness by painters such as the Le Nain brothers. The Sun King's great-grandson and successor, Louis XV, only sometimes known as "The Well-Beloved," inherited a barbarously neglected and exploited people who were becoming increasingly desperate. Louis XV, however, had neither his ancestor's broad ambition nor his intransigence.

Madame de Pompadour, who lived at Versailles as Louis XV's *maîtresse en titre* for nearly two decades, beginning in 1745, and who strongly influenced the king in political, commercial, and artistic matters, sponsored architectural and literary projects, and hosted his soirées. She was a patron of Voltaire, the Encyclopedists, and painters. She founded the Sèvres porcelain factories, and employed skilled artisans, such as the furniture makers who produced some of the finest pieces in Europe. The look of the mid-eighteenth century, named for Louis XV, owes its style to her.

Perhaps inspired by the receptions of the great salonnières, including the king's mistress, *amateurs* held regular social gatherings dedicated to discussions of art, and the absence of the royal collection from Paris increasingly began to be felt. It may also have been due to *La Pompadour*'s sway that in 1750 the first public exhibition of the king's paintings would be held. And it would take place not at the Louvre, by now all but abandoned to its motley population, but at the Luxembourg.

The Luxembourg project brought the question of restoration frankly to the fore. At Versailles, even the king's favorite works were subjected to the perils of direct sunlight, heat, and cold. Many more paintings and statues were in storage there, or at the Louvre, where paintings were often stacked haphazardly, prey to extremes of temperature and the attentions of vermin; at the Luxembourg, the famous Rubens cycle was exposed to the damaging light and heat of the sun. It was no coincidence that recent years had seen developments in the science of restoration, including the transferral of paintings from wood supports to canvas. One of the most important pictures in the royal collections, Raphael's *Saint Michael*, painted for Francis I and once hung over Louis XIV's throne at the Tuileries, was saved from destruction through this process, although the problems resulting from the method are only just becoming apparent. The techniques of restoration resonated as well with the enthusiastic, educated aristocracy that was fielding the scientists of the day, while conveniently masking the king's refusal to send major works from his collection at Versailles.

Even as the Luxembourg exhibition opened, there was much politicking behind the scenes in favor of giving permanent space in the Louvre to a museum. The Salon, the show of contemporary art by members of the Royal Academy, had been open to the public since its inception in 1672. Perhaps by extension, since it abutted in the Salon Carrée, the Grande Galerie was, almost from the beginning,

the focus of the movement for a national museum in the royal palace. It is interesting that this movement, supported by the king himself, was taking place when the balance of power between the monarch and the people was increasingly in question, with the king attempting to maintain the absolutism reaffirmed by his predecessors. Discussions of restoration suggested that, more than the reigning king's personal possessions, the royal collections were a national patrimony. At the same time, restoration of the paintings in the royal collections, made public in the course of the preparation for the exhibition in the Luxembourg Gallery, had metaphoric weight, implying prudent stewardship generally, and hence good government—in a period when both were in short supply.

Other reasons prompted a permanent public exhibition: a vocal current of criticism argued that French painting had declined since the days of the old king, Louis XIV. In the second quarter of the 1700s, the quality of the applicants for the Prix de Rome—which sent French students to the Eternal City to study with living masters and learn by copying the masterpieces of the greats—was so abysmal that the prize was not awarded at all for several years. Exposing the "protected" students of the Academy to great models in Paris would give them a head start; it would also "prevent the kind of infatuation that is so common among the young following their arrival in Rome," as the painter Jean-Baptiste Pierre wrote in a letter of 1775. Between the lines, he was suggesting that they learn from the great French as well as Italian examples. Nor was France the only state to recognize the didactic value of public exhibitions: when Pope Benedict XIV acquired a group of paintings in 1748, he was moved to place them on public display, in part "to provide instructive examples for the young people who are inclined to the study of the Liberal Art."

The organizers of the Luxembourg exhibition were following contemporary art and art education theory when they juxtaposed the paintings of the great European masters so as to allow burgeoning artists

The rage of a portion of the public towards the foreign-born alleged spendthrift Marie-Antoinette is evident in this 1791 political cartoon. The title, *La Poulle d'Autru(y)che*, is a play on words, identifying her as both "the ostrich hen" and "the Austrian whore." The caption reads: *I digest gold and silver with ease, but I can't swallow the Constitution.*

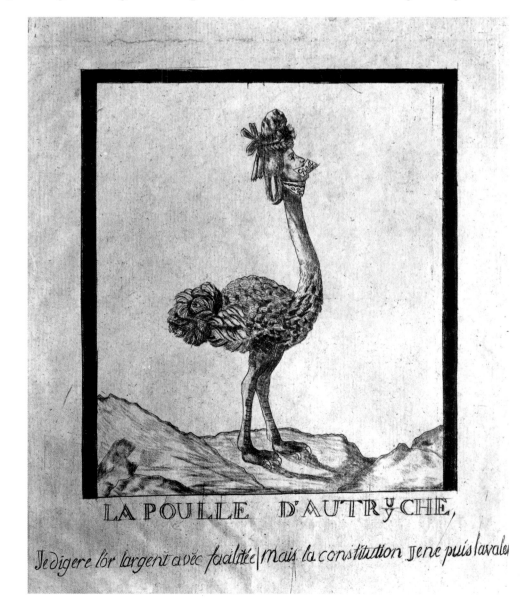

LA POULLE D'AUTRYCHE,

Je digere l'or l'argent avec facilitée mais la constitution je ne puis l'avale

to compare their forebears' strengths and weaknesses, and so improve their own work. For three hours on Wednesdays and again on Saturdays, the public could peruse works such as Rubens's Marie de Médicis cycle, once reserved for nobler eyes. The galleries were open mornings in the shorter winter days, and in the afternoons in summer.

Louis XV died in 1774. Four years later, Louis XVI gave the Luxembourg Palace to his brother, the future Louis XVIII, and the gallery was closed the following year. Although during the quarter century of the Luxembourg exhibition various forces had converged toward installing permanent public galleries within the Louvre—with judiciously placed rumors sampling and rousing support— any movement toward making the Louvre the home of the royal exhibition spaces was ultimately frustrated by the condition of the buildings. The north and east wings of the Cour Carrée were floorless and roofless shells; chance-planted urban saplings were growing on the unfinished roof of Perrault's Colonnade.

The halls of the great edifice that had rung with music and singing now echoed with the orotund tones of artistic and scientific discourse. Where the menageries of monarchs had stalked, squawked, and crawled, now a stuffed camel, elephant skeleton, and pickled body parts fueled scientific debate. In particular, the Grande Galerie was given over to scale models of French towns, of primary importance for military use. Every part of the royal palace was either occupied or uninhabitable.

Besides the academics, artists, and squatters in the royal halls, a shantytown had gradually grown up in the Cour Carrée. In 1754, so shameful was the appearance of the royal palace of Paris, that the outraged people of the city demanded that the king address the Louvre's shocking state. Money was tight, but in response to the strong, perhaps already menacing expression of popular discontent, Louis XV had the courtyard vacated, some of the façades restored, and a narrow esplanade cleared in front of the Colonnade. However, with little space available in front of it for the grand landscaping its scale requires— the Colonnade is across from the venerable, immovable royal parish church of Saint-Germain-l'Auxerrois, whose façade was classicized in 1754—Louis XIV's grandiose would-be entrance reads as an architectural afterthought, an irrelevant side door.

Work on the Grande Galerie was set to begin in 1773, but with the accession of Louis XVI in 1774, Charles-Claude de Flahaut, Comte de la Billarderie d'Angiviller became the king's director general of royal buildings, a position of vast scope. Although his background was in the military, not remotely the arts, the comte d'Angiviller in 1776 made the creation of a museum in the Louvre his personal project, taking on the best in their fields as consultants. Despite a general consensus that France would be well served by a museum—however that would be defined—the logistics, and the finances, were something else again. Once the Grande Galerie was selected, two major problems were immediately obvious: what to do about Poussin's painted ceilings, left unfinished when the artist had returned in a huff to Rome in the early 1640s, and how to light the gallery.

At first, the king gave generously to the project, enabling D'Angiviller to pursue his acquisition program of buying not only some of the most important European masterpieces that came on the market, but also significant works by lesser artists. The count's plan was to fill in gaps in the national schools in the royal Old Master collections, while boosting the presence of French artists. In addition, D'Angiviller's conservation standards were high, and his subsidy of restorers promoted major improvements in restoration techniques. After much debate, Poussin's wooden ceilings, which represented a serious fire hazard, were torn down. It was France's support of the American Revolution from 1778 to 1781 that abruptly cut off the count's inspired buying spree.

By early 1789, desperate economic conditions and the king's stubborn wavering on accepting a constitution had brought tensions in Paris to an explosive point. In July, the people took arms from the Hôtel des Invalides and cannon from Charles V's Bastille. On October 6, 1789, insurrectionists broke into Versailles, cut down the king's guard, and almost breached the royal apartments. Fearing for his life and his family's, Louis took General Lafayette's advice and returned through a furious, screaming press to Paris and the Tuileries. The Constituent Assembly took over the nearby Salle du Manège, the royal riding school.

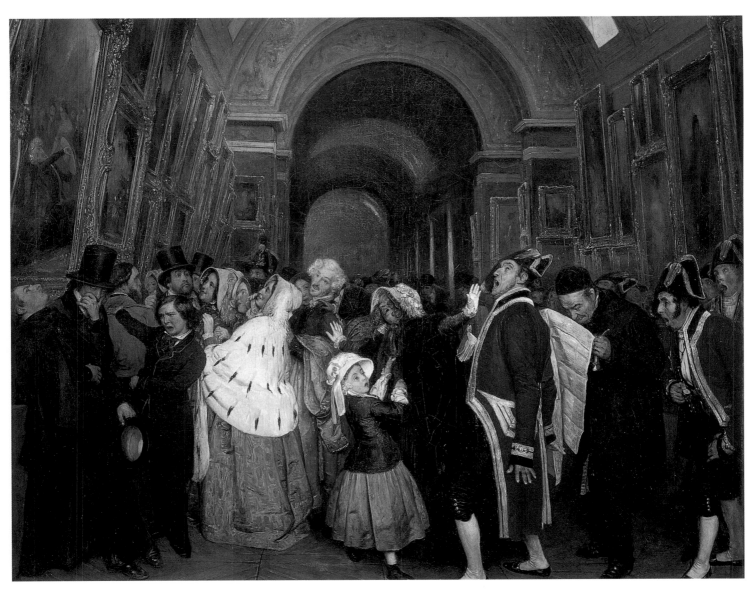

François-Auguste Biard. *Four O'Clock: Closing Time at the Louvre*. 1847. Oil on canvas. 22 ⅝ x 26 ½ in. (57.5 x 67.5 cm).

During the years of the Revolution, the debates concerning the makeup of a national museum continued, even as the new nation itself took shape, in the tensions created by its own emerging identity, and increasingly under attack at its borders. Revolutionary politicians and theoreticians proposed a universal research institution embracing the arts and sciences, modeled upon the famous *musaeum* of ancient Alexandria; this concept eventually went by the board, outweighed by the educational value of an art museum to French artists.

In particular, the Royal Academy of Painting and Sculpture, like the Academy of Science, was organically bound to the Ancien Régime, not only because it was supported by the king, but because the themes that it passed down to its students were perceived as reflecting and serving a privileged elite, and restricting the education available to artists. The idea of creating an inferential system of education, whereby artists drew logical lessons from great works themselves, as well as from classes, was, like the Revolution itself, an outgrowth of two contemporary related intellectual currents: Enlightenment discussions of "nature" and Romantic emphasis on the individual. In one respect, the art-educational revolution went further than its political counterpart: where the progressive waves of enfranchisement concerned only males, several of Hubert Robert's drawings and paintings of the Louvre project prominently feature women drawing after the masterpieces in the Grande Galerie.

On August 10, 1792, the people took the Tuileries, forcing the royal family to seek refuge in the keep of the Temple, which was, in the round way of history, built during the reign of Saint Louis. On that same day, Louis XVI was jailed and stripped of the executive powers briefly granted him by the new constitution. The right to vote, in an earlier stage tied to property ownership, now became "universal,"

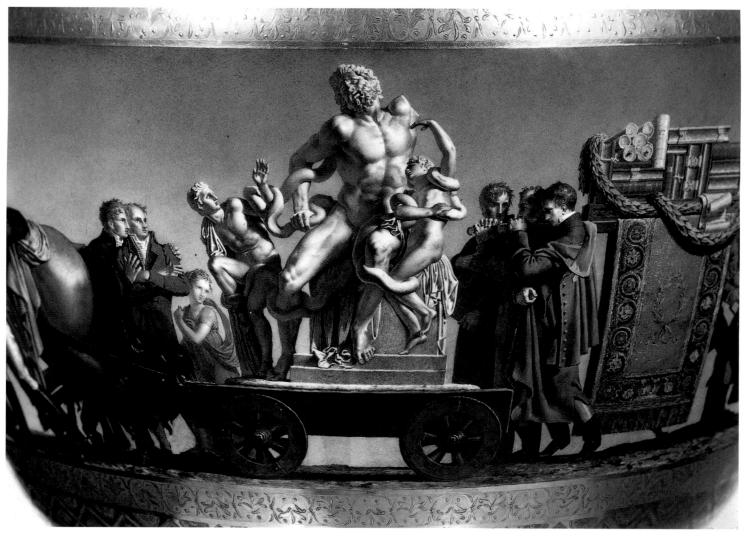

Antoine Beranger. Detail from a Sèvres china vase depicting the entry into Paris of the artworks (here, *Laocoön*, from the Vatican collection) destined for the Musée Napoléon. 1813. Porcelain.

that is, extended to all freeborn males. The feudal lords in effect lost their hereditary rights, and the National Assembly pushed the previous years' anticlerical reforms further, exiling more than thirty thousand clergy who had refused to swear a loyalty oath. When the convents were closed, and the religious orders and congregations dissolved, their property went to the state; this transfer would have profound consequences for the new national museum.

The monarchy was formally abolished on September 21, 1792, and the Republic declared the following day, which would become the first day of the Revolutionary calendar, but these cool legalisms merely formalized the heated events of August. The following January, the former king was tried, found guilty of treason, and executed; Marie-Antoinette, his queen, would follow him to the guillotine in October. In between, on the very deliberately chosen date of August 10, 1793 (23 Thermidor, Year I), what was now called the Muséum Central des Arts opened the doors of the Grande Galerie to the public, fulfilling the decree of the National Convention.

The first exhibition, held alongside the annual Salon exhibition of works by living artists, displayed 538 paintings and other objects from the former royal collections. Both exhibitions were temporary, and closed on September 30. The Galerie du Muséum Central des Arts opened permanently on the following November 18. The galleries were open to artists on the first five days of every *décade*—the ten-day week of the Revolutionary calendar—while the last three days were accessible to the general public. The two days in between were dedicated to cleaning and other maintenance tasks.

Even as the thirteen-hundred-year-old French monarchy tumbled in the blood lust of the Terror, the Louvre retained its legitimizing power. Hundreds of thousands of *livres* the new regime could scarcely afford went to roof the last buildings of the Cour Carrée and restore the great paintings of the royal

collections, in one of the most conscious and urgent—but also most idealistic—public relations efforts of all time. D'Angiviller had sent the military models to the Invalides, so the Grande Galerie could be prepared for the exhibition that would welcome the people into the palace that now belonged to the nation. There, they would see objects that had once been the privileged possessions of the ruling class but that now belonged to them. According to the July 27, 1793, decree of the Convention, the museum would house not only paintings and sculpture, but also "vases" and "painted furniture." (In this, the Revolution was following in the traces of the royal plans, which had called for setting smaller works upon fine furniture.) The museum's administrators, although for political, rather than class considerations, followed the direction of the Ancien Régime in the matter of taste as well, disdaining to hang in the Louvre the more accessible works, particularly landscapes and genre scenes, that were popular with the less instructed audiences that visited the Salons, but would hardly inspire them with Revolutionary zeal.

The rigorously secular Revolutionary government was concerned about displaying religious works, but concluded that decontextualizing them removed the taint of religiosity. More problematic were the masterworks that exalted the monarchy, but whose quality demanded that they be shown. The Marie de Médicis cycle was an obvious case in point. *The Treaty of Angoulême* was chosen, because it celebrated an event in French history with allegory; traces of the monarchy were discreetly painted out.

Initially, the paintings—hung from ceiling to floor, after the style in the aristocratic *cabinets*—were organized following the same didactic principles as in the Luxembourg, that is, grouping works in such a way as to highlight specific formalist categories. However, within a year the scientific model prevailed, and works were rearranged chronologically and by national school, the organization most museums have had ever since. This taxonomy, besides mirroring the organization by genus and species, implied an evolution that in effect exalted the French school, the latest paintings in the exhibition. The works on display were not only from the former royal collections, but confiscated from religious institutions and from the aristocratic émigrés who had fled the country. The walls crowded with paintings were not universally admired—the poet and critic Paul Valéry wrote in 1923, "Only a civilization without a sense of pleasure or reason could have set up this house of incoherence." Today, this tiered hang, though modified, still obtains in the Grande Galerie and elsewhere, in part precisely because a number of paintings were composed to be viewed from below.

Everything that museum-goers take for granted today had to be invented: for example, within a few years of the opening of the museum it became clear that what was self-evident to the highly educated leaders of the Revolutionary museum was less so to the general public. The directors of the museum had seen to it that wall labels identified the émigrés to whom the works had once belonged; the idea was to let viewers see that the Revolution had transferred these items to the people. The people, however, lacking a classical education, "mistook the nobility's busts of Plato and Alexander the Great for the Duc de Brissac and the Prince de Condé," the busts' previous owners.

❧　　❧　　❧

About the time the Muséum Central des Arts was opening its doors, a young officer with a mixed record in the Revolutionary Army was languishing in prison, following the fall of Robespierre, whose star he had followed. Soon freed, Napoleon Bonaparte was offered, and declined, the opportunity to head a brigade of infantry. After considering going over to the service of the Turkish sultan, Bonaparte opted instead to join the royalist forces in 1795. He was among the defenders of the Tuileries, leading his artillery in driving off the "Parisian mob," and for his effectiveness and fervor was set at the head of the army in Italy the following year. A few days before leaving Paris, Bonaparte married Josephine de Beauharnais, the widow of a guillotined nobleman and general.

Josephine, too, had known the inside of a prison cell, after the fall of her husband, the vicomte, but she rallied to become a leader of Parisian society as one of the brilliant and influential salonnières. And here one of the most important figures in the destiny of the museum in the Louvre makes his entrance.

Baron Dominique-Vivant Denon, whom events made D'Angiviller's post-Revolutionary spiritual heir, was born in 1747 to a family of landed gentry, whose vineyards in Burgundy allowed him to pursue his artistic training as an engraver and his vocation as a lover. Vivant Denon was in many ways the epitome of

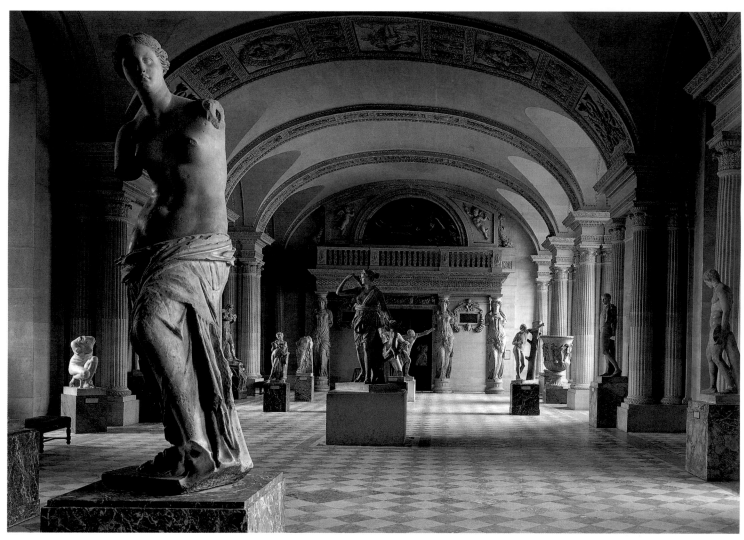

The Greek sculpture hall at the Louvre—formerly the Salle des Caryatides, the ceremonial reception hall of Francis I and Henry II—with the *Venus de Milo (Aphrodite)* in the left foreground.

the Enlightenment dilettante, a word today debased, but once meaning a person who exhibits creditable competence in several fields. His passionate curiosity and his instinctive and cultivated taste, combined with early travels and a political agility that enabled him to survive his country's tumultuous changes in regime, together made him the right—quite possibly the only—person in the right place at the right time.

Denon had spent two long sojourns in Italy; on his return from his first voyage, he sold some 540 ancient vases to Louis XVI, jump-starting an interest in classicism that would sweep artistic expression in every field from clothing and the decorative arts to architecture. (References to the democracies of ancient Greece and Rome also fueled revolutionary governments seeking the aegis of historical precedent.)

Denon genuinely liked women: for the rest of his long life—he would die in 1825—he corresponded with a Venetian woman of letters with whom he had enjoyed a passionate affair while in his thirties and forties. He adapted a medieval reliquary to hold, among other "relics," a lock of the hair of Agnès Sorel, the famously beautiful mistress of Charles V. His attraction to the salon of Josephine de Beauharnais, however, was probably prompted by ambition as much as by pleasure in good conversation, and in 1798 Vivant Denon was off to Egypt with Bonaparte.

Though the Egyptian campaign was not a great military success, Denon was thrilled to discover artifacts that he was among the first to identify as preceding and inspiring Greek, hence Roman, hence European culture. As with the art of ancient Italy, his taste and fervor—not to mention crates and crates of mummies, canopic jars, statuettes, winding cloths, and so on—found their way back to Paris. Denon also wrote and illustrated what became a turn-of-the-century bestseller about the expedition: published in France in 1802, it appeared that same year in the English translation of Francis Blagdon as *Travels in Upper and Lower Egypt in Company with Several Divisions of the French Army under the Command of General Bonaparte.*

Vivant Denon's dedication in *Travels* says much about him as a courtier (although his language was not excessive for the period), but more about his concern for historic preservation:

To Bonaparte
 To combine the Lustre of your Name with the splendor of the Monuments of Egypt, is to associate the glorious annals of our own age with the fabulous epocha of antiquity; and to reanimate the dust of Sesostris and Mendes, who like you were Conquerors, and like you Benefactors.

In 1802, Bonaparte was acclaimed consul for life, a step closer to the "Cesarization" Robespierre had pessimistically foretold. The new consul named Denon director of what was now the Musée Central de la République; the following year, Denon, displaying some foresight himself, renamed the galleries the Musée Napoléon. The regal first-name appellation proved prophetic: in 1804, Bonaparte crowned himself emperor at Paris.

Denon's goal was to make the Louvre "the world's most beautiful institution," and he succeeded. Called "Napoleon's eye," he traveled in person, or sent emissaries with shopping lists, in the wake of Napoleon's military victories and diplomatic treaties. Denon's imperial forces plundered Italy especially, in keeping with the French art establishment's grudging acknowledgment that it was that country that had produced Europe's greatest artists. Now, however, French artists would have the home advantage. During Napoleon's reign, over five hundred paintings were taken from the Vatican alone; among the Pope's sculptures, was the celebrated *Laocoön*, an ancient Greek marble that had been unearthed in Rome in 1506. Denon was the first public person to value painters such as Cimabue, Giotto, and other "primitives," as the artists preceding Raphael were called, and he proceeded with a specific pedagogic program in mind: to illustrate not only the lineage of the masters—what they learned from *their* masters—but the recognizable spark of genius that is independent of any academic, transmittable skill.

The indefatigable baron also directed the Sèvres and Gobelins factories and the manufactory of medallions known as the Monnaie, hiring the most prominent French artists of their day, among them, Antoine-Jean Gros, Jacques-Louis David, François Gérard, and Pierre-Paul Prud'hon. Through these directorships, Denon was influential in shaping the Empire style in the decorative arts.

Denon was a gifted and enthusiastic propagandist, but Napoleon was aware himself of the value of public display. Taking a leaf from his imperial Roman predecessors, he choreographed triumphs, victory processions in which the greatest works of art of conquered Europe were paraded before the people. Newly designed services of Sèvres china showed these processions, illustrating for example, the *Laocoön* drawn in a chariot, a captive of the French emperor and his "eye."

Some of Europe's most magnificent works of art were pouring into Paris, and straight into the Louvre, no longer a national museum, but an imperial one. As in Egypt, Napoleon was not just a conqueror, but a benefactor, or so the party line went, and not without justification. France's—and thus the world's—greatest restorers took on the hundreds of paintings that arrived over more than a decade and a half, and there is little doubt that a number of works would have eventually disintegrated, had their destiny not made them spoils of war.

Meanwhile, Napoleon, too, sought to claim the Louvre, although he lived in the Tuileries. In 1809, he divorced Josephine and when, for reasons of state and procreation, he married the archduchess Maria Louisa of Austria the next year, it was down the quarter mile of the Grande Galerie that he processed with his second, more imperial, and, he hoped, more fertile bride to the Salon Carrée, temporarily transformed into a wedding chapel.

In 1806, Napoleon had evicted the last of the academicians, including David and Jean-Honoré Fragonard. His favorite architects, Charles Percier and Pierre Fontaine, replaced the roofs of the Cour Carrée, and restored and completed its façades, more or less in keeping with Pierre Lescot's Italianate Renaissance flavor and Jean Goujon's strong and sinuous caryatids. At long last, the overhead skylights that D'Angiviller's committees had recommended were set into the roof of the Grande Galerie, and an

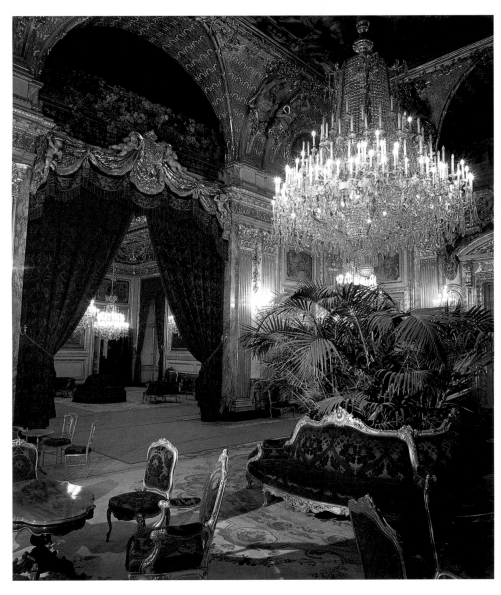

The plush, ornate interior appointments of the Grand Salon of Napoléon III's private apartments.

intensive program of interior decoration carried out. A wing was begun from the Tuileries parallel to the Grande Galerie, and another piece from the north side of the Cour Carrée. An avenue was plowed through the Paris quarter that still occupied the ground between the two palaces, to allow the emperor to move more regally between his residence in the Tuileries and his imperial palace. A triumphal arch erected on the Carrousel and modeled on that of Septimius Severus in Rome was the occasion for testing Napoleon's ability to absorb hero-worship: Denon had an immense lead statue of the emperor set atop the arch, but an embarrassed Napoleon ordered it taken down immediately after the statue's inauguration. It was replaced with the four horses from Saint Mark's Basilica in Venice.

Napoleon's downfall in 1814–15 had cataclysmic results for the museum that bore his name. When the victorious allies demanded their art back, the restitutions concerned some five thousand works of art; the imperial collections were effectively disassembled. Estimates of just how much of the art was returned vary from about 80 to 95 percent (about half of the Vatican's paintings remained in France, and a handful of pieces fell between the bureaucratic cracks). The disintegration of his beloved museum was too much even for the resilient Denon. In October 1815, he wrote a correspondent: "Amazing circumstances raised an immense monument; circumstances no less extraordinary have just toppled it. It took the conquest of Europe to create this trophy of war; all of Europe had to unite to destroy it."

But the museum was far from destroyed; it now had a destiny of its own, independent of any regime. Paintings, drawings, and decorative objects; southwest Asian, Egyptian, and Greek, Roman, and Etruscan sculpture; and Renaissance and contemporary statuary occupied the Cour Carrée, the Grande Galerie, and the Petite Galerie. When the Musée des Monuments Français—whose director, Antoine Lenoir, risked his life to save a selection of his nation's great sculpture during the Terror—closed in 1816, its treasures went to the Louvre. The Enlightenment's passion for classical Greece, now become the science of

archeology, was bringing the splendors of those centuries into the Louvre: the *The Venus de Milo* entered the collection in 1821, revitalizing the Department of Antiques. In 1826, under Charles X, the Egyptologist Jean-François Champollion, who deciphered the hieroglyphs, founded the Egyptian division and was named its curator. The "Assyrian museum" was created in 1847. Over the next three-quarters of a century, as France expanded its colonial presence, the nation became a birthplace of explorers, who in many cases brought their spoils to Paris and the museum in the Louvre.

Throughout the nineteenth century's convulsive, often bloody succession of regimes, monarchs and republicans alike continued Henry IV's Grand Plan. Louis XVIII, a brother of the executed king, continued Napoleon's north wing, and sponsored interior decoration and renovation projects. The Second Republic, instituted in 1848, reorganized and restored the interior of "The People's Palace," to keep up with the flood of acquisitions and gifts. The rooms of the Grande Galerie were designed to guide viewers through the installations—one of the first museological initiatives. The republican administration also established a museum of "ethnography"—African and Asian works—in the Cour Carrée, which housed a naval museum as well. The complex of exhibition spaces was christened the Musée du Louvre.

The president of the Second Republic, Louis Napoléon Bonaparte, nephew of Napoleon I, had been elected in 1848 for a ten-year term. Three years later, he engineered a coup d'état, and in 1852 proclaimed himself the emperor Napoléon III. That same year, he turned his energies to the "Nouveau Louvre"; over the next decade and a half, he would raze the last city structures within the Louvre–Tuileries precincts and finish the north gallery, thus enclosing the Tuileries gardens and the Carrousel.

In addition, the imperial architects, Louis Visconti, then Hector Lefuel, doubled the wings of what are now the Cour Napoléon, in order to adjust for the axis of the wings between the Cour Carrée and the Tuileries. This created the small courtyards that today house sculpture from several epochs. In the Denon Pavilion, where once the Prince Imperial took his riding lessons, the handsome brick vaults shelter antique marbles—but in a small, yet-to-be restored courtyard, a viewer may see the shallow, curving stairs up which the emperor's horses were led into the Salle du Manège. The emperor's initial, within a garland of laurel, crowns the roofs of the pavilions facing the Cour Napoléon. Although the State Department and other administrative offices, including the Office of Finance, would later occupy them, Napoléon built private apartments in the north wing of the Richelieu Pavilion. In 1870, with the empress Eugénie and their son, he moved in, the first ruler to live in the Louvre since Louis XIV had abandoned the palace, the heart of the city he feared and hated.

The Grand Salon of the emperor's apartment, originally the offices of the Ministry of Finance, is grand indeed, but it is also a comfortable, sociable, aristocratic drawing room in the plush and splendid Victorian manner. Fifteen crystal chandeliers add festive brilliance to the ornate surroundings, a sumptuously elegant composition of gilt stucco, mirrors, ormolu, putti, marble and bronze fireplaces, and frescoes. Looking down upon all this imperial grandeur are four lunettes, a series of paintings known as the Étapes du Louvre—the stages of the Louvre. There, framed in gilded arcs are Francis I, Catherine de Médicis, Henry IV, and Louis XIV. And holding pride of place in the center of the ceiling is *The Joining of the Louvre and the Tuileries by Napoléon III*. Literally central to Napoléon III's identity as ruler of France, to his right to live in the palace, is the palace itself.

The imperial family would spend little time in the Grand Salon. In 1870, during the Franco-Prussian war, Napoléon III was taken prisoner and held until the peace treaty of March 1 of the following year. He was deposed in absentia by the National Assembly in Bordeaux, which declared him "responsible for the ruin, invasion, and dismemberment of France." In the capital, the insurrectionist Paris Commune had taken over. The repression cost tens of thousands of lives—more than the sanguinary months of the Terror of 1793–94.

On May 23, Communards set fire to the Ministry of Finance, the Tuileries, and the Louvre library, among other architectural and historical treasures. The Tuileries Palace was in ruins. During the first decade of the hard-won Third Republic, the broken walls and masonry rubble of Catherine de Médicis's creation stood like a ghost palace amid the manicured gardens, an accusation and a propaganda problem.

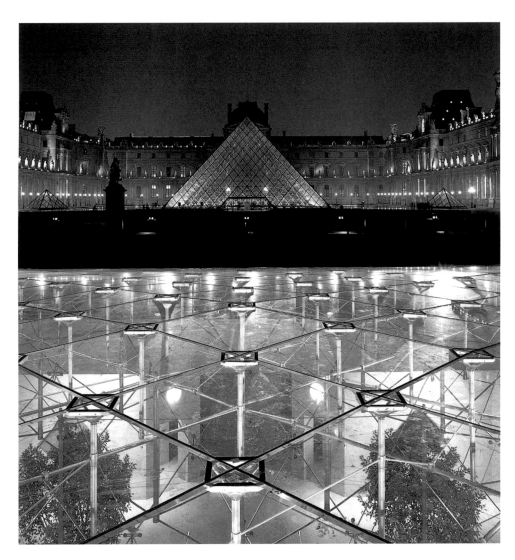

In the foreground, one of the planes of geometric webbing that reveals the Hall Napoléon (housing visitors' services) below.

Finally, in 1882, the ruins were cleared, opening the Louvre westward, to the Place de la Concorde—once Place Louis XV, then Place de la République, where Louis XVI was beheaded—with its obelisk, and beyond it to the Champs-Élysées and the broad avenues of Haussmann's Paris. (Baron Haussmann's *grands boulevards* epitomize the thinking of their imperial patron, Napoléon III: vast and splendid, they not only facilitated circulation, but permitted the imperial guard to monitor the formation of mobs—and to shoot cannon at them.)

In the last decades of the nineteenth century, the Louvre refined its identity, spawning new museums with the works it shed. During World War I, the greatest masterpieces of the world's greatest museum were evacuated, as they were again from August 1938 to December 1939. The plans to save the Louvre's artworks had been made even before the Munich agreements of 1938, but thousands of crates had to be built. The Louvre, still mainly a government building housing administrative offices, had only one truck, so transport was borrowed from the Samaritaine, a nearby department store. Two days before war was declared, all the art in the Louvre was out of Paris, its priceless treasures sent out to châteaux throughout France, sometimes only a step ahead of the advancing Germans. The Resistance kept the British informed of the artworks' movement, which allowed the BBC to mount an effective propaganda campaign, emphasizing the success of the Resistance.

Also in the 1930s, Lefuel's unfinished staircase was completed, and the *Winged Victory of Samothrace*, her mighty wind-whipped wings raised aloft, was set on her prow on the landing. Only one work of twentieth-century art graces the palace: in 1953, Georges Braque was commissioned to paint his bright blue *Birds* on the ceiling of Henry II's soberly wood-paneled antechamber—a happy and unique marriage of styles.

With the jet age—the era of international mass transit—beginning in the mid-1960s, the Louvre, already beloved by Parisians and the French generally, became one of the globe's most popular tourist destinations. By 1977, three million people a year were visiting the museum, and the strain was beginning to be felt. In 1981, François Mittérand, president of the French Republic, unveiled the Grand Louvre

project, born as much from a pragmatic assessment of the Louvre's situation as from the principle that the leader of a nation owes a legacy to the people of that nation.

Although some accused the president of self-aggrandisement, the fact was that the number of visitors was growing geometrically, to a point where only a reconceived new infrastructure could meet the museum's needs. The museum's some 34,000 holdings—ranging from the *Mona Lisa* to pottery shards to thousands of ancient amulets—required more room and better conditions. The Louvre's vast technical and scientific projects needed more space. Mittérand approached Pei Ieoh Ming with the project; Pei's plan called for the Louvre's last non-museum occupants, the Ministry of Finance, to move. (In an interview Pei pointed out that the president and he were thus in the position of evicting the very people they were asking for money.)

Pei's plan is both ambitious in its scope—the Louvre now receives on average some five million visitors a year, and the museum complex includes cafés, a restaurant, shops, parking, even a post office—and modest in its relation to the nineteenth-century edifice—the glass of the pyramids is specially made to be as transparent as physically possible. From below, the delicate geometric webbing, borrowed from the rigging of a World Cup sailboat, sets off the stolid grandeur of Napoléon III's pavilions, while the entire structure allows maximum daylight down into the Hall Napoléon, where the visitors' services are located.

The Burgundy stone used throughout the new spaces provides continuity with the warm tint of the original limestone, mediating between boldly sober architectural elements and the varied historical environments of this living edifice. In the Hall Napoléon, below the pyramid's understated webbing, two staircases connect the street level and the floor below; one of the two staircases is a spiral. While this allows for an elevator at its core, it is also a tribute to an earlier architect and his celebrated *escalier à vis* in Charles V's late-medieval castle. This combination of taste, tact, and utility is the secret of the success of the Grand Louvre: the goal of supporting the art and serving the visitor is evident everywhere.

If Mittérand's choice of a non-French architect was controversial, Pei's pyramid, inaugurated on March 30, 1989, was far more so. Yet it is a—literally—lucid solution to a number of requirements, including the French president's only aesthetic condition: "No pastiche." It is also only the visible tip of the radical work undertaken so far for the Grand Louvre, which is far from finished, just as the museum continues to evolve, with bequests and acquisitions changing the shape of the collection. The first stage of Pei's project was underground, where archeological excavations cleared the area around the base of Philip Augustus's great keep, first identified during excavations in 1866. Visitors approach it after walking through the former moat around Charles V's walls, below the Cour Carrée. The dramatically lit tower, which so impressed Philip Augustus's contemporaries, is a solemn edifice, its blind walls rising into the shadows.

Even musing, a visitor can walk around the part of the Great Tower that is accessible in much less than a minute; Philip Augustus's entire castle took up one-quarter the area of Louis XIV's Cour Carrée. Yet, this, the Louvre, its very name lost in legend and speculation, was the determined heart and beginning of France. It is far more than a symbol—or else it reminds us of the timeless strength of symbols.

Returning to street level, the visitor approaches the Cour Napoléon from the lively Tuileries Gardens and the Carrousel, its triumphal arch now little more than a benign architectural folly amid the crowds, the parterres, and the neat rows of chestnut trees. At first approach, the Pyramid seemed outsized, arrogantly dwarfing the stately, slightly stuffy buildings surrounding it, making them look overdressed, almost dowdy. Now, it is a transparent reference reaching delicately, deftly into the past, a gently ironic tribute to Napoléon's unsuccessful military foray into Egypt, to the sixteen pyramids that greeted the third convoy of masterworks to arrive at the first emperor's Louvre, and to Denon's and Champollion's profound and far more long-lasting contributions. The pyramids go back further still, to the earliest pieces in the museum, and back to the very source of Mediterranean art and culture and the pharaoh's tombs, meant to last forever.

Time is deconstructed in this palace and its courts, built over lifetimes: the tiny clock face of the artisan-king Louis XIII's Pavilion de l'Horloge rises behind and above the pyramid, like a temporal moon, a mechanical toy marking minutes and hours above a reminder of millennia, of queens, emperors, pharaohs, and the ceaseless quest for beauty, human dignity, and peace.

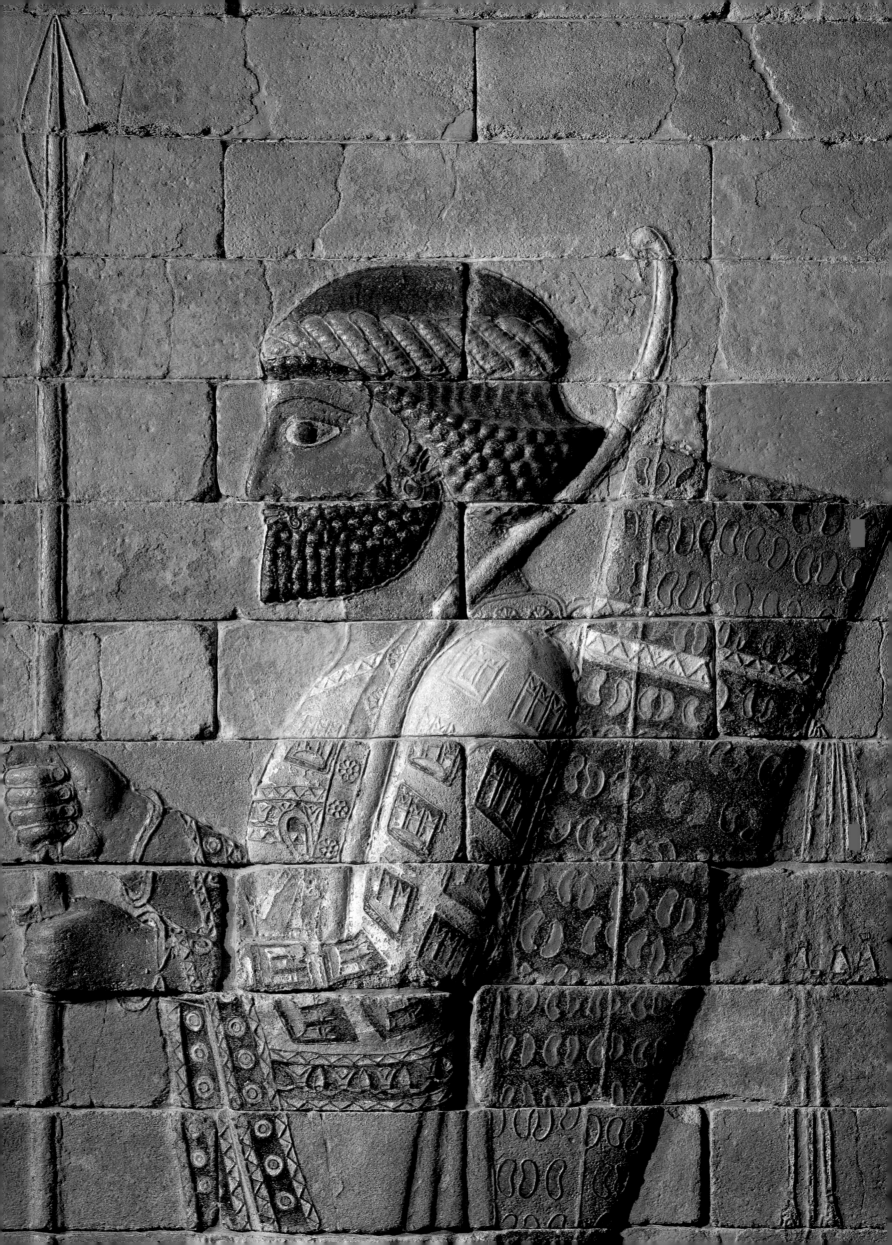

~ ORIENTAL ANTIQUITIES

Idol of the Eyes. Northern
Mesopotamia. 3300–3000 B.C.
Terracotta. 10 ⅝ inches
(27 cm) high.

At the same time that some artists,
especially in Uruk, in southern
Mesopotamia, were sculpting
representational reliefs, others were
making abstract figures such as this
one, shaped by hand of terracotta,
and assumed to have been
intended for ritual purposes.

LEFT
Painted Goblet. Susa. c. 5000–4000
B.C. Painted terracotta. 22 ¾ inches
(58 cm) high;
6 ¼ inches (16 cm) diameter.

The design of this goblet is
sophisticated and witty: the top
register shows ranks of cranes
elongated vertically, the one below,
running dogs, elongated in length;
below them, a standing ibex, or
wild goat, is composed of triangles
and sweeping circular horns,
symbols of the animal's energy.

P. 38
The Archers of Darius (detail).
Susa. c. 500 B.C. Glazed brick.
78 ¾ inches (200 cm) high.

Stele of Naram-Sin. Mesopotamia. c. 2250 B.C. Pink sandstone. 78 ¾ x 41 ⅜ in. (200 x 105 cm).

Naram-Sin—"Beloved of the Moon-God"—here celebrates his triumph over the Lullubians of the Zagros Mountains, at today's border between Iran and Iraq. In this delicately carved and artfully composed relief, Naram-Sin, who tramples his defeated enemies underfoot, wears a horned headpiece indicating his divinity.

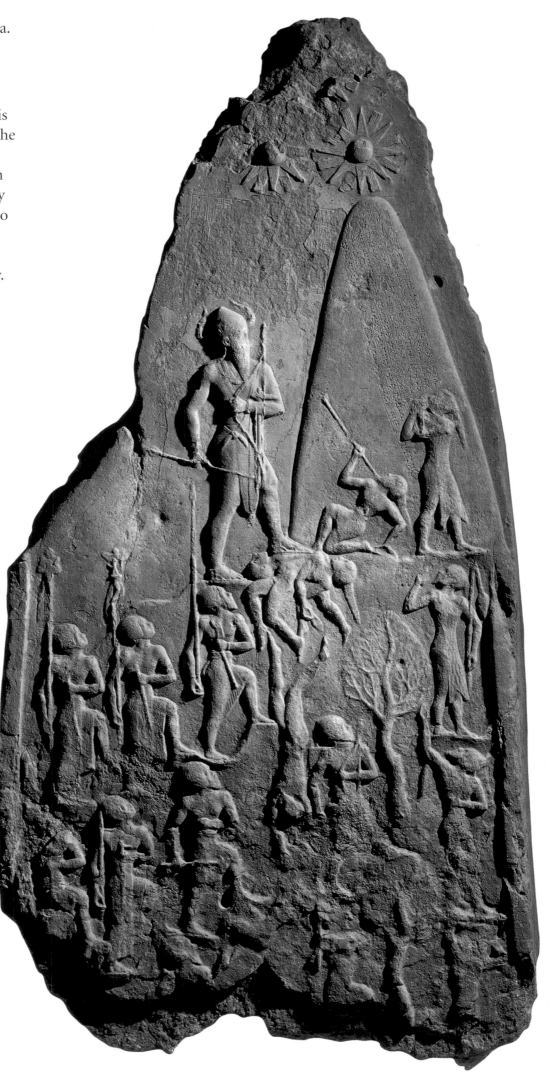

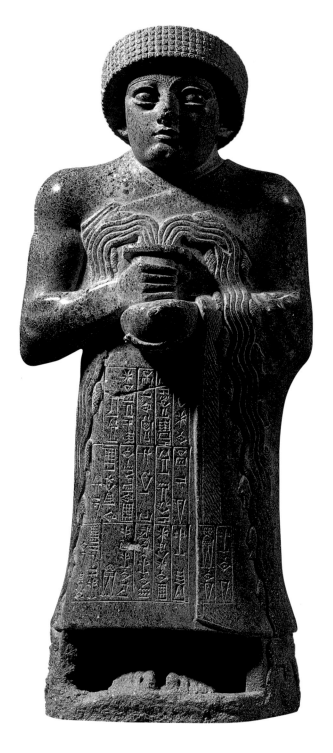

LEFT
Statue of Gudea (with Overflowing Vase). Sumer. 2140 B.C. Dolerite. 24 ⅜ inches (64 cm) high.

The discovery of Lagash inspired the founding of the Louvre's department of Oriental antiquities in 1881. This monumental sculpture depicts Gudea, a prince of that Sumerian city, whose greatest gift to his people was a lasting peace. Here, he provides them with water, life itself.

RIGHT
Woman with a Scarf. Sumer. 2140 B.C. Diorite. 6 ⅞ x 3 ½ in. (17 x 9 cm).

The prince Gudea was a patron of the arts. Since the arts served the monarchy almost exclusively, this lady is most likely a member of the ruling family, probably Gudea's wife. Very striking is the humanism of the treatment, which would only recur in Greece more than a thousand years later.

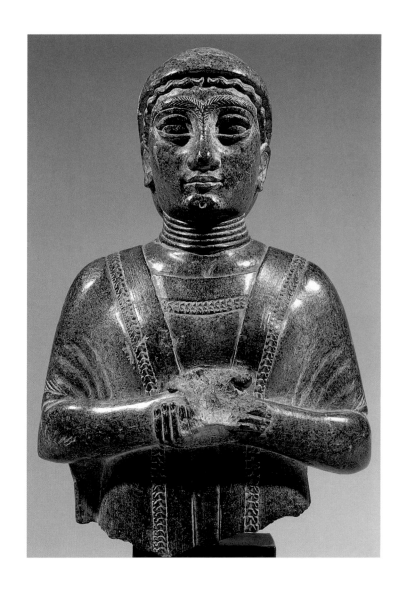

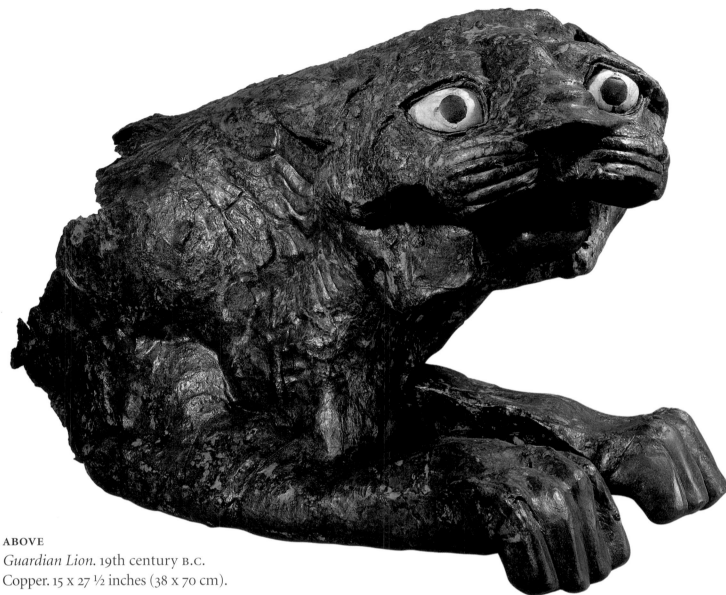

ABOVE

Guardian Lion. 19th century B.C.
Copper. 15 x 27 ½ inches (38 x 70 cm).

This lively creature is one of the
lions who, more powerful than their
size would suggest, protected the
temple of Dagan, a western Semitic
deity, close by the royal palace of
Mari, on the Euphrates. The eyes
have retained the glass inserts—and
the expressiveness these allow—
that much ancient statuary has lost.

RIGHT

Luristan Bronze (Circular Standard).
Iran. 19th–18th century B.C. Bronze.
9 x 7 ⅛ in. (22.9 x 18.1 cm).

Intended to be used in battle as a
visual rallying point, as flags later
were, this standard was made in
what is today western Iran. The
area includes the Zargos
Mountains, whose inhabitants were
conquered by Naram-Sin of the
Akkadian dynasty some four or five
hundred years earlier.

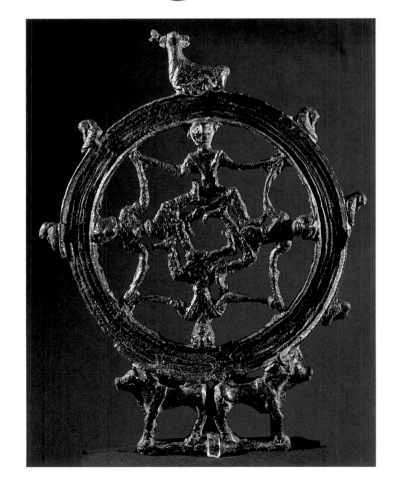

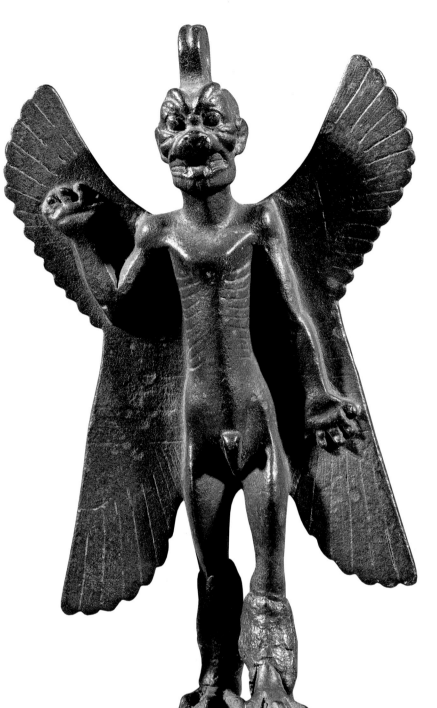

Demon-God. Assyria. 10th–6th century B.C. Bronze. 6 inches (15 cm) high.

An inscription reads: "I am Pazuzu, king of evil spirits, and of the winds that come raging down from the mountains . . . " The grotesque figure stands for "evil," that is, what endangers or harms human beings; the notion of spiritual deformation was a later one. This Assyrian demon may have been the object of fearful propitiation.

Statue of Queen Napirasu. Susa. 1350 B.C. Bronze. 50 ¾ x 28 ¾ in. (129 x 73 cm).

Susa, at the crossroads of trade and nomadic routes, benefited from a lively exchange of cultures. The reign of King Untash Napirisha witnessed dramatic improvements in metalworking: the queen's statue weighs almost two tons. An alphabetic script was coming into use, but cuneiform was used for the queen's name, titles, and gifts to the gods—and for curses against vandals.

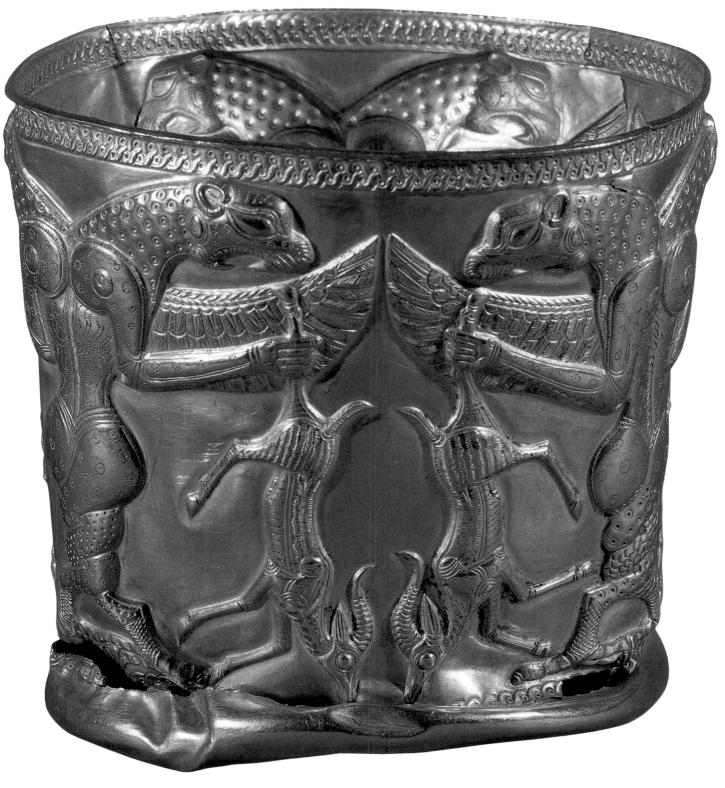

ABOVE

Goblet Adorned with Fabulous Monsters. Northern Iran. 13th–12th century B.C. Electrum. 4 ¾ inches (11 cm) high.

Monsters—those potent combinations of species—originated in Mesopotamia: the entwined birds' legs of these magnificent winged felines end in fierce talons. This regal goblet, from what is today northern Iran, is made of a naturally occurring alloy of gold and silver.

P. 46

Female Idol, Arms Lifted in Prayer. Syria. Terracotta. 5 ½ inches (14 cm) high.

A human petitioner may have fashioned this image as a form of perpetual prayer, to be placed in a god's presence in a sanctuary. The Mycenean figure is from Ugarit, on the Syrian coast of the Mediterranean; the city reached its apogee beginning in 1450 B.C.E., but an earthquake leveled the metropolis some two hundred and fifty years later.

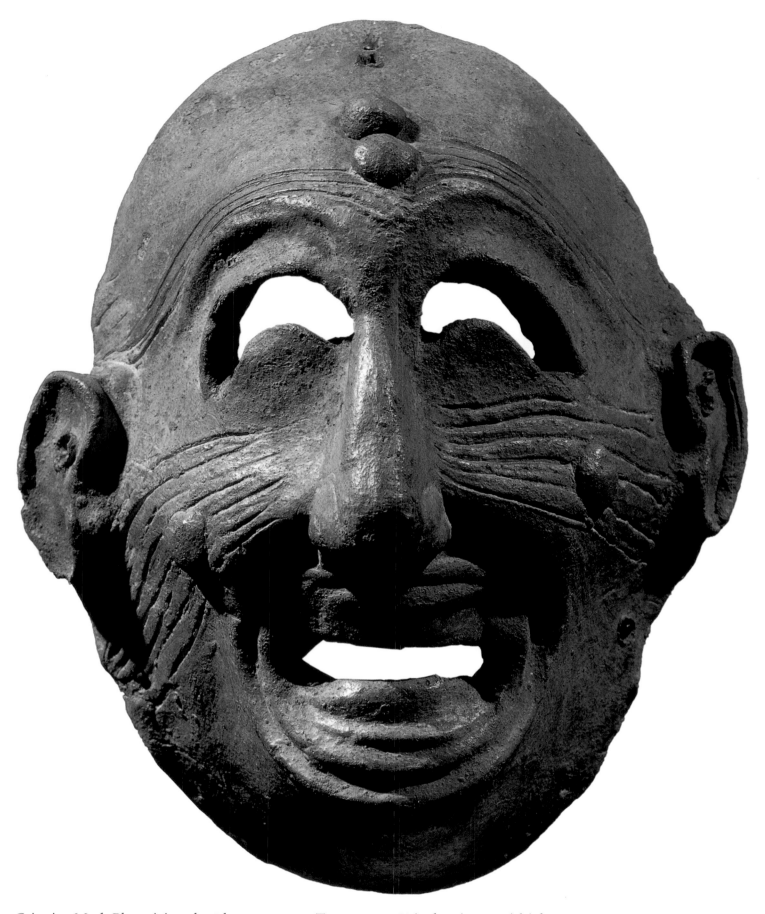

Grinning Mask. Phoenicia. 7th–6th century B.C. Terracotta. 7 ⅝ inches (19.5 cm) high.

The Phoenician custom was to bury a terracotta mask like this one with the deceased; such masks have been found in all the areas of Phoenician influence, including Sicily. The grotesquely contorted features are meant to avert evil, either protecting the dead soul in the afterlife, or the tomb in this one.

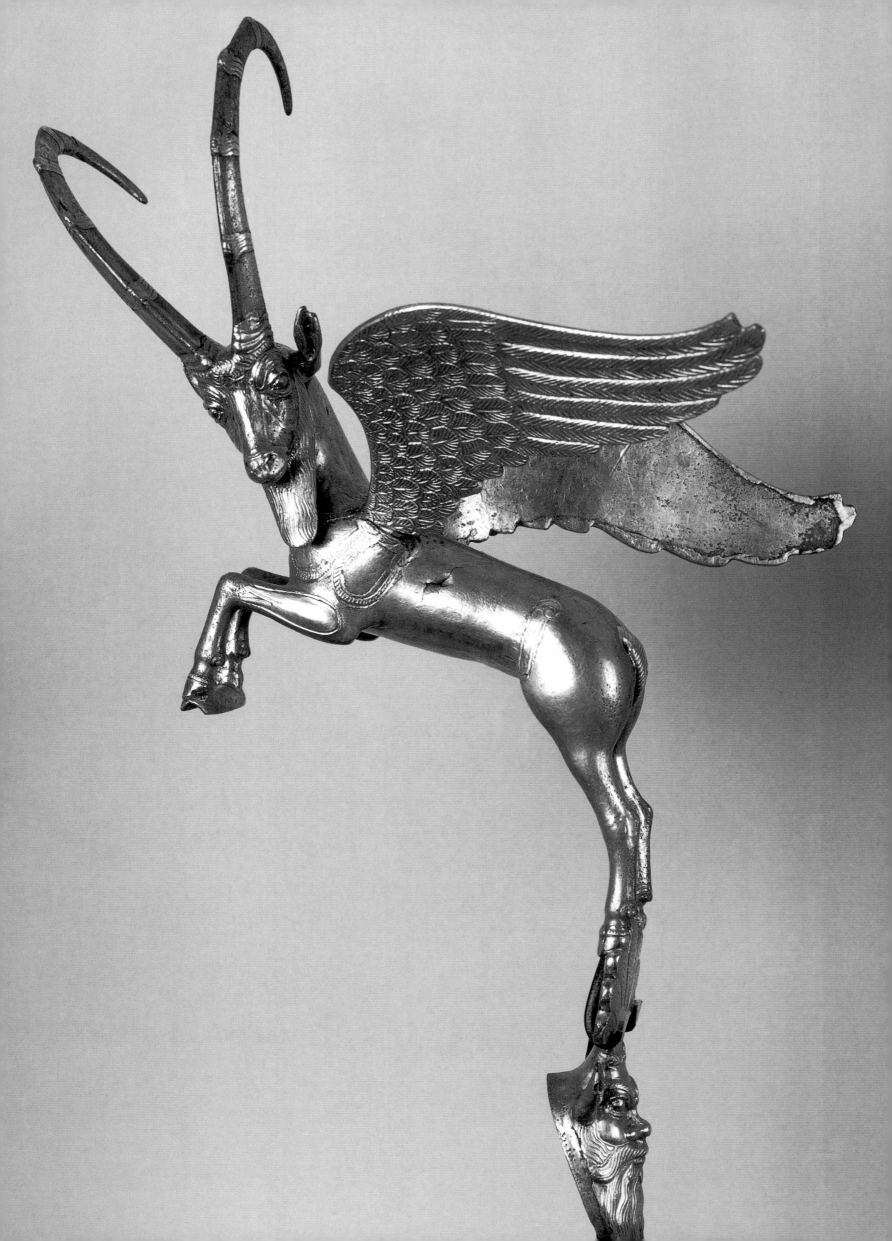

Alabaster Female Figure.
Mesopotamia. 312–64 B.C.
9 ⅞ inches (25 cm) high.

This Babylonian figure displays the decorative Hellenistic style, especially in the treatment of the hair and face; she may have been dressed in fabric clothing. The crescent moon that crowns her suggests her identification as the goddess Astarte, but she may also represent a ritual prostitute.

OPPOSITE

Winged Ibex. Iran. 5th century B.C.
Silver and gold. 10 ⅝ x 5 ⅞ in.
(27 x 15 cm).

This graceful, finely wrought "monster," one of two jar handles, dates to the Achaemenid dynasty, and is Persian in style. Its hind hooves rest on a head of Silenus, however, which is Greek Ionian in inspiration. Since Silenus was associated with Dionysus, the jar was probably used to hold wine.

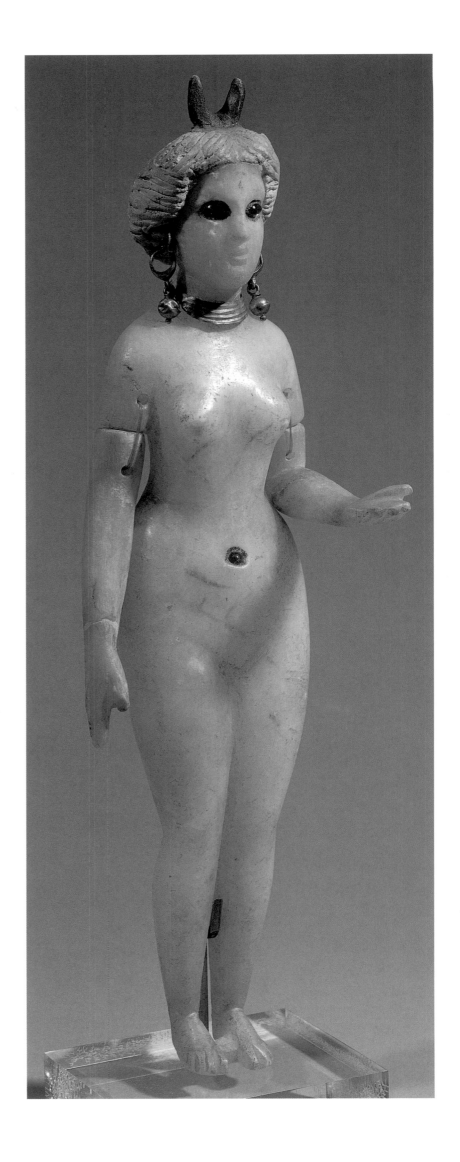

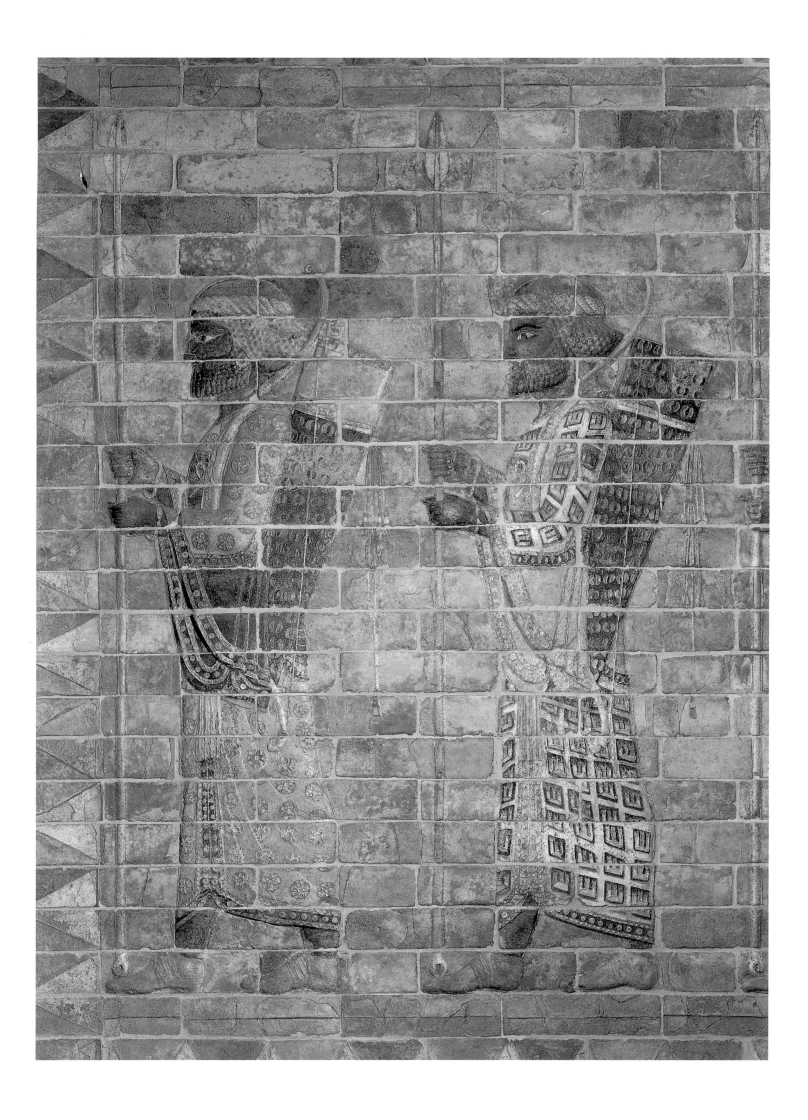

ABOVE

Cup with Falconer on Horseback. Iran. Late 12th or early 13th century. Siliceous ceramics with overglaze embellished in gold and metallic lusters. 2 ⅝ inches (6.5 cm) high; 8 ⅝ inches (22 cm) diameter.

In Persia, the Islamic injunction against specific representation, derived from the Bible, long coexisted with a syncretic decorative tradition. Here, for example, a Chinese influence is evident in the figures, while Arabic inscriptions line the lip and inside of the bowl.

OPPOSITE

The Archers of Darius. Susa. c. 500 B.C. Glazed brick. 78 ¾ inches (200 cm) high.

Darius' "Immortals," his elite guard, wear ceremonial, not battle, dress, and their lances are tipped with gold and silver. The Persian kings resurrected the ancient Mesopotamian use of enameled brick; these warriors, part of the army that crushed the Greeks at Marathon, adorned the winter palace of Darius I at Susa.

~ Egyptian Antiquities

Statuette of a Man. c. 4000–3500 B.C. Hippopotamus tooth. 9 ⅜ inches (24 cm) high.

This statuette, a stylized remnant from predynastic, prehistoric Egypt, was most likely carved with a flint knife. He may have served any number of purposes, including as an ex-voto, a gift to a god or goddess in thanks for divine favor received.

Concubine of the Dead. 32nd–27th B.C. Ivory figurine, 1st–2nd Dynasties.

Official funerary practices assumed that in the afterlife symbols would suffice to provide the aristocratic deceased with all the comforts of life. Egyptian culture in the Archaic period was itself virtually eternal: this ivory statuette might have been carved at any time during a period of five hundred years.

The Miller Woman. c. 2400–2300 B.C. Painted limestone. 6 ½ x 10 ⅛ inches (16.5 x 25.7 cm).

This weary old woman rests from grinding grain for the exalted deceased throughout all eternity. She may stand for a less literal function, one of the most fervent of Egyptian good wishes: plentiful food. Whereas depictions of the great were idealized, those of servants were rendered more realistically.

P. 52

Bull and Papyrus Plants. c. 1350 B.C. Painting on glazed brick. Fragment.

Seated Scribe. Sakkara, Old Kingdom. c. 2620–2350 B.C. (4th or 5th dynasty). Limestone, alabaster, and rock crystal. 21 ⅛ inches (53.7 cm) high.

This scribe was among the significant discoveries that Auguste-Ferdinand-François Mariette, of the Louvre's Egyptian Department, made in the early 1850s at Saqqara in Lower Egypt. The knowledge of writing was largely limited to priests and functionaries; this man's inlaid eyes express intelligent attention.

Raherka and Merseankh, Husband and Wife. c. 2500–2350 B.C. (5th dynasty). Painted limestone. 20 ¾ inches (52.8 cm) high.

Raherka, supervisor of the vizier's scribes, was important enough to merit tomb furnishings, such as this sculpture. Two conventions are apparent in this affectionate group: Merseankh's fond, confident gesture, and the difference in skin color: hers is lighter because of her presumed indoor life.

OPPOSITE, TOP
*Scarab Decorated with Animals
Making Music.* c. 16th century B.C.
(Predynastic period)
Oval slate with carved relief.

Except during the period of
Akhenaton, Egyptian art was very
conservative—so much so that this
playful scene can only be dated
within five hundred years. Animals
appear frequently in secular
images, such as games, as well as in
sacred portrayals of the Gods.

OPPOSITE, BOTTOM
King Sesostris III.
c. 1878–1842 B.C. Stone fragment.

As the empire expanded,
Egyptian art underwent a
transition from more realistic
to more idealized representation,
especially of its rulers.
Sesostris III is recognizable in
more than twenty statues of
himself at different ages; here,
more than old, he is full of
power and cognizant of his
responsibility.

RIGHT
*Flask in the Shape of a Bunch of
Grapes.* 1400–1300 B.C. Glass.
7 inches (18 cm) high.

Although historians believe that
glass was probably invented in
southwest Asia, the Egyptians
adapted the malleable medium
with style and wit. The lines on
the neck are created with small
colored-glass rods, the "grapes"
with larger stumps allowed to
melt slightly.

Cosmetics Spoon: Young Girl Carrying a Vase. 16th–14th century B.C. Painted wood. 5 ⅜ inches (13.5 cm) high.

This charming container for a precious unguent or perfume has a lid that pivots out. The young woman may be a kind of lady-in-waiting; although she stoops beneath the weight of the vase, her hair is elaborately coiffed and she wears a handsome pectoral. She carries water lilies in her left hand.

OPPOSITE, RIGHT

Female Torso, also called *Nefertiti.* c. 1365–1347 B.C. Crystallized red sandstone. 11 ⅞ inches (29 cm) high.

This figure is emerging into the third dimension, leaving behind the iconic columnar conventions of earlier—and later—regimes. The aristocrat, perhaps Queen Nefertiti, wife of Pharoah Amenhotep IV Akhenaton, wears a meticulously pleated, sheer linen garment, elegantly draped and tied beneath her right breast.

RIGHT

The Goddess Hathor and King Seti I. From the tomb of Seti I. Valley of the Kings. c. 1303–1290 B.C. (19th dynasty). Painted limestone. 89 ⅛ inches (226.5 cm) high.

This mural from the pharaoh's tomb in the Valley of the Kings is as elegant as the couple featured on it, and displays the Egyptians' sophisticated handling of color and line. Hathor, bearing a moon disk between her cow horns, gives Seti her necklace, which is filled with a protective liquid.

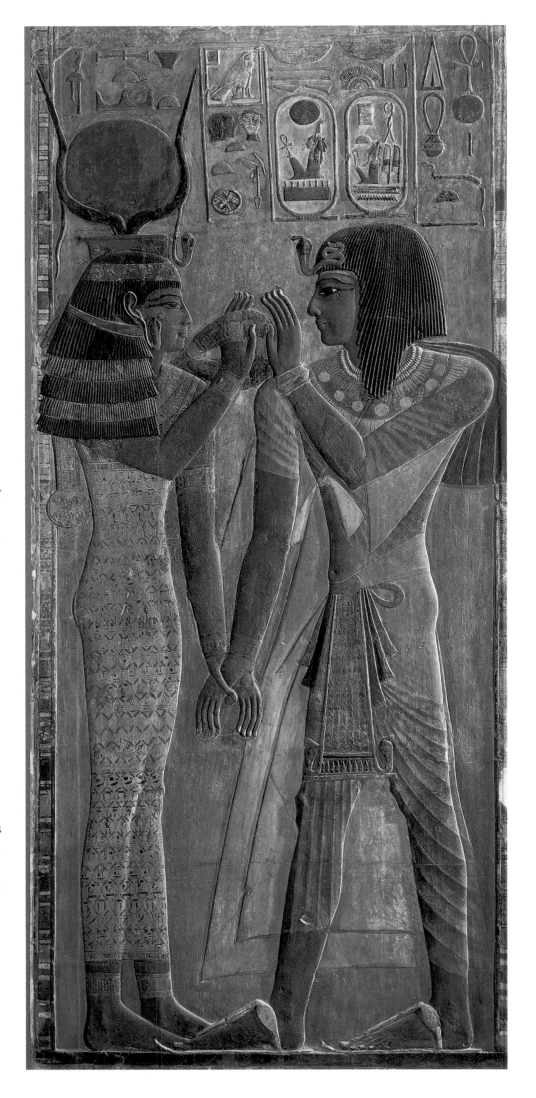

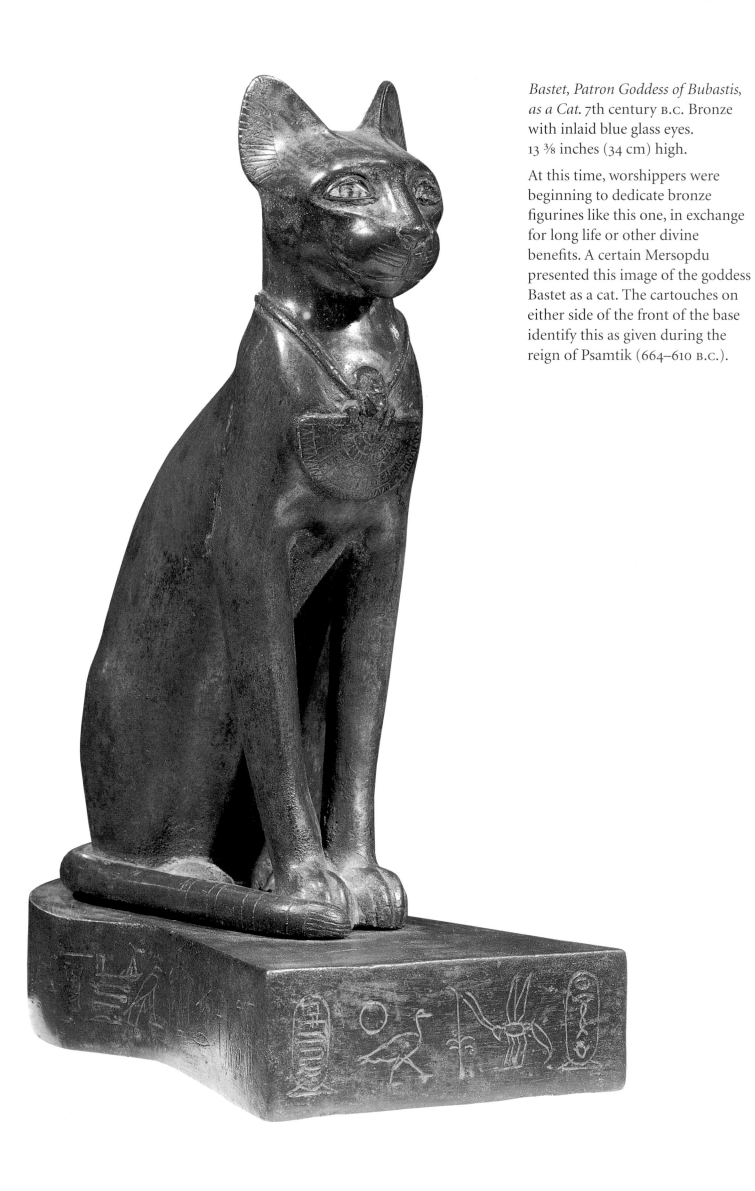

Bastet, Patron Goddess of Bubastis, as a Cat. 7th century B.C. Bronze with inlaid blue glass eyes. 13 ⅜ inches (34 cm) high.

At this time, worshippers were beginning to dedicate bronze figurines like this one, in exchange for long life or other divine benefits. A certain Mersopdu presented this image of the goddess Bastet as a cat. The cartouches on either side of the front of the base identify this as given during the reign of Psamtik (664–610 B.C.).

Mummy Covering of Imeneminet.
c. 800 B.C. (22nd dynasty). Various
materials, plastered and painted.
74 inches (188 cm) high.

The intricate and skillful decoration,
worthy of the deceased chancellor,
illustrates the soul's voyage through
the Underworld. Featured are the
resurrected god Osiris, in the white
crown of Lower Egypt; the jackal-
headed Anubis; and Mut, the
vulture-goddess, who stretches her
wings out in sign of protection.

BELOW

*Pharaoh Taharka Offering Two
Wine Cups to the Falcon God
Hemen.* 7th century B.C. Wood,
schist, gold, and silver leaf.
8 x 4 x 10 in. (20 x 10 x 26 cm).

Taharka wears a *shendot*, the formal
loincloth that the pharaohs wore
for more than two thousand years.
He ruled for twenty-five years,
many of them peaceful, despite his
resistance to the Assyrian kings; in
the end, however, Ashurbanipal
defeated Taharka, who sought
refuge in Nubia, where he died.

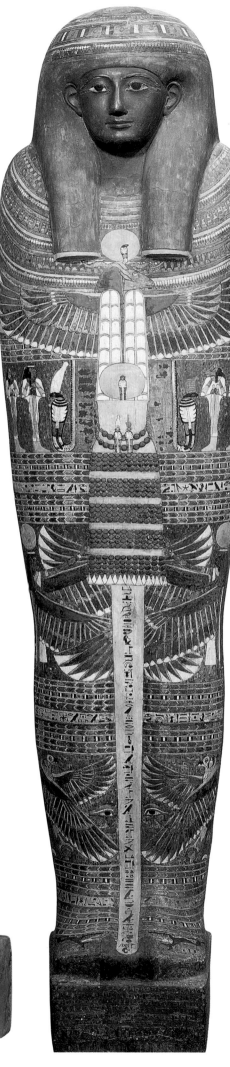

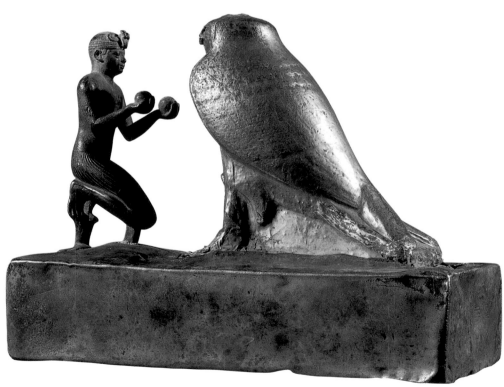

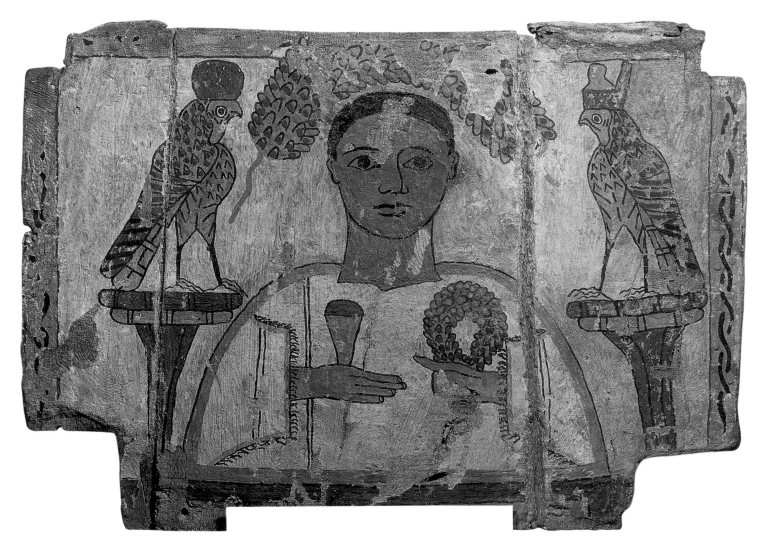

Funeral Portrait of a Boy. 4th century. Canvas on fig wood, painted stucco. 11 ⅜ x 16 ⅛ in. (29 x 41 cm).

After Egypt became a Roman province, local burial customs survived, some of them adopted by Coptic communities. At Al-Faiyum, for example, portraits of the deceased, the only extant Classical paintings on panel, were rendered with startlingly expressive realism.

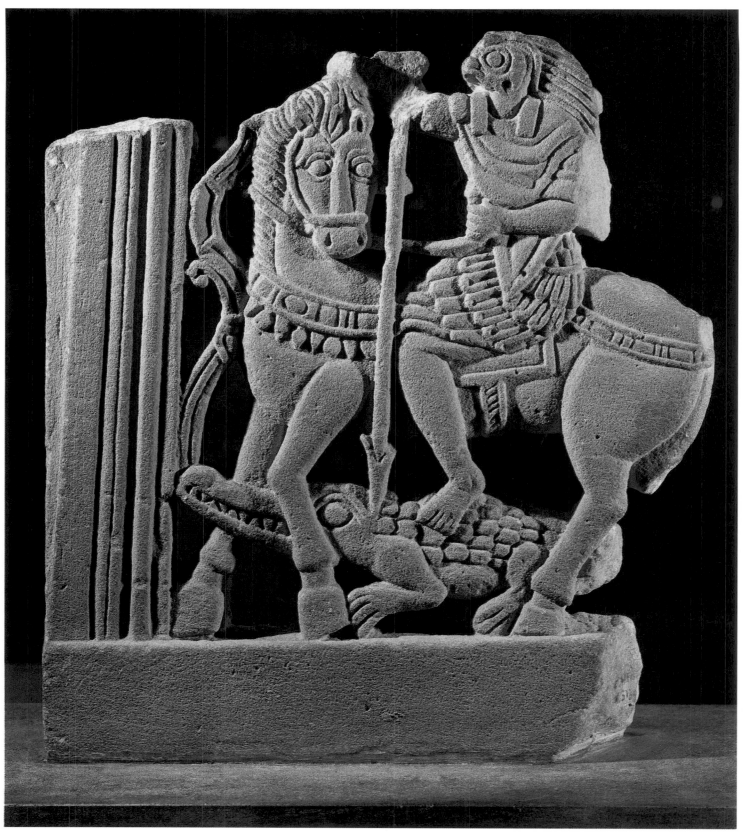

Mounted Horus. 4th century. Sandstone.

At times early Christian policy dictated tolerance and even assimilation of non-Christian elements, especially in the interest of converting local populations. Saint George is represented as the young Egyptian falcon-god Horus, while the dragon he slays is another scaly creature: a crocodile.

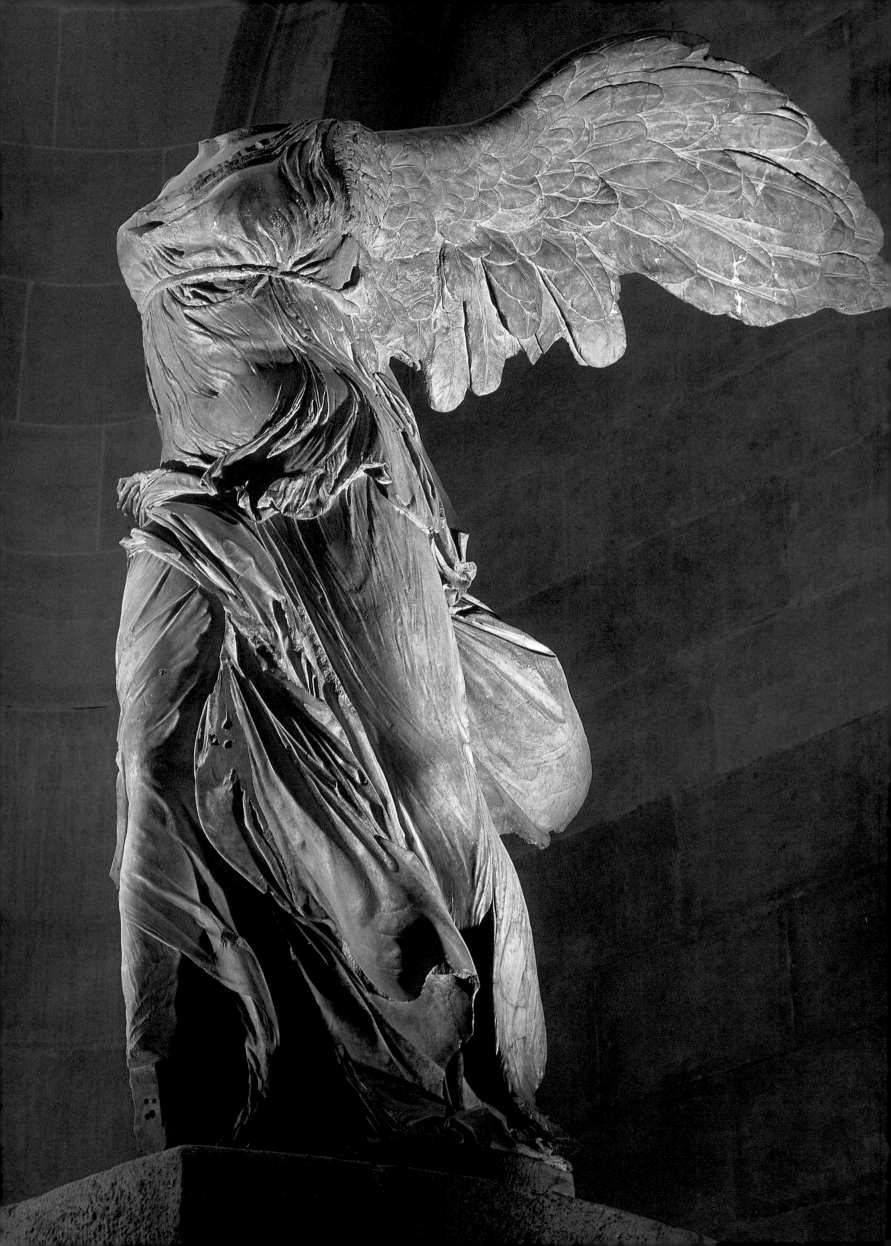

~ Greek, Etruscan and Roman Antiquities

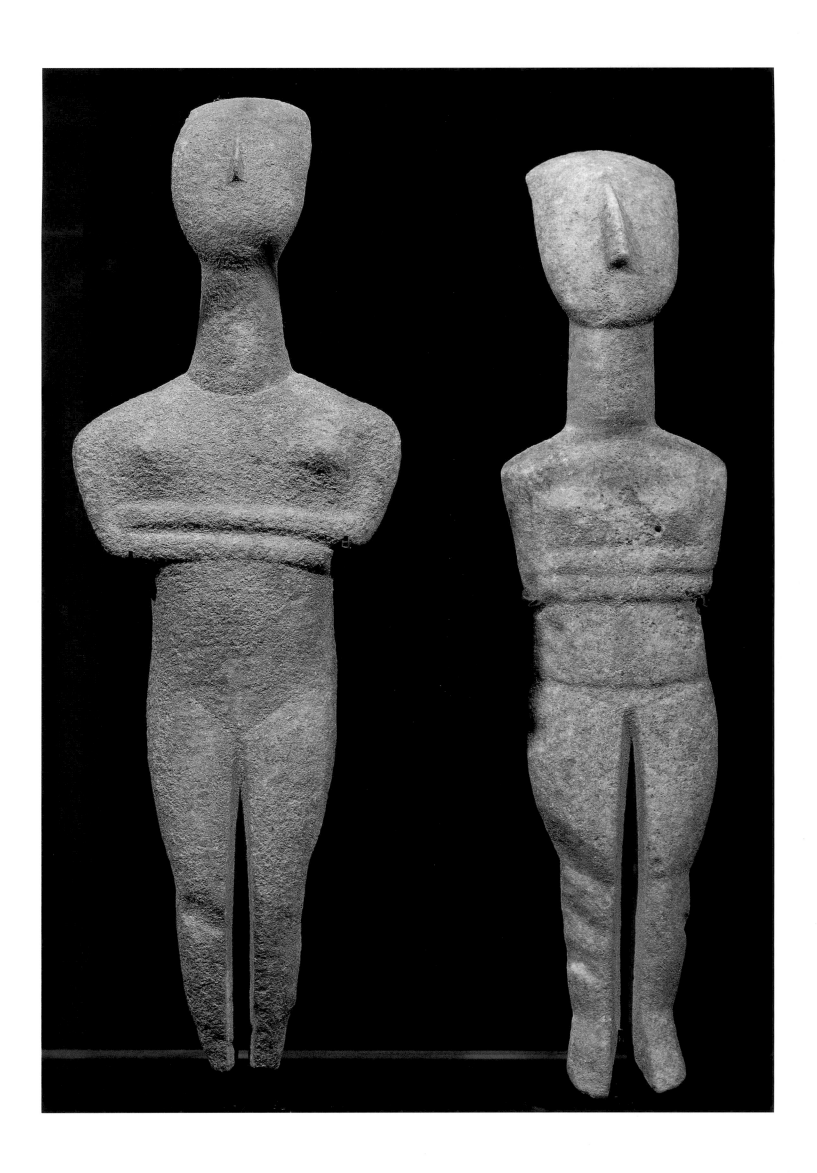

ABOVE

Amphora. c. 720–700 B.C. Terracotta. 18 ⅔ x 8 ⅞ inches (47.4 x 22.5 cm) across.

Amphora–two-eared pitchers later used for storage–were originally grave markers. The three-dimensional serpent motif suggests that this container served that function, since snakes in ancient Greece were associated with the Earth and the underworld. The registers of rhythmical geometric patterns and repeated figures are typical of this period.

OPPOSITE

Cycladic Female Idol with Arms Crossed. c. 2700–2400 B.C. Marble. 10 ⅝ inches (27 cm) high.

As stylized as these figures from the southern Aegean are, there is a naturalism about their posture that suggests a stylistic choice made by the early Bronze Age artist. The female figures are more slender and geometric than goddesses from other European cultures.

P. 66

The Winged Victory of Samothrace. c. 190 B.C. Marble and limestone. 10 ft. 9 ⅛ inches (3.28 m) high.

OPPOSITE

Rampin Horseman. c. 550 B.C. Marble. 10 ⅝ inches (27 cm) high.

The Greeks invented the equestrian statue: this head, which shows traces of the original colors, is part of one of the earliest known examples. It was found in the Acropolis in Athens; fragments of the horseman's torso and of his horse are kept in that city.

ABOVE

The Kouros of Actium. c. 560 B.C. Marble. 39 ⅜ inches (100 cm) high.

Like all *kouroi*, this Archaic figure is nude; he was found in a temple of Apollo in the ancient town of Actium, and scholars hypothesize that he was intended to represent the god himself. Like traditional Egyptian figures, the kouros displays a marked frontality.

RIGHT

Standing Woman (the "*Hera of Samos*"). c. 570 B.C. Marble. 75 ⅝ inches (192 cm) high.

One of the earliest examples of an Archaic Greek *kore*, this columnar figure from Samos is the female equivalent of the male *kouros*. She wears an elaborate ceremonial costume: an inscription on her veil identifies her as a gift to the goddess Hera from Cheramyes, a citizen of Samos.

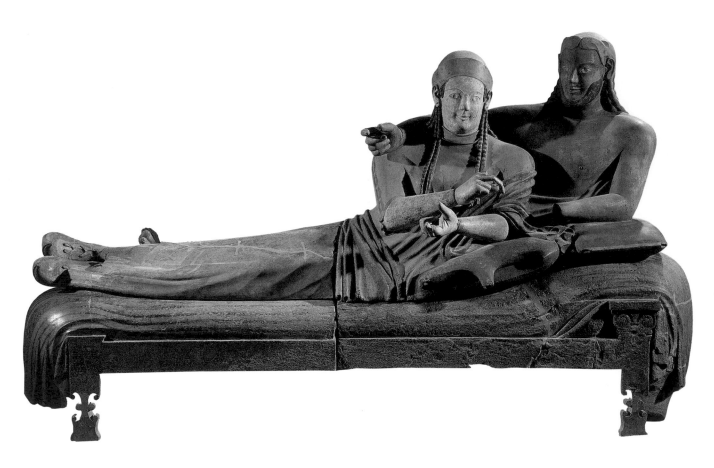

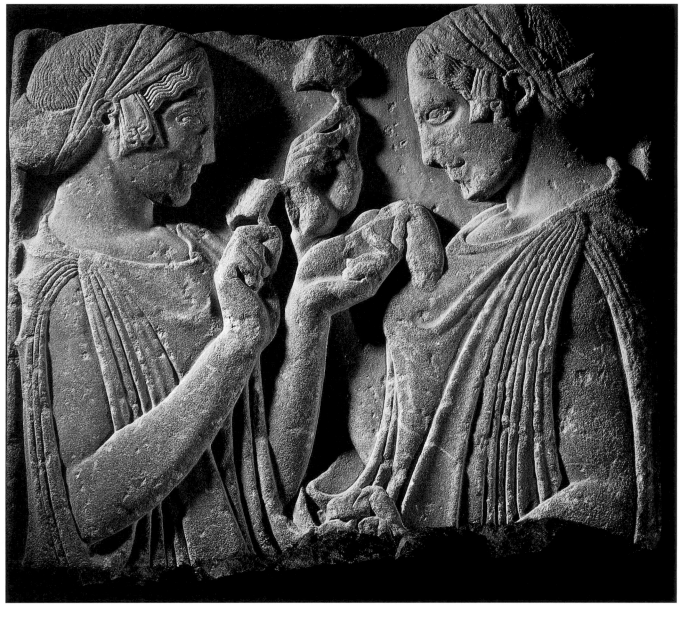

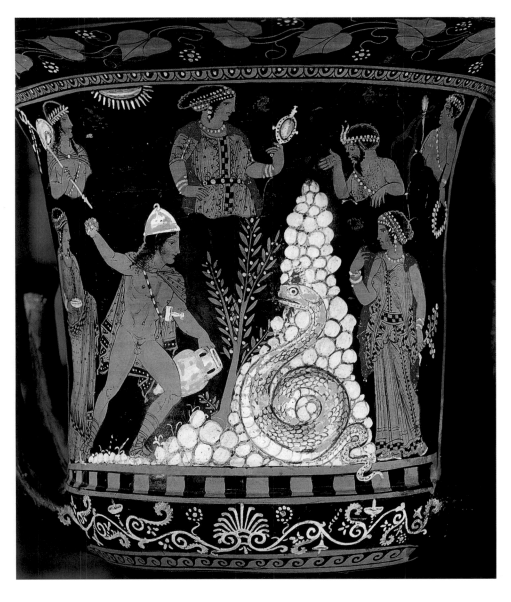

OPPOSITE, TOP

Sarcophagus of the Wedded Couple.
Late 6th century B.C. Terracotta.
44 ⅞ x 74 ¾ in. (114 x 190 cm).

This tomb for two is one of the
finest of Etruscan objects. The
affectionate couple, shown as if in
lively conversation at a banquet,
display the gentle "Archaic smile."

OPPOSITE, BOTTOM

"The Exaltation of the Flower."
c. 460 B.C. Marble.
23 ⅝ inches (60 cm) high.

It is uncertain what these female
figures are exchanging: this
delicately formal relief may be a
funerary stele, or a votive image of
Demeter, goddess of grain, and her
daughter, Core.

ABOVE

*Krater in the Form of a Chalice,
Cadmos Fighting a Dragon*
(obverse). c. 300 B.C. Terracotta.
22 ½ inches (57 cm high).

Wine was never drunk unmixed in
ancient Greece; it was combined
with water in these vessels. This
krater recounts the tale of Cadmus,
who founded the city of Thebes—
but not before killing a terrible
dragon.

RIGHT

Filiform Aphrodite. Nemi.
4th century B.C. Bronze.

The artist who forged this female
divinity was inspired by earlier
styles, visible in her two
dimensionality. Her diadem and
elaborate hairstyle suggest her
identity to be Aphrodite, or her
Etruscan counterpart, Turan.

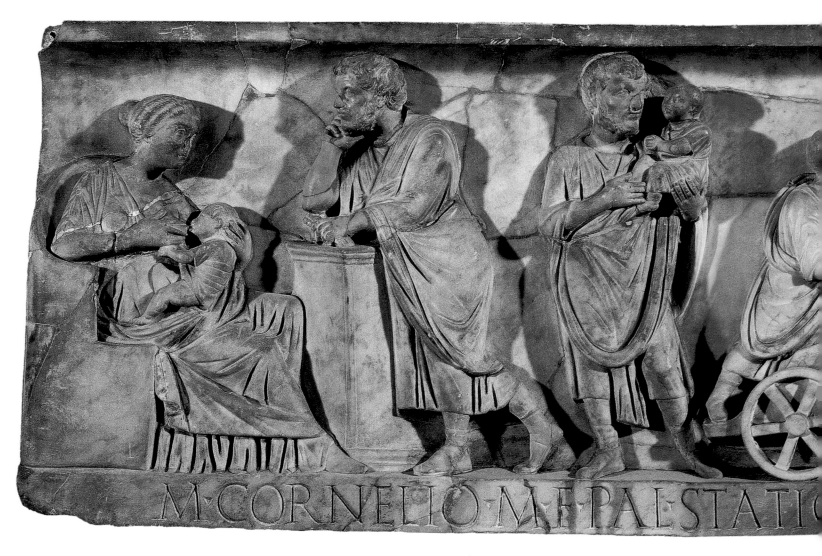

ABOVE

Child Driving a Small Cart. c. 150 B.C. Marble. 80 ⅝ inches (205 cm) long.

M. Cornelius Statius was buried in this sarcophagus; the childhood scenes depicted on it suggest that the deceased was a child himself. His wealthy and perhaps aristocratic family would have had a country house and farm outside of town, where the boy would have had the freedom for play of this kind.

OPPOSITE, BELOW

Sleeping Hermaphrodite. 2nd century B.C. Marble. 55 ⅛ inches (148 cm) long.

This lightly perverse Hellenistic masterpiece, probably a replica of an Alexandrian sculpture, was purchased in 1808 from Prince Camillo Borghese, husband of Maria-Paulette, a sister of Napoleon. The figure was discovered in Rome in the early seventeenth century; Bernini sculpted the mattress.

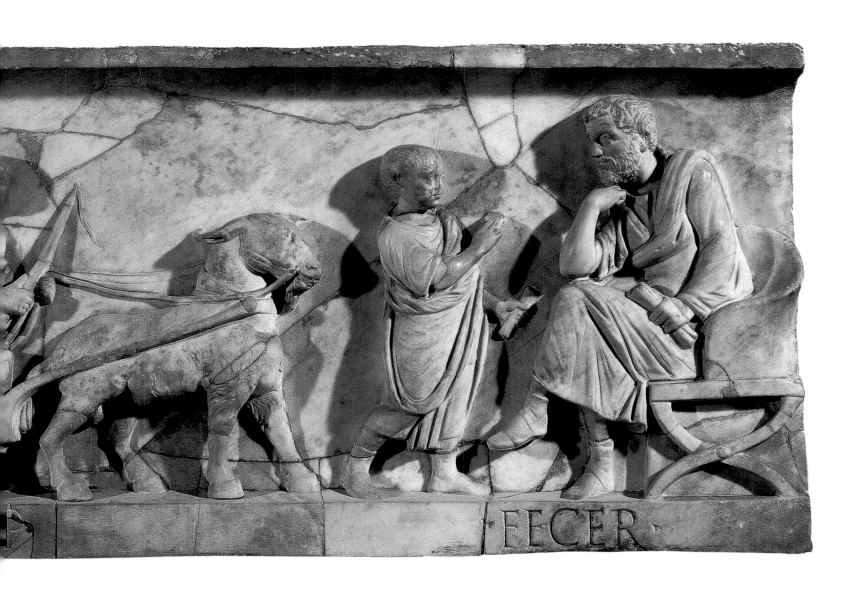

FECER

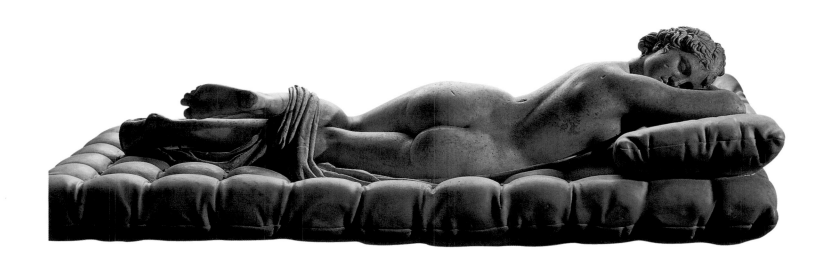

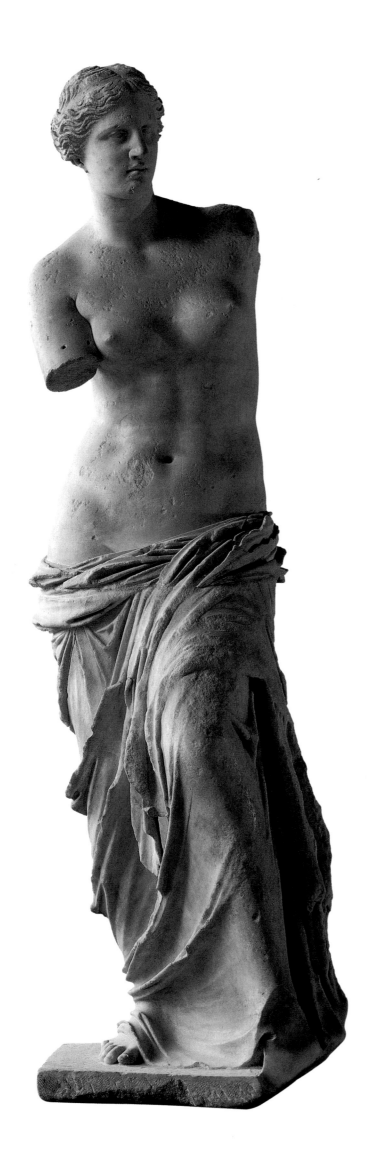

Venus de Milo, also called *Aphrodite.* 100 B.C. Marble. 79 ½ inches (202 cm) high.

As well known as the other lady of the Louvre, this standing woman, discovered in 1820 on the Cycladic island of Melos (Milo in Italian), is stylistically transitional. Her serene, almost distant expression is still Classical, while her attitude and the artist's selective realism are Hellenistic.

OPPOSITE

Livia. c. 100 B.C. Basalt. 13 ⅜ inches (34 cm) high.

Basalt, often used in ancient Egypt, permits the sculptor to work with great precision. At the same time, it is a hard stone that can be polished for a metallic, superhuman effect; it may be no coincidence that it was used for this official portrait of Livia, wife of the first Roman emperor and near-God, Augustus.

ABOVE

Mithras Immolating the Bull. 2nd century. Marble. 35 ½ x 30 ⅜ in. (90 x 77 cm).

An ancient Persian god of light, Mithras was the divinity of an immensely popular mystery cult. His adepts were men, and so Mithraism spread throughout the army and the empire, at a time when the monotheistic Christians, who refused to worship the emperor, were the object of imperial persecution.

OPPOSITE

Votive Hand. 1st–3rd century. Bronze. 5 ⅛ inches (13 cm) high.

This extraordinary hand with symbols clustered on it may be an ex-voto, offered in pious gratitude for divine healing of a petitioner's hand. It may also be an apotropaic sculpture, a superstitious object intended to avert ill fortune from its owner.

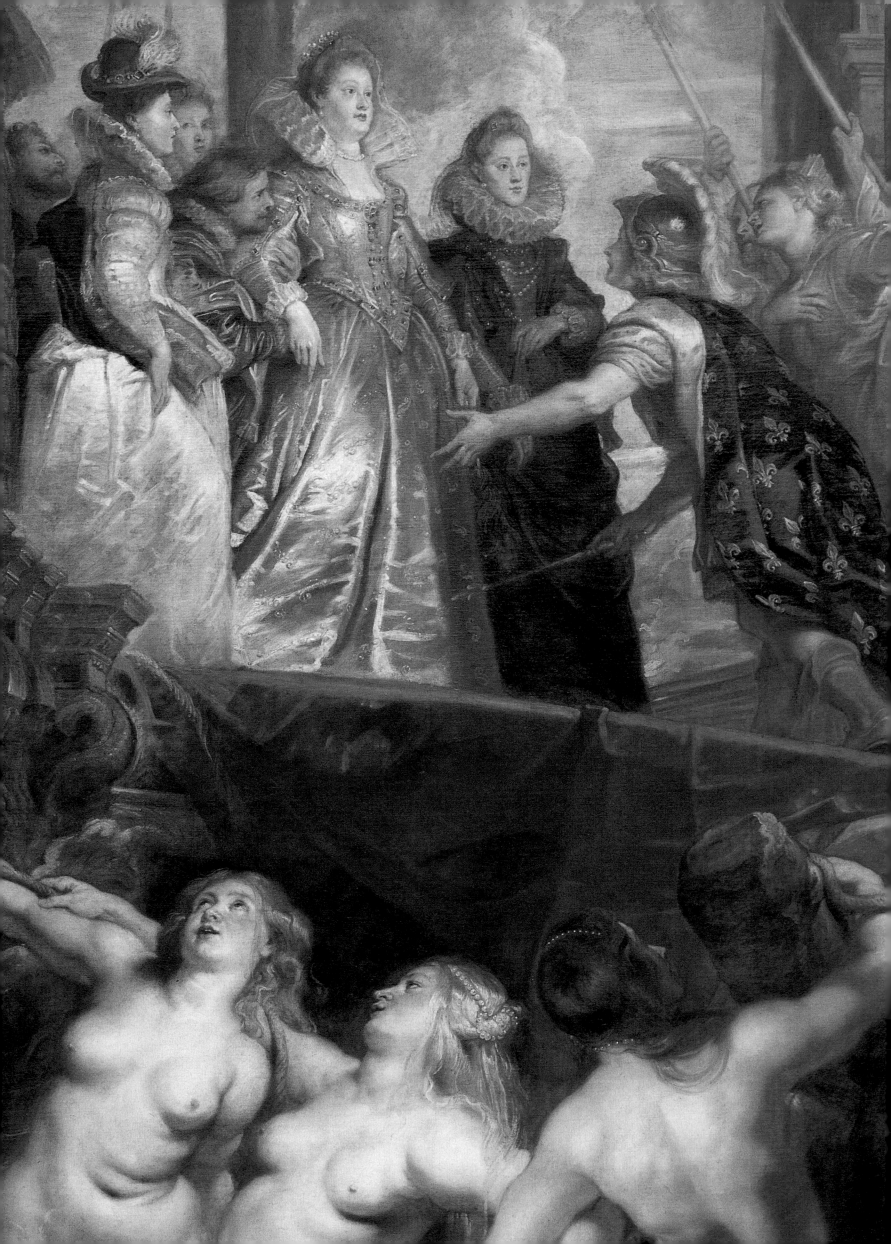

~ Paintings

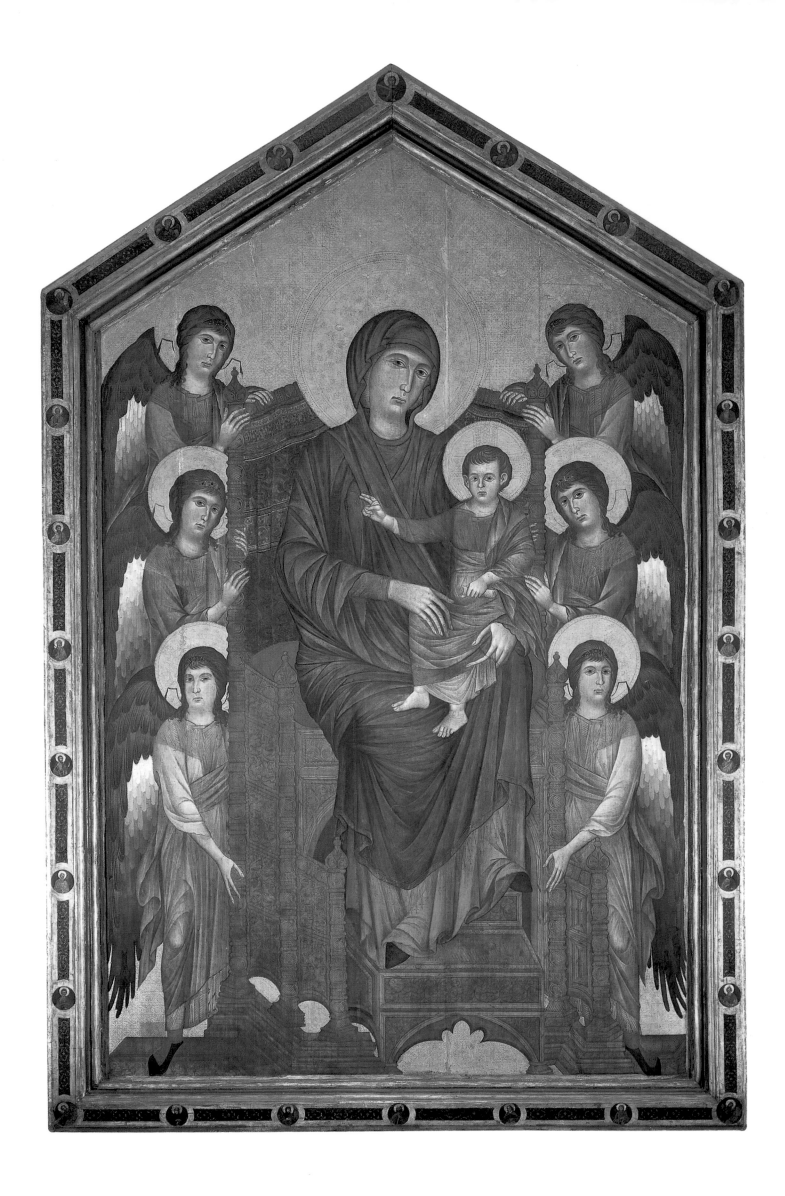

Cimabue. *Madonna and Child in Majesty Surrounded by Angels.* c. 1280. Tempera and gold on wood. 168 ⅛ x 110 ¾ in. (427 x 281 cm).

This is one of the first *maestà*, or compositions showing the Virgin and Child enthroned and surrounded by angels. Painted for the Church of Saint Francis in Pisa some fifty years after the saint's death, it displays both maternal tenderness and the beginnings of spatial arrangement. This is one of the works that Napoleon brought to the Louvre.

Giotto da Bondone. *St. Francis Receiving the Stigmata.* c. 1295–1300. Oil and gold leaf on wood. 123 ¼ x 64 ⅛ in. (313 x 163 cm).

Giotto was admired for humanizing what had been static theological emblems: Francis is in a landscape, however stylized, and episodes of his life anchor the altarpiece. The saint, whose followers identified him closely with Christ, receives the stigmata, the five wounds Christ received on the Cross.

Peter Paul Rubens. *The Arrival of Marie de Médicis at Marseilles, November 3, 1600* (detail). c. 1621–25. Oil on canvas. 155 ⅛ x 116 ⅛ in. (394 x 295 cm).

Master of the Taking of Taranto. *The Triumph of Venus, Venerated by Six Legendary Lovers: Achilles, Tristan, Lancelot, Samson, Paris, and Troilus.* 1st half of the 15th century. Oil on canvas. 20 inches (51 cm) diameter.

The six lovers are Achilles, Tristan, Lancelot, Samson, Paris, and Troilus. Courtly love and admirable women were popular subjects in all the arts at this time. Although Dante made his lady love his spiritual guide in the *Divine Comedy*, the identification here of Venus with the Virgin finds startling expression.

Master of the Rebel Angels. *Saint Martin Dividing His Cloak* and *Fall of the Rebel Angels* (two sides). c. 1350.
Oil on canvas, transferred from wood. 25 ¼ x 11 ⅜ in. (64 x 29 cm).

A model of charity and humility, Martin was one of the most popular saints of the early Middle Ages. A soldier as a young man, he once cut his cloak in two and gave half to a beggar. The second panel shows exemplars of pride: the angels who followed Lucifer in defying God were cast out of Heaven.

ABOVE

Jean Malouel (attributed to). *Pietà*. c. 1400. Oil on wood. 25 ½ inches (65 cm) diameter.

A *pietà* illustrates the piteous grief of the Virgin over the death of her son, just descended from the Cross. Often, she is shown seated, holding Christ across the lap that bore Him; here, God the Father holds Him to her view, as angels express their heavenly sorrow.

OPPOSITE

French School. *Jean II Le Bon, King of France*. c. 1350. Oil on wood. 23 ½ x 17 ½ in. (59.8 x 44.6 cm).

This portrait of the duke of Normandy, who was shortly to become king of France—he would be known as "John the Good"—is believed to be the oldest surviving French painting. John's son Charles V would begin the transformation of the Louvre fortress.

Master of the Osservanza. *Stories of Saint Jerome and the Lion*. After 1425. Oil on wood. 9 ½ x 30 ½ in. (24 x 78 cm).

According to legend, Jerome once removed a thorn from a lion's paw. The grateful lion remained at the monastery, where he befriended the monks' ass. When a caravan stole the ass, the lion was desolate; when the caravan next passed that way, the lion chased ass, camels, and all back to the monastery.

P. 88

Amiens. *The Priesthood of the Virgin*. 1438. Oil on wood. 39 x 22 ½ in. (99 x 57 cm).

This unusual representation of the Virgin being ordained by her son is set in the church of Notre-Dame in Amiens, still the largest Gothic church in France and one of the finest in Europe. The painting was commissioned by the master of a confraternity, one of the lay religious societies essential to the medieval world.

P. 89

School of Dijon (early 15th century). *Virgin and Child*. n.d. Oil on wood. 8 ¼ x 5 ⅞ in. (21 x 15 cm).

Dijon was the seat of the Valois dukes of Burgundy, a court that at this time reached a degree of wealth and elegance unparalleled in Europe. Rather than her customary blue robe, the stars that stud the Virgin's rich black gown identify her as the queen of Heaven.

 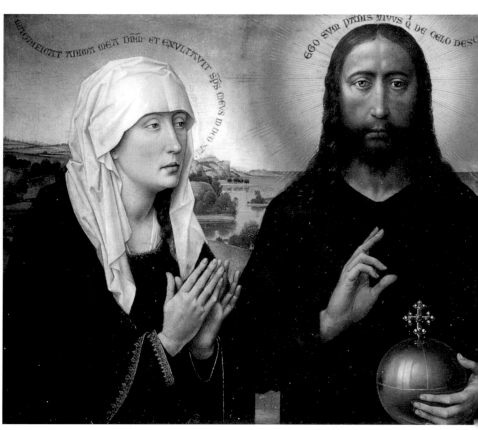

ABOVE

Rogier Van der Weyden. *The Braque Family Triptych.* c. 1450. Oil on wood. 16 ⅛ x 13 ⅜ in. (41 x 34 cm).

This portable altarpiece shows the influence of Van der Weyden's journey to Italy. The first known example of half-length figures in Flemish painting, they are, from left to right, Saint John the Baptist, the Virgin, Christ the Redeemer, Saint John the Evangelist, and Saint Mary Magdalene.

OPPOSITE

Henri Bellechose. *The Retable of Saint-Denis.* c. 1416. Oil on canvas, transferred from wood. 63 ¾ x 83 in. (162 x 211 cm).

The monastery of Saint Denis, the apostle to the Gauls and the first bishop of Paris, was under the protection of the French kings, who were traditionally buried there. This narrative painting relates episodes of the saint's persecution, martyrdom, and sainthood under the emperor Valerian.

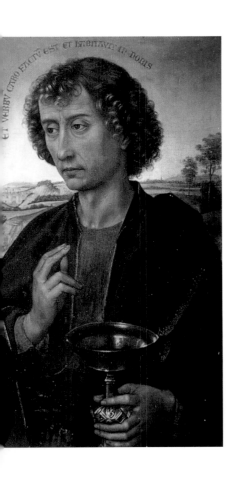

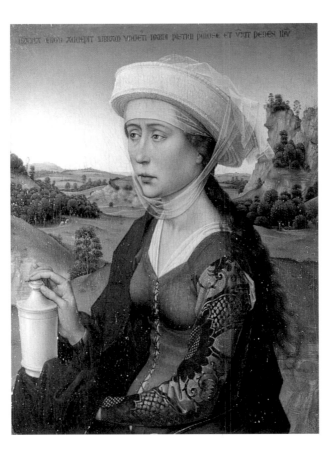

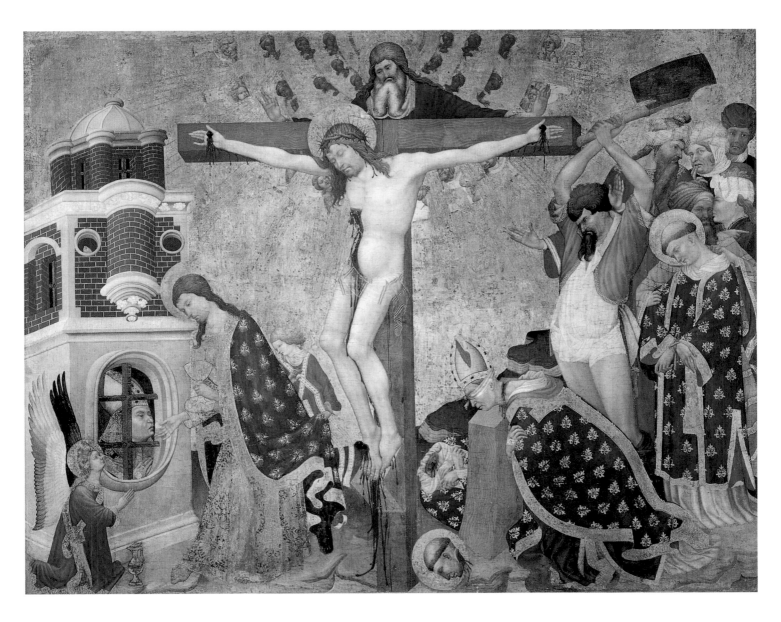

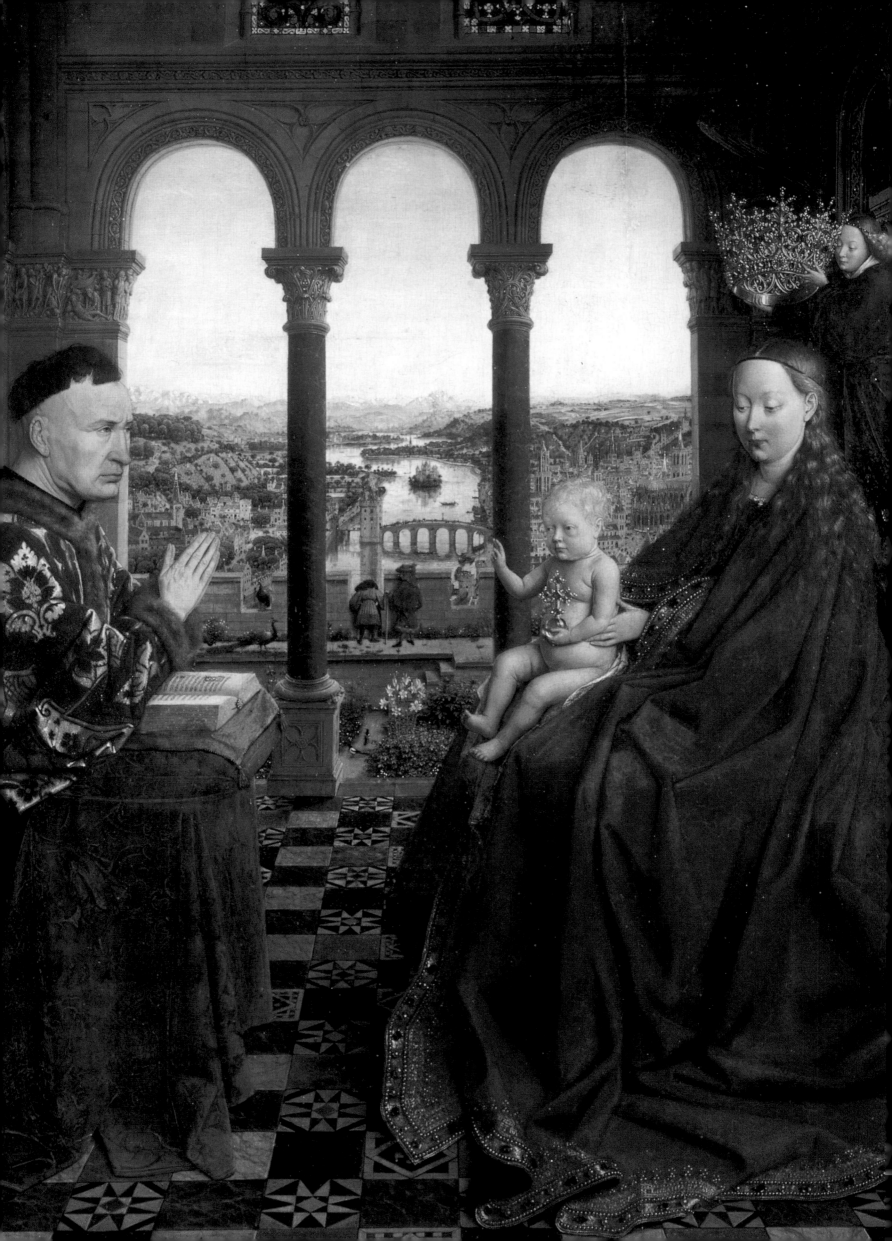

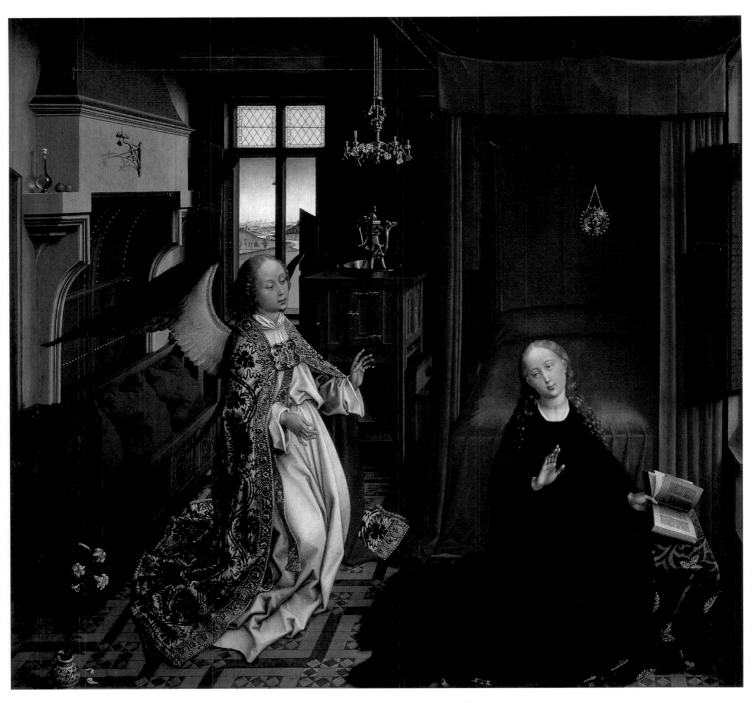

ABOVE

Rogier van der Weyden. *The Annunciation.* c. 1435. Oil on wood. 33 ⅞ x 36 ⅝ in. (86 x 93 cm).

The Virgin hears, but does not see, Gabriel, who announces, in the words of the Evangelist Luke: "Hail, full of grace, the Lord is with thee; blessed art thou among women." The mystery of the Immaculate Conception is taking place, represented by the light entering from the window on the right.

OPPOSITE

Jan van Eyck. *The Rolin Madonna.* c. 1435. Oil on canvas. 26 x 24 ⅜ in. (66 x 62 cm).

The kneeling donor who commissioned this aristocratic work is Nicolas Rolin, chancellor of Burgundy. The Virgin, usually mantled in the blue of Heaven, here wears royal crimson, while the river of space between donor and Christ Child, Virgin, and angel is the distance between time and eternity.

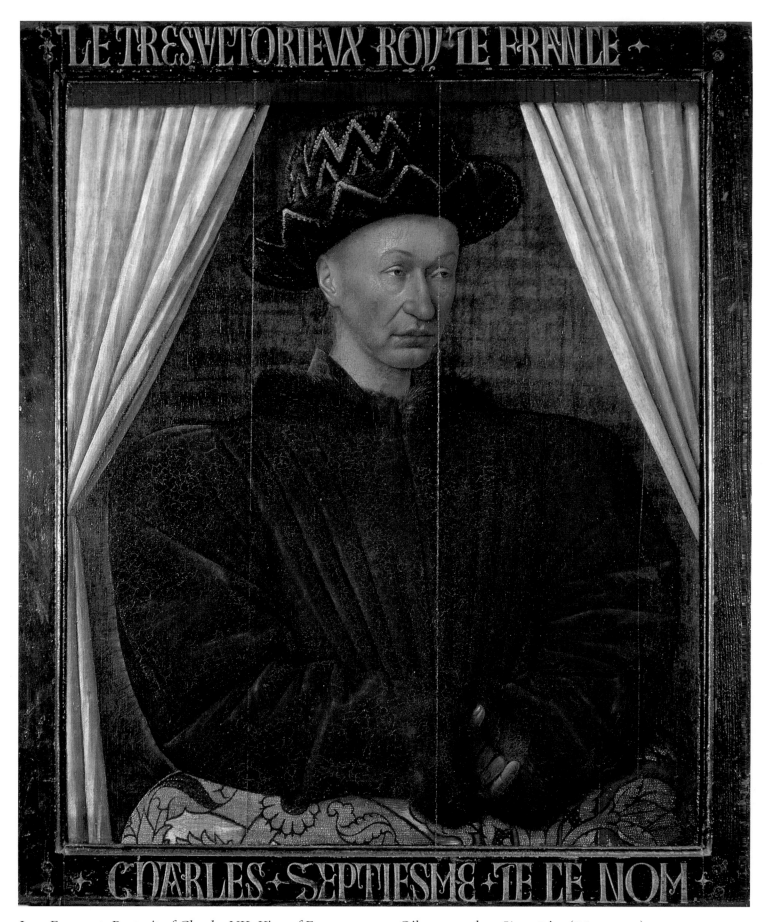

Jean Fouquet. *Portrait of Charles VII, King of France.* c. 1450. Oil on wood. 33 ⅞ x 28 in. (86 x 71 cm).

The inscriptions on the frame read: "The very victorious king of France./Charles seventh of this name," so the painting may celebrate Charles's triumph over England. Two women played important roles in his life: Joan of Arc, to whom he owed his throne, and Agnes Sorel, his lover and advisor.

Jean Fouquet. *Self-Portrait*. 1450. Copper, enamel, and gold on wood. 2 ⅔ inches (6.8 cm) diameter.

This is the earliest known self-portrait by a French artist. Fouquet, who also illustrated manuscripts, became the royal painter under Louis XI, whose tomb he worked on. Here, the copper support was covered with black enamel, then gray-brown enamel, and finally the portrait was hatched in gold.

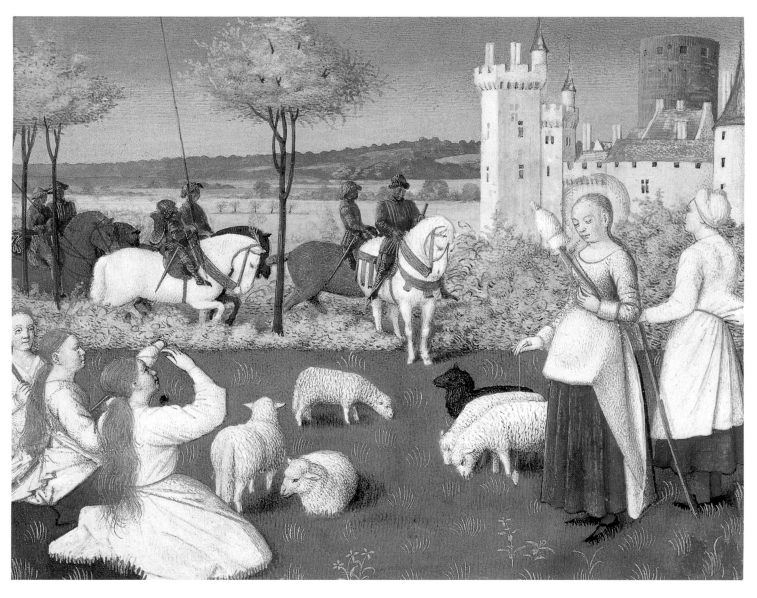

ABOVE

Jean Fouquet. *Saint Marguerite*, from the *Hours of Étienne Chevalier*. 1452–1460. Vellum on paper.
3 ½ x 4 ½ in. (9 x 12 cm).

Her legend recounts that Saint Margaret was watching sheep, when the Roman prefect Olybius rode by and was smitten with her beauty. Despite her looks, fearless faith, and wit, she was martyred. The castle, with its blunt round tower, resembles the Louvre of Charles V, which Fouquet knew well.

OPPOSITE

Spanish School. *Lady with Pansies*. After 1450. Oil on wood. 14 ½ x 10 ¼ in. (37 x 26 cm).

"Pansies are for thoughts," Ophelia muses in William Shakespeare's *Hamlet*, a century or so after this handsome portrait was painted. In French, the word for these flowers and thoughts are the same—*pensées*. The theme is continued in the banner, which avers something like "Out of sight, but not out of mind."

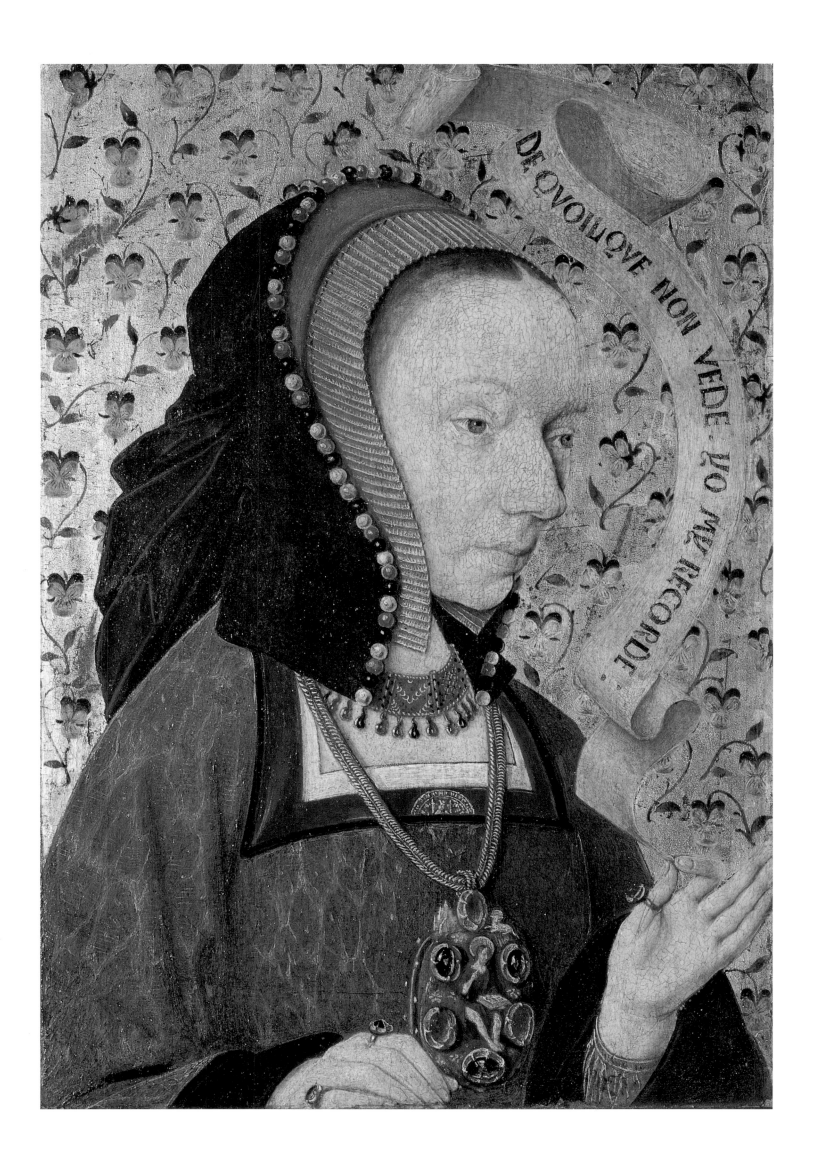

School of Provence. *Three Prophets.* After 1450. Oil on wood. 24 x 37 ½ in. (61 x 95 cm).

The legacy of the papal presence in Avignon was a sophisticated, animated, and vigorously religious style. The banner above the heads of the three prophets reads: "There shall come forth a rod out of the stem of Jesse, and a Branch shall grow out of his roots" (Isaiah 11).

Enguerrand Quarton. *The Pietà of Villeneuve-lès-Avignon.* c. 1455. Oil on wood. 64 ⅛ x 86 in. (163 x 218.5 cm).

This masterpiece of emotion and characterization was long unattributed because of its multinational quality. The reverent donor is in, but not of, the space of the saints; beautiful Saint John tenderly plucks thorns from Christ's brow; the Virgin is pale with grief and acceptance; and large-hearted Saint Mary Magdalene weeps unaffectedly.

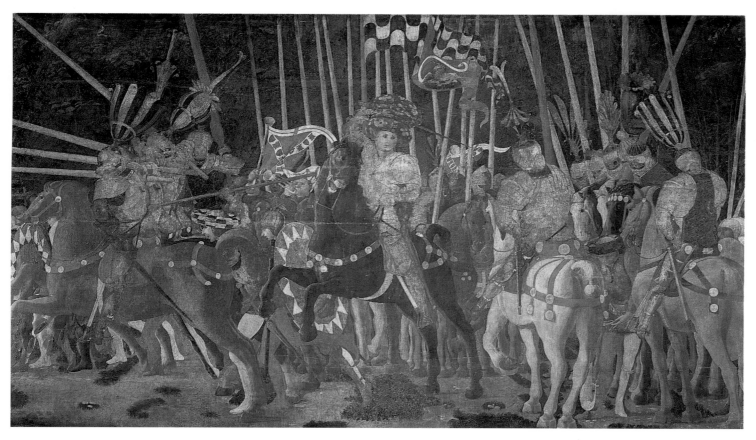

ABOVE

Paolo Uccello. *The Battle of San Romano.* 1450–56. Distemper on wood. 71 ⅔ x 124 ¾ in. (182 x 317 cm).

This enigmatic record of a battle between Florence and Siena identifies neither winners (Florence), losers (Siena), nor many of the individual participants. The graphic effect of the bristling lances continues in the legs of beasts and soldiers, which also establish depth through planes of color.

OPPOSITE

Piero della Francesca. *Portrait of Sigismondo Malatesta.* 1450. Oil on wood. 17 ⅓ x 13 ⅓ in. (44 x 34 cm).

The artist worked at the court of the Malatesta family of Rimini. Sigismondo, in his early thirties at the time this portrait was made, was a Renaissance man: a patron of the arts and letters, and an inveterate soldier. In 1460, Sigismondo declared war on Pope Pius II and was excommunicated.

P. 104

Jacopo Bellini. *The Virgin and Child Adored by Leonello d'Este.* c. 1440. Oil on wood. 23 ⅔ x 15 ¾ in. (60 x 40 cm).

The artist's interest in landscape is a Renaissance trait, but the relative sizes of the Virgin and Child and the donor, the prince Leonello d'Este, reflect medieval thought. Leonello's priceless red and gold brocade may be the painter's tribute to the legendary textiles of his native Venice.

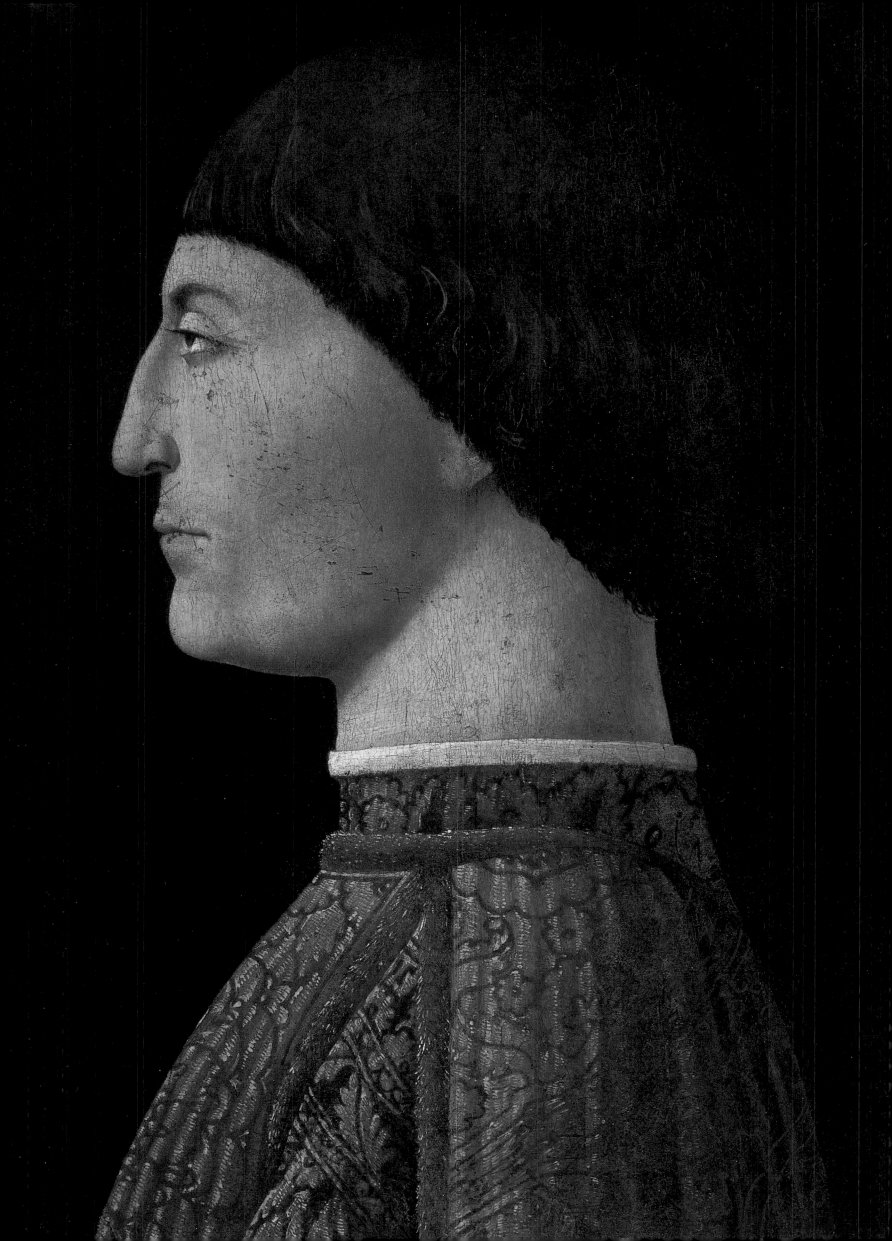

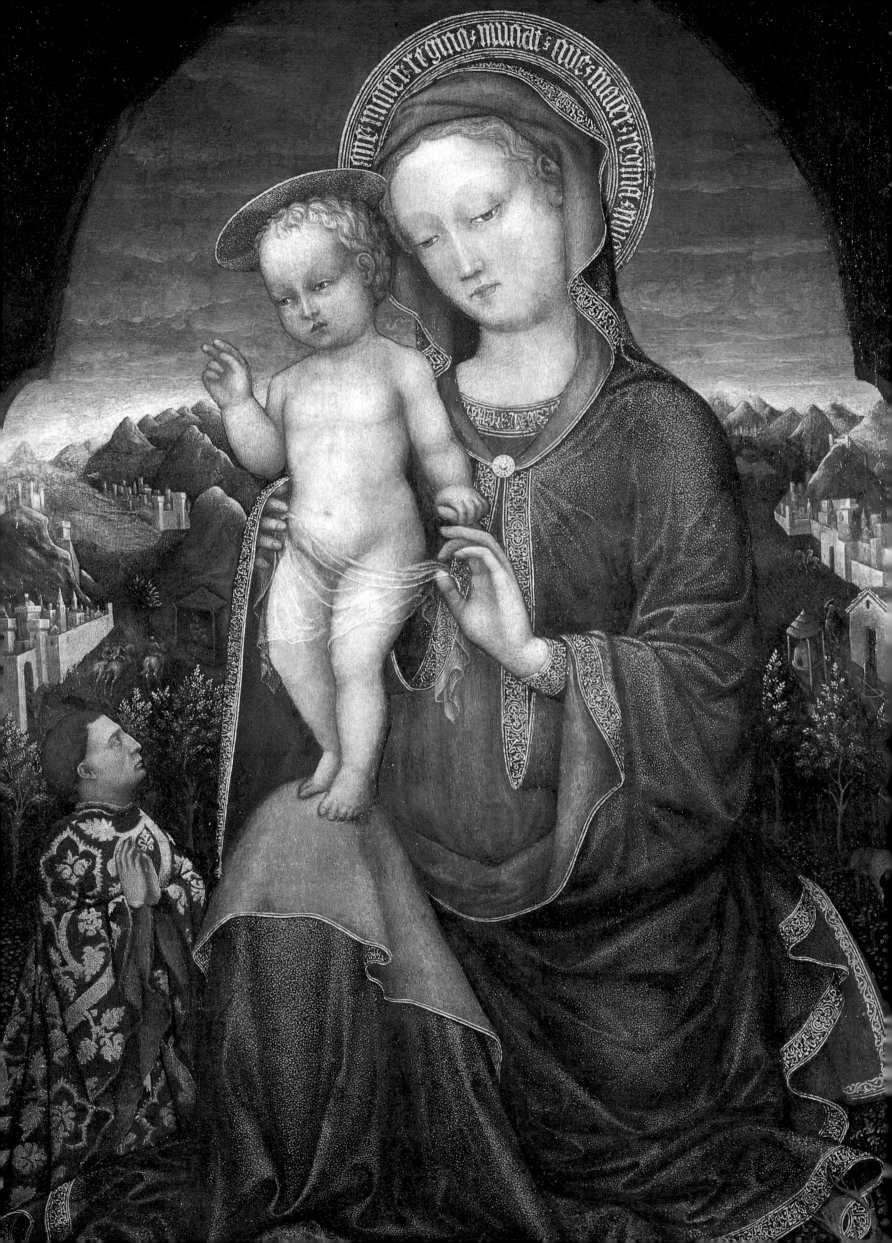

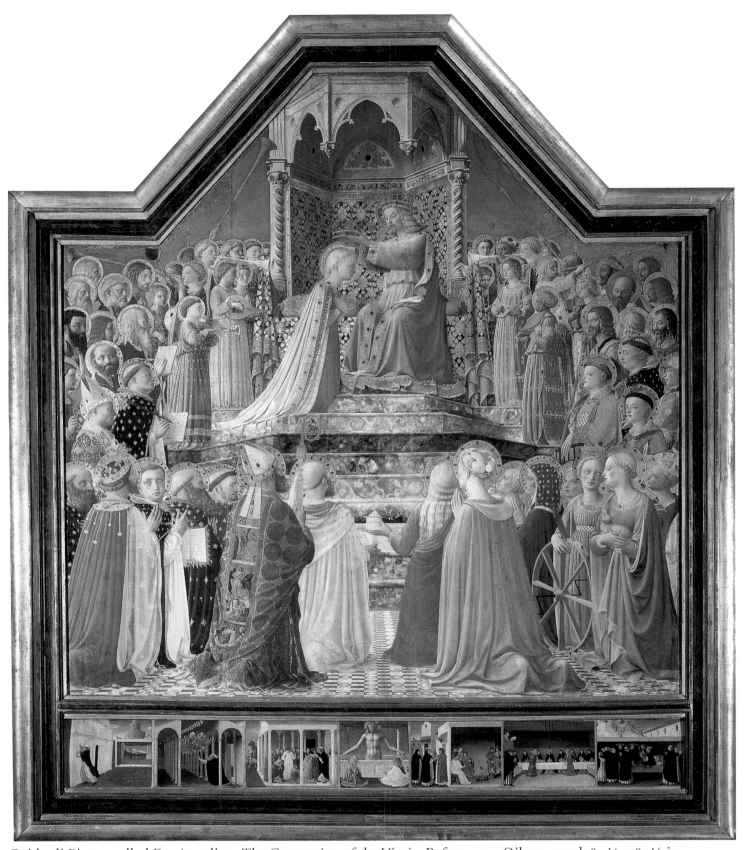

Guido di Pietro, called Fra Angelico. *The Coronation of the Virgin*. Before 1435. Oil on wood. 82 ¼ x 81 ⅛ in. (209 x 206 cm).

Fra Angelico was the prior of the Church of Saint Dominic, in Fiesoles, for which he painted this altarpiece. Episodes from the life of Dominic occupy the predella, while the saint himself is on the left, looking out at the viewer and directing our attention to the joyous event.

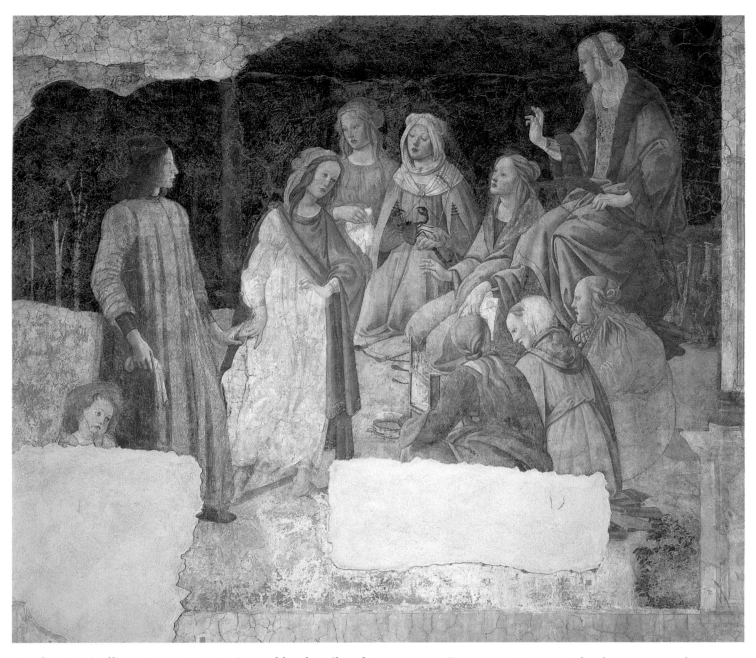

Sandro Botticelli. *A Young Man Is Greeted by the Liberal Arts.* c. 1473. Fresco. 93 ⅓ x 106 ¼ in. (237 x 270 cm).

This and the fresco opposite were found in a villa outside Florence, where they commemorated the marriage of Giovanna degli Albizzi and Lorenzo Tornabuoni. Lorenzo is shown here with figures representing a Renaissance education, from Rhetoric and Music, to Astrology and Dialectic.

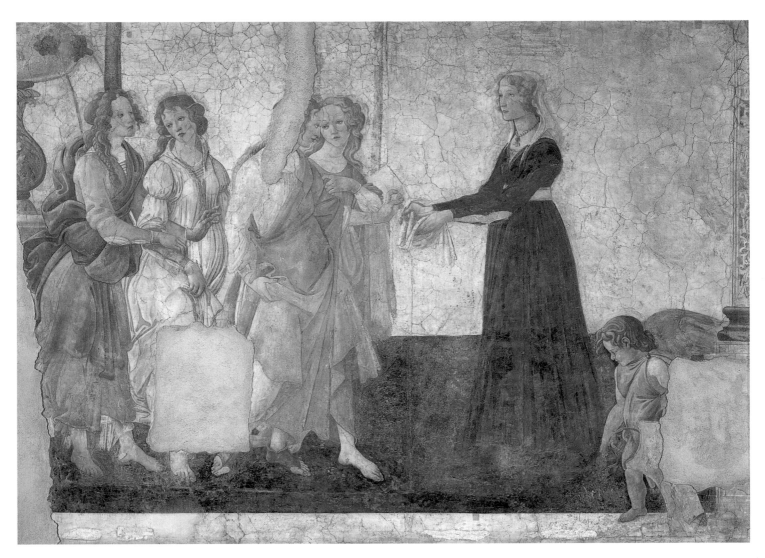

ABOVE

Sandro Botticelli. *A Young Woman Receives Gifts from Venus and the Three Graces.* 1483. Fresco.
83 x 111 ⅜ in. (211 x 283 cm).

Giovanna degli Albizzi was famously beautiful, and Botticelli was celebrated for his ideal beauties. The Three Graces are elsewhere identified, in relation to Giovanna, as Chastity, Beauty, and Love. This fresco and its companion are particularly notable for their lyrical rhythms and colors.

P. 108

Jean Hey, the Master of Moulins. *Madeleine de Bourgogne, presented by Saint Magdalen.* c. 1480–1500. Oil on wood.
22 x 15 ¾ in. (56 x 40 cm).

The donor, the lady on the left-hand panel of a triptych, is presumed to be Madeleine of Burgundy because she is being presented by another great and pious lady, the saint of the same name, identifiable by the jar of ointment she holds, in memory of her humble washing of Christ's feet.

P. 109

Jean Hey, the Master of Moulins. *Suzanne de Bourbon,* or *Child at Prayer.* Part of a triptych. 1492–93. Oil on wood.
10 ½ x 6 ½ in. (26.8 x 16.5 cm).

The Flemish master was a presence in the courts of Charles VIII and Louis XII. Combining the realism of northern painting with the fuller lines of the French manner, Hey conveyed with expression and gesture the personality of this child, the daughter of Anne of Beaujeu, who was regent of France until 1491.

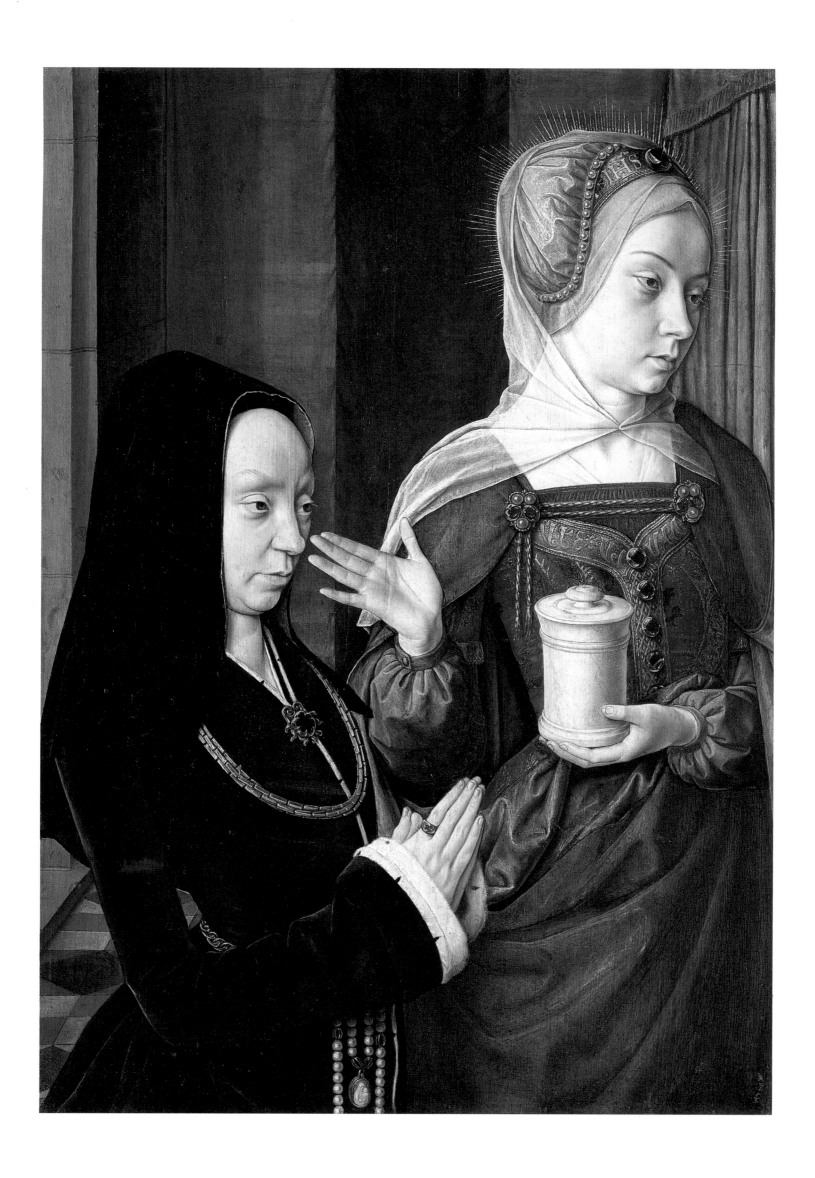

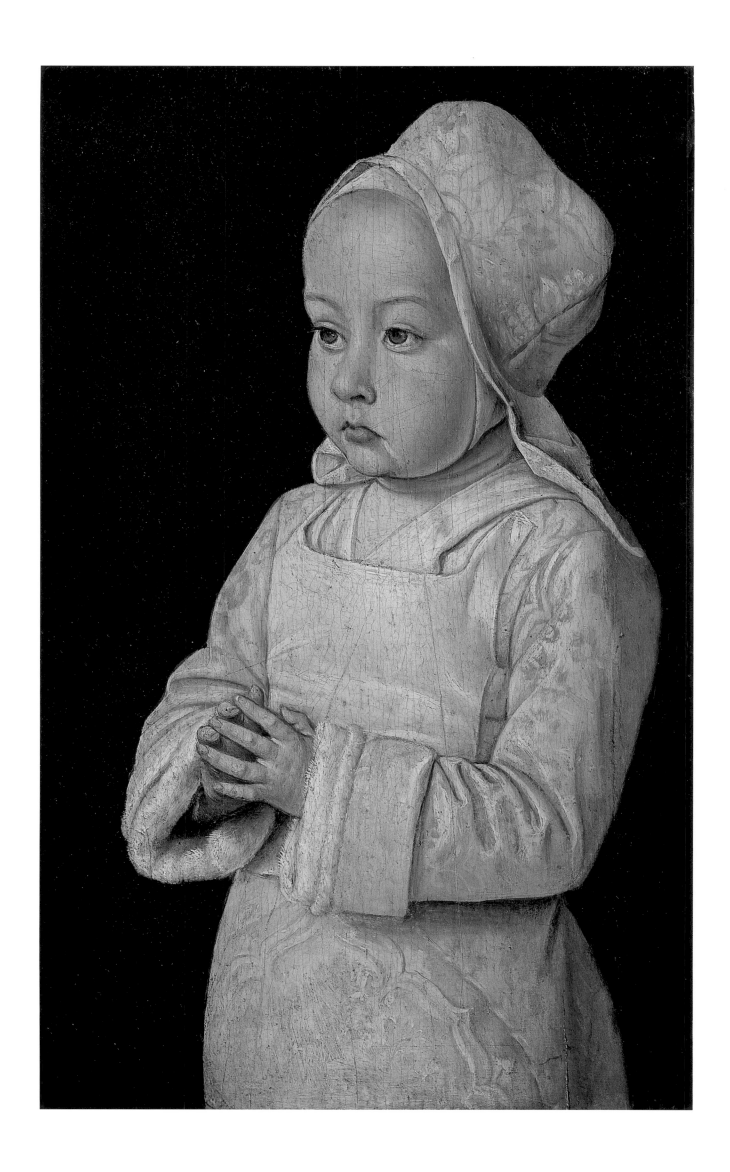

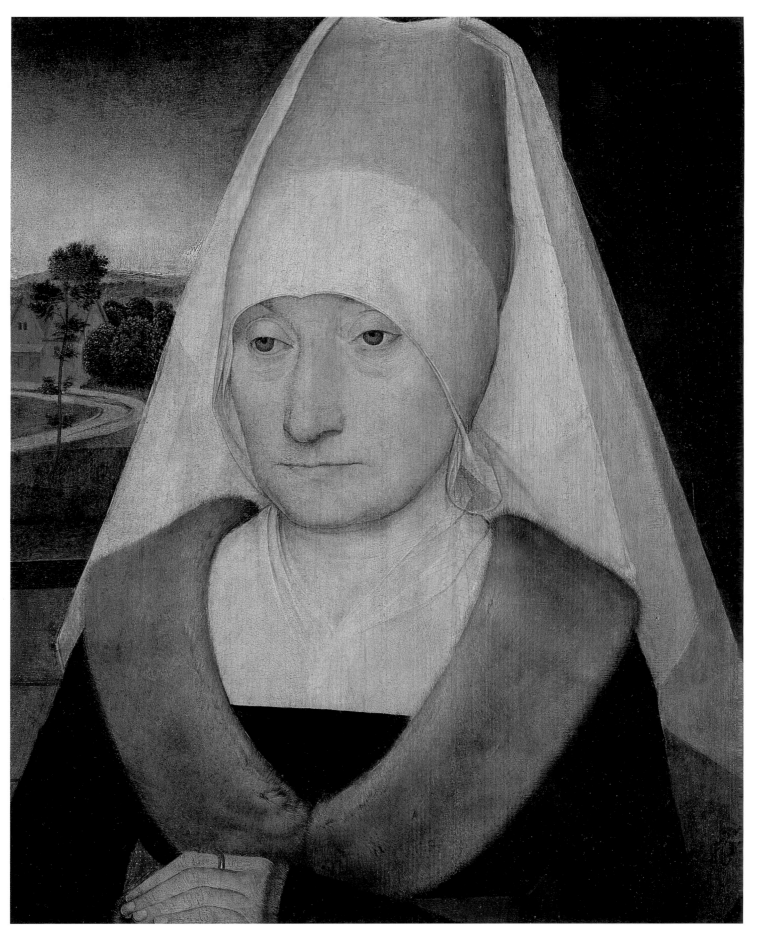

Hans Memling. *Portrait of an Old Woman.* 1470–75. Oil on wood. 13 ¾ x 11 ½ in. (35 x 29.2 cm).

This meditative lady represents a northern European bourgeois ideal. Well but soberly dressed, she neither despises the things of this world, nor is captive to them, but keeps her thoughts on higher things. In the context of this painting, the road in the back symbolizes the journey of life.

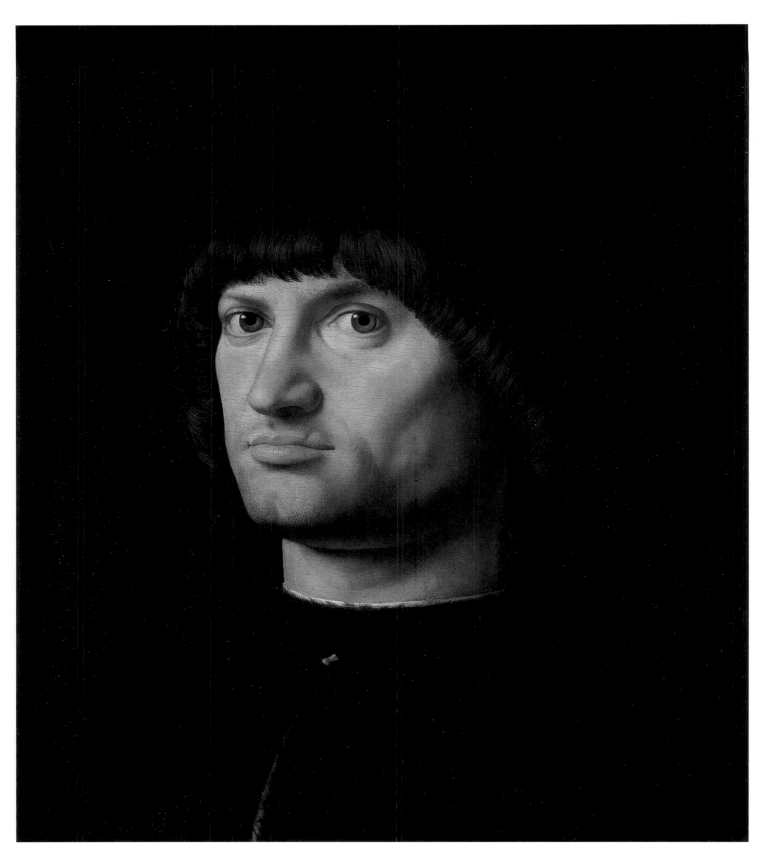

Antonello da Messina. *Portrait of a Man, called The Condottiere.* 1475. Oil on wood. 14 ⅛ x 11 ¾ in. (36 x 30 cm).

The well-traveled Antonello is credited with popularizing the northern European medium of oil paint in Italy. Though the sitter's name is unknown, his clear-eyed gaze and resolute features may explain his identification as a *condottiere*, a general-and-military-strategist-for-hire.

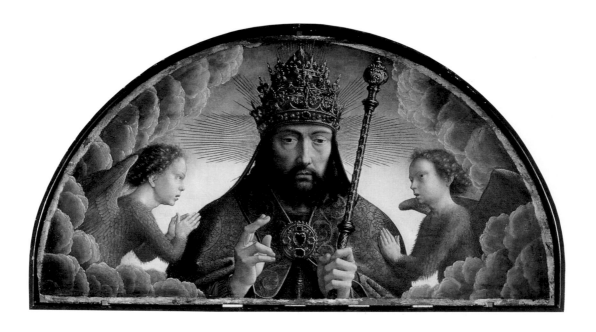

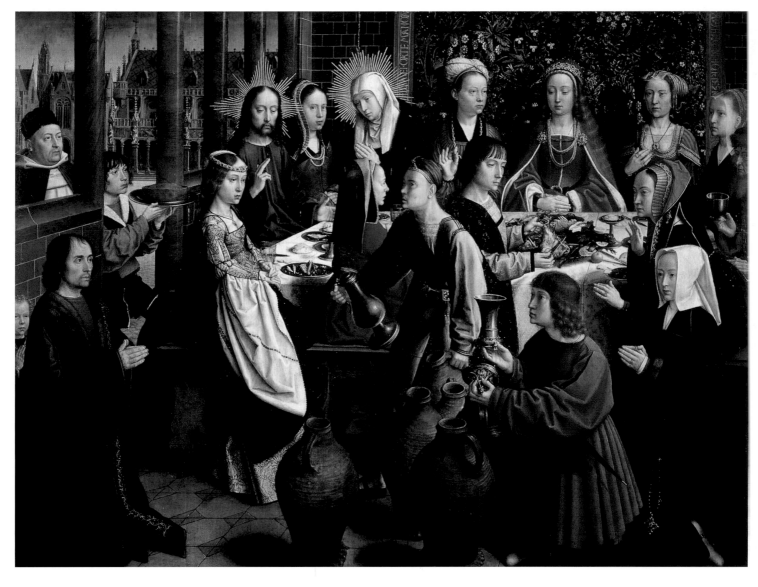

RIGHT

Benozzo Gozzoli. *The Triumph of St. Thomas Aquinas.* n.d. Oil on wood. 90 ½ x 40 ⅛ in. (230 x 102 cm).

Formerly in the Cathedral of Pisa, this panel entered the Louvre, then the Musée Napoléon, in 1813. The angelic doctor is flanked by Aristotle on the left and Plato on the right; the great achievement of the Dominican religious order was to unify classical philosophy with Christian teachings.

OPPOSITE

Gérard David. *The Wedding at Cana.* n.d. Oil on wood. 39 ⅜ x 50 ⅜ in. (100 x 128 cm).

The lunette shows a blessing by God the Father, on his head the three-tiered papal crown. In the feast scene, servants display empty wine vessels. The beguin, or linen headdress, of the married donor on the right relates her to the Virgin, in wimple and veil.

P. 114

Hieronymus Bosch. *The Ship of Fools.* c. 1500. Oil on wood. 22 ⅞ x 12 ½ in. (58 x 32 cm).

The title of this fiercely antic work was taken from a best-selling poem on the theme of folly—the mortal tendency to neglect the immortal soul. The prominence of a nun and a monk recalls popular outrage at the widespread irreligiosity of the clergy, a discontent that would fuel the birth of Protestantism.

Hans Baldung Grien. *The Knight, the Young Girl, and Death.* n.d. Oil on wood. 14 x 11 ⅔ in. (35.5 x 29.6 cm).

Macabre allegories were passing out of style when Grien, a student and friend of Dürer, painted this. The almost garish colors resemble those of the hand-painted cards the recently invented printing press was disseminating. The plants in the foreground, however, are rendered in tenderly realistic detail.

Filippino Lippi. *Three Scenes from the Life of Virginia.* n.d. Oil on wood. 17 ¾ x 50 in. (45 x 127 cm).

This panel adorned a cassone, probably given as a wedding gift. These chests often bear scenes featuring women, in this case, the Roman maiden Virginia, who is arrested then condemned to slavery by the despot Appius Claudius, so that he may rape her. Virginia's father then kills her to save the family honor.

P. 118

Domenico Ghirlandaio. *Portrait of an Old Man with a Young Boy* (after restoration). 1490.
Oil on canvas. 24 ⅔ x 18 ¼ in. (62.7 x 46.3 cm).

This tender double portrait shows the open and mutual affection between Francesco Sassetti, a wealthy Florentine banker, and his grandson, who approaches his grandfather with absolute confidence. The costly red of their costumes accentuates the continuity of the prosperous line.

P. 119

Leonardo da Vinci. *Portrait of a Lady from the Court of Milan.* n.d. Oil on wood. 24 ¾ x 17 ¾ in. (63 x 45 cm).

This painting is also called *La Belle Ferronnière*, or "the beautiful metalworker's wife," a mistaken reference to a mistress of François I. The attribution to Leonardo is based on features such as the depth of the sitter's gaze, the smoky treatment of light and shadow, and the cracking on the surface, characteristic of Leonardo's mix of oils.

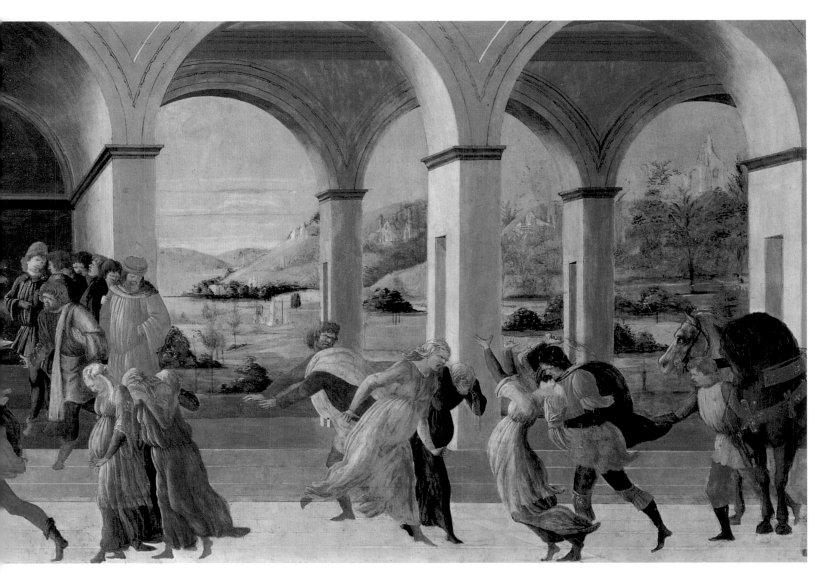

P. 120

Albrecht Dürer. *Self-Portrait*. 1493. Oil on parchment mounted on canvas. 22 x 17 ⅓ in. (56 x 44 cm).

This is one of the first self-portraits executed as such—as opposed to within another subject—in northern Europe. The thistle that the fashionable young man holds may be either a token of fidelity, making this painting a betrothal gift, or else a symbol for the suffering of Christ.

P. 121

Leonardo da Vinci. *The Virgin of the Rocks*. 1483. Oil on canvas. 78 ⅔ x 48 in. (199 x 122 cm).

This picture resonates with enduring mystery. Rocks in the middle ground resemble the ruined mangers of earlier paintings that connote the Nativity's ending of the Old Law. Mary's left hand, in shocking perspective, shelters her son, who with thumb and two fingers makes a gesture symbolizing the Trinity.

P. 122

Leonardo da Vinci. *The Virgin and Child with Saint Anne*. 1508. Oil on wood. 66 ⅛ x 51 ⅛ in. (168 x 130 cm).

François I probably invited Leonardo to France to make this painting of the Virgin and her mother, Saint Anne, playing with the Christ Child. The Virgin sits in her mother's lap, like a child herself, while the Child holds a lamb, symbol of his future Passion, all against a strange, lifeless, lunar landscape.

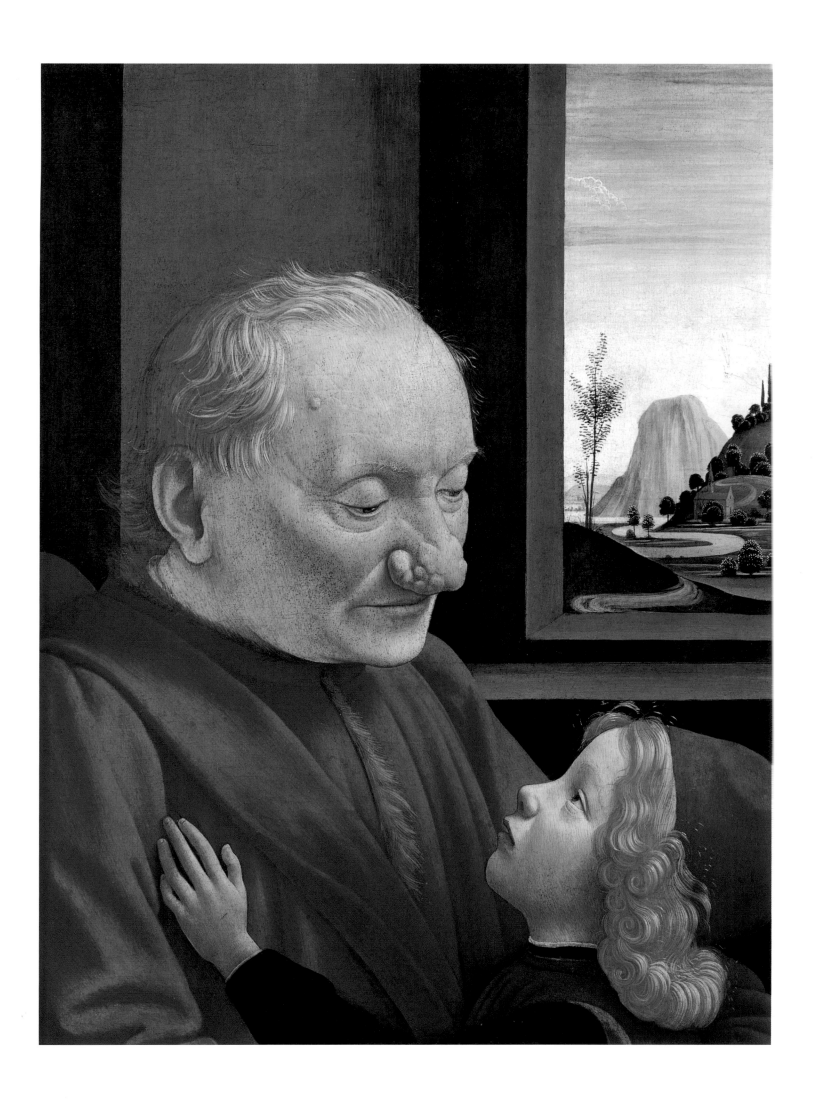

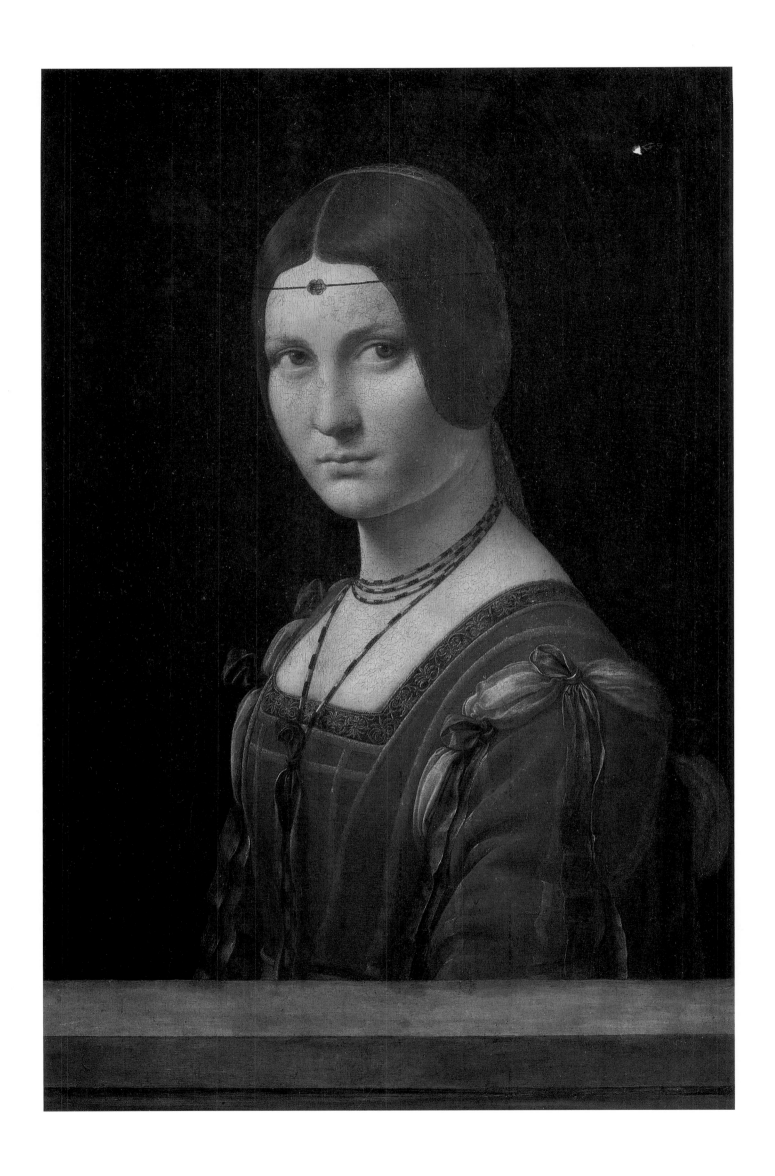

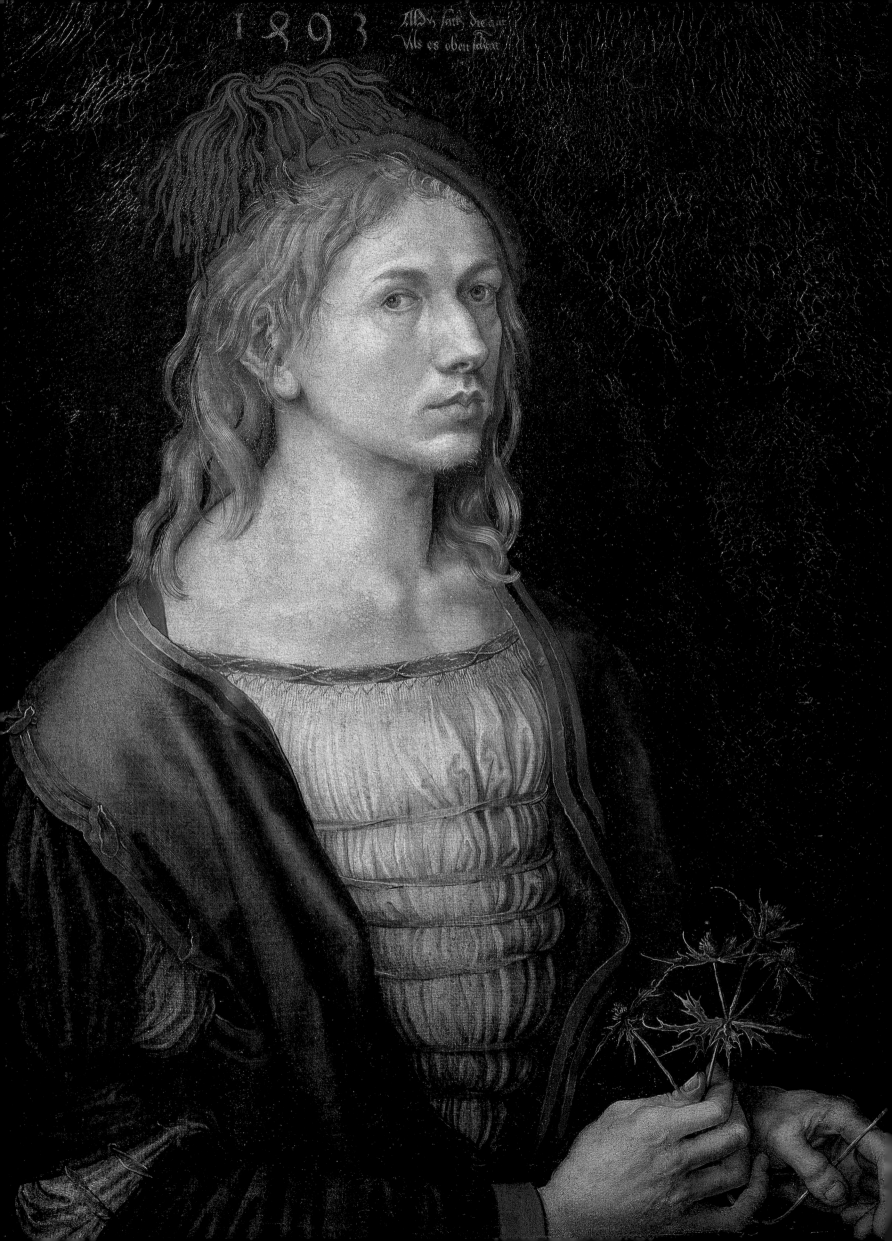

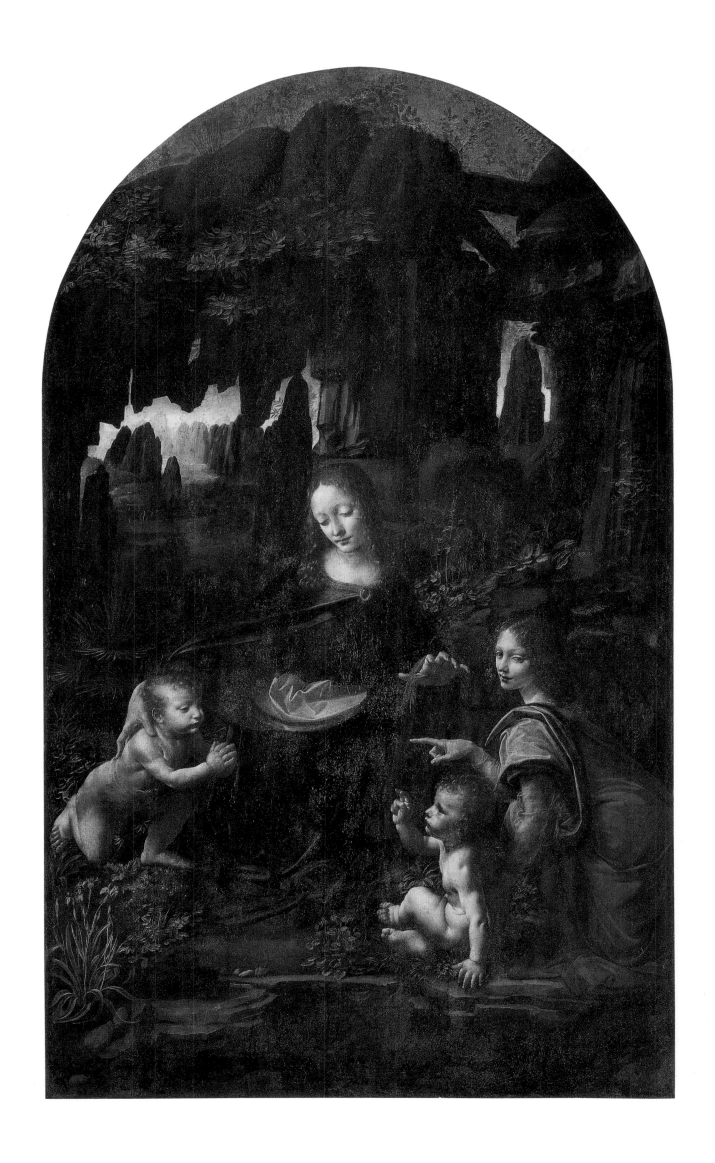

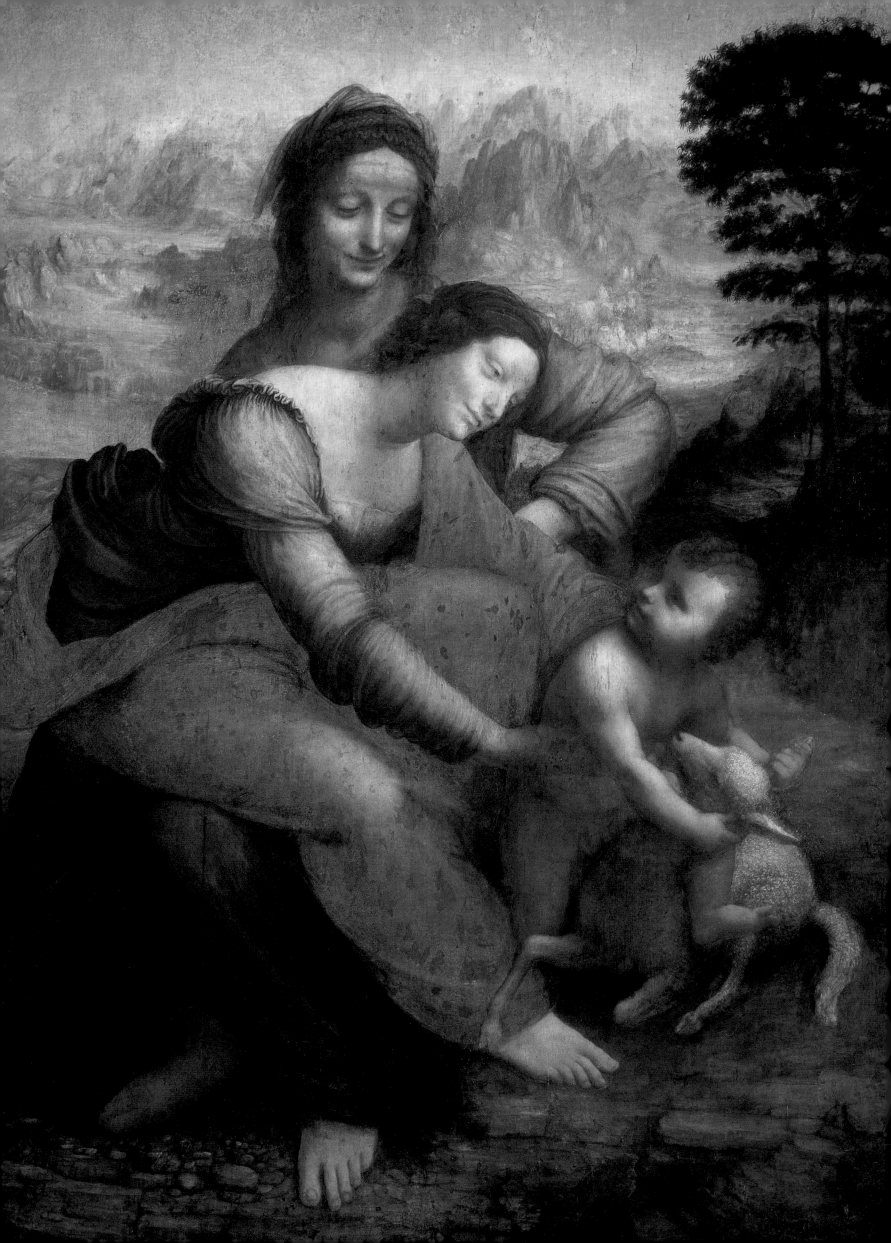

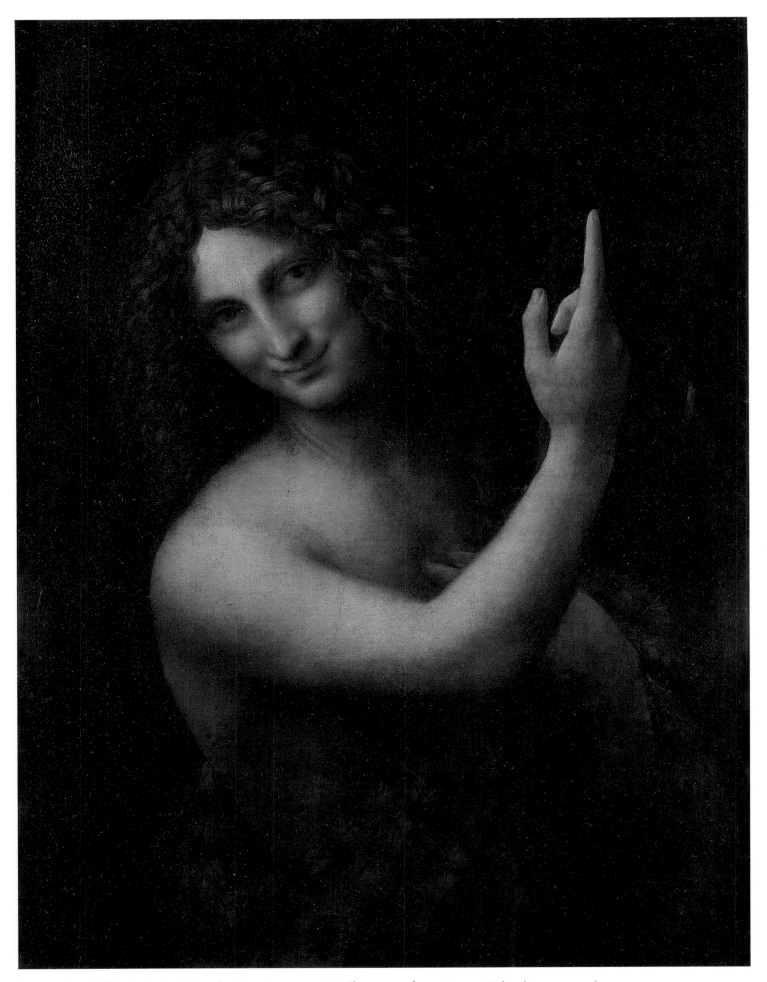

Leonardo da Vinci. *Saint John the Baptist.* 1513–16. Oil on wood. 27 ⅛ x 22 ½ in. (69 x 57 cm).

Some of the power of this enigmatic figure is his ambiguity. He holds a simple cross and gestures heavenward, but his smile and compelling gaze are far from saintly. Sensuous curves animate this cryptically lit composition: the saint's hair and animal skin form one oval; his right arm forms another.

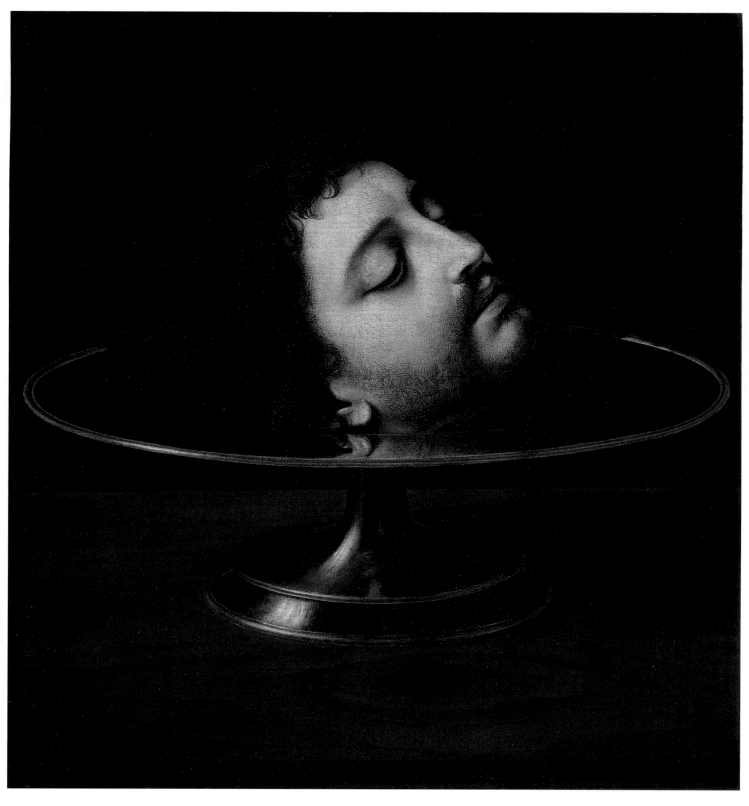

Andrea Solario. *Head of John the Baptist.* 1507. Oil on wood. 18 ⅛ x 17 in. (46 x 43 cm).

The artist was Leonardo's best Milanese student, and the master's haunting style, which seems to call the image out of mystical darkness, is evident here. Solario, who was in France from 1507 to at least 1510, painted a small self-portrait on the neck of the dish.

Raffaello Santi, called Raphael. *The Virgin and Child with Saint John the Baptist,* or *La Belle Jardinière.* 1507. Oil on wood. 48 x 31 ½ in. (122 x 80 cm).

Warm light sculpts the contours of this intimate and graceful group, to which a pyramidal construction adds a subtle, grounded power. Francis I, the artist's contemporary, brought Raphael's paintings to France, and with them, the Italian style and classicism.

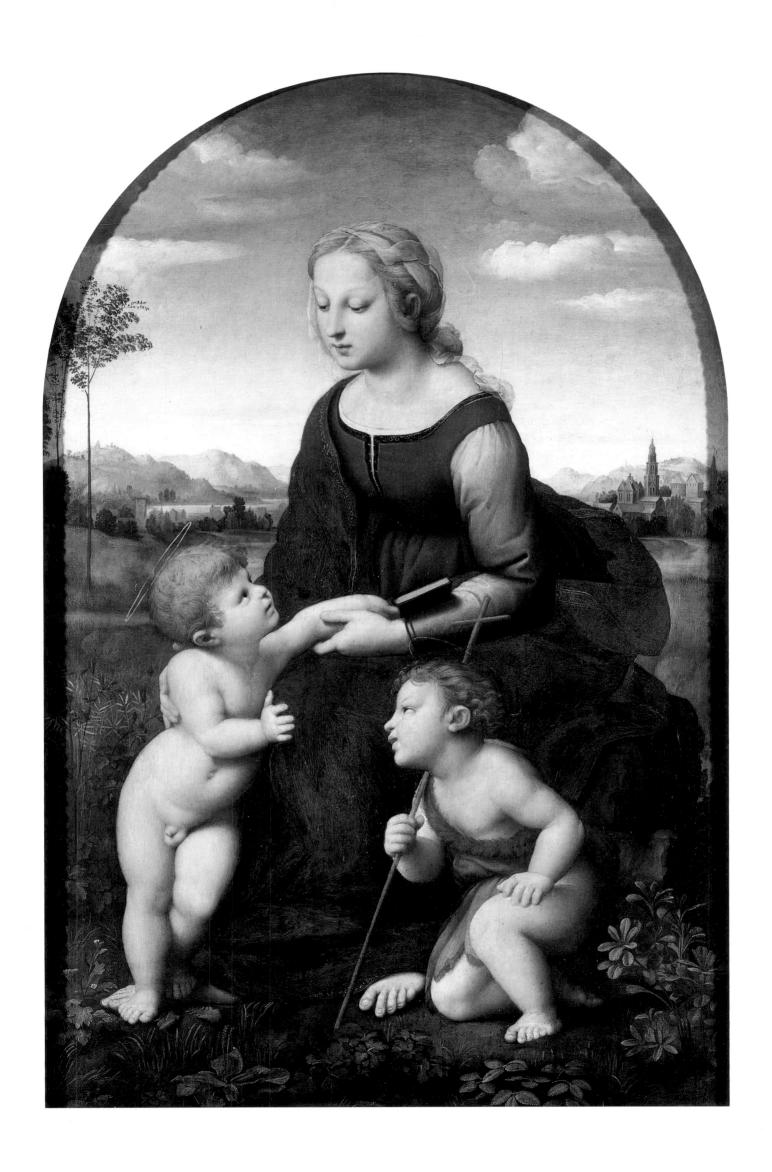

Colijn de Coter. *The Three Marys in Lamentation* (right wing of *The Throne of Grace*). n.d.
Oil on wood. 66 x 24 ½ in. (167.5 x 62.3 cm).

The Virgin, Mary Magdalene, and Mary, the Mother of James the Less, attend the Deposition, on the right-hand panel of the *Throne of Grace* triptych. The Magdalene's red is the color of Christ's Passion; the Virgin's black, her maternal mourning; the third Mary's green, the color of faith.

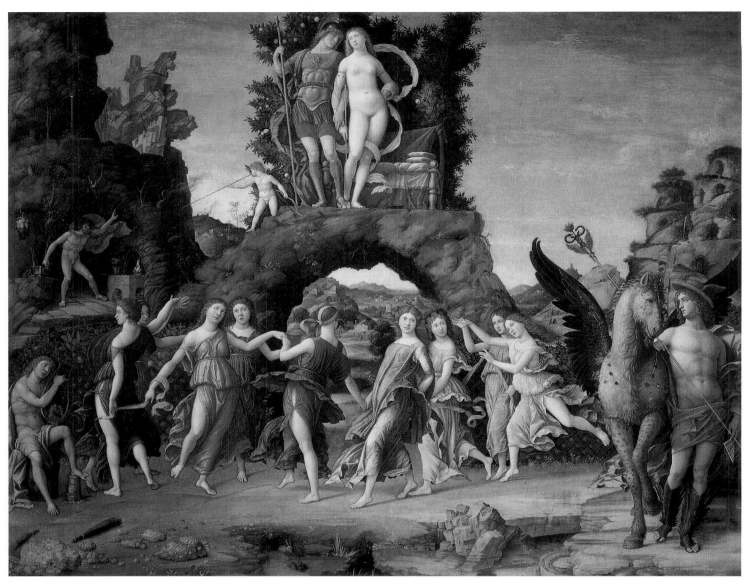

Andrea Mantegna. *Mars and Venus*, also called *Il Parnasso*. c. 1502. Oil on canvas. 62 x 75 ½ in. (159 x 192 cm).

Isabella d'Este, a patron of the arts and fond of puzzles, sketched the composition the artist was to execute for her studiolo. The meeting of the deities Mars and Venus marked Isabella's marriage to Francesco Gonzaga, marquis of Mantua: those planets were conjoined on her wedding day.

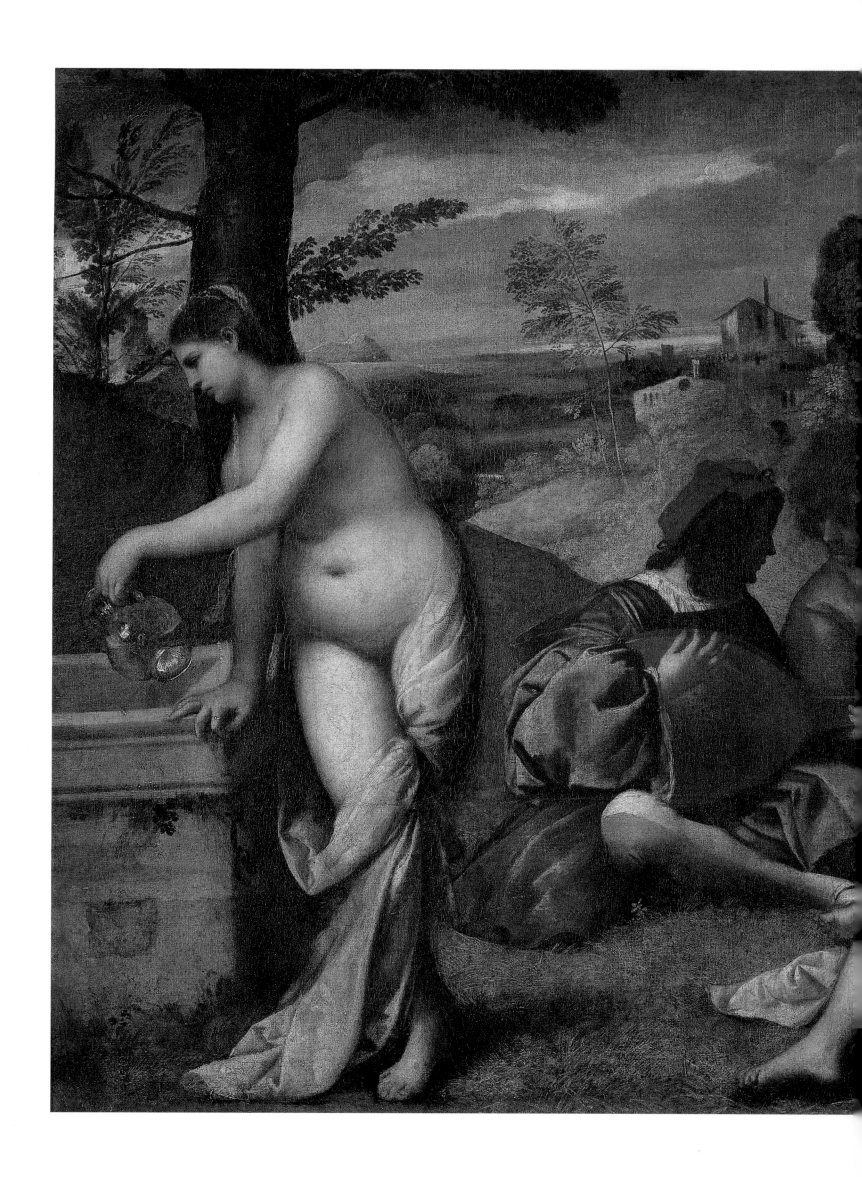

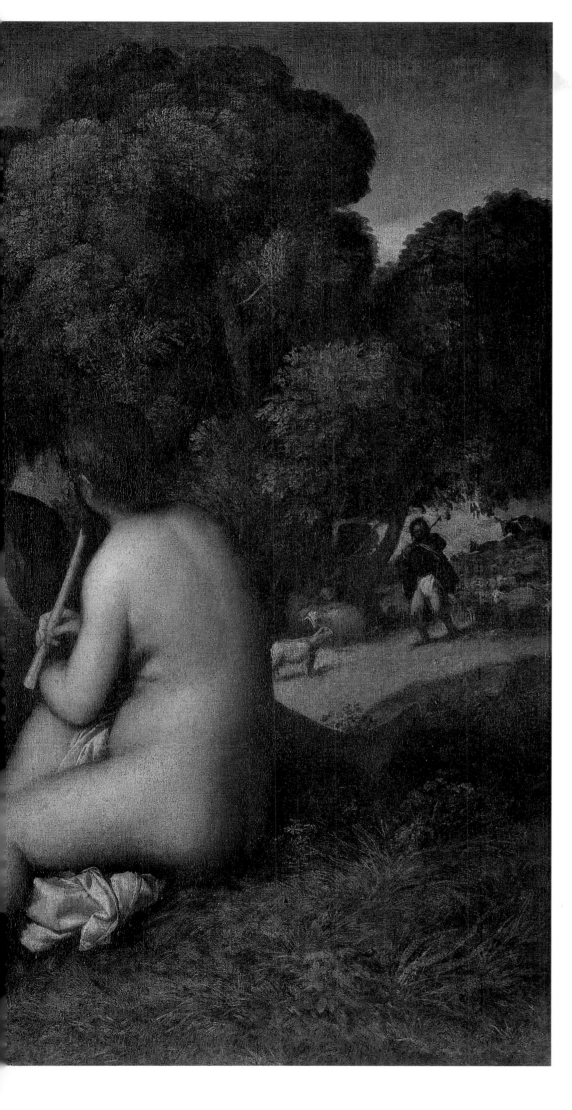

Titian. *Concert in the Country.* 1510–11. Oil on canvas. 43 ⅓ x 54 ⅓ in. (110 x 138 cm).

This painting, perhaps commissioned by Isabella d'Este of Mantua, eventually made its way to the collection of Louis XIV. It has influenced works for centuries—Manet's *Déjeuner sur l'herbe* of 1863 is one. Are the women muses, invisible to the city fellow who converses with his country counterpart?

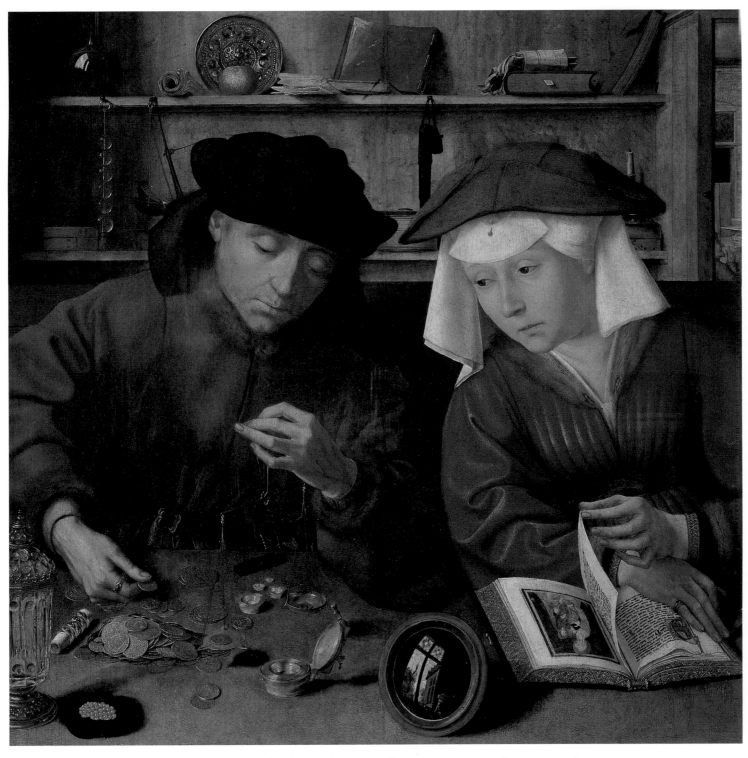

Quentin Metsys. *The Banker and His Wife*. 1514. Oil on wood. 27 ½ x 26 ⅜ in. (70 x 67 cm).

Some of the objects, such as the scales and the devotional book, which complement each other, testify to the ideal of a balanced life. Others, such as the string of glass balls and the bottle just above, are virtuoso displays of illusionism. The mirror facing out brings the viewer into the picture.

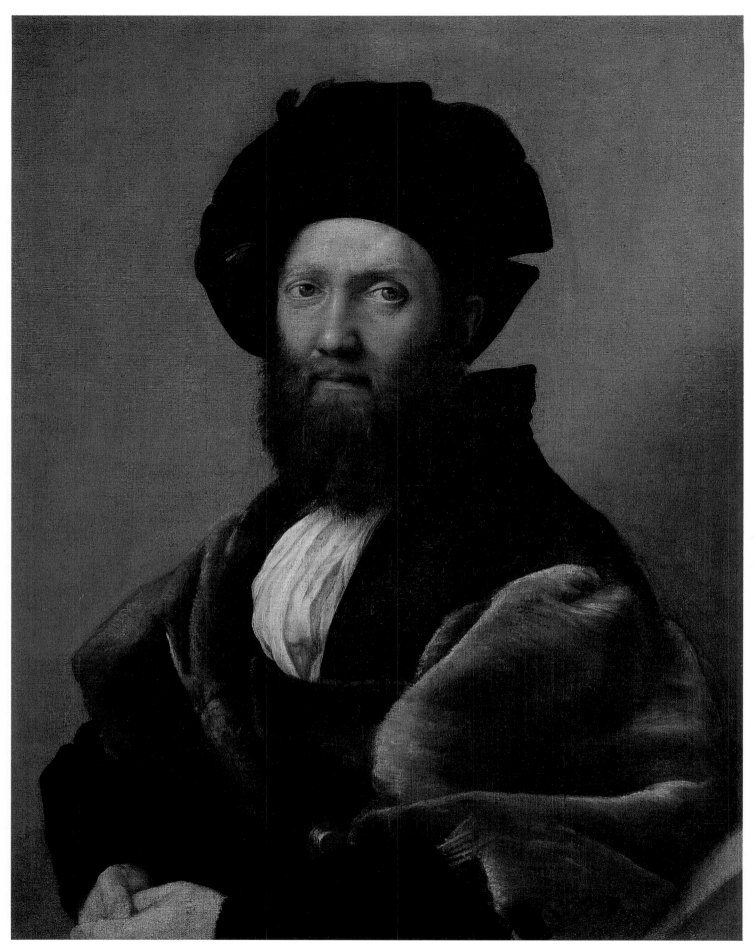

Raffaello Santi, called Raphael. *Portrait of Baldassare Castiglione*. 1514. Oil on canvas. 32 ¼ x 26 ⅜ in. (82 x 67 cm).

Castiglione, a diplomat and poet, became one of the most influential people in Europe with *The Courtier*, his dialogue on correct and pleasing courtly behavior. The author, ambassador to the Vatican at the time, commissioned this portrait when the artist was executing frescoes for Pope Leo X.

ABOVE

Jan Gossaert, called Mabuse. *The Carondelet Diptych: Jean Carondelet and Virgin and Child.* 1517.
Oil on wood. Each panel: 16 ¾ x 10 ⅝ in. (42.5 x 27 cm).

The Flemish Gossaert journeyed to Rome during 1508 and 1509, in the service of Philip of Burgundy, then lord of Flanders as well. Gossaert brought an Italian look back north with him, visible here especially in the soft modeling of Virgin and Child.

OPPOSITE

Andrea del Sarto. *Charity.* 1518. Oil on canvas. 72 ⅞ x 54 in. (185 x 137 cm).

One of the first works in the royal collection to have been transferred from panel to canvas in 1750 under Louis XV, this allegorical painting was displayed at the Luxembourg Palace as an important example of the king's restoration project.

P. 134

Raffaello Santi, called Raphael. *The Holy Family.* 1514. Oil on canvas. 81 ½ x 55 ⅛ in. (207 x 140 cm).

Full, billowing draperies and sweeping, circular lines express exuberant joy in this group picture. Two angels at upper left observe as the elderly Elizabeth, Mary's cousin, encourages her son, a rambunctious infant Saint John, to pray. Saint Joseph, obscured in shadow, also watches, outside the lively scene.

Sebastiano del Piombo. *The Visitation*. 1519–21. Oil on canvas. 66 ⅛ x 52 in. (168 x 132 cm).

The elderly Elizabeth, unexpectedly pregnant with the future John the Baptist, went to visit her cousin Mary, upon learning that Mary, too, was with child. Sebastiano, who treated this popular theme monumentally, enclosed the two women within the lines of their cloaks, as if within a miraculous arch.

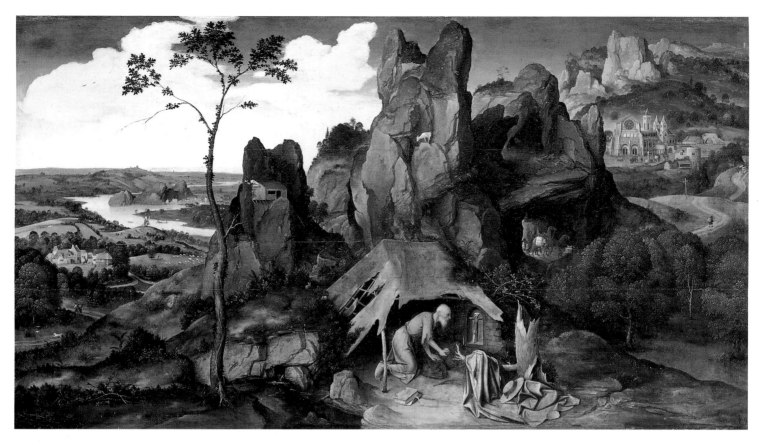

Joachim Patinier. *Landscape with Saint Jerome* c. 1520. Oil on wood. 30 ½ x 54 in. (78 x 136 cm).

Patenier was primarily interested in landscape, in part as a site for symbols, such as the goat who clings to the cliff above the saint's hermitage that might stand for Jerome's stubborn faith, and the church on the right. Jerome was never a cardinal: the red hat recalls his status as a doctor of the Church.

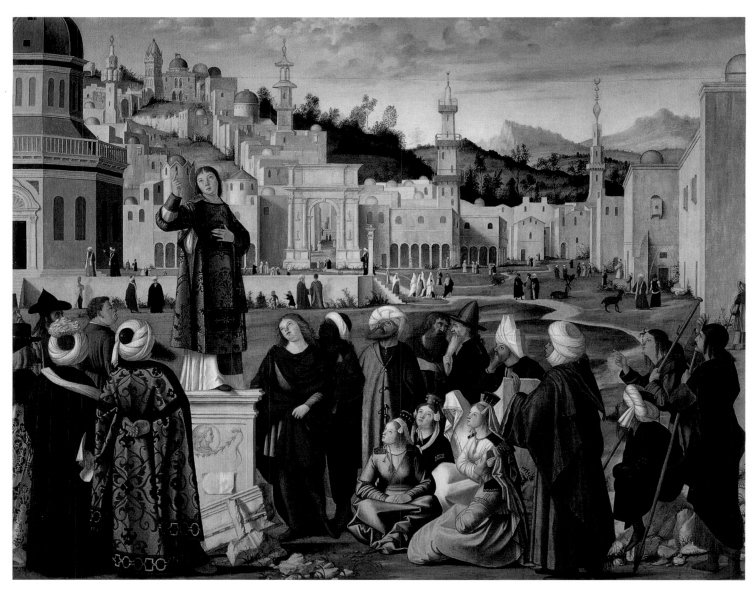

Vittore Carpaccio. *Saint Stephen Preaching at Jerusalem.* 1514. Oil on canvas. 58 ¼ x 76 ⅜ in. (148 x 194 cm).

Stephen, one of the earliest Christian martyrs, was stoned to death after defending himself to the Sanhedrin. The Venetian Carpaccio (whose rich reds gave the artist's name to a gourmet dish) invented the city of Jerusalem, but would have seen costumes such as these in the streets of his native city.

P. 138

Hans Holbein the Younger. *Anne of Cleves.* 1539. Oil on parchment on canvas. 25 ½ x 18 ⅞ in. (65 x 48 cm).

Holbein's formal treatment and detailed reportage of Anne's costly dress are suited to the portrait's purpose: to introduce to Henry VIII the woman Cromwell would have had him marry. The king described the Protestant leader's daughter as homely—"no better than a Flanders mare"—and had the marriage annulled after six months.

P. 139

Hans Holbein the Younger. *Portrait of Erasmus.* 1523. Oil on wood. 16 ½ x 12 ½ in. (42 x 32 cm).

The great Desiderius Erasmus of Rotterdam is here composing his *Commentaries on the Gospel of Saint Mark.* Holbein's insight is evident in this profile portrait of a focused, precise, and patient temperament, whose rings and costume show him to be a man of the world as well.

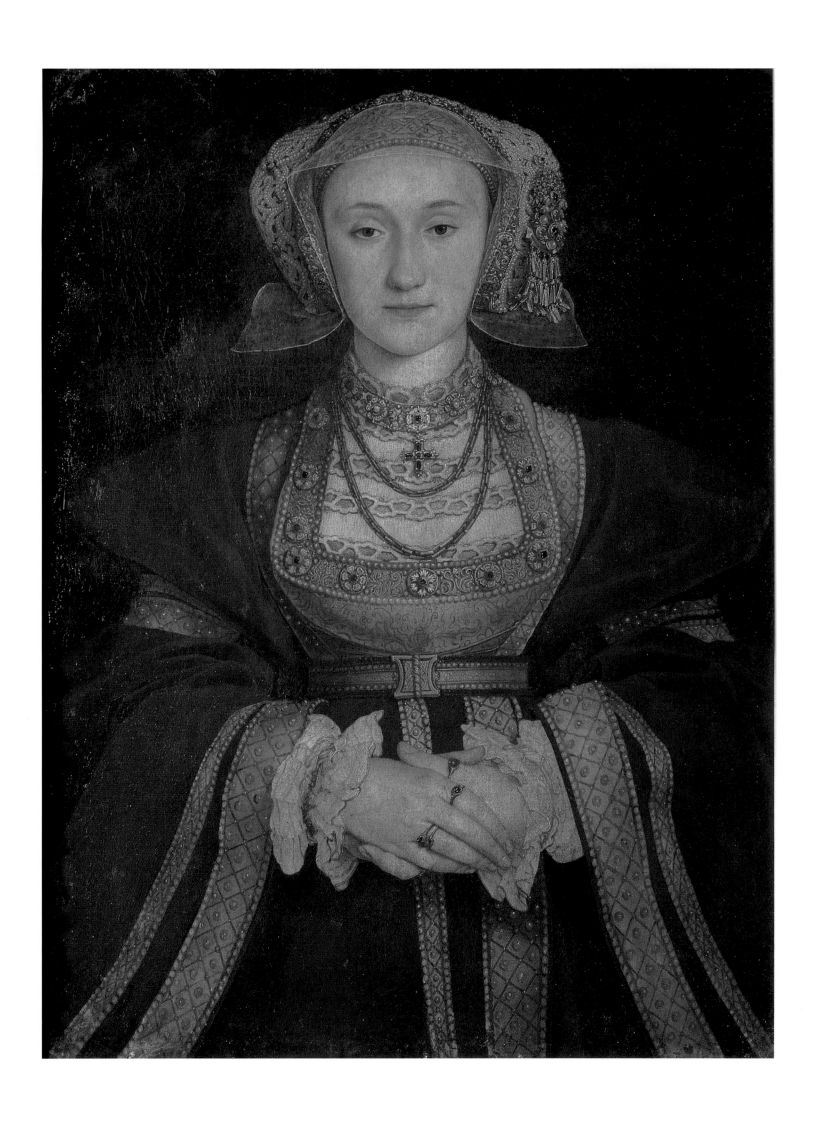

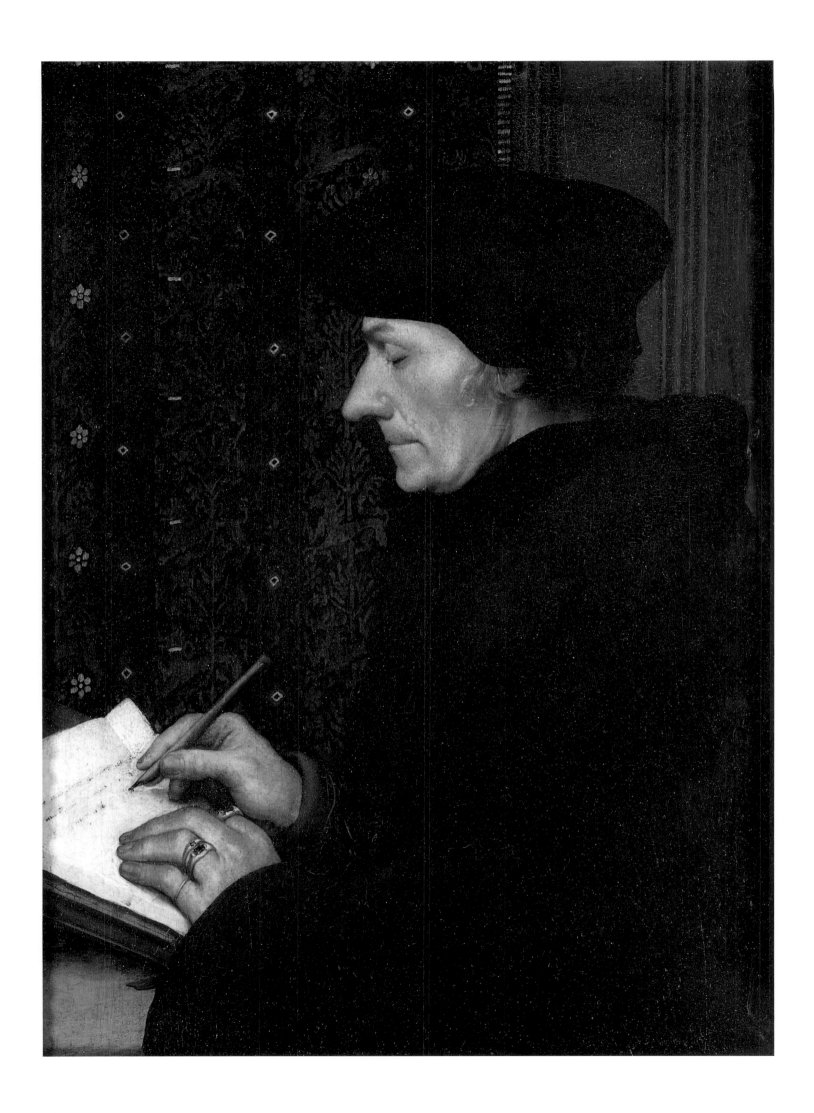

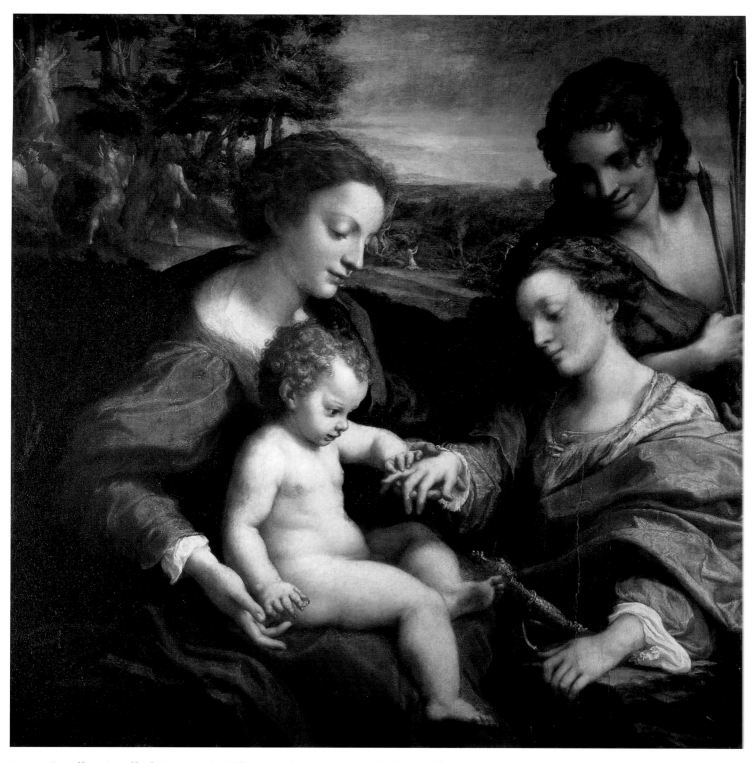

Antonio Allegri, called Correggio. *The Mystic Marriage of Saint Catherine.* c. 1526–27. Oil on canvas.
41 ⅛ x 40 ⅛ in. (105 x 102 cm).

In a pastoral, almost secular mood, Correggio depicted the famous vision of Catherine of Siena, in which she was married to Christ. Behind her is Saint Sebastian, identifiable by his arrows—which make the handsome boy look more like Eros than like a Roman soldier—and by the scene of his martyrdom in the background.

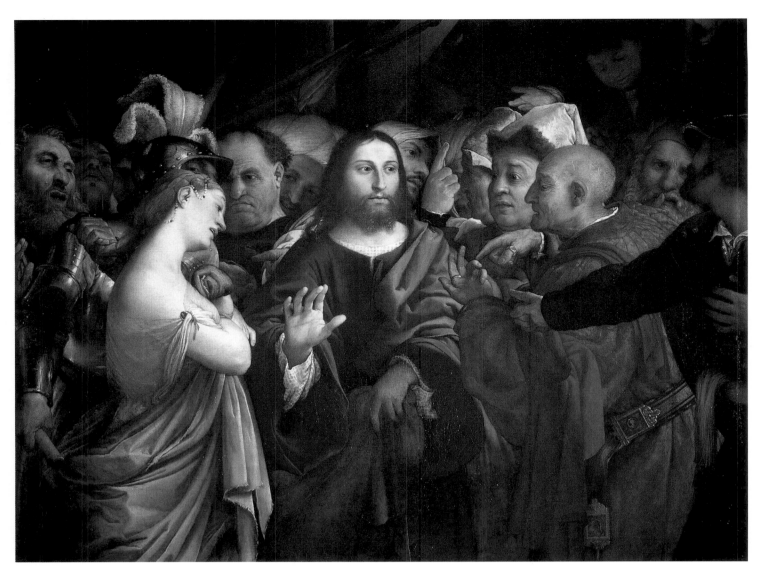

ABOVE

Lorenzo Lotto. *Christ and the Woman Taken in Adultery.* c. 1530–35. Oil on canvas. 48 ⅞ x 61 ⅜ in. (124 x 156 cm).

An oval of light allies Christ and the woman, but the artist's interest is in the portrait gallery of faces around the island of sin and tolerance. Lotto was a master of characterization, and here he displayed everything from obtuse, prurient curiosity, to sexual speculation, legalistic condemnation, and more.

OVERLEAF

Tiziano Vecelli, called Titian. *The Entombment.* c. 1520. Oil on canvas. 58 ¼ x 83 ½ in. (148 x 212 cm).

Light is the artist here, on the apostle's red coat and other fabrics, and on the livid, collapsed, and heavy body of Christ. The lowering, light-torn sky reflects the drama of the moment, not just the grief of Christ's mother and his followers, but the haste and secrecy of their dangerous, pious act.

ABOVE

Domenico Beccafumi. *San Bernardino of Siena Preaching*. n.d. Oil on wood. 13 x 20 in. (33 x 51 cm).

Bernardino, a famous preacher, spoke at open-air pulpits because the churches could not contain his audiences. Beccafumi's lozenge-shaped piazza and contrast of light and dark bring the viewer's attention to the saint; the empty chair may stand for the rank of bishop, which he refused three times.

OPPOSITE

Jacopo Carrucci, called Pontormo. *The Virgin and Child with Saint Anne and Four Saints*. Before 1529. Oil on wood. 89 ¾ x 69 ¼ in. (228 x 176 cm).

The medallion in the foreground commemorates the Seigniory of Florence's annual procession to the convent of Saint Anne, for which this painting was made. The saints surrounding the Virgin are, from lower left, Peter; Sebastian; Anne; Philip, The Good Thief; and Benedict.

ABOVE

Jean Cousin. *Eva Prima Pandora.* c. 1550. Oil on wood. 38 ½ x 59 in. (98 x 150 cm).

Cousin, one of the French artists influenced by François I's Italians, deployed a conventional thematic identification of Eve, whose curiosity allegedly damned the human race to original sin, and Pandora, driven to open a forbidden box—here a jar—thereby releasing all the evils of the world. The city of Paris is in the background.

OPPOSITE

Jean Clouet. *Elisabeth of Austria, Queen of France.* Before 1572. Oil on wood. 14 ⅛ x 10 ¼ in. (36 x 26 cm).

François Clouet, like his father, Jean, was painter to François I; he fulfilled the same office for Henry II, Francis II, and Charles IX, husband of Elizabeth of Austria. Little is known of Elizabeth, except that she was a gentle soul, horrified at her husband's role in the Saint Bartholomew's Day Massacre.

OVERLEAF

Antoine Caron. *Sibyl of Tibur/Augustus and the Tiburine Sibyl.* 1575–80. Oil on canvas. 49 ¼ x 67 in. (125 x 170 cm).

The painter Caron also designed spectacular royal entertainments, like this one in the Tuileries. Catherine de Médicis stands in the opening of the balustrade in the middle ground, Henry III watches a tournament from the loggia in the background, and Charles IX plays the Emperor Augustus, whom the Sibyl exhorts to Christian worship. The subtext, during the years of the religious wars, was an affirmation of Roman Catholicism.

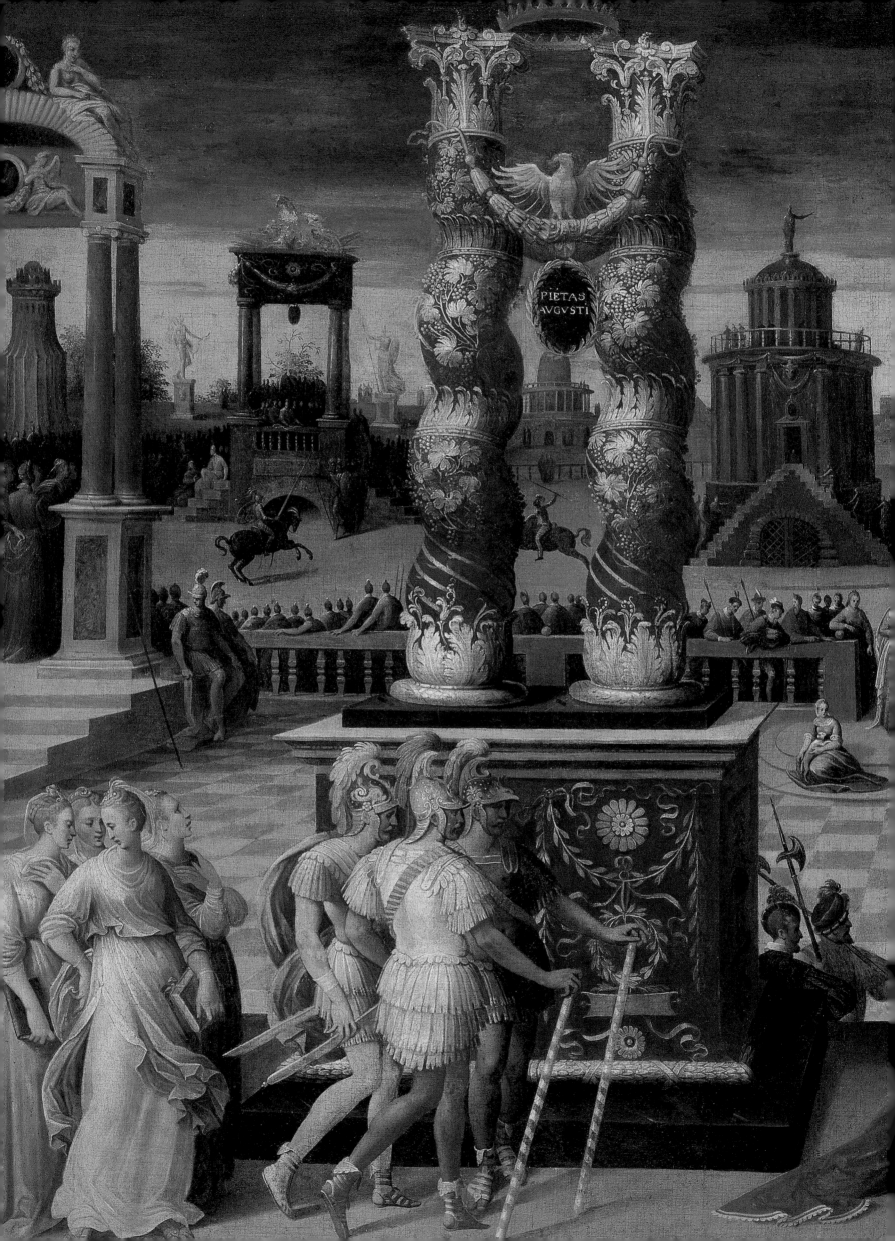

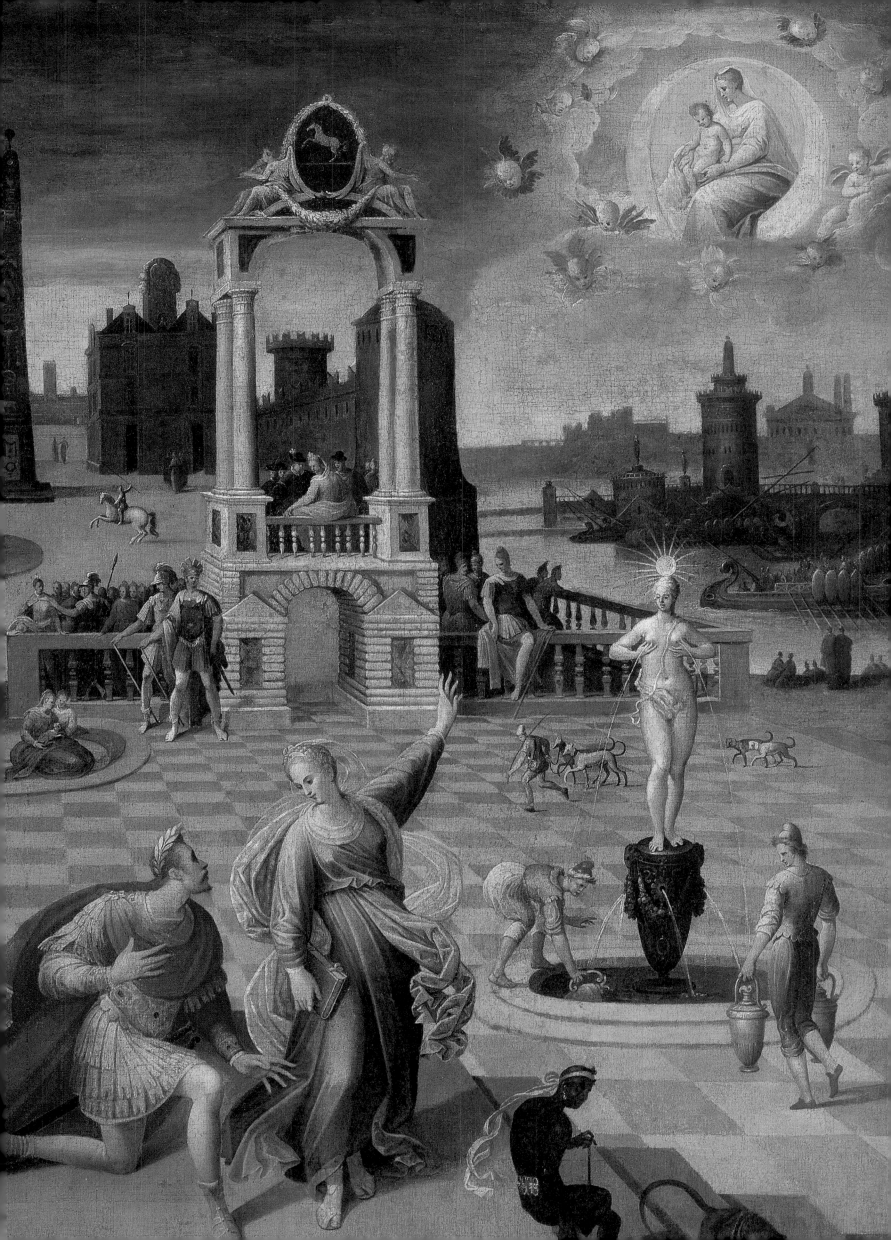

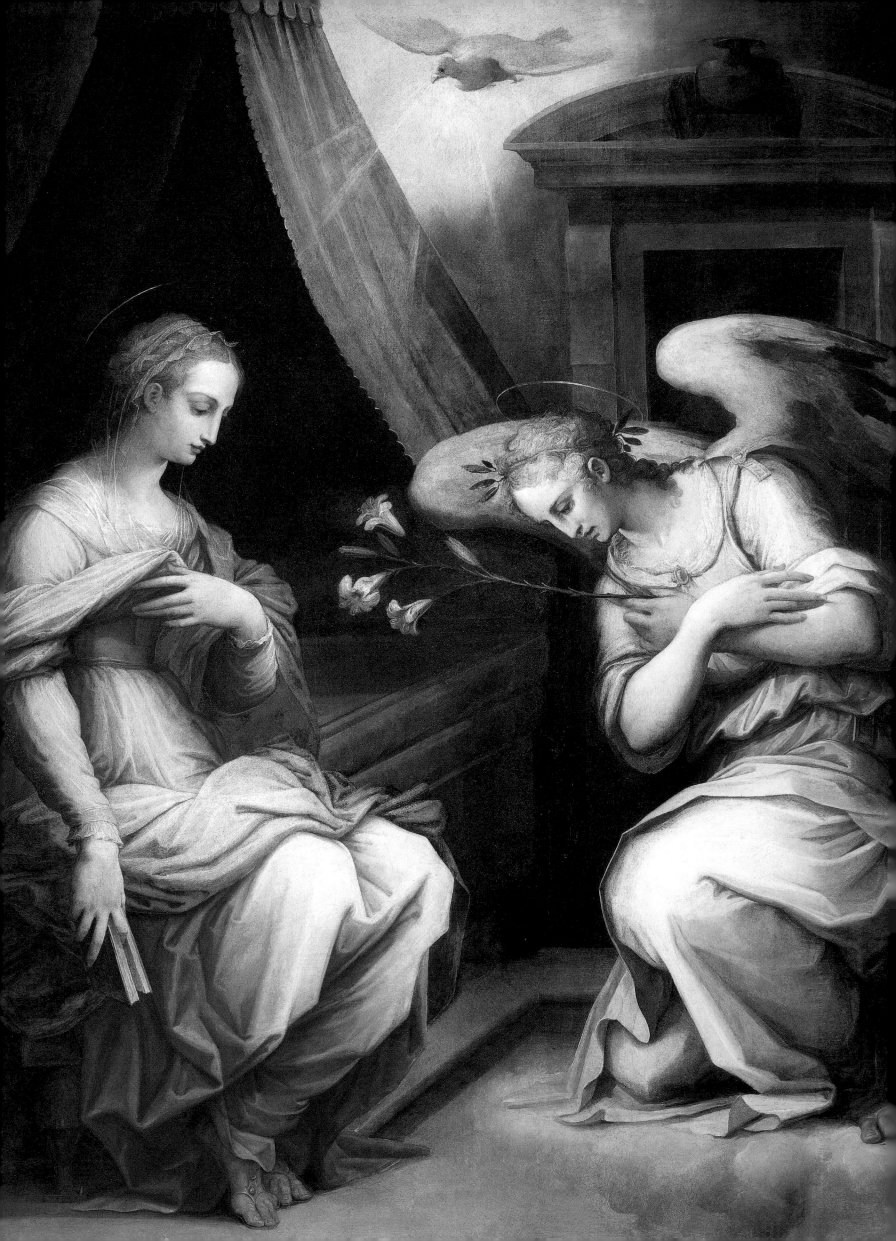

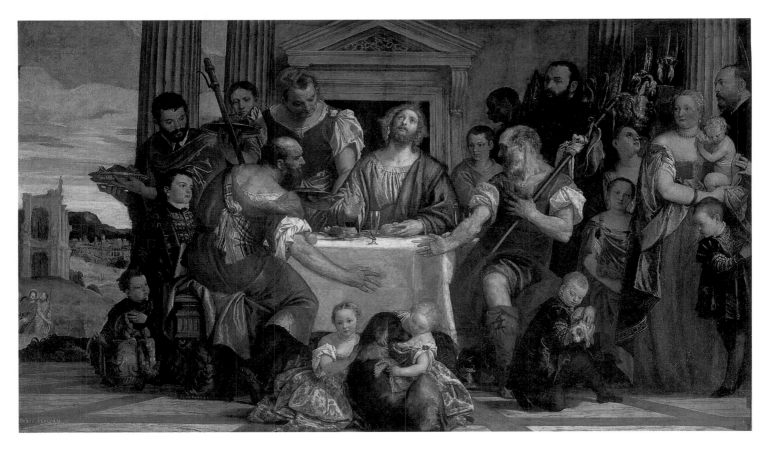

Paolo Caliari, called Veronese. *Supper at Emmaus.* c. 1560. Oil on canvas. 95 x 163 ½ in. (241 x 415 cm).

This was the most famous Italian painting on display in the state apartments of Versailles; it was exhibited in the Luxembourg Gallery and then in the first *muséum* in the Louvre Palace, as an example to art students of a sublime application of color.

Giorgio Vasari. *The Annunciation.* n.d. Part of a triptych. Oil on wood. 85 x 65 ⅔ in. (216 x 166 cm).

Vasari, who studied with Andrea del Sarto and Michelangelo, is best known for his art historical biographies of Italian artists. His own work could be modest, graceful, and original: Mary and the angel resemble each other, the bed is in darkness, and the Virgin's gesture of holding her place in her book is touchingly specific.

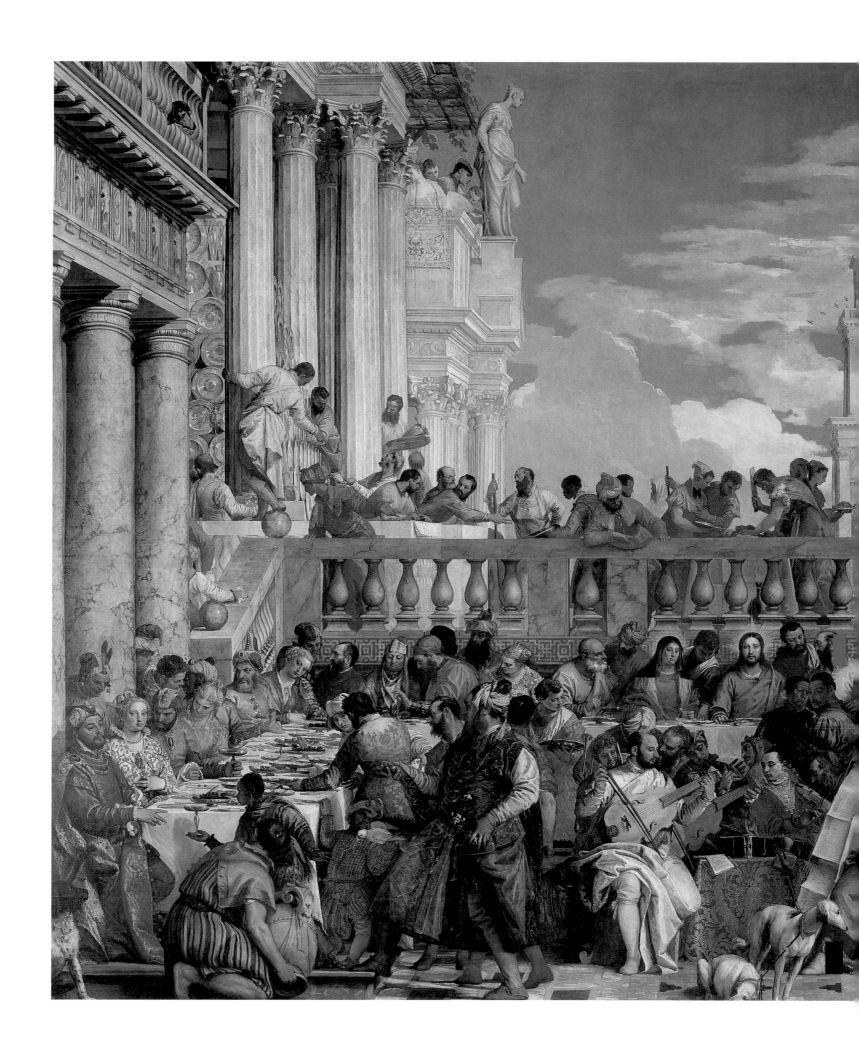

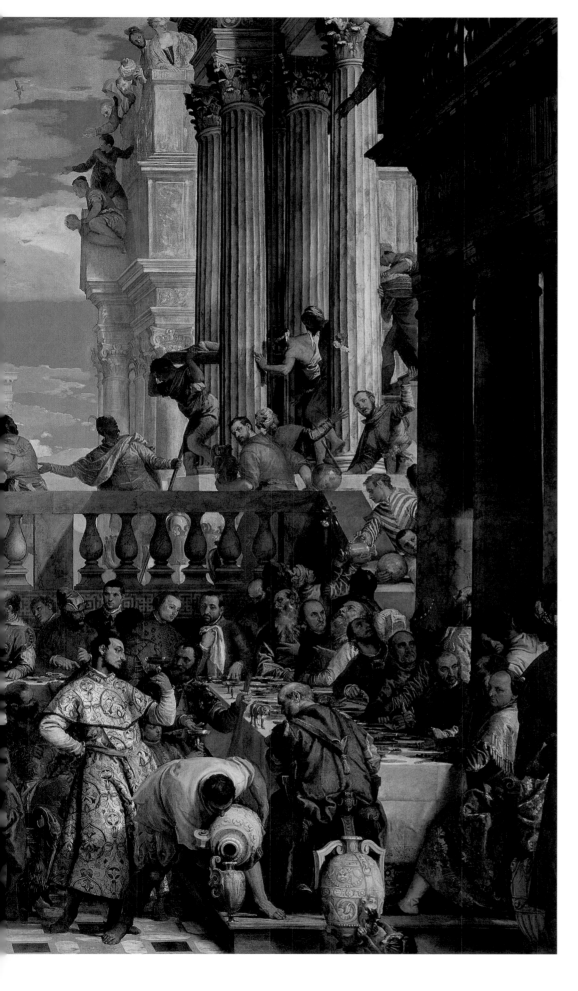

LEFT

Paolo Caliari, called Veronese. *The Wedding Feast at Cana* (after restoration). 1562–63. Oil on canvas. 262 ¼ x 389 ¾ in. (666 x 990 cm).

This vast canvas was made for the refectory of the Benedictine monastery adjacent to Palladio's church of San Giorgio Maggiore in Venice. According to tradition, the banqueters on the left include European royalty, while the musicians are portraits of great Venetian artists, including Veronese himself, Titian, and others.

P. 154

Anthonis van Dashorst, called Antonio Moro. *Cardinal de Grandvelle's Dwarf.* c.1560. Oil on wood. 49 ⅝ x 36 ¼ in. (126 x 92 cm).

The Dutch painter Anthonis Mor van Dashorst called himself Antonio Moro at the Spanish court of the Emperor Charles V. His portrait of an unnamed courtier in the retinue of a powerful prelate endows the dwarf with dignity, while using the fine dog to display both the man's size and his importance to his master.

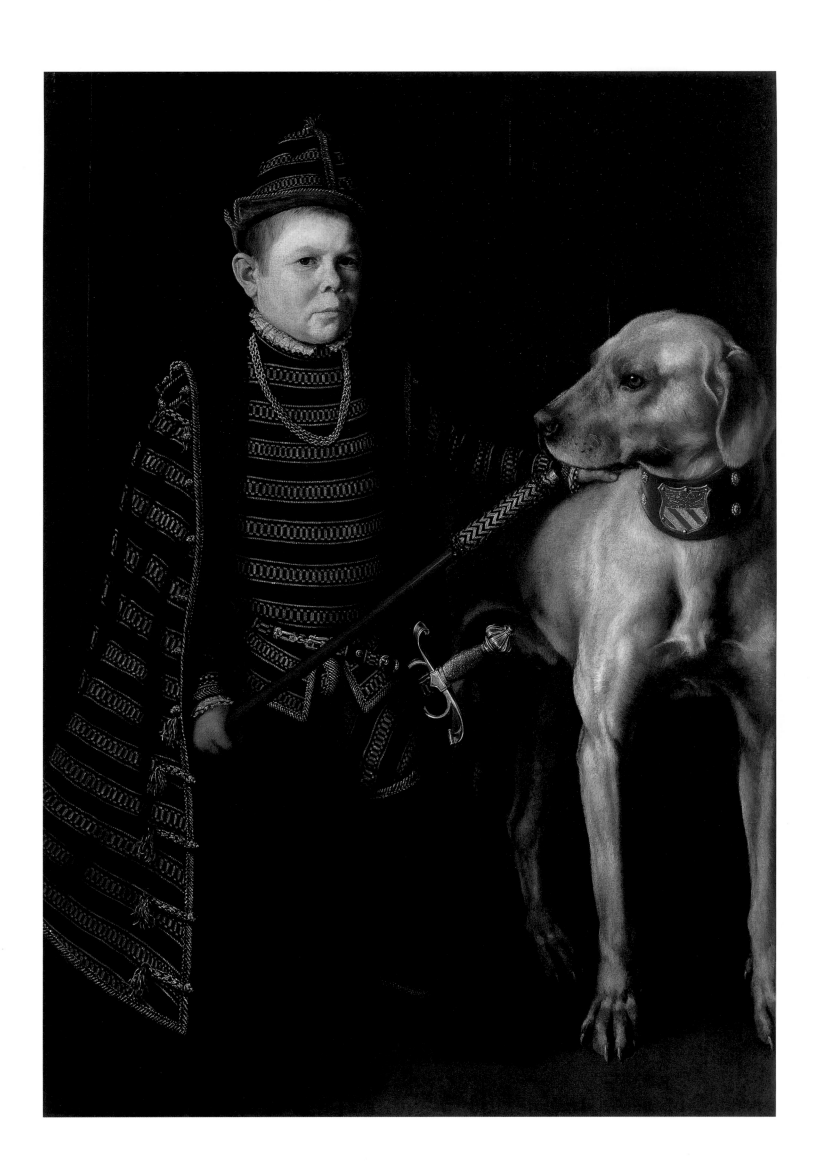

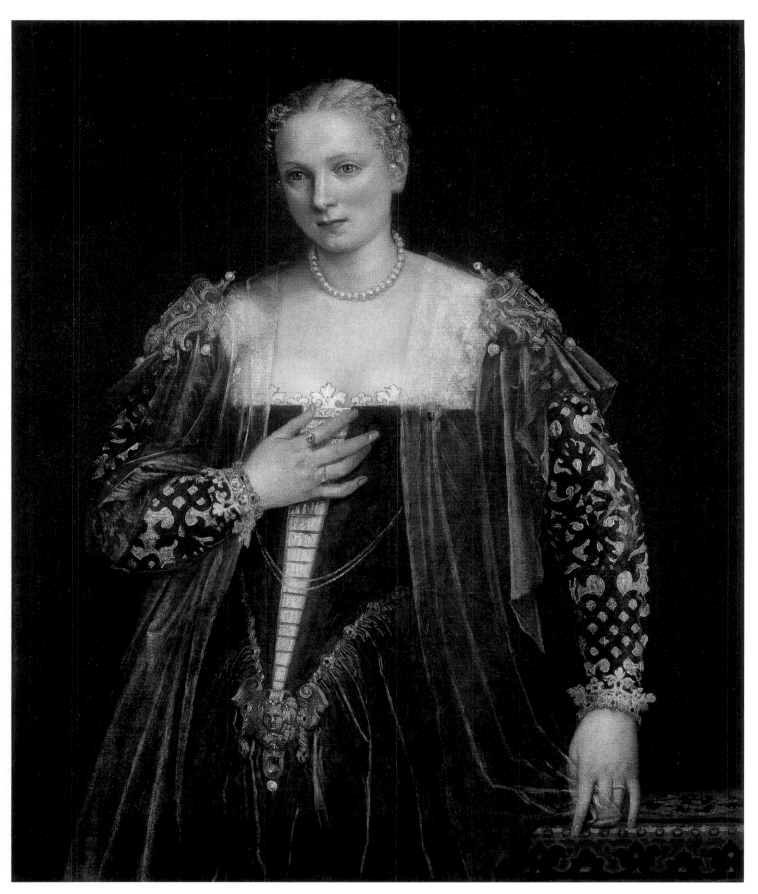

Paolo Caliari, called Veronese. *La Belle Nani, Portrait of a Woman.* n.d. Oil on canvas. 46 ⅞ x 40 ½ in. (119 x 103 cm).

The great late-Renaissance Venetian painters were Titian, Tintoretto, and the Verona-born Paolo Caliari, who moved to Venice in 1553 to work in the Doge's Palace. This lady recurs, slightly transformed, in several other paintings: here, he depicted her sunny but ladylike demeanor with delicate attention.

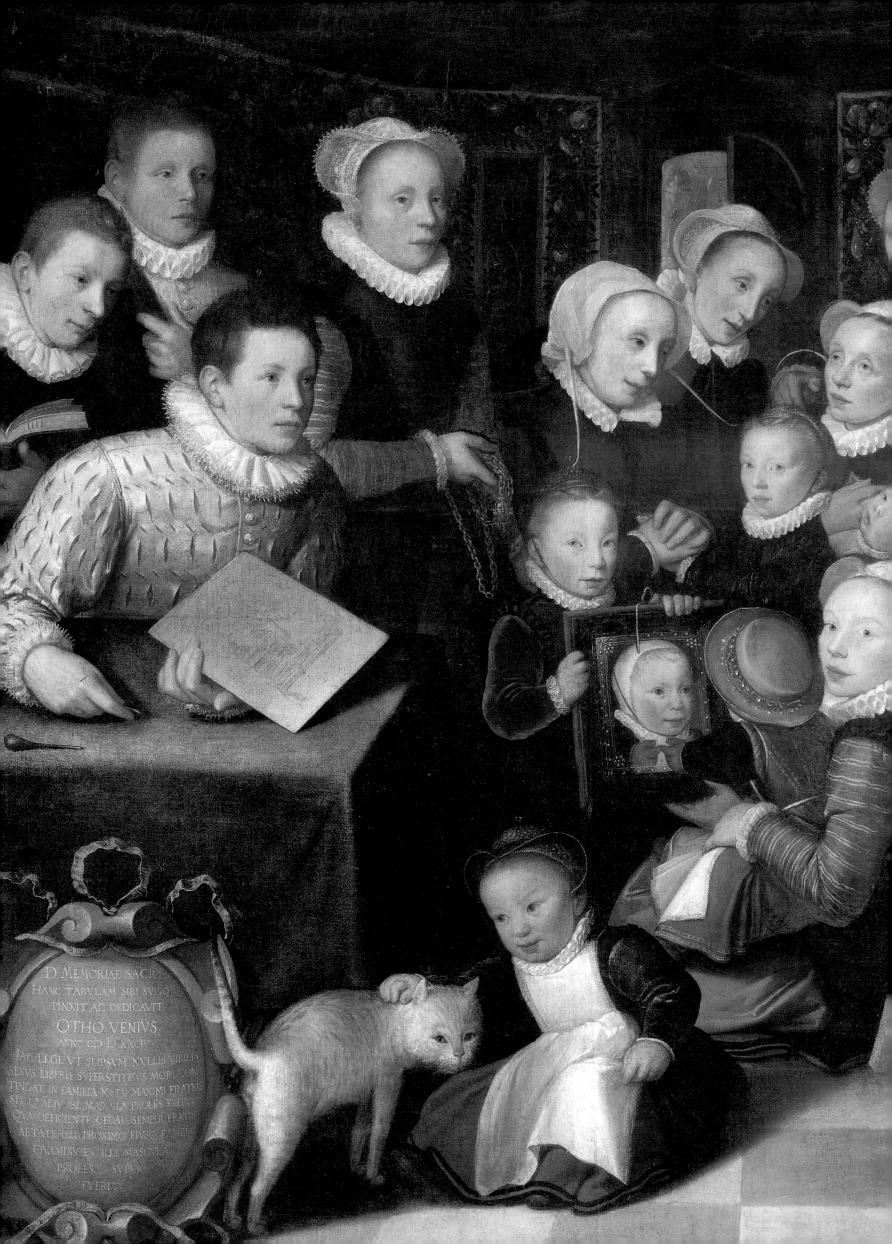

D·MEMORIAE·SACR·
HANC·TABVLAM·SIBI·SVISQ
PINXIT·AC·DEDICAVIT
OTHO·VENIVS
ANNO·ꝯ·ꝯ·ꝯ·XXCIV·
IAC·LEGE·VT·SVIPSVM·NVLLIS·VIRILIS
SEXVS·LIBERIS·SVPERSTITIBVS·MORI·CON
TINGAT·IN·FAMILIA·N.TV·MAXIMI·FRATRIS
SIT·QVANDIV·IBI·MASCVLA·PROLES·FVERIT
QVA·DEFICIENTE·CEDAT·SEMPER·FRATRI
AETATE·ILLI·PROXIMO·EIVSQ·FAMILIA
QVAMDIV·ILLI·MASCVLA
PROLES·SVPER
FVERIT·

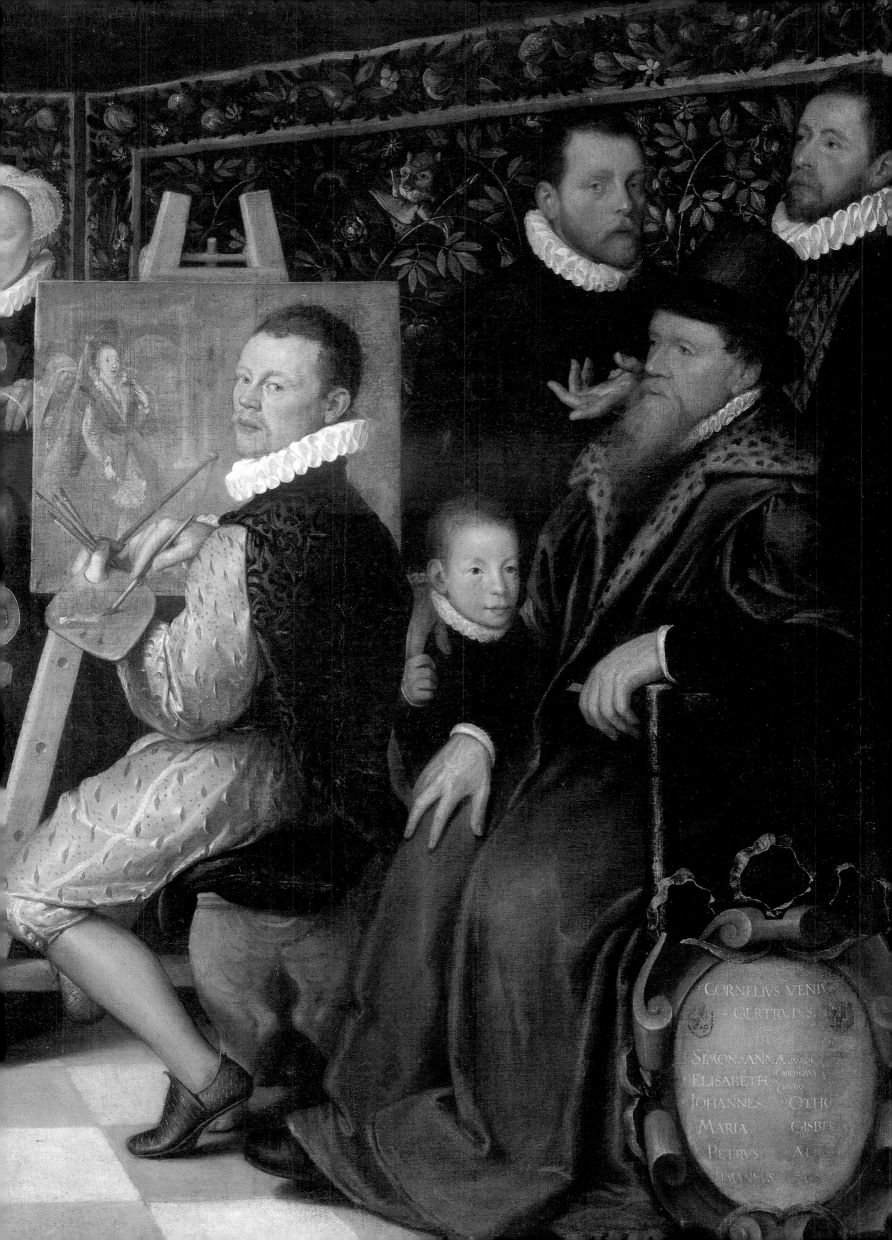

CORNELIVS VENIV̇
GERTRVD·S
SIMON·ANNA·VXOR
NICOLAVS
HVGO
ELISABETH
IOHANNES·OTHO
MARIA·GISBE
PETRVS·A
IMANNVS·AGA

ABOVE

Pieter Brueghel the Elder. *The Beggars.* 1568. Oil on wood. 7 x 8 ½ in. (18 x 21.5 cm).

One of the last paintings that Brueghel executed before he died bears an odd inscription on the back: *Legless cripples, take heart, may your affairs prosper.* It may represent the revolt against the Spanish occupation of Flanders that began in 1568.

PP. 156–57

Otto van Veen. *Otto Venius (the Artist) Painting, Surrounded by His Household.* 1584. Oil on canvas. 69 ¼ x 98 ½ in. (176 x 250 cm).

Otto van Veen was a humanist, a *pictor doctus,* or learned painter, and this may have been one reason Rubens chose him as his teacher. The medallions at lower left and right, in fact, Latinize the name of the painter at his easel, surrounded by his aristocratic relations. Venius himself married in 1593.

Annibale Carracci. *Fishing Scene.* 1585–88. Oil on canvas. 53 ½ x 99 ⅝ in. (136 x 253 cm).

This picture has a companion piece, *The Hunt;* the Roman prince Emilio Pamphilij gave the two paintings to Louis XIV in 1665. A pure landscape, without learnèd allusions, it shows peaceful coexistence between the aristocrats on shore—including the viewer—and the fisherfolk of the title.

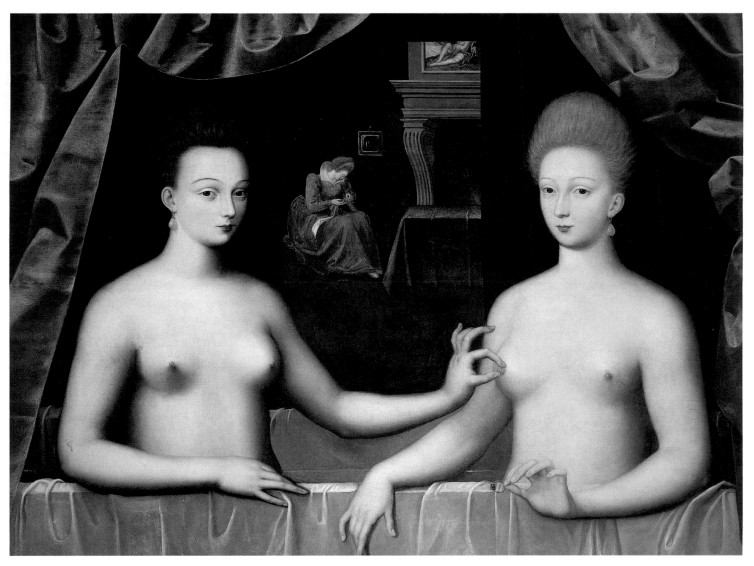

School of Fontainebleau. *Gabrielle d'Estrées and One of Her Sisters.* 1595. Oil on wood. 37 ¾ x 49 ¼ in. (96 x 125 cm).

Sometimes identified as a frankly erotic double portrait, another interpretation has her sister indicating Gabrielle d'Estrées's upcoming delivery of a child by Henry IV. The ring may refer to d'Estrées's projected marriage to the king, which never took place; she died in childbirth in 1599.

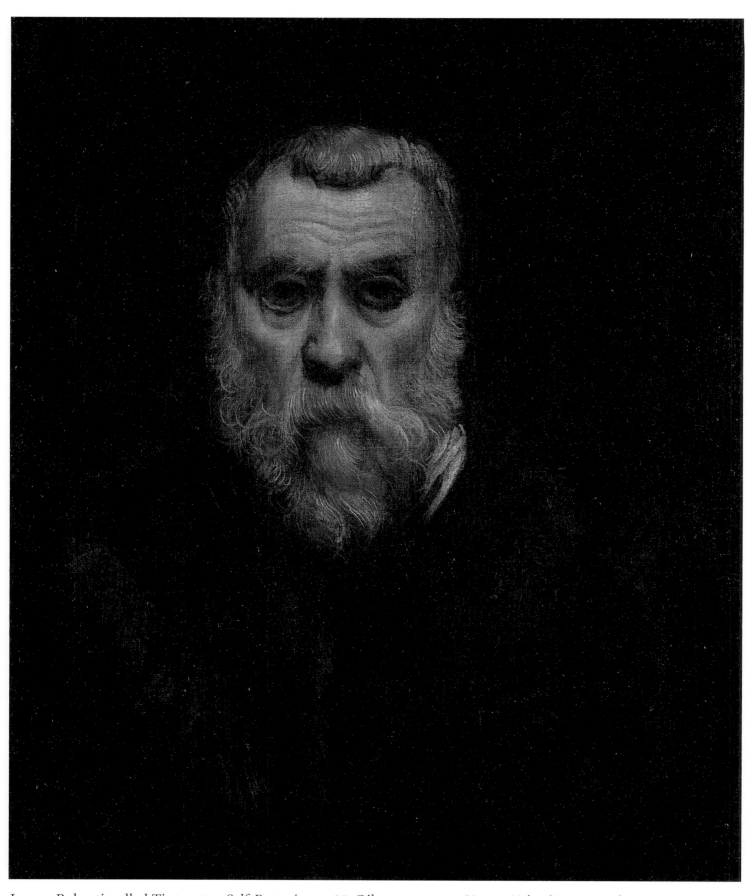

Jacopo Robusti, called Tintoretto. *Self-Portrait*. c. 1588. Oil on canvas. 25 ⅝ x 20 ½ in. (65 x 52 cm).

Tintoretto, Venetian-born and-bred—he was the son of a dyer, a *tintore*—wears black, as required of La Serenissima's citizens in this period. His intense and wary expression in this work finds a correspondence in the thunderous palette and nervous movement of his more public paintings.

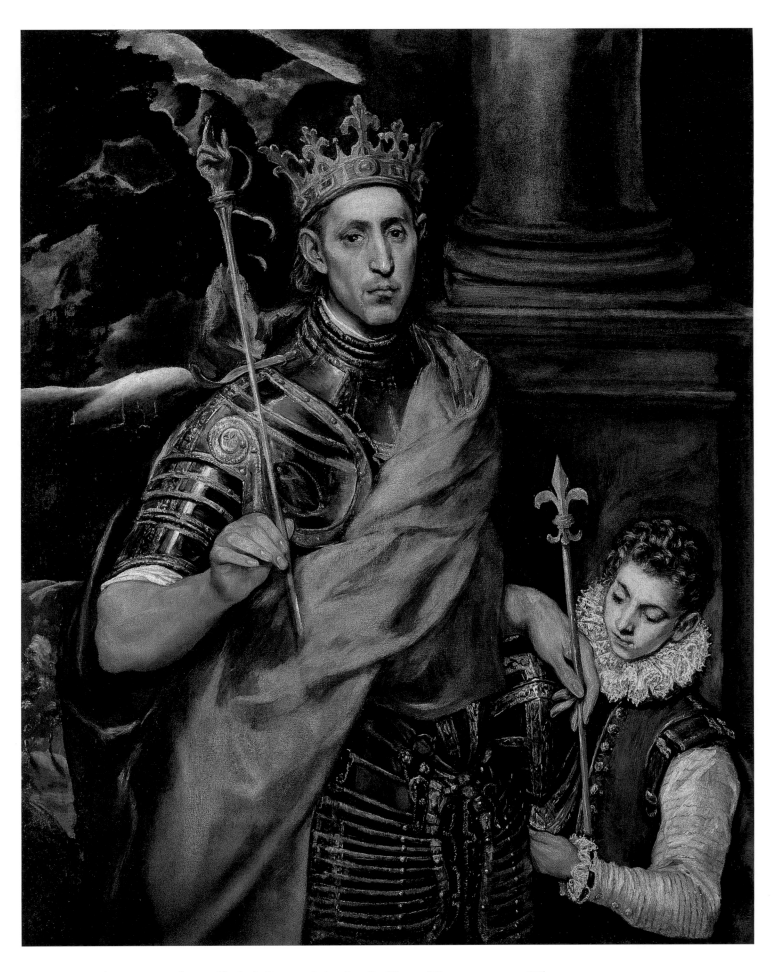

Domenico Theotocopoulos, called El Greco. *Saint Louis, King of France.* c. 1585. Oil on canvas. 47 ¼ x 38 ⅛ in. (120 x 97 cm).

There is something both ghostly and angelic about this portrait of the mournful crusader king and saint, Louis IX, who holds the sign of the Trinity higher than the fleur-de-lys of France—ghostly, in the painter's disregard for perspective, and angelic in the swathe of red fabric that rises up behind him.

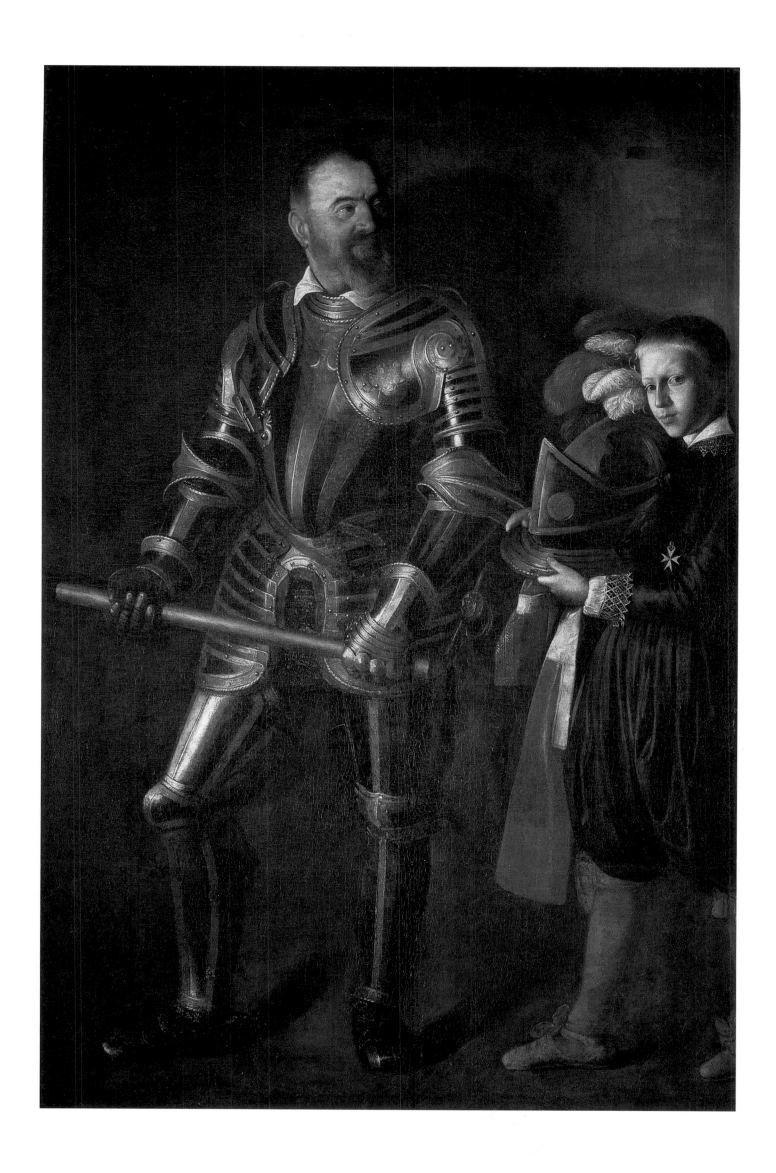

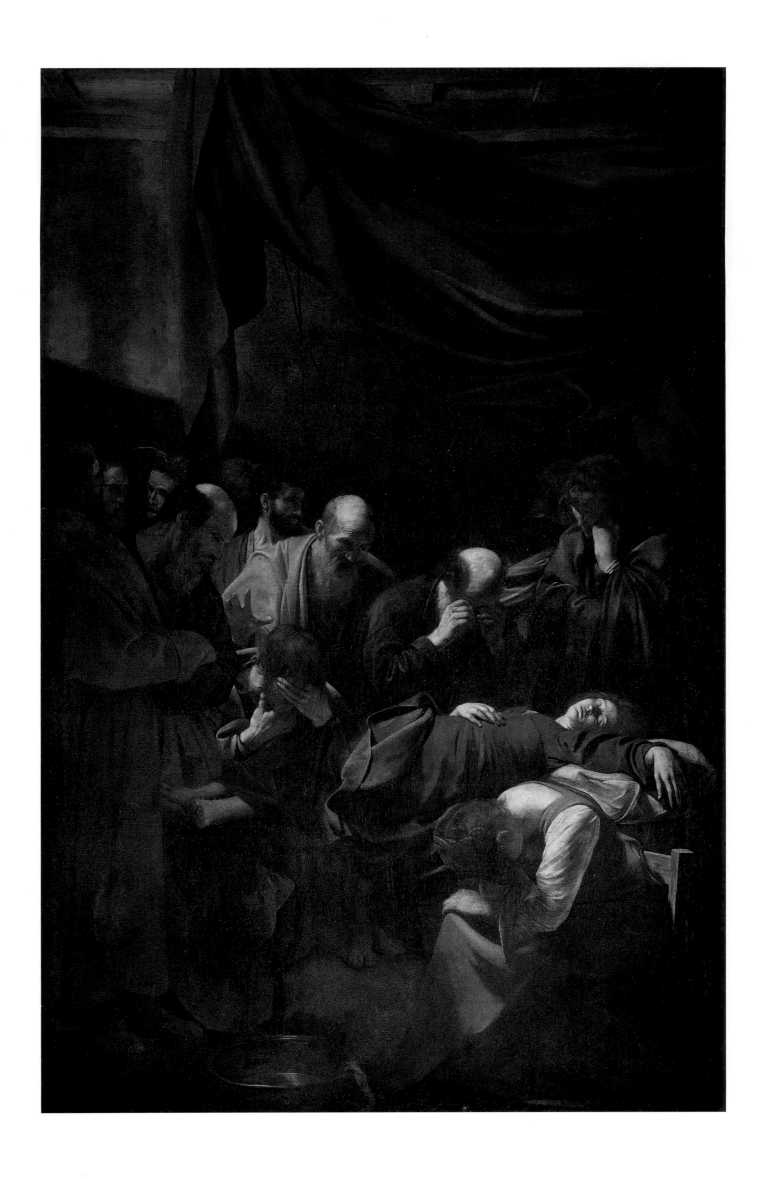

ABOVE

Adriaen van de Venne. *Feast on the Occasion of the Armistice, 1609.* 1616. Oil on wood. 24 ⅜ x 44 ½ in. (62 x 113 cm).

The artist's innovation was to reduce the classical and symbolic elements of conventional allegory to a token putto and a few doves. Van de Venne was not only a poet and political painter, he was a book illuminator, and his precise details enchant, in the kind of crowd portrait he was known for.

OPPOSITE

Michelangelo Merisi, called Caravaggio. *The Death of the Virgin.* 1605. Oil on canvas. 145 ¼ x 96 ½ in. (369 x 245 cm).

This painting was angrily refused by the Roman church that commissioned it. Not only was the model for the Virgin a young woman found drowned in the Tiber, but Caravaggio had depicted the Mother of God with dirty feet. Poussin claimed that Caravaggio would destroy painting with his vulgar naturalism; Rubens persuaded the duke of Mantua to purchase this work.

P. 163

Michelangelo Merisi, called Caravaggio. *Alof de Vignacourt and His Page.* c. 1608. Oil on canvas. 76 ⅜ x 52 ¾ in. (194 x 134 cm).

Caravaggio left Rome after he killed a man in a gambling brawl, eventually arriving in Malta in order to become a knight of St. John. As in Italy, his patrons were of the highest classes: this armored gentleman was grand master of the Knights Hospitallers.

ABOVE

Valentin de Boulogne. *Concert.* c. 1622–25. Oil on canvas. 68 ⅛ x 84 ¼ in. (173 x 214 cm).

While some artists took the high road of idealized painting, others followed Caravaggio. Valentin de Boulogne lived most of his life in Rome: this group of ordinary folks in dramatic chiaroscuro surrounds a bas-relief, perhaps a statement about real life versus static emulations of the antique.

OPPOSITE

Domenico Zampieri, called Domenichino. *Saint Cecilia with an Angel Holding Music.* c. 1620. Oil on canvas. 63 x 42 ¼ in. (160 x 120 cm).

Intellectual values are the vehicles for spiritual ones in this charming painting of the patron saint of musicians. Although the significance of the image is as rigorously clear as the execution, the artist devised a riddle: the heavenly music that Cecilia hears and performs is itself a metaphor.

P. 168

Peter Paul Rubens. *The Arrival of Marie de Médicis at Marseilles, November 3, 1600.* c. 1621–25. Oil on canvas. 155 ⅛ x 116 ⅛ in. (394 x 295 cm).

Marie de Médicis was almost fifty when she commissioned this painting cycle for her Luxembourg Palace; she was little more than half that age when she disembarked in France to marry Henri IV, twenty years her senior. The power and rhythms of the sea-beings and creatures are unequalled in Rubens's body of work.

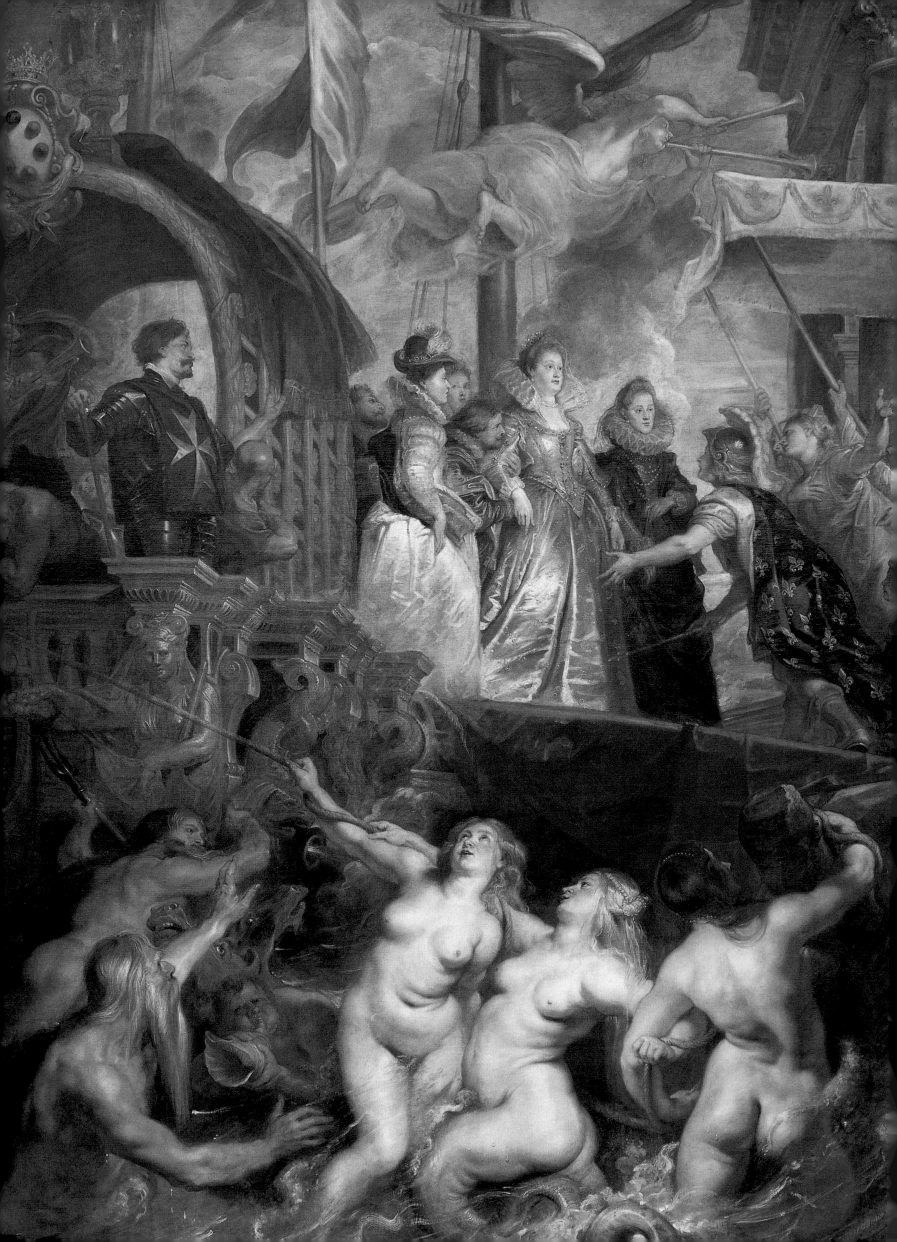

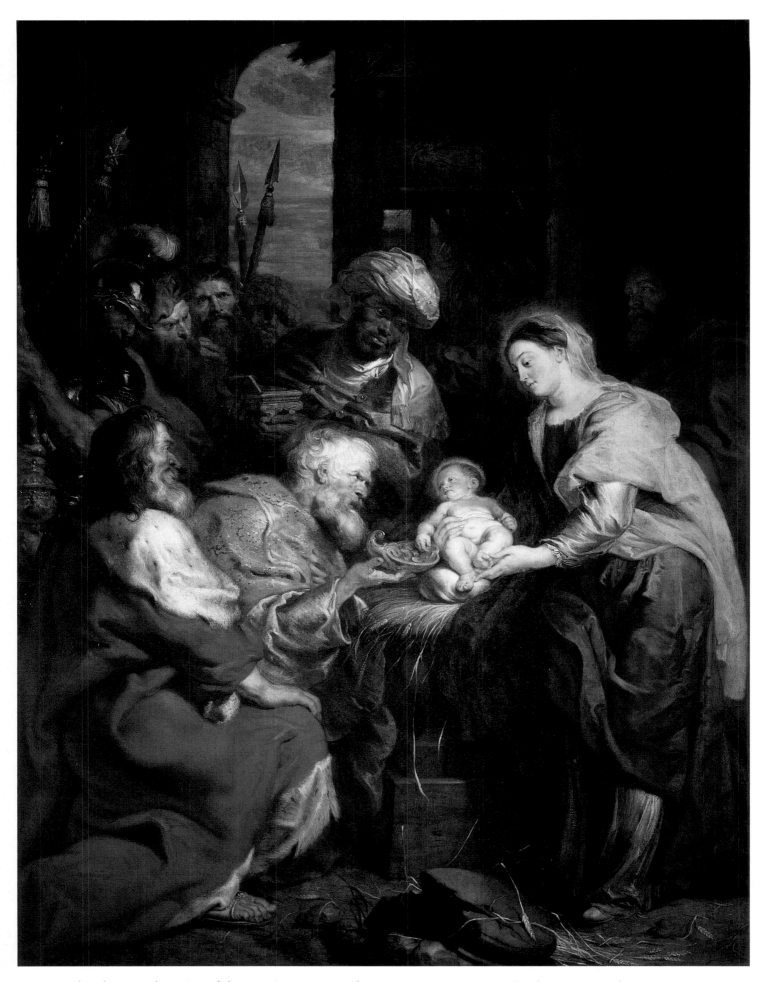

Peter Paul Rubens. *Adoration of the Magi.* 1626–29. Oil on canvas. 111 ⅜ x 86 ¼ in. (283 x 219 cm).

In 1777, the religious houses of certain northern cities were dissolved, and their contents put up for sale. Rubens's *Adoration of the Magi*, a refined and energetic Baroque concert of color, gesture, light, and shadow, was purchased in Brussels for the Louvre at that time.

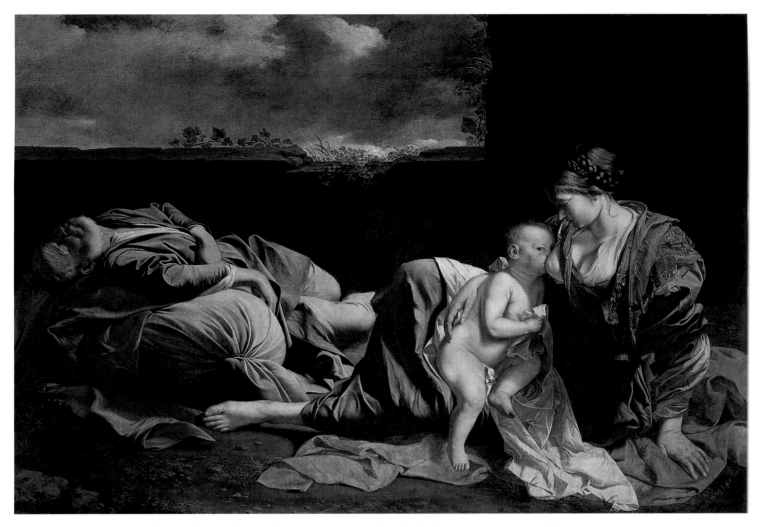

Orazio Gentileschi. *The Holy Family on the Rest During the Flight into Egypt.* 1628. Oil on canvas. 61 ⅞ x 88 ½ in. (157 x 225 cm).

Fleeing Herod's massacre of the children, Joseph, Mary, and Jesus fled to Egypt. Here, in a moment of respite, Mary nurses her son, while Joseph sleeps; the parapet suggests protection. Gentileschi's treatment of the fabrics is lush, his colors are cool.

Paul Bril. *Stag Hunt*. n.d. Oil on canvas. 41 ⅓ x 54 in. (105 x 137 cm).

This painting was in the collection of Louis XIV before the end of the century, reminding us that Versailles was originally a hunting lodge. A transition is taking place, from nature as a decorative element—for example, the leaves of the trees—to light as realistic subject matter.

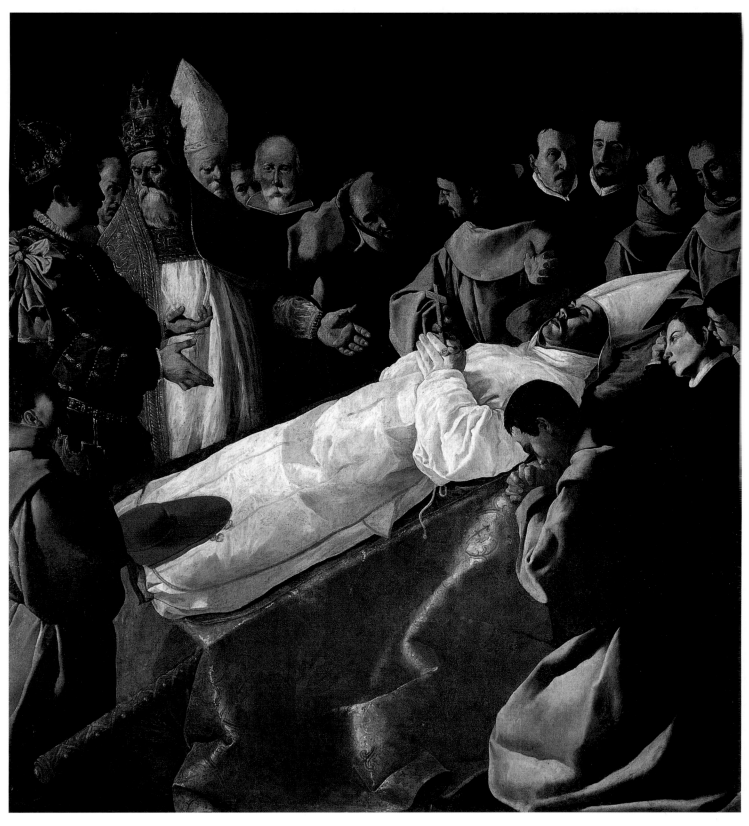

Francisco de Zurbarán. *The Exposition of the Body of Saint Bonaventure.* 1629. Oil on canvas. 96 ½ x 86 ⅝ in. (245 x 220 cm).

The Franciscan cardinal and saint died in 1274; his body lay in state, surrounded by King James I of Aragon, Pope Gregory X, and Bonaventure's Franciscan brothers. Zurbarán abandoned realistic perspective in the interest of displaying the saint to the viewers.

Francisco de Zurbarán. *St. Apollonia.* n.d. Oil on canvas. 52 ¾ x 26 ⅜ in. (134 x 67 cm).

One version of Saint Apollonia's legend recounts that her tormentors pulled out all her teeth in the course of her martyrdom; for this reason, she is the patron saint of dentists, and here holds her attribute. Her engaging expression and the rainbow colors of her costume contrast with the artist's frequent tenebrism.

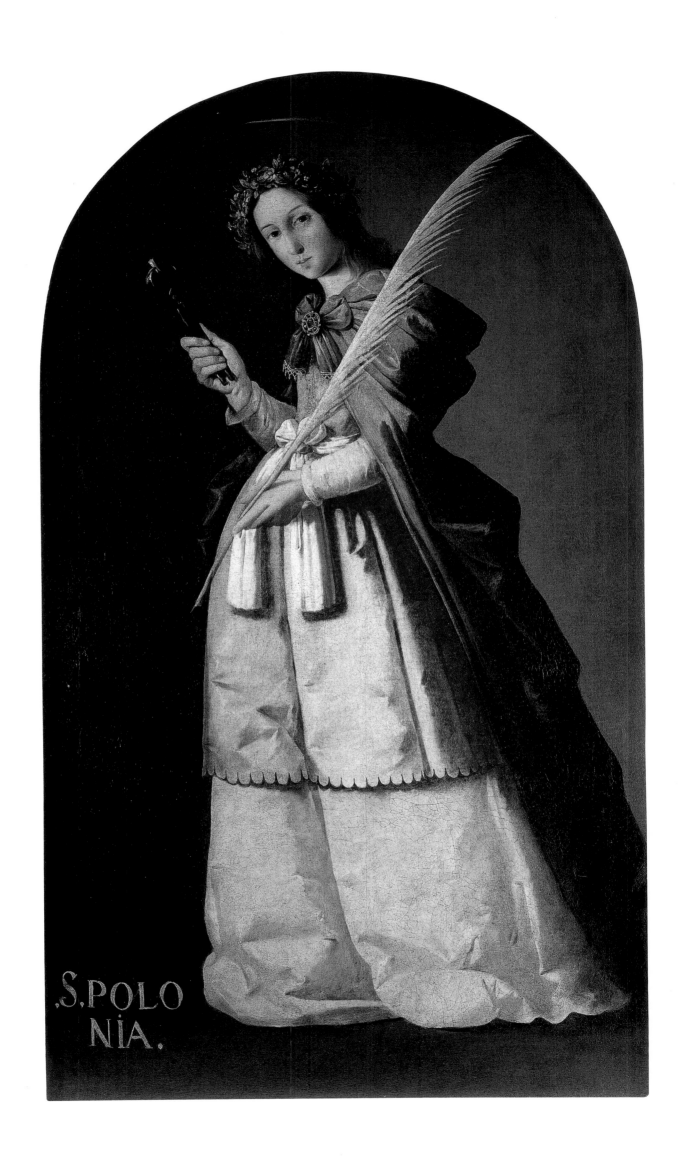

S. POLO
NIA.

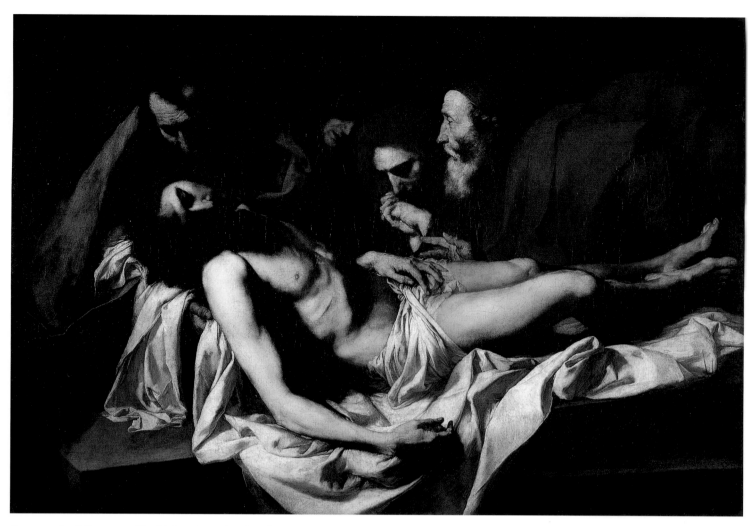

Jusepe de Ribera, called The Spaniard. *The Deposition.* n.d. Oil on canvas. 50 x 71 ⅔ in. (127 x 182 cm).

One of the most melancholy moments of the Passion, the Deposition is particularly suited to Ribera's signature tenebrism. His tense deployment of light, shadow, and character manifests the relation of sight to grief: wherever the apostles' gazes touch, their sorrow springs up.

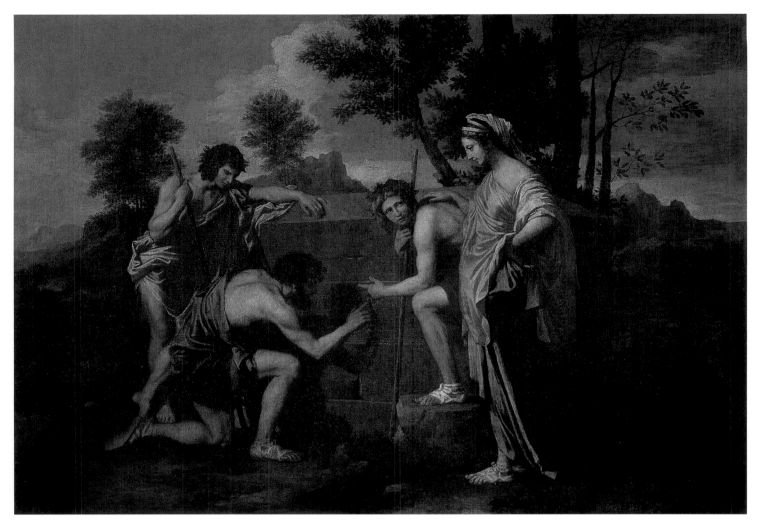

Nicolas Poussin. *The Shepherds of Arcadia.* c. 1650. Oil on canvas. 33 ½ x 47 ⅝ in. (85 x 121 cm).

The Latin words on the tomb declare, "I, too, lived in Arcadia," a *memento mori,* or reminder of death, brought home to the youths, and to the viewer by the gaze of one of them, amid the bright colors and vibrant youth of these splendidly restrained classical figures

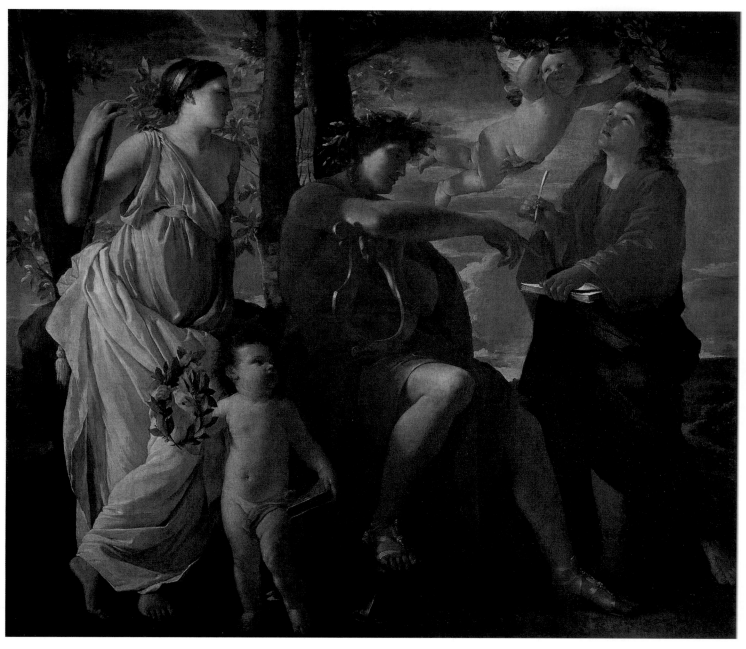

Nicolas Poussin. *Inspiration of the Poet.* 1638. Oil on canvas. 71 ⅞ x 83 ⅞ in. (182.5 x 213 cm).

This painting, as robustly and gracefully poetic as the epics it celebrates, also demonstrates the erudition expected of a first-rate artist: its sources are as varied as Raphael's *Parnassus* and Plato's *Phaedrus.* On the left is Calliope, the muse of epic poetry; Apollo, the god of the arts, is in the center; the poet may be Virgil.

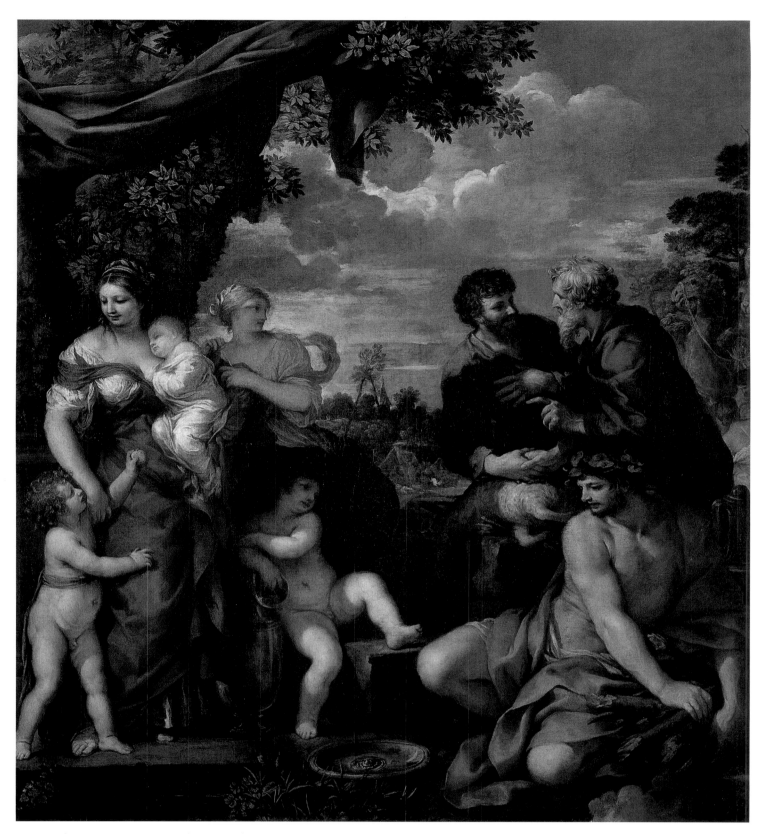

Pietro da Cortona. *Reconciliation of Jacob and Laban.* 1630–35. Oil on canvas. 77 ½ x 69 ¼ in. (197 x 176 cm).

When the Comte d'Angiviller purchased this work for the Louvre in 1784, it was the priciest painting bought at auction in France that year. The Old Testament episode, from Genesis 31, relates the peace made between Jacob and Laban, after Jacob stole Laban's sons, daughters, and goods.

Guido Reni. *The Abduction of Helen.* 1631. Oil on canvas. 76 x 102 in. (193 x 259 cm).

Helen, Aphrodite's divine Greek bribe to the Trojan prince Paris, seems rather to be taking a meeting on the run, than being kidnapped. The Royal Academy praised Reni's body of work for its noble, elevated quality, and recommended his example to art students.

OPPOSITE
Simon Vouet. *Virtue.* c. 1640. Oil on canvas. 82 ⅝ x 44 ½ in. (210 x 113 cm).

Vouet, who also designed tapestries for the Louvre workshops, was recalled from Italy by Louis XIII. The passages of marked chiaroscuro he learned from Caravaggio, while the bright hues and the active diagonals of staff, wings, and drapery convey, perhaps, the predestined quality of French victory.

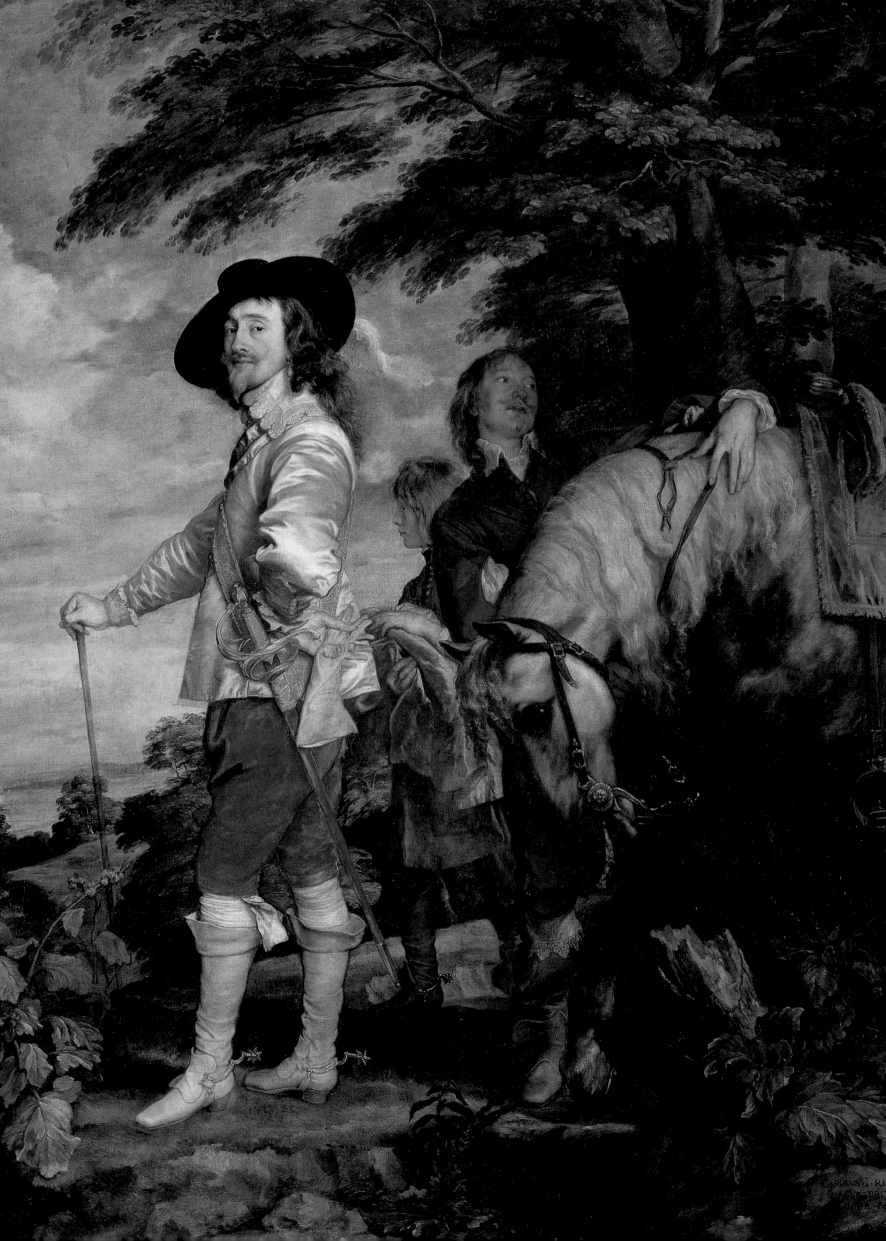

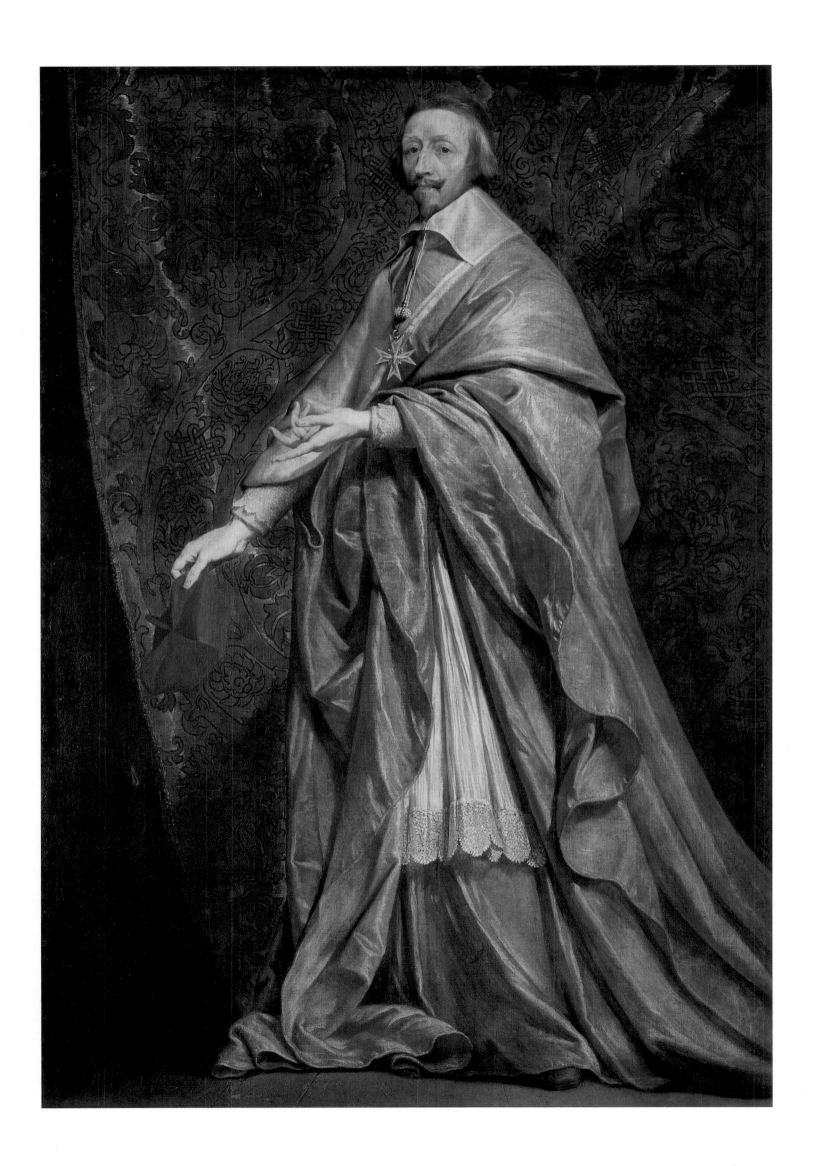

Lubin Baugin. *Still Life with Wafer Biscuits.* c. 1630–35. Oil on canvas. 16 ⅛ x 20 ½ in. (41 x 52 cm).

Rooms, once multipurpose, evolved toward specific uses, and dining rooms often received still lifes, virtuoso exercises in the inner life of objects. The simplicity and warm light contribute to the decorous, yet intimate quality of this arrangement.

ABOVE

Michael Sweerts. *The Young Man and the Procuress.* n.d. Oil on copper. 7 ½ x 10 ⅝ in. (19 x 27 cm).

Caravaggio's in-your-face street life and the realist tradition of northern Europe are here tamed into allegory. A young man is visibly torn between sexual curiosity and justified apprehension about its consequences, while the ageless, toothless procuress in unkempt linen approaches him with the authority of death.

OVERLEAF

Georges de La Tour. *The Cheat.* 1635. Oil on canvas. 41 ¾ x 18 ⅛ in. (106 x 46 cm).

Thematically, one of Caravaggio's legacies was high life among the low-lives. The metaphorical warning, perhaps directed to ladies in particular, is to beware the young man with aces up his doublet. The bright, somewhat stylized clothing and forms and the black background lend a theatrical air to the scene.

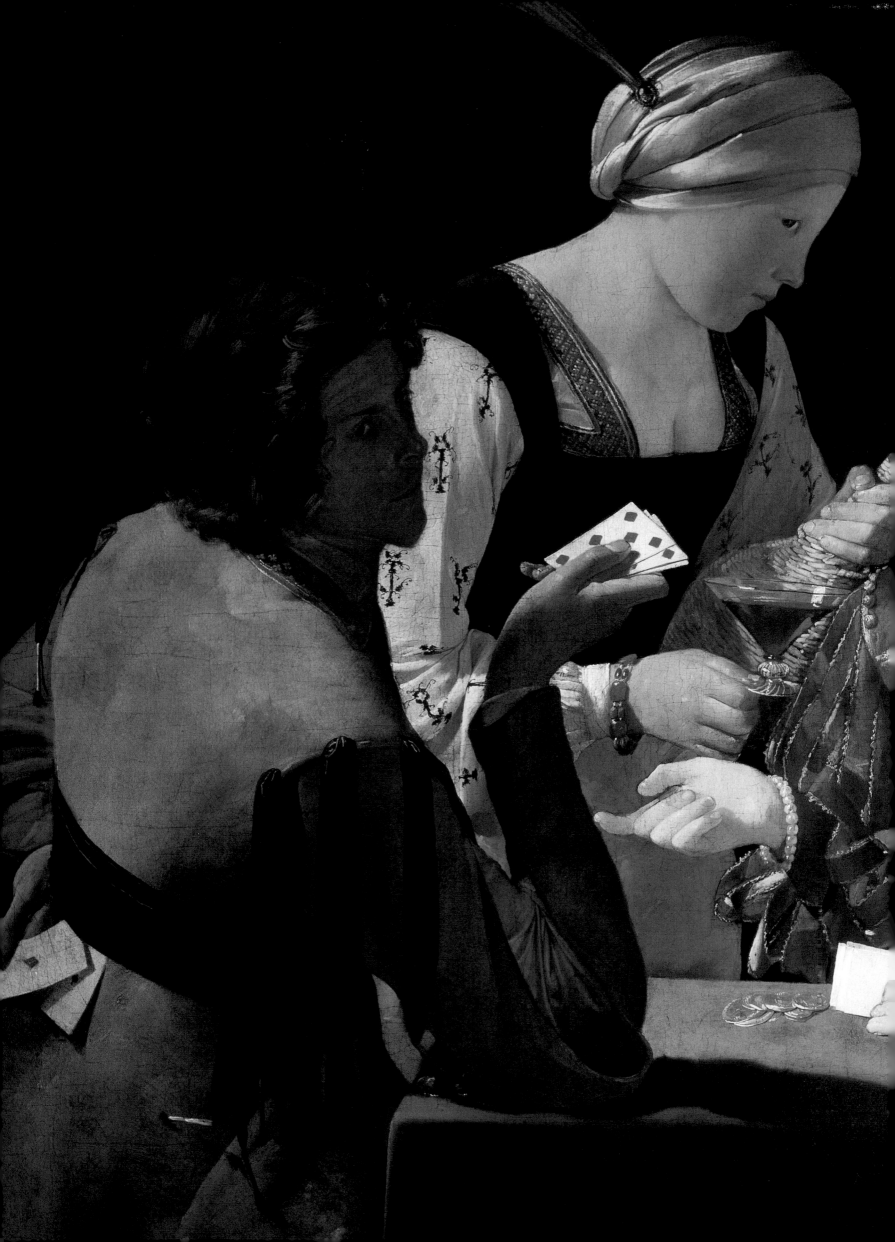

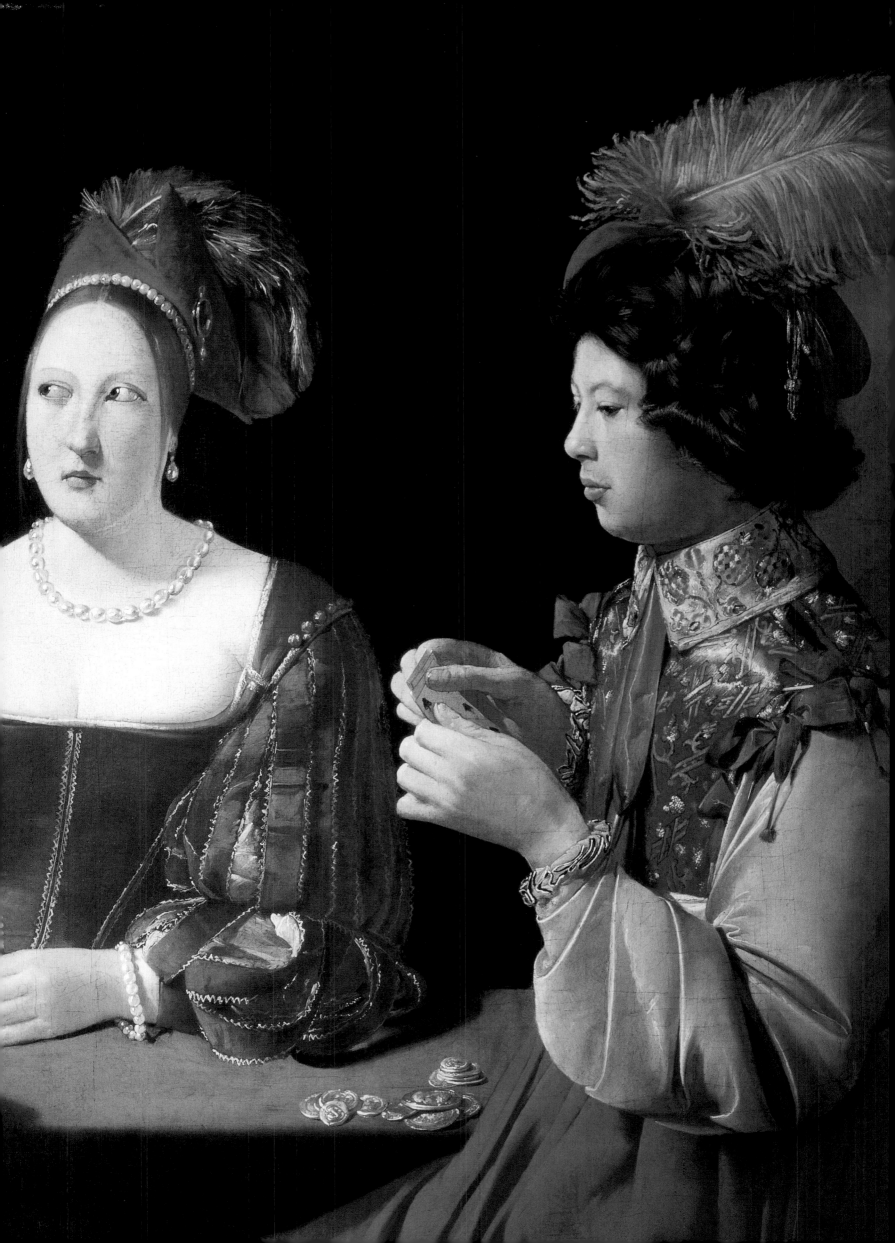

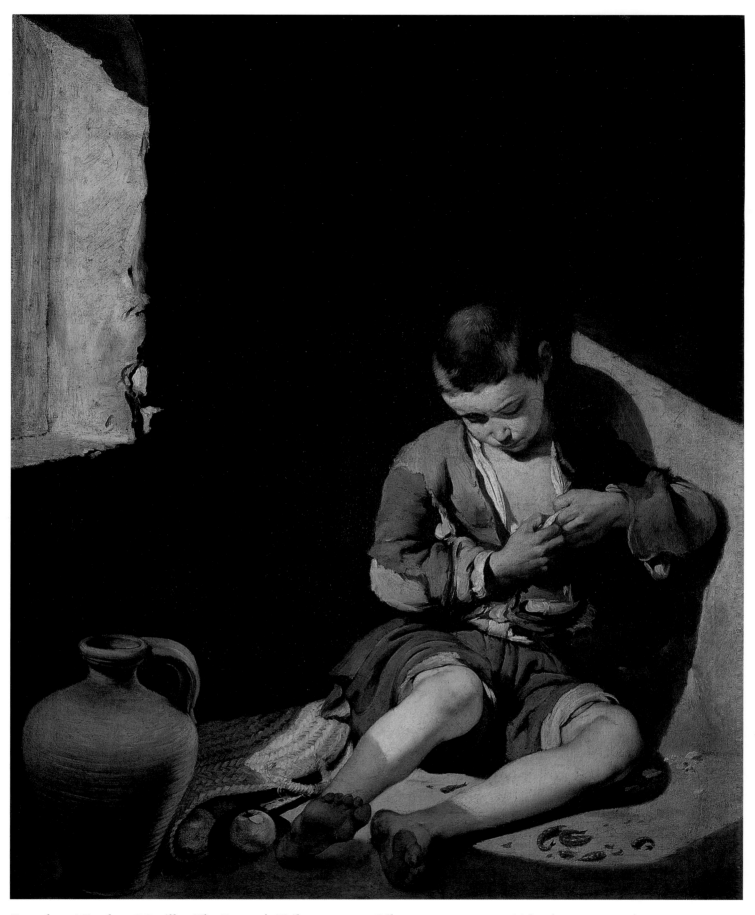

Bartolomé Esteban Murillo. *The Beggar's Toilet.* 1645–50. Oil on canvas. 53 x 39 ¼ in. (134 x 100 cm).

In the harsh light of midday, a street urchin picks a louse. The realism of this genre image, depicting the underside of Spain's Golden Age, is mitigated by the dramatic formal handling of light and dark areas, and the handsome still life at lower left. The painting was purchased for the French royal collections in 1782.

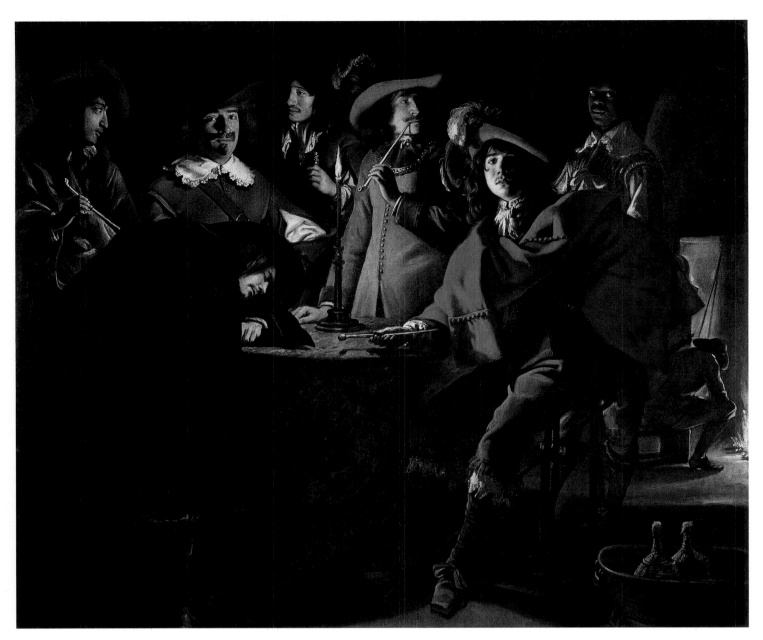

Louis Le Nain. *The Guard Room.* 1643. Oil on canvas. 46 x 54 in. (117 x 137 cm).

This painting by one of the three Le Nain brothers is particularly accomplished, both in the draftsmanship and the chiaroscuro, which is in the Dutch fashion. An early version of "Smoke 'em if you got 'em," this celebrates the congenial leaf that had arrived in France less than a century before.

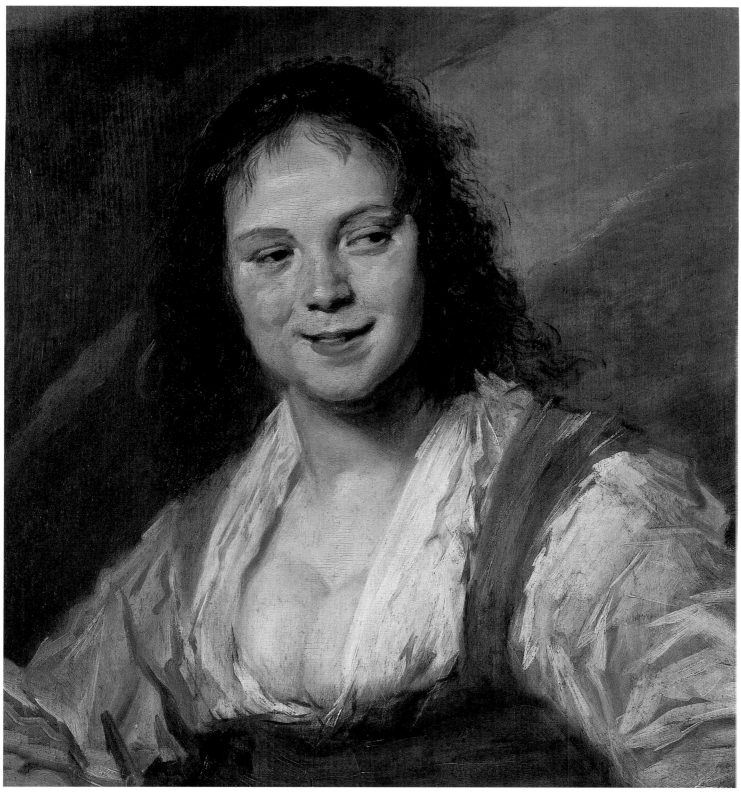

Frans Hals. *The Gypsy Girl.* 1628–30. Oil on wood. 23 x 20 ½ in. (58 x 52 cm).

The young woman's electric energy results from her good-humored, assessing gaze and from the animated brushstrokes of her blouse, which contrast with the smooth, finely modeled skin of her face and décolletage. She is not, strictly speaking, a Gypsy, but rather a sexually available free spirit.

Jusepe de Ribera. *Boy with a Clubfoot.* 1642. Oil on canvas. 64 ½ x 37 ⅜ in. (164 x 95 cm).

The cheeky, dimpled child holds a paper that pleads, in Latin, "Give me alms, for the love of God." Otherwise, he seems carefree, far from the unknown, if not menacing, underworld revealed by the Naples-based Ribera's near-contemporary and geographical neighbor Caravaggio.

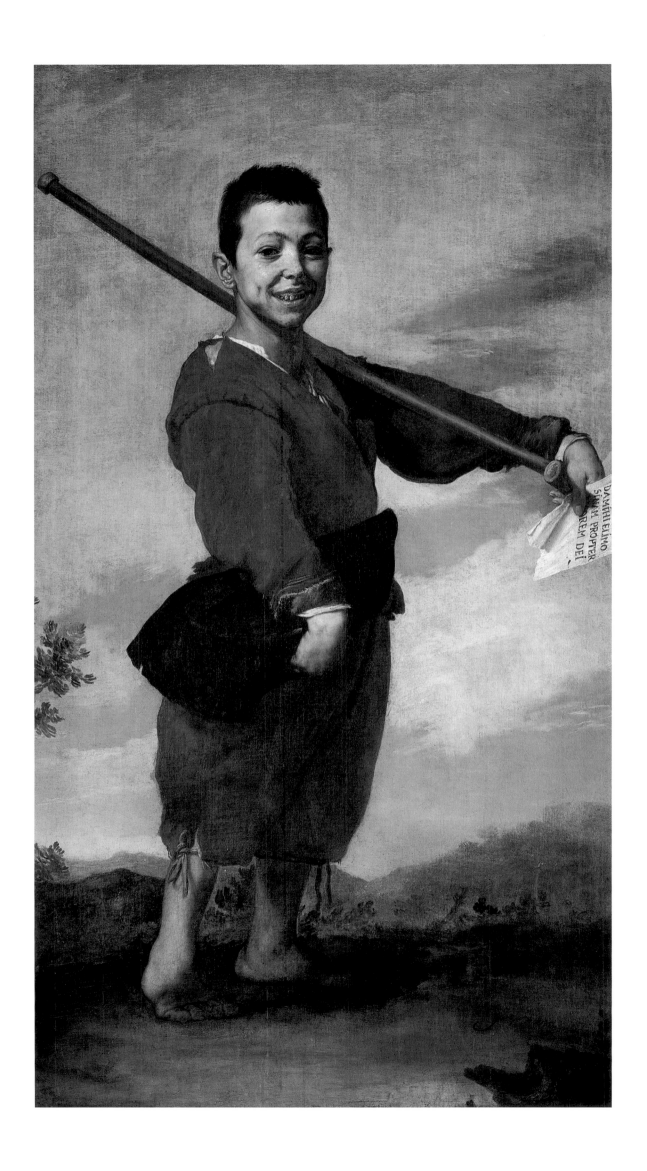

Gabriel Metsu. *The Vegetable Market in Amsterdam.* c. 1655. Oil on canvas. 38 ⅛ x 33 ¼ in. (97 x 84.5 cm).

The city of Amsterdam is the backdrop for a busy market scene. In the welcome shade of a tree, amidst the buying and selling, a man tries his luck with a shopper, while Metsu placed a homely still life in the lower right corner.

OPPOSITE, ABOVE
Louise Moillon. *At the Greengrocer.* 1630. Oil on canvas. 47 ¼ x 65 in. (120 x 165 cm).

Moillon was an early French painter of still lifes, perhaps because, as a Protestant, she was closer to the northern European tradition that prized daily domesticity. Her genre scene, built around robust natural hues, maintains class conventions: the lady's features are finer than the greengrocer's.

Pieter van Laer, called Il Bamboccio. *Milking the Cows.* c. 1640. Oil on wood. 12 ½ x 17 in. (32 x 43 cm).

People fleeing the Thirty Years' War brought into Italy small scenes of humble folk, common in the north but new

Claude Gellée, called Claude Lorrain. *View of the Campo Vaccino.* c. 1636. Oil on canvas. 22 x 28 ⅜ in. (56 x 72 cm).

Claude spent most of his working life in Rome, and recorded real-life landscapes in that city. The people of the Eternal City grazed their cattle in the Campo Vaccino, the "cowfield;" excavated in the following century, it would become known as the Roman Forum.

Peter Paul Rubens. *The Kermess.* 1640. Oil on canvas. 58 ⅝ x 103 in. (149 x 261 cm).

Rubens's Baroque attention to color and movement set him apart from the more solemn and sculptural classical painters such as Poussin. The partisans of the two masters, known as "rubenistes" and "poussinistes," would continue to diverge. This jolly festival is far removed from Bosch's medieval cautionary spirit.

ABOVE

Claude Gellée, called Claude Lorrain. *David Crowned by Samuel*. 1643. Oil on canvas. 46 ⅞ x 59 in. (119 x 150 cm).

This is the companion painting to *Disembarkation of Cleopatra at Tarsus*; in both, Claude's love for light is the true subject. The day occupies center stage, while the title episode takes place to one side, perhaps expressing the artist's view that the great events of history are, in the flow of time, less meaningful than those of ordinary life.

OVERLEAF

Jan Davidsz de Heem. *Dessert, Still Life*. 1640. Oil on canvas. 58 ⅝ x 80 in. (149 x 203 cm).

Still today, De Heem stands out as one of the great still life painters. Besides illustrating a menu of virtuosity, the work flattered its owner as a person of culture and worldly success. Indeed, such is the patron's wealth that these delicious and rare foods are mere leftovers, cleared onto the title sideboard.

Georges de La Tour. *The Adoration of the Shepherds*. n.d. Oil on canvas. 42 ⅛ x 51 ½ in. (107 x 131 cm).

La Tour's composition implicitly includes the viewer in the intimate circle around the swaddled babe; the expressions of those present range from delight to contemplation to humble awe. The theology of Joseph's gesture of sheltering the candle is that we see only a small part of a great mystery.

Georges de La Tour. *Joseph the Carpenter*. 1642. Oil on canvas. 54 x 40 ⅛ in. (137 x 102 cm).

This familial conjunction of Joseph and the Christ Child echoes the pairing of old age and youth popular in moralizing paintings, but also permitted the painter to foreshadow the Crucifixion in the awl's cross shape, the mallet, and the massive beam.

P. 202

Georges de La Tour. *Magdalene with the Nightlight*. n.d. Oil on canvas. 50 ⅜ x 37 in. (128 x 94 cm).

By the seventeenth century, Mary Magdalene no longer wears her opulent costume, but the simplest of clothes, belted with a penitent's rope. La Tour's dramatically simplified contours and areas of color suit his theme of sober austerity, in keeping with the quietist religious feeling of the time.

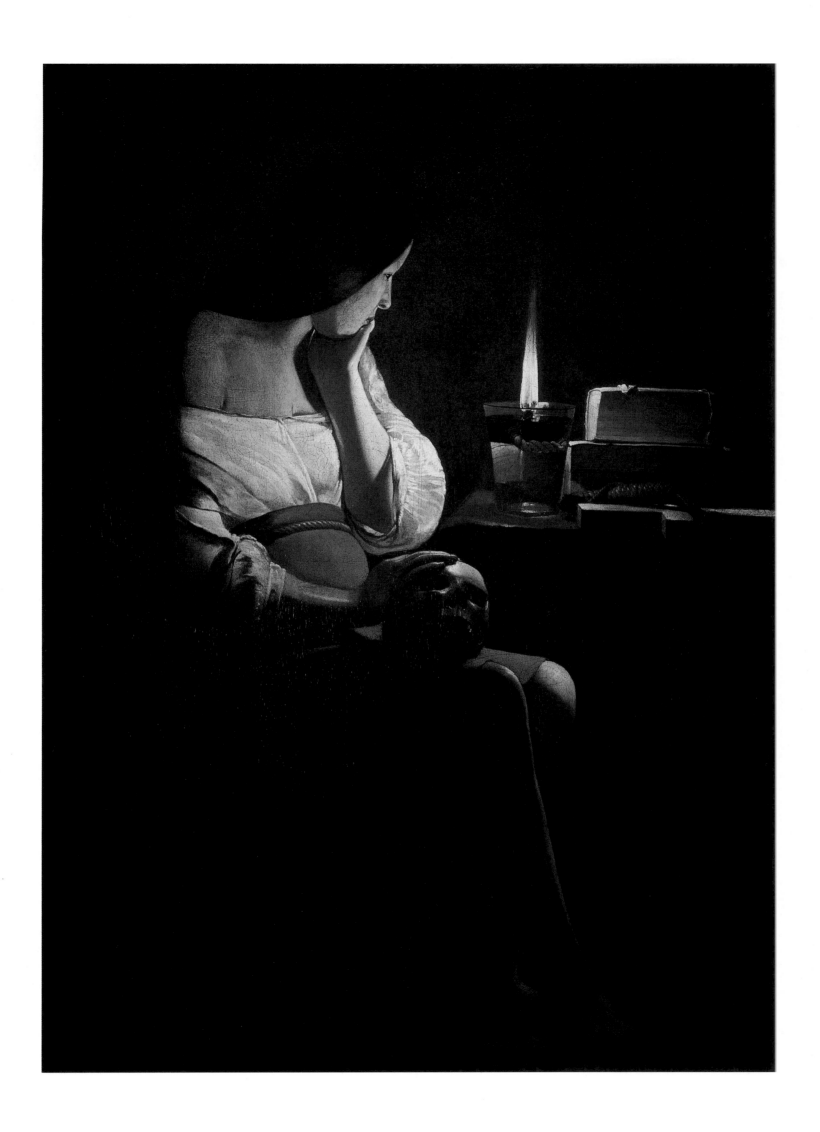

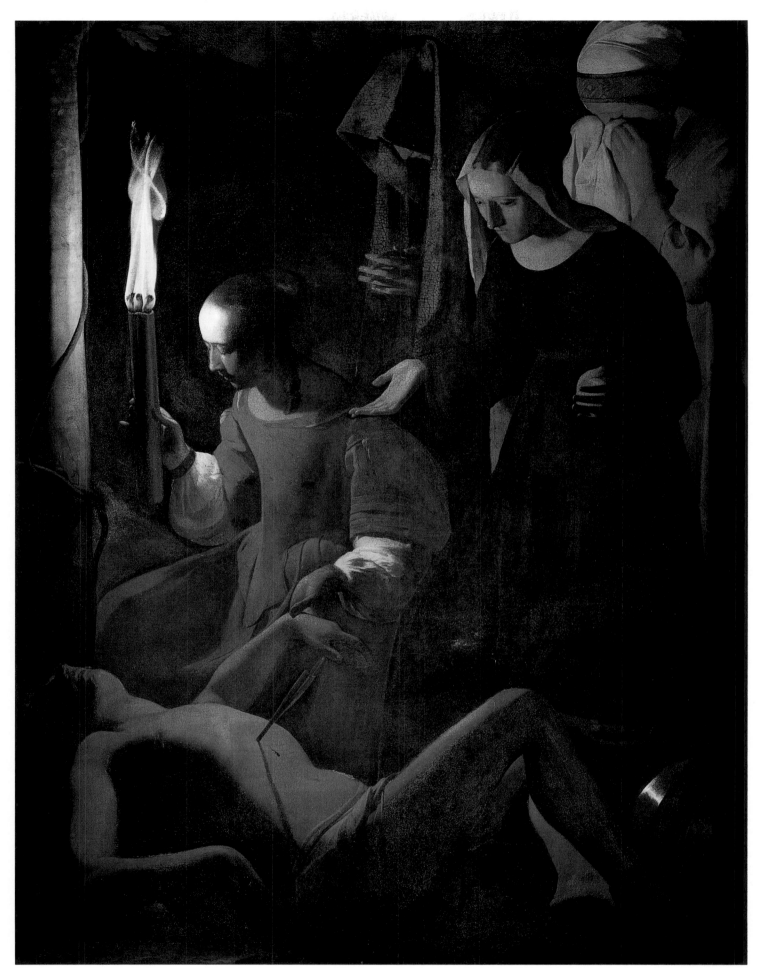

Georges de La Tour. *St. Sebastian Tended by St. Irene.* 1649. Oil on canvas. 65 ¾ x 51 ½ in. (167 x 131 cm).

Sebastian, a native of southern France, according to *The Golden Legend*, was a member of the Roman imperial retinue, who was martyred with arrows, then, in some accounts, tended by a Saint Irene. Sebastian was associated with relief from the plague, which recurred virulently in Europe in the late 1620s.

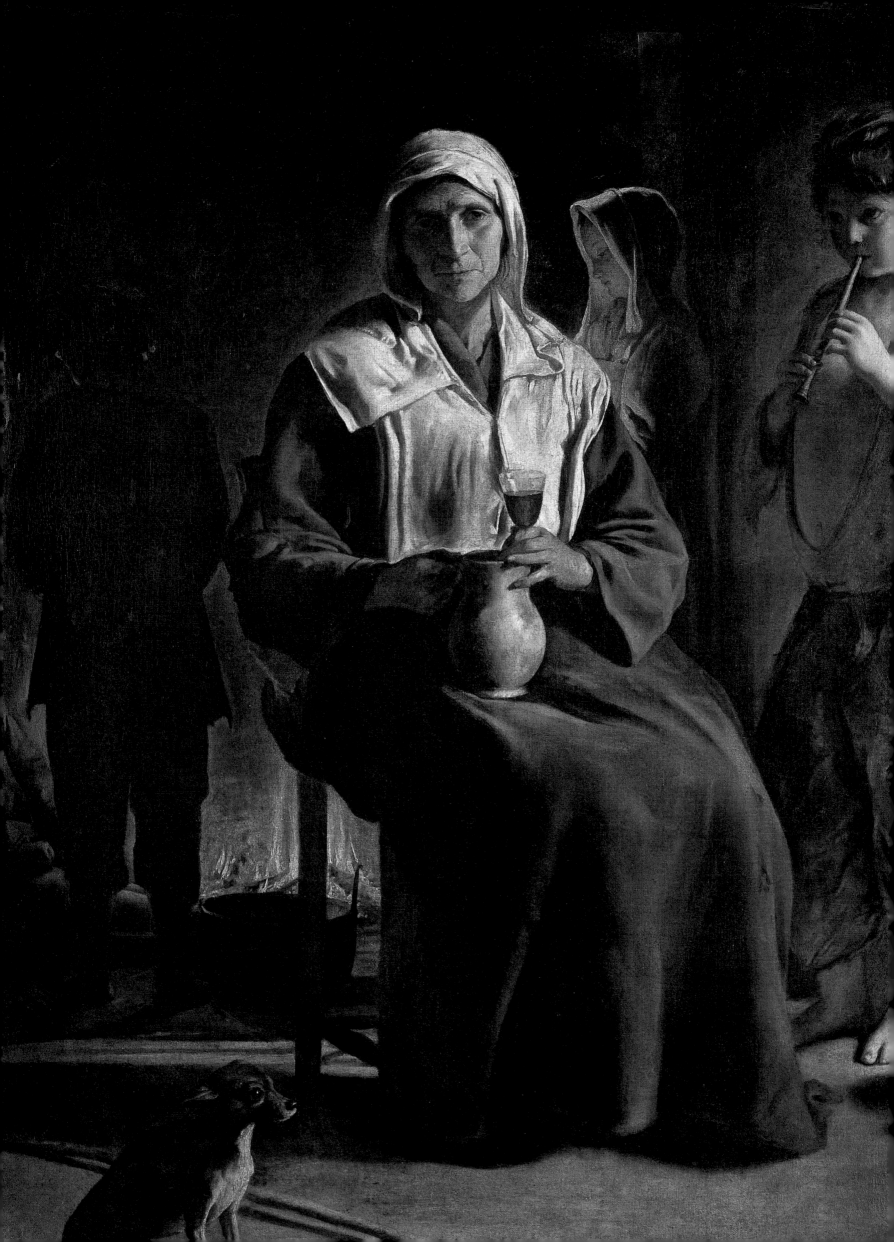

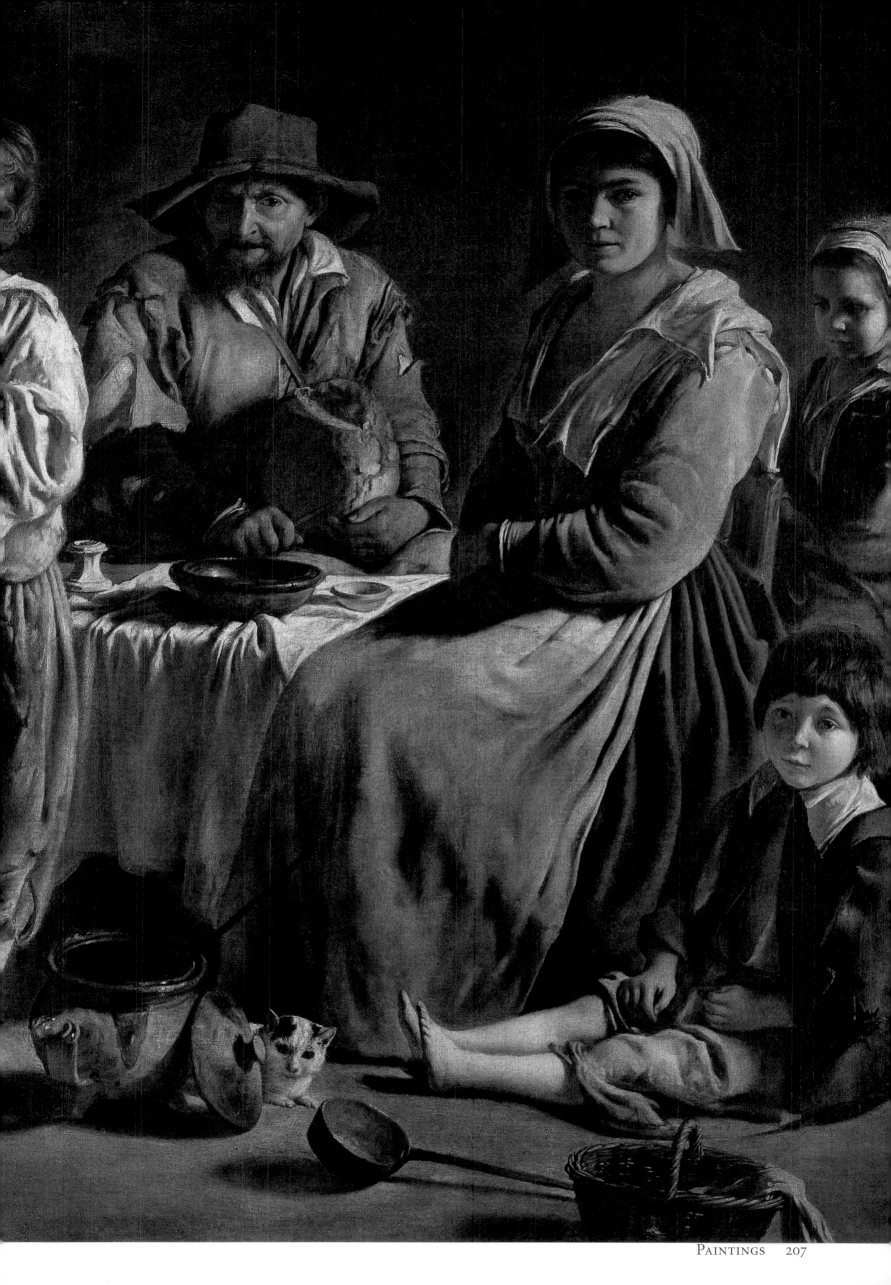

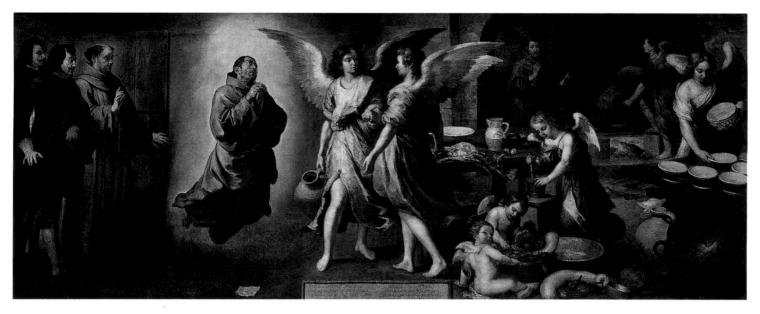

ABOVE

Bartolomé Esteban Murillo. *The Angel's Kitchen.* 1646. Oil on canvas. 70 ⅞ x 177 ⅛ in. (180 x 450 cm).

One of eleven paintings of Franciscan saints painted for a Seville monastery, the miracle of Saint James shows him levitating, to the astonishment of his abbot and two patrons on the left. On the right, angels take up the humble tasks of the saint, rendered unavailable by ecstasy.

OPPOSITE

Diego Velázquez de Silva. *The Infanta Margarita.* c. 1654. Oil on canvas. 27 ½ x 22 ⅞ in. (70 x 58 cm).

Velázquez was court painter to Philip IV of Spain when he painted this portrait of the king's three-year-old daughter, one of Velázquez's favorite subjects. His ability to shape light and color were supreme at this time: the little princess appears to be created from the dark around her.

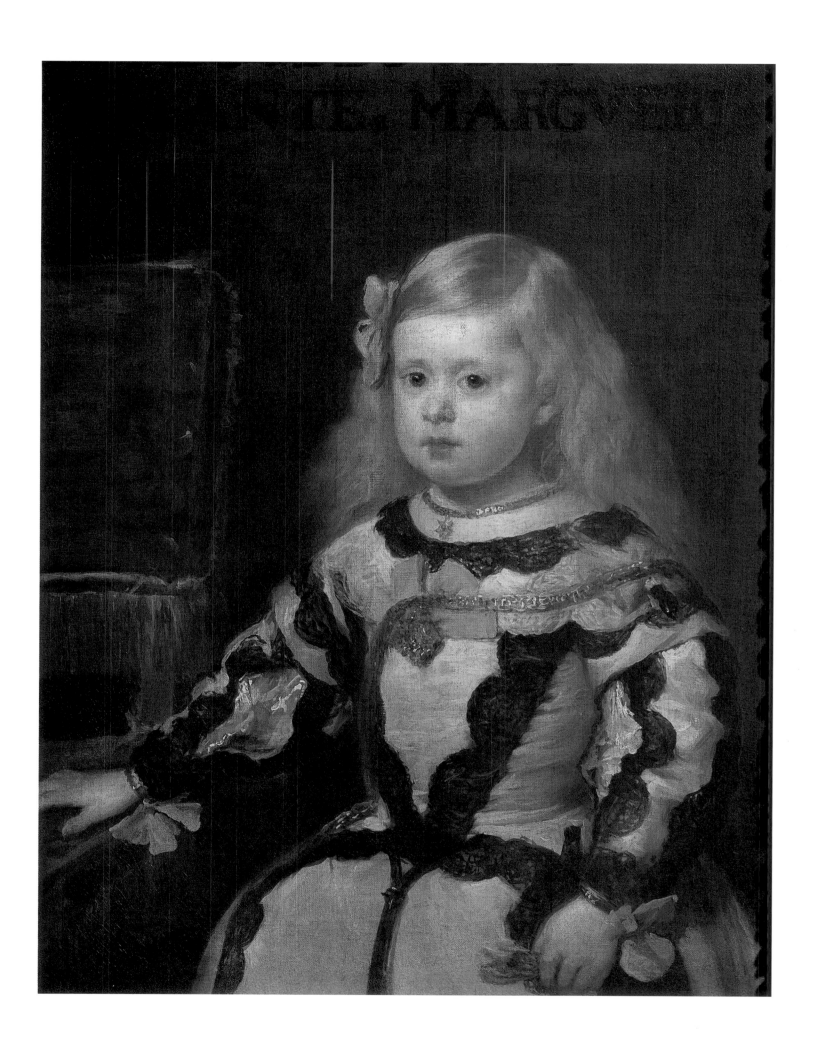

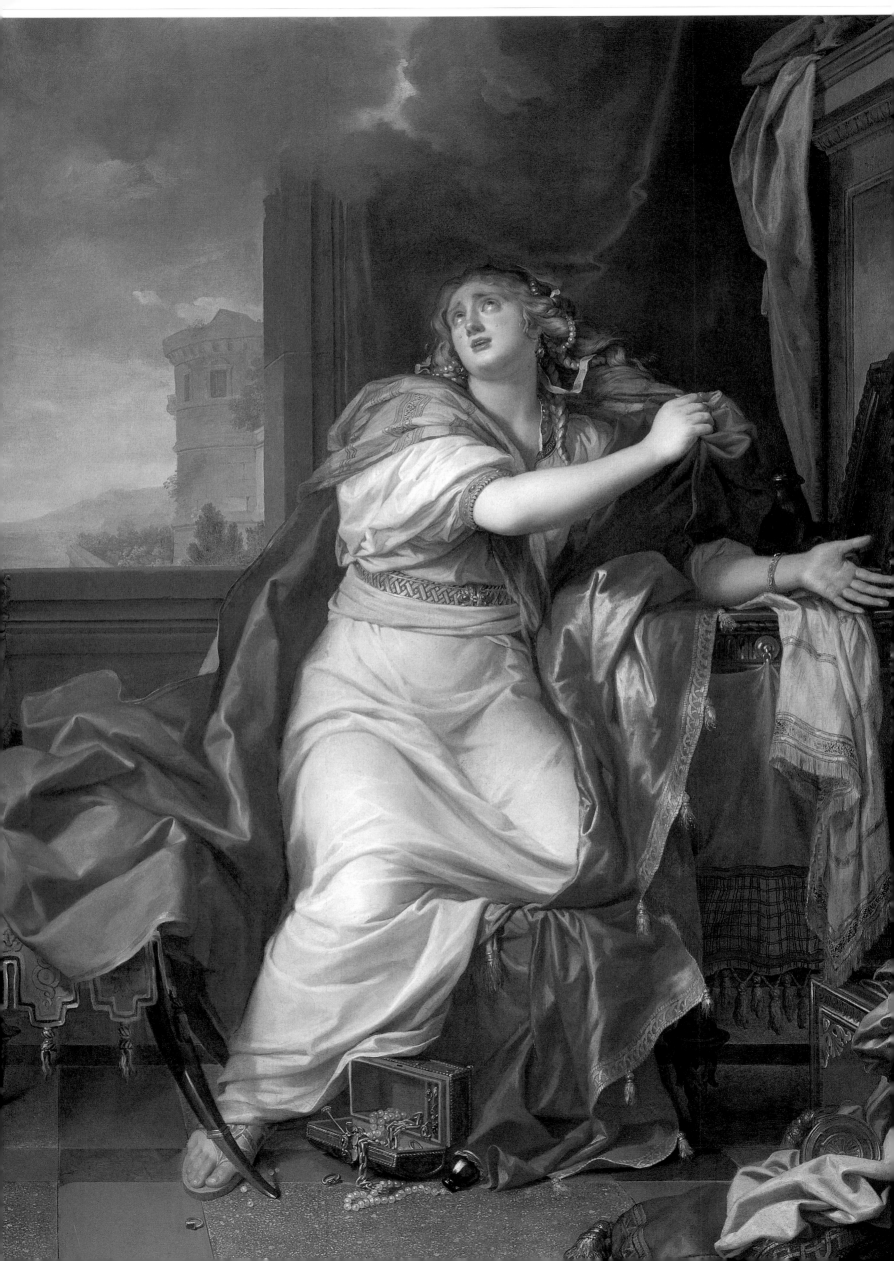

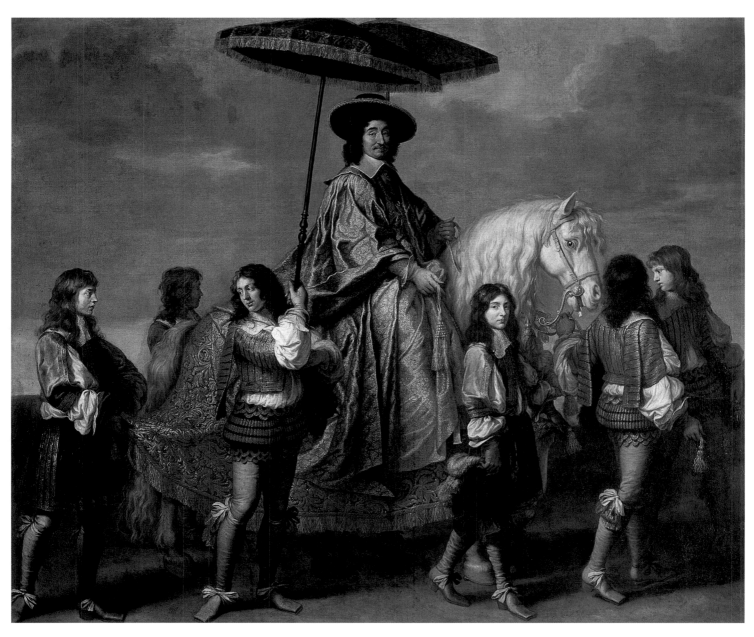

ABOVE

Charles Le Brun. *Chancellor Pierre Séguier.* c. 1655–57. Oil on canvas. 116 ⅛ x 131 ⅛ in. (295 x 351 cm).

This frieze-like portrait shows Le Brun's then patron entering Paris with the king in 1661, following the Fronde rebellion. The treatment of sky and horizon endows the composition with almost mythological importance, appropriate to the second most important personage of the kingdom.

OPPOSITE

Charles Le Brun. *The Penitent Magdalene.* After 1650. Oil on canvas. 99 ¼ x 67 ⅜ in. (252 x 171 cm).

The model for the Magdalene was long, but incorrectly, believed to be Louise de la Vallière, a mistress of Louis XIV, who retired to a convent at the age of thirty. The artist's return to the iconography of the wealthy woman of the world abjuring her material goods may have fueled the enduring rumor.

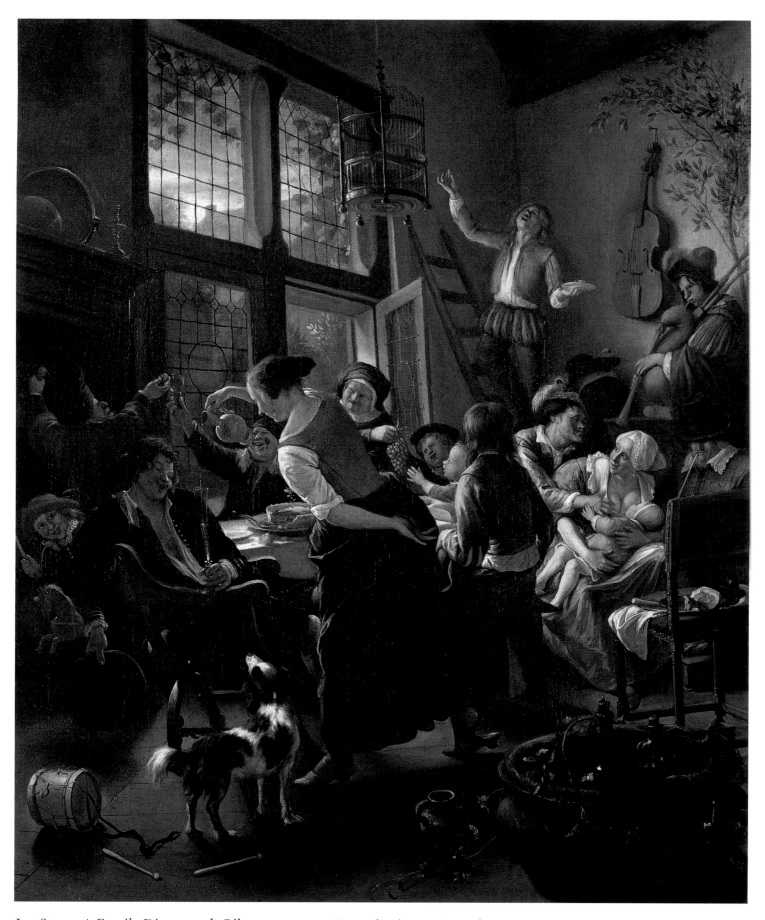

Jan Steen. *A Family Dinner*. n.d. Oil on canvas. 32 ¼ x 27 in. (82 x 68.5 cm).

Jan Steen was known and enjoyed for scenes of noisy, anarchic merriment like this, and still today the Dutch describe a disorderly home as "a Jan Steen house." Side by side with the onset of puritanical movements, genre paintings such as this proposed a good-natured acceptance of human frailty.

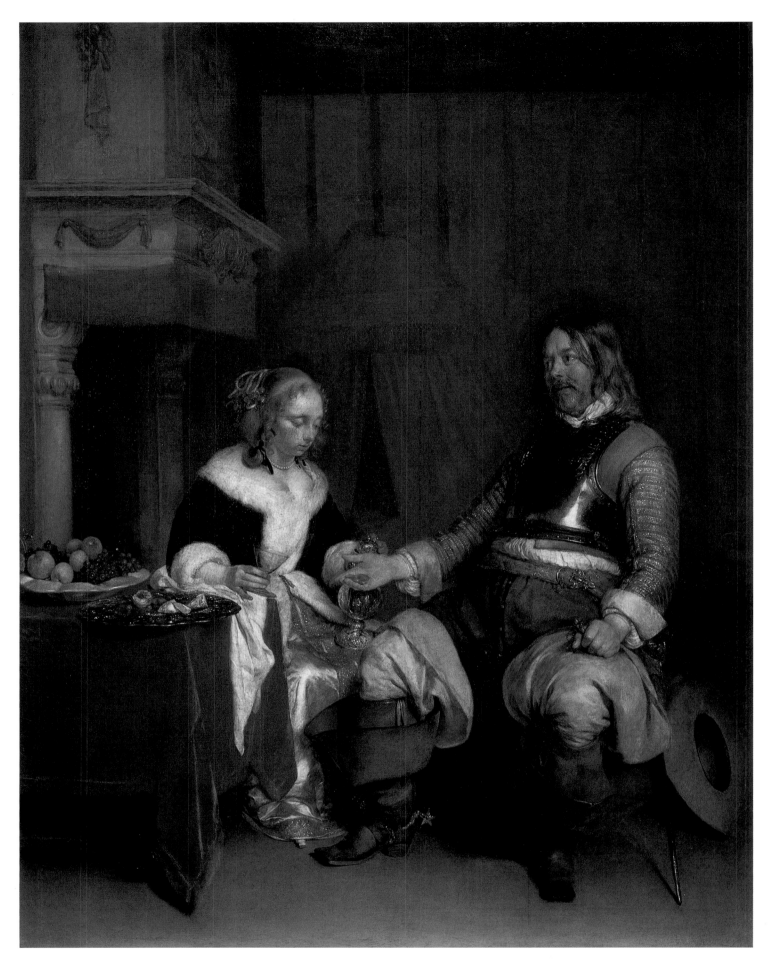

Gerard ter Borche. *The Dashing Officer*. n.d. Oil on canvas. 26 ¾ x 21 ⅝ in. (68 x 55 cm).

Beside his contemporaries' more rollicking scenes of ordinary immorality, Ter Borch's intimate genre scene, though mocking, is more sympathetic to human frailty. Even the ambiguous title—whose point of view does it represent?—is gently tongue in cheek rather than harshly ironic.

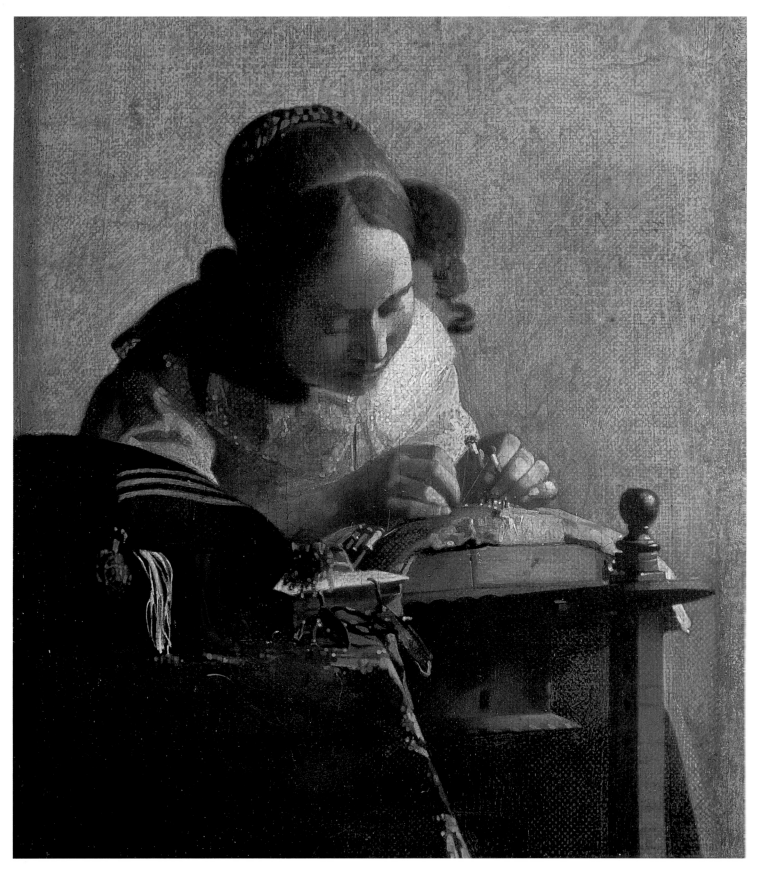

Jan Vermeer. *The Lacemaker.* 1665. Oil on wood. 9 ½ x 8 ¼ in. (24 x 21 cm).

Light in Vermeer's paintings acquires an otherworldly radiance, which here hallows the lacemaker's absolute concentration and stillness. Her intentness is accentuated by the point of view, which is close up to and slightly below her, and by the serene certainty of the colors. The artist succeeded in portraying one of the wonders of existence: the tranquil timelessness of a moment.

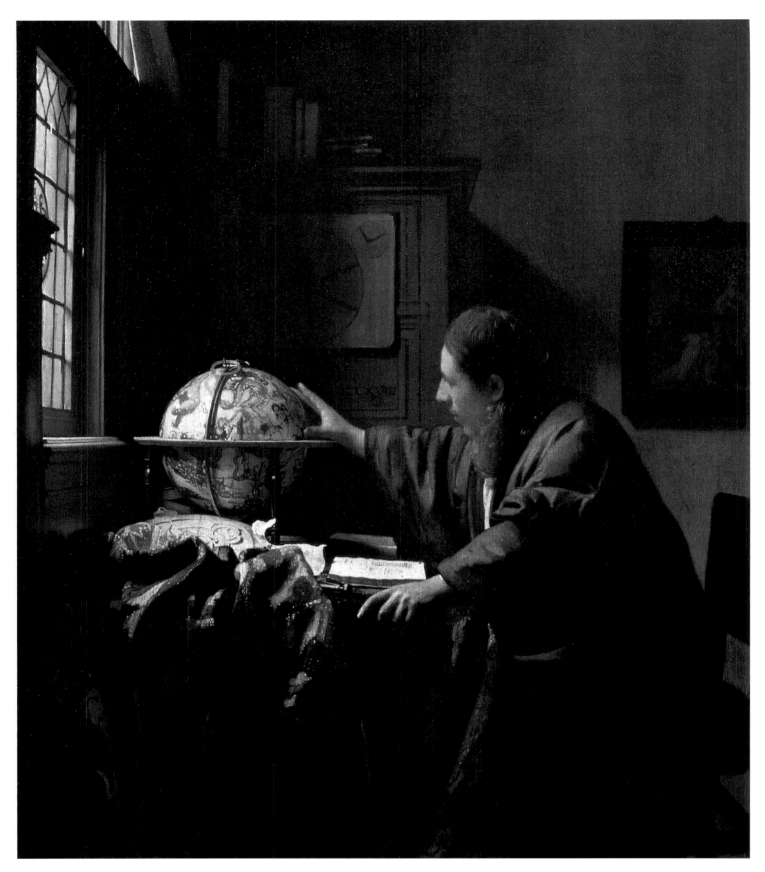

Jan Vermeer. *The Astronomer*. c. 1668. Oil on canvas. 20 x 17 ½ in. (51 x 45 cm).

The artist was himself fascinated by maps, although he probably never left his native Delft. The astronomer is studying a globe of the heavens: we can see the Great Bear in the upper left quadrant. Vermeer used light and gesture to convey the precise feeling of a new thought forming.

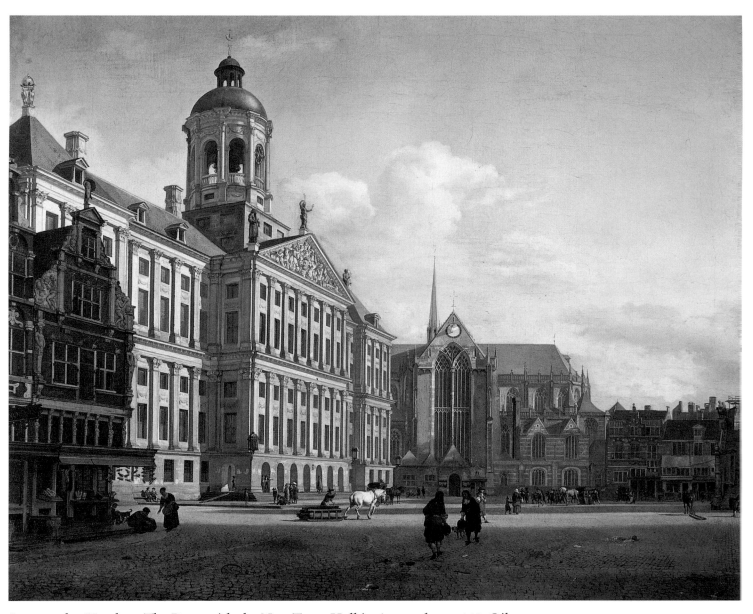

Jan van der Hayden. *The Dam with the New Town Hall in Amsterdam*. 1668. Oil on canvas.
28 ¾ x 33 ⅞ in. (73 x 86 cm).

The artist was famous for the precisely rendered imaginary townscapes of Amsterdam in which he specialized,
the exact equivalents of the composite landscapes of his place and time. Absent from his idealized paintings are
Van der Hayden's practical inventions, such as streetlighting and fire engines.

Carlo Maratta. *Sleeping Christ Child with Music-Making Angels.* 1697. Oil on wood. 47 ¼ x 38 ¾ in. (120 x 98.4 cm).

Maratta, the leading Roman painter of his time, was more than seventy when he depicted Mary delighting in her son, flanked by a heavenly host. Here, the painting's Baroque three-dimensionality is appropriate to the period's theatrically monumental architecture.

ABOVE

Hyacinthe Rigaud. *Madame Rigaud, Mother of the Artist, in Two Different Positions.* Oil on canvas. 36 ⅝ x 40 ½ in. (93 x 103 cm).

The exalted members of the courts of Louis XIV and XV appreciated Rigaud's talent for rendering rank worn with ease, a quality he may have learned from the work of Sir Anton Van Dyck. More personal studies display Rigaud's ability to render character: insight, humor, and the dignity of age.

OPPOSITE

Hyacinthe Rigaud. *Louis XIV, King of France.* 1701. Oil on canvas. 109 x 76 ⅜ in. (277 x 194 cm).

Louis XIV, who expanded the Louvre, then abandoned it for Versailles, created the most sumptuous court in Europe. Rigaud portrayed an absolute monarch—and elegant gentleman, as the turned leg reveals. Louis, in his early sixties and much sicker than he looks here, is literally mantled in power.

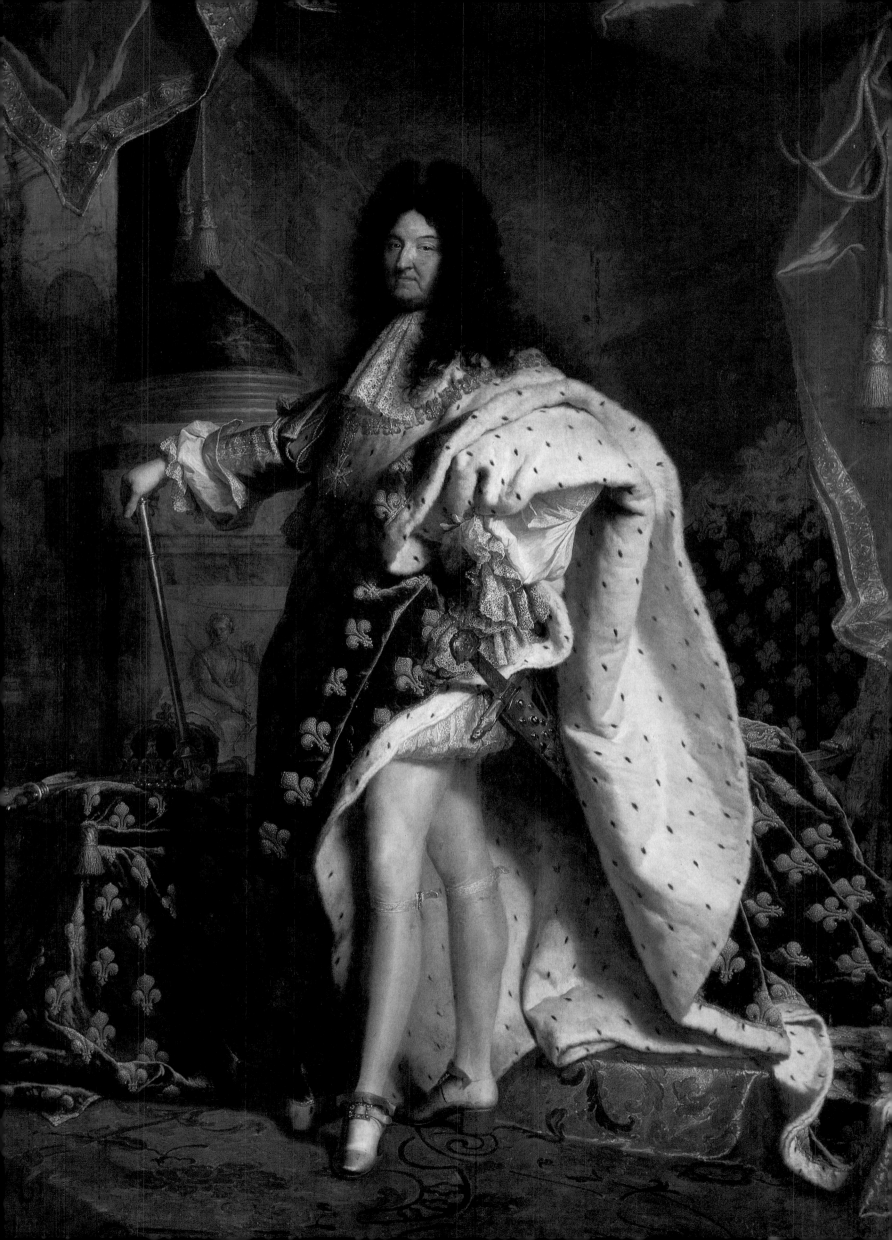

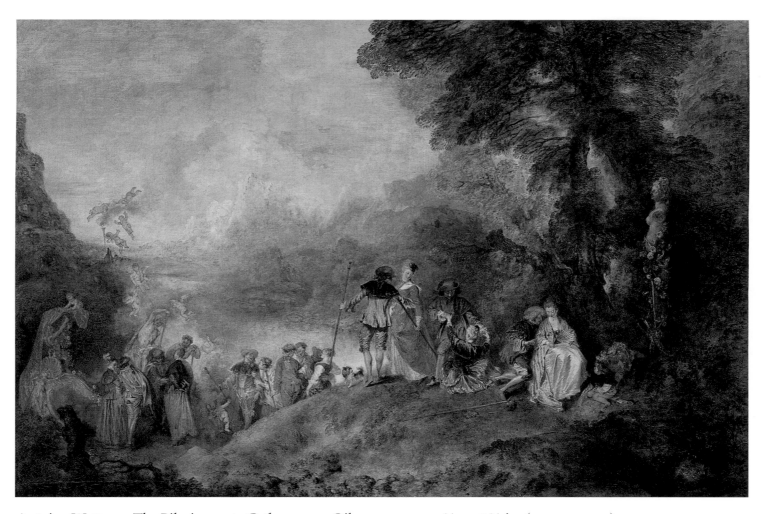

Antoine Watteau. *The Pilgrimage to Cythera.* 1717. Oil on canvas. 50 ¾ x 76 ⅜ in. (129 x 194 cm).

According to one legend, Venus, the goddess of love, emerged from the sea at the island of Cythera. This fulsome, Rococo *fête champêtre,* or country party, a deft composition of more and less dense brushstrokes, was Watteau's admission piece for the Académie Royale de Peinture et Sculpture.

Antoine Watteau. *Assembly in a Park*. Before 1721. Oil on wood. 13 x 18 ½ in. (33 x 47 cm).

In the second half of the eighteenth century, the arbiters of mores denounced the art of Watteau and his fellow Rococo artists as trivial, their impeccable colors, delicate nuances, and graceful lines too frivolous. The reaction against Rococo, inspired by the archaeological discoveries of the time, gave rise to Neoclassicism.

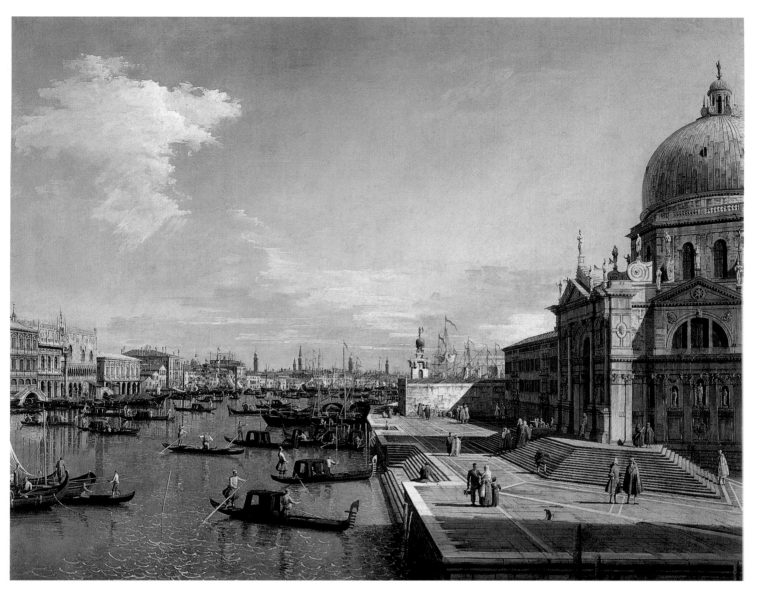

Giovanni Canal, called Canaletto. *Venice: The Church of La Salute.* n.d. Oil on canvas. 46 ⅞ x 60 ¼ in. (119 x 153 cm).

English travelers on the Grand Tour created a booming market for the Italian cityscapes known as *vedute*. Canaletto was one of the first to exploit the demand for these high-class souvenirs, with depictions of identifiably Venetian light and sights, such as this Baroque architectural gem.

Jean-Baptiste-Siméon Chardin. *Still Life with Pipe.* 1737. Oil on canvas. 12 ¾ x 16 ½ in. (32.5 x 42 cm).

The Académie Royale ranked still lifes low, yet Chardin, a former decorative artist, raised them to some of the finest art of his time, and showed several paintings in the Salon. Born into the middle class, he represented the world of "his habits, thoughts, and affections," as the nineteenth-century art critics the Goncourt brothers wrote.

ABOVE

Luis Eugenio Meléndez. *Still Life with Figs.* n.d. Oil on canvas. 14 ½ x 19 ¼ in. (37 x 49 cm).

Outside the tradition of aristocratic still lifes, this dramatically lit array of summer peasant plenty is a study in the senses of sight, textures, aromas, and sweet and savory flavors. Such is the artist's attention to detail that the viewer can almost hear the creak of the basket.

OPPOSITE

Jean-Baptiste-Siméon Chardin. *Saying Grace.* c. 1740. Oil on canvas. 19 ⅝ x 15 ⅜ in. (50 x 39 cm).

Chardin stood alone in several ways, including his stylistic independence: avoiding stereotype and sentimentality in his genre scenes, he was a precursor of realism. The artist showed this work in the 1740 Salon, then presented it to Louis XV later that year. The encyclopedist Denis Diderot wrote that what Chardin mixed on his palette was "the very substance of things."

ABOVE

François Boucher. *The Rape of Europa.* 1747. Oil on canvas. 63 ⅓ x 76 ⅜ in. (161 x 194 cm).

Boucher, a pupil of Watteau, was an uncontested star: his Rococo version of Classicism romps in an informal composition of impeccably suave lines. Zeus, disguised as a beautiful bull, is about to carry off the Asian maiden Europa to make her his bride; all the territory they will cover in their flight will be named for her.

OPPOSITE

Jean-Marc Nattier. *Anne Josephe Bonniere de la Mosson, the Duchess of Chaulnes as Hebe.* 1744. Oil on canvas. 56 ⅝ x 43 ⅜ in. (144 x 110 cm).

Classical learning influenced upper-class costume parties, tableaux vivants, and portraiture. With seemingly casual Rococo lines, Nattier, an artist of the Russian imperial and French royal courts, here immortalized a member of the nobility dressed as Hebe—in Greek mythology, the goddess of youth.

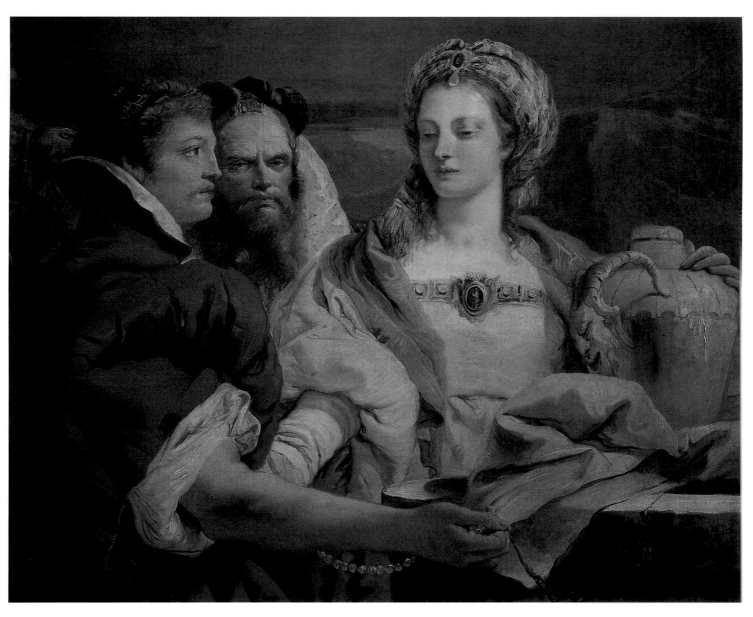

Giovanni Battista Tiepolo. *Rebecca at the Well*. n.d. Oil on canvas. 33 x 41 ⅜ in. (84 x 105 cm).

Tiepolo's famous draftsmanship adds to the sultriness of this epochal biblical moment, rendered immediate by the figures' half-length. Isaac has announced that he will know his future wife by her generosity in bringing water, not only to him, but to his camels. That woman is Rebecca.

François Boucher. *The Luncheon*. 1739. Oil on canvas. 32 ¼ x 26 in. (82 x 66 cm).

The virtuoso charms of Rococo are presented in a fond family scene, set in a fashionable interior, appropriate to the home of a successful painter and decorator. Shown here are the artist's wife and daughters; the little girl on the right, holding her beloved toys, considers a proffered teaspoon of hot chocolate.

ABOVE

Carle Van Loo. *Halt in the Hunt.* 1737. Oil on canvas. 86 ⅞ x 98 ⅝ in. (220 x 250 cm).

Van Loo painted this epicurean and amorous interlude for the dining room of Louis XV's private apartments at Fontainebleau. After the Revolution, the more ardent Republicans kept the works of Rococo artists like Van Loo out of the Louvre, to protect young artists from their "effeminate" example.

OPPOSITE

Louis Toqué. *Madame Dangé, Wife of General François-Balthazar Dangé du Fay, Tying Knots.* 1753–55. Oil on canvas. 32 ⅝ x 24 ⅞ in. (83 x 63 cm).

This portrait of Anne Jarry, wife of a royal tax collector, appeared in the Salon of 1753. The attractive sitter wears a fashionable at-home costume dripping with lace so precious it is or will be an heirloom. Jarry also observes the centuries-old stricture that a lady is never idle—and if her activity shows off her fine hands, so much the better.

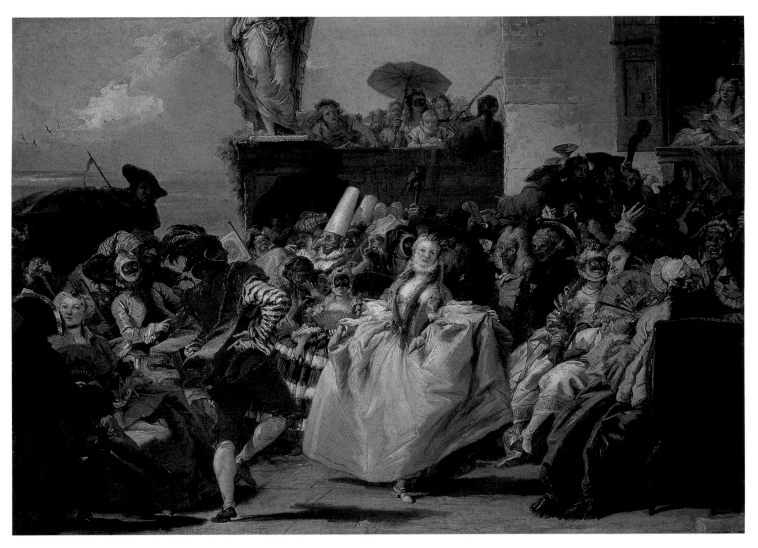

Giovanni Domenico Tiepolo. *Carnival Scene.* 1745–50. Oil on canvas. 31 ⅞ x 43 ¾ in. (81 x 111 cm).

Giovanni Battista's son and pupil specialized in whimsical, often imaginary Rococo Venetian genre scenes, based on what the tourists hoped to see. *Carnival Scene*, with its thrillingly licentious under- and overtones, was the archetypical Venetian festival, shown here as a gathering at a country palazzo.

Thomas Gainsborough. *Lady Alston.* c. 1760. Oil on canvas. 89 ¾ x 65 ⅜ in. (228 x 166 cm).

Gainsborough, with Reynolds, was one of the fashionable society portraitists of his time. He lived for a time in Bath, a resort town frequented by royalty and the aristocracy, including Lady Alston, who glows as if illuminated from within. The artist and his subject both accentuated her fine, very white hands.

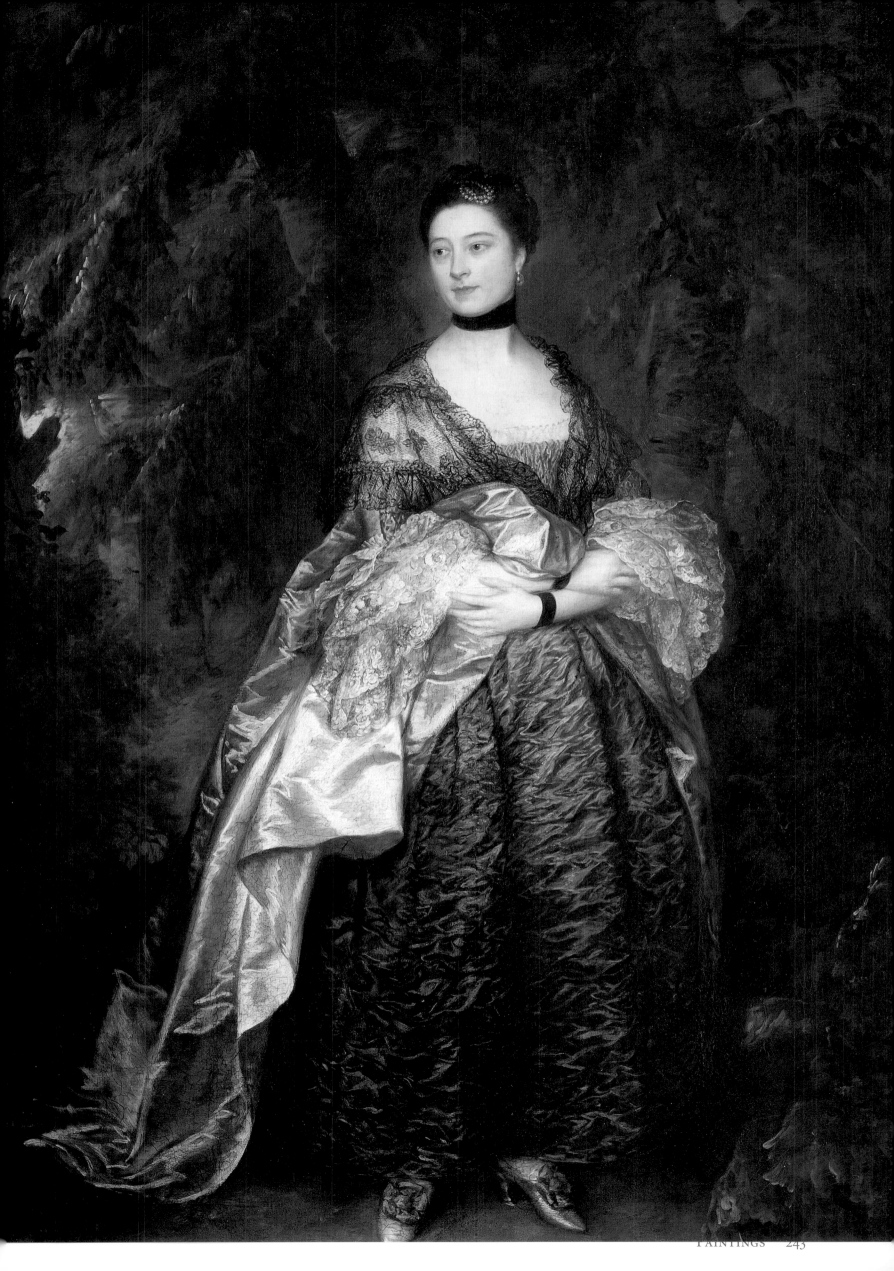

Gabriel de Saint-Aubin. *View of the Salon du Louvre.* 1779. Oil on canvas. 76 x 56 ⅝ in. (193 x 144 cm).

The crowded hang was derived from the private cabinets, with smaller paintings at eye level, and large paintings hung at an angle in order to be viewed more easily. The Salon became an increasingly public attraction: in 1801, 268 artists showed 485 works; in 1841, a magazine claimed that one million people had attended that year's exhibition.

P. 246

Elisabeth Vigée-Lebrun. *Self-Portrait with Her Daughter.* 1786. Oil on canvas. 51 ⅛ x 37 in. (130 x 94 cm).

One of the most successful painters of her, or any other, time, Vigée-Lebrun was court painter to Queen Marie-Antoinette. During the ten-odd years of the Revolution, Vigée-Lebrun was a popular portraitist, especially in England. Here, in the spirit of the times, she emphasized her maternity.

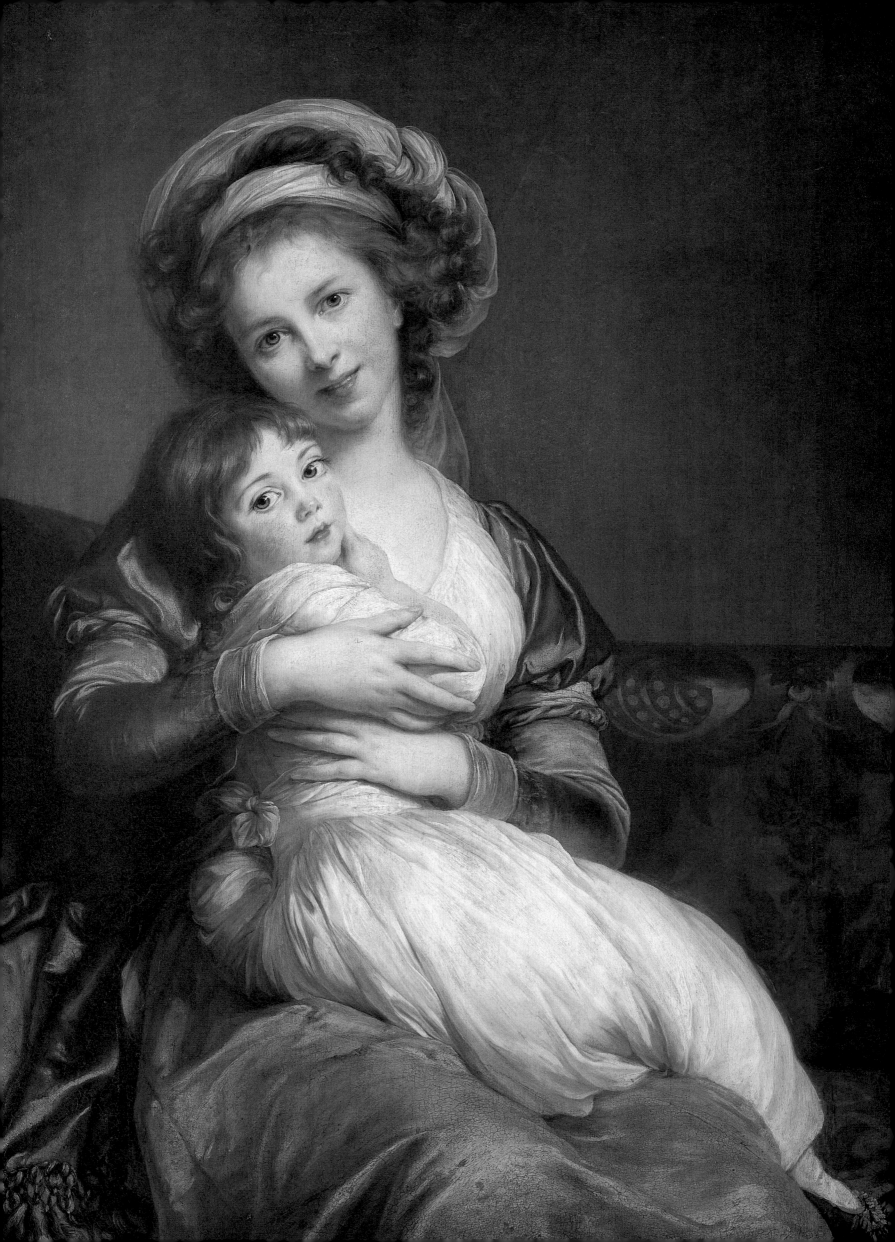

Jean-Honoré Fragonard. *A Study*. n.d. Oil on canvas. 32 ¼ x 26 in. (82 x 66 cm).

Fragonard, who studied with Chardin and Boucher, made this painting as one of a decorative series of four, two of women and two of men. According to inscriptions on the back of the studies of men, they were executed "in an hour's time," and the same may be true of this appealingly sketched work.

Adélaïde Labille-Guiard. *Portrait of the Painter Vincent.* c. 1798. Oil on canvas. 28 ½ x 22½ in. (72.4 x 57.2 cm).

The artist presented this portrait of her second husband, also a painter, on the occasion of her 1771 admission to the Académie Royale, as well as in the Salon. Although she painted royal portraits, Labille-Guiard was sympathetic to the goals of the Revolution, and so was able to remain in France during those turbulent years.

Sir Joshua Reynolds. *Master Hare*. 1788–89. Oil on canvas. 30 ⅜ x 25 in. (77 x 63.5 cm).

Sir Joshua Reynolds, who founded the Royal Academy of Great Britain and was later painter to King George III, was especially praised for his portraits of women and children. Young Master Hare is lively and inquisitive, and his Romantic portrait is in the informal fashion of the time.

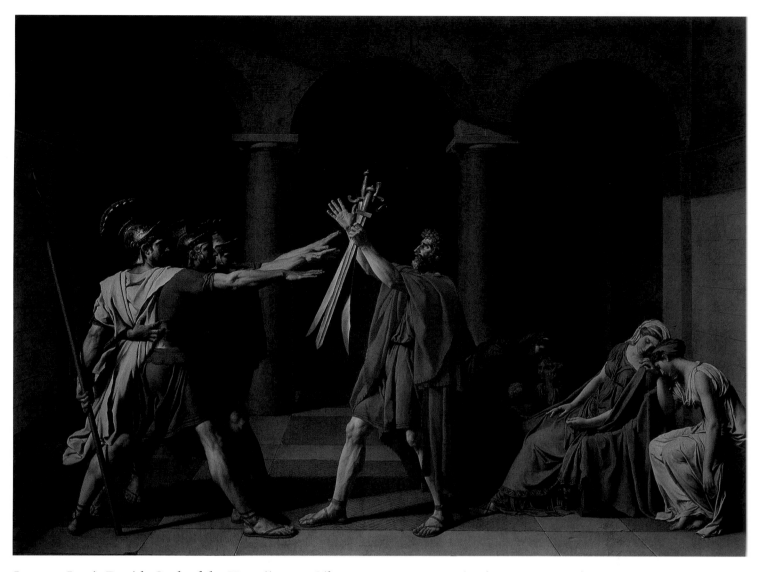

Jacques-Louis David. *Oath of the Horatii*. 1784. Oil on canvas. 130 x 168 in. (330 x 426.7 cm).

Drawing on a seventeenth-century French tragedy, David depicted the three sons of Horatius swearing allegiance to Rome, as they go to fight their sisters' betrothed, the three sons of Curiatius of Alba Longa. Commissioned by Louis XVI for the Louvre, it is, with its formal, even stagy composition, and clearly contoured figures born out of a reaction to Rococo, a famous manifesto of Neoclassicism.

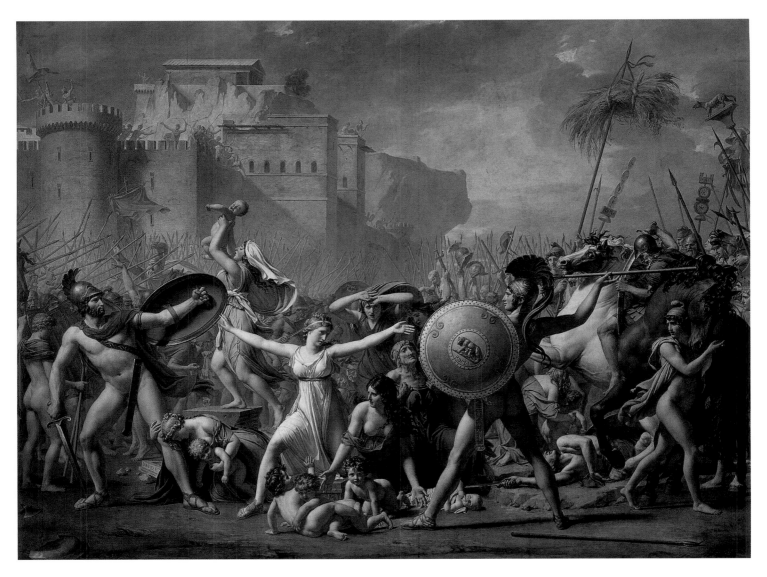

Jacques-Louis David. *Intervention of the Sabine Women.* 1799. Oil on canvas. 151 ½ x 205 ½ in. (385 x 522 cm).

In 1794, the Revolutionary painter-turned-politician Gabriel Bouquier argued that the "effeminate" art of the old regime must be replaced with a "virile and energetic style." Heroic nudity and spectacle abound in this episode from Roman history, in which the Sabine women, now married to their Roman abductors, strive to make peace between the two tribes.

P. 252

Marie-Guillemine Benoist. *Portrait of a Negress.* 1800. Oil on canvas. 31 ⅝ x 25 ⅝ in. (81 x 65 cm).

Although the unnamed sitter's dress is in the modified classical style of the time, Benoist avoided any stylistic rhetoric. Best known as a portraitist, the artist, a student of Vigée-Lebrun and briefly of David, executed portraits of Napoleon and his family after 1803, and won a gold medal in the 1804 Salon.

P. 253

Francisco Goya y Lucientes. *The Marquesa de la Solana.* c. 1793. Oil on canvas. 71 ¼ x 48 in. (181 x 122 cm).

The Marquesa, an educated and cultured woman, belonged to the enlightened aristocratic world frequented by the artist. When, terminally ill, she commissioned this portrait as a memento for her daughter, Goya constructed an innovative, multipurpose background that pays subtle tributes to the sitter.

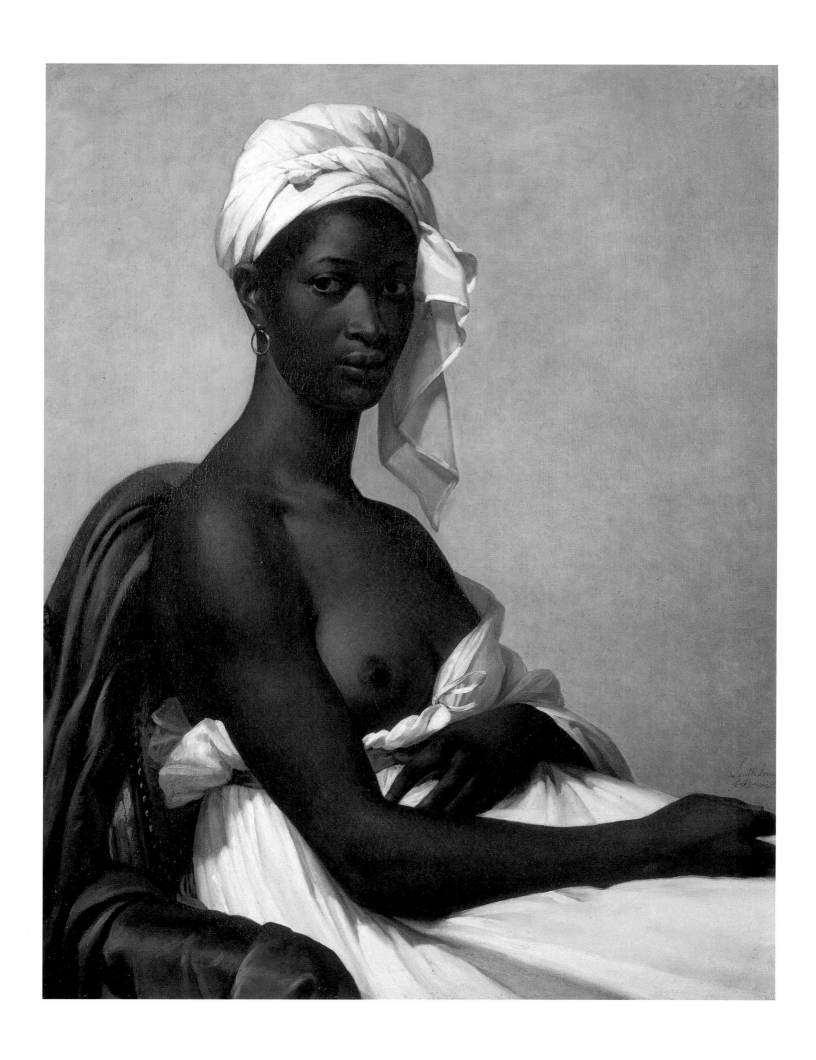

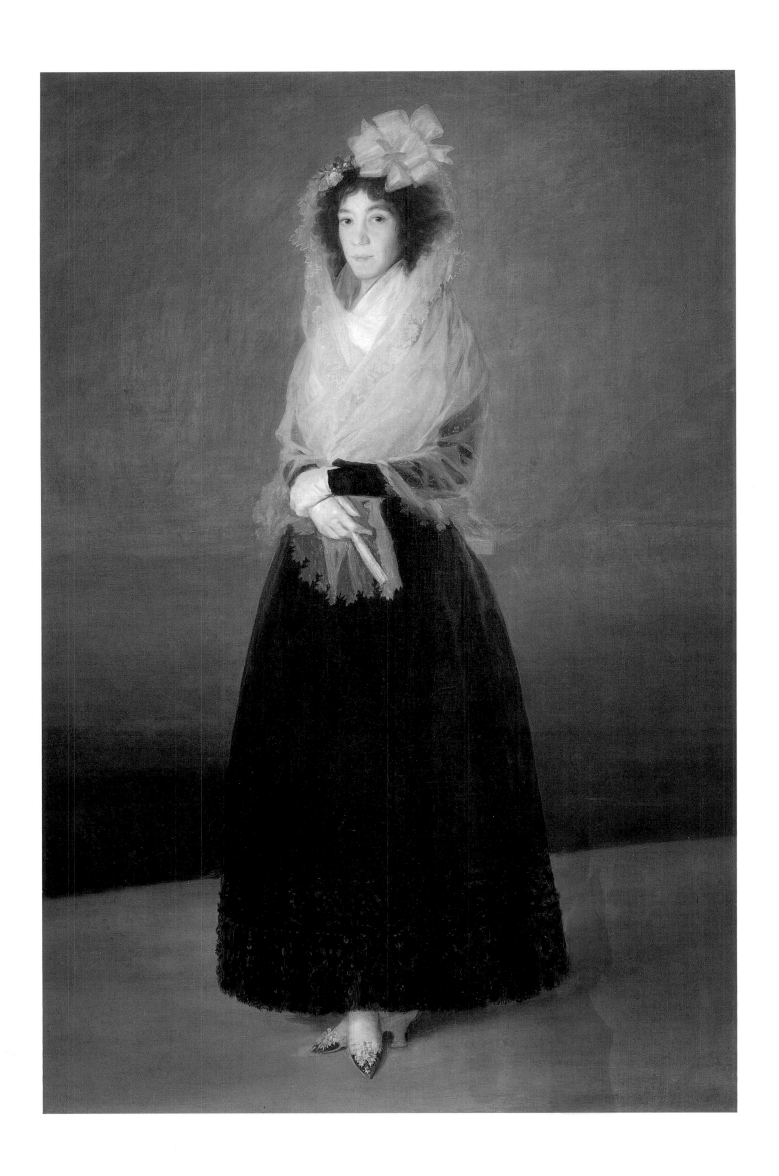

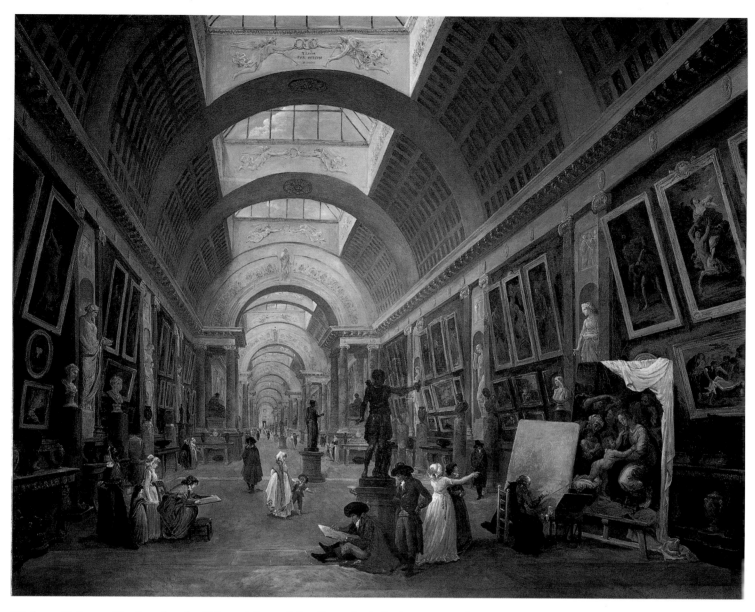

Hubert Robert. *Project for the Disposition of the Grande Galerie.* 1796. Oil on canvas. 44 x 56 ¼ in. (112 x 143 cm).

In 1784, the artist was made keeper of the king's pictures; in 1795, the Directoire assigned him the task of organizing the exhibit space of the renovated Grande Galerie. Robert, who lived in the Louvre, painted a series of real and imaginary views of the gallery. Top lighting was first suggested in the 1780s; these skylights would finally be constructed in 1806, a revolution later.

ABOVE

Hubert Robert. *Imaginary View of the Grande Galerie in Ruins.* 1796. Oil on canvas. 45 x 57 ½ in. (114.5 x 146 cm).

This Romantic reminder of the passage of time appeared at the Salon of 1796. Michelangelo's *Dying Slave* lies broken on the right, the Apollo Belvedere, one of the prizes of Napoleon's "confiscations," stands on the left. Passersby wonder over a Classical head, while a dedicated student sketches.

OVERLEAF

Jacques-Louis David. *Madame Récamier.* Begun in 1800, left unfinished. Oil on canvas. 68 ½ x 96 in. (174 x 244 cm).

In this portrait, it is as if David's Neoclassicism deflated, leaving behind Classical elements, such as the tripod, the modishly unconstructed dress, and the couch that would take its name from the celebrated salonnière. There is something suddenly modern in the dabbed background.

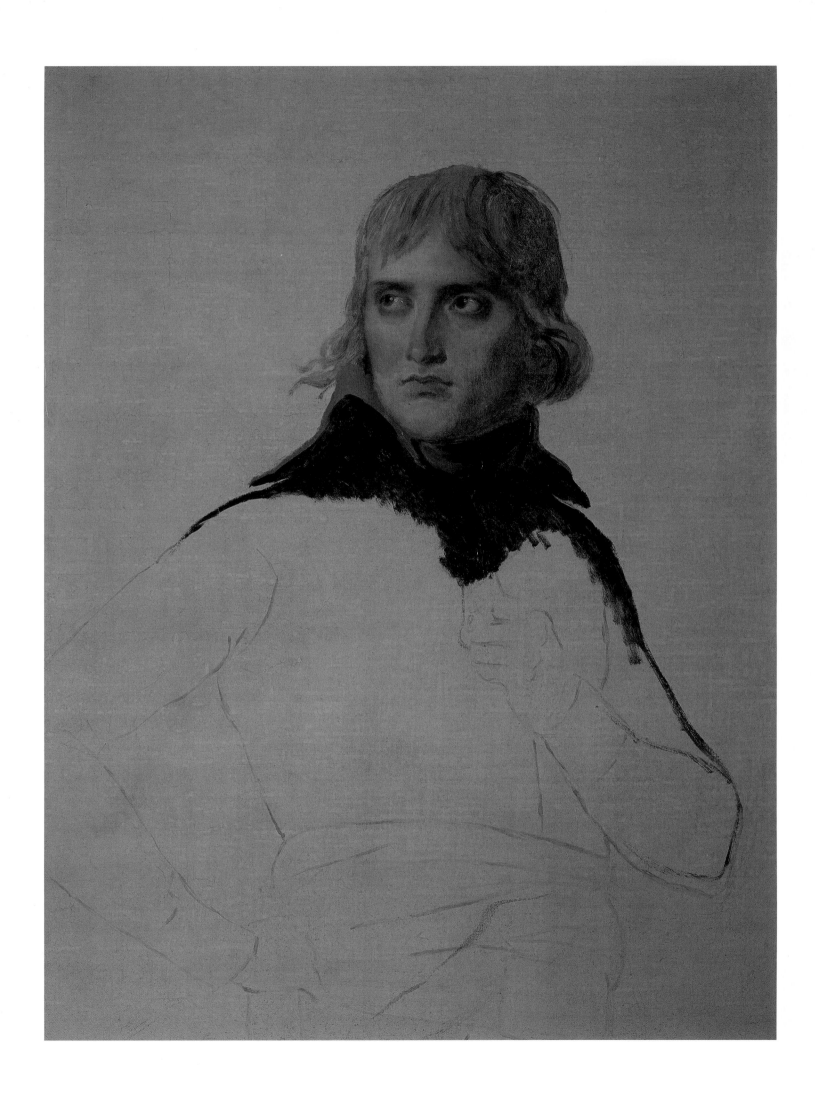

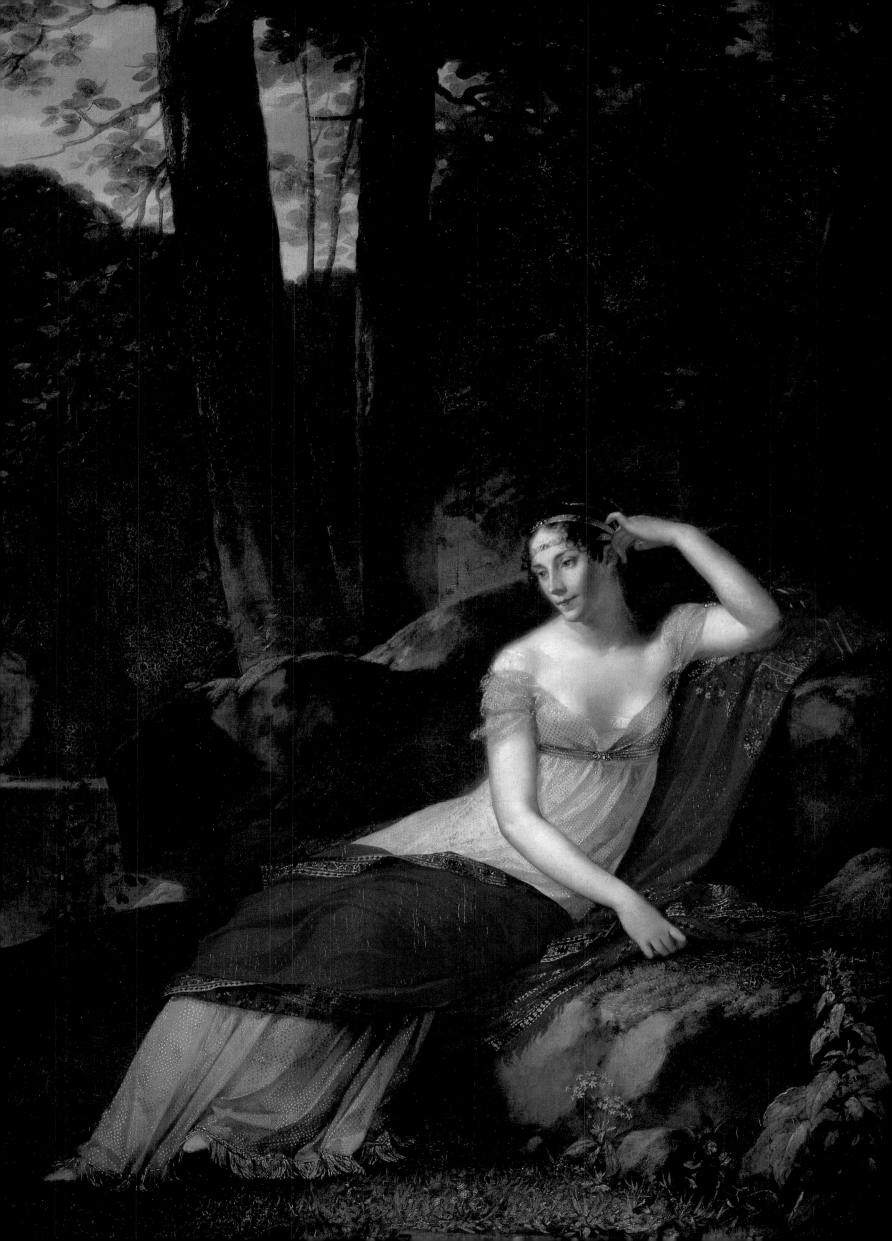

ABOVE

Pierre de Valenciennes. *Villa Farnese: Two Poplar Trees.* c. 1780s. Oil on canvas. 10 ¼ x 15 ⅜ in. (26 x 39 cm).

A journey to Italy transformed Valenciennes, an enthusiastic follower of Poussin, who thenceforth devoted himself increasingly to landscapes. His serene studies of distinct light are a link between the Classical schools and nineteenth-century realism.

OPPOSITE

Constance Mayer. *The Unhappy Mother.* 1810. Oil on canvas. 76 x 56 ⅞ in. (193 x 144.5 cm).

This is a companion piece to *The Happy Mother.* Mayer, a student of Prud'hon as well as his companion, employed Leonardesque shadows to evoke the mourning that engulfs the figure, whose grieving, delicate gesture calls attention to the womb in which she bore her child.

P. 258

Jacques-Louis David. *General Bonaparte, Study.* 1797–98. Oil on canvas. 31 ⅞ x 25 ½ in. (81 x 65 cm).

This unfinished portrait captures the young general's energetic, Romantic appeal, in contrast with the official and commemorative works that project the *gravitas* proper to an emperor. It was in these years that General Bonaparte's treaties and conquests brought the great art of Europe into the Louvre.

P. 259

Pierre-Paul Prud'hon. *The Empress Josephine, First Wife of Napoleon I.* 1805. Oil on canvas. 96 x 70 ½ in. (244 x 179 cm).

One of the favorites of Napoleon's Imperial court, Prud'hon retained Leonardo's shadows and the delicate sensibility of the previous century, while painting his sitter in an unconstructed, post-Revolutionary gown and simple hairstyle. Nevertheless, the fabric across her legs is a regal red.

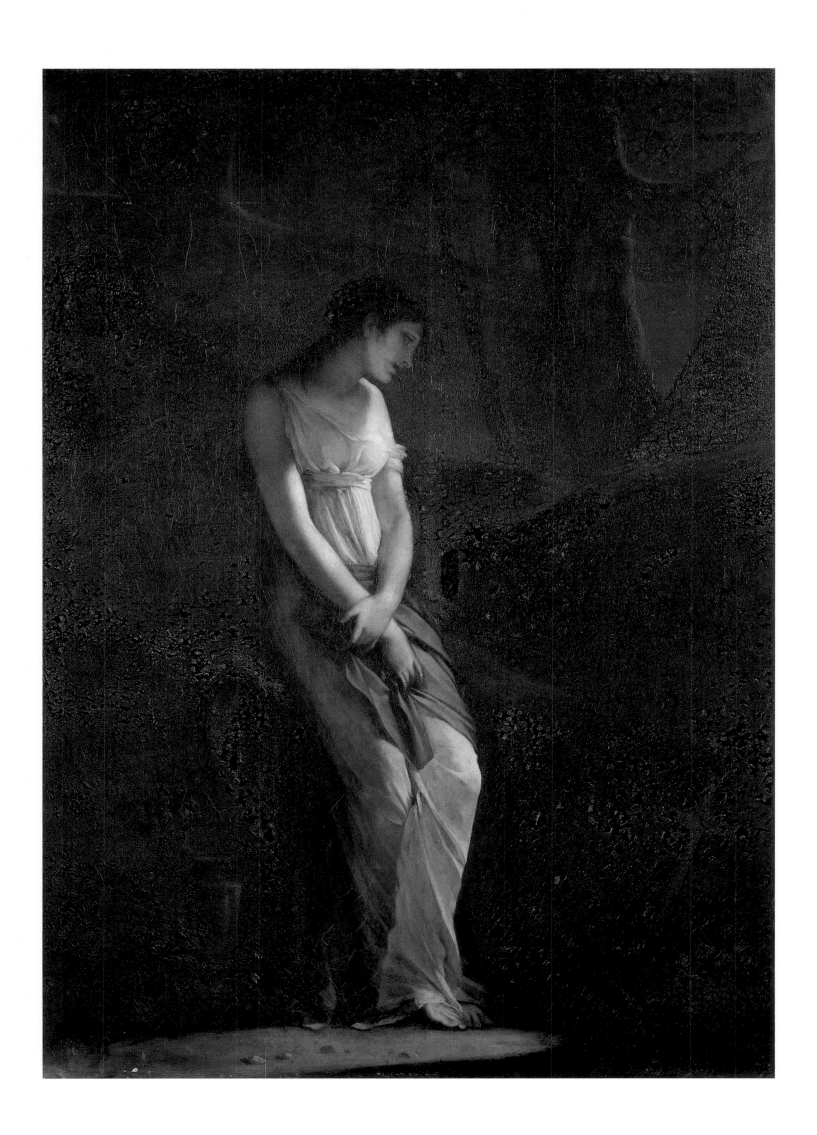

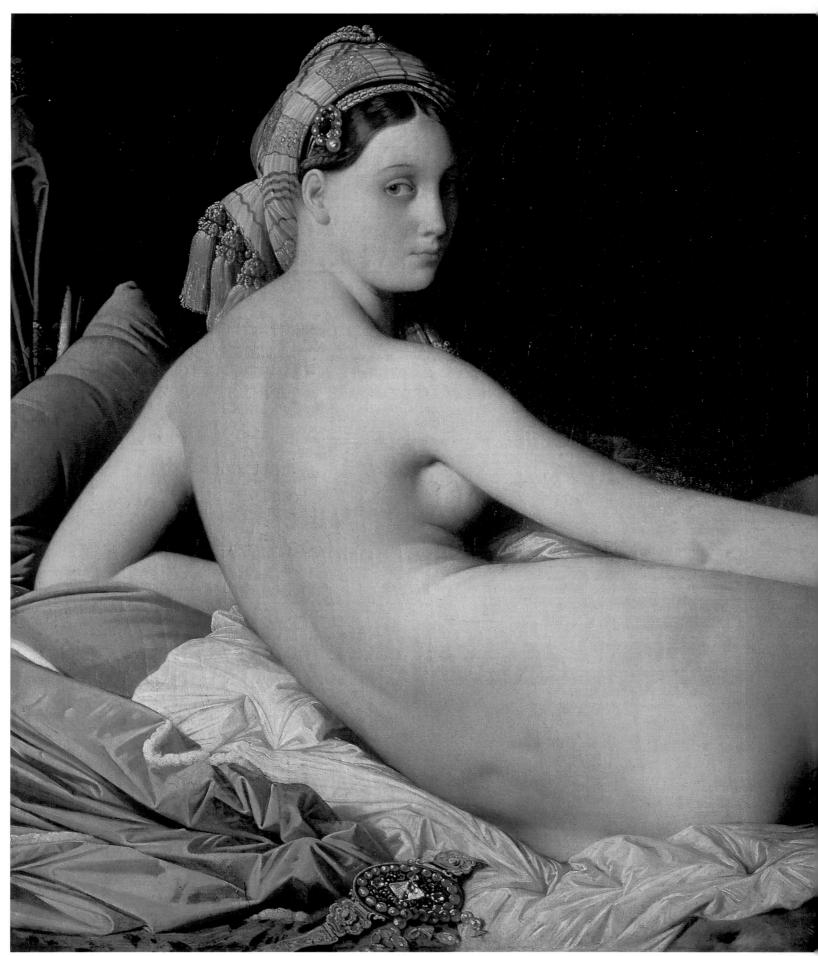

ABOVE

Jean-Auguste-Dominique Ingres. *La Grande Odalisque.* 1814. Oil on canvas. 35 ⅞ x 71¾ in (91 x 162 cm).

Although he favored the clean lines of Neoclassicism and the trappings of Orientalism, Ingres evolved a look all his own, most noticeable in a series of "harem women," creamy confections of blush-pink skin tones and richly hued, sensual accents. This painting was commissioned by Caroline Murat, queen of Naples, a sister of Napoléon I.

P. 264

François Gérard. *Psyche Receiving the First Kiss of Love*. 1798. Oil on canvas. 73 ¼ x 52 in. (186 x 132 cm).

The baron, a student of David, painted for emperors and kings. He did a number of portraits of celebrities, including Madame de Staël, the duke of Wellington, and Tsar Alexander I, as well as popular historical subjects and mythological motifs such as this.

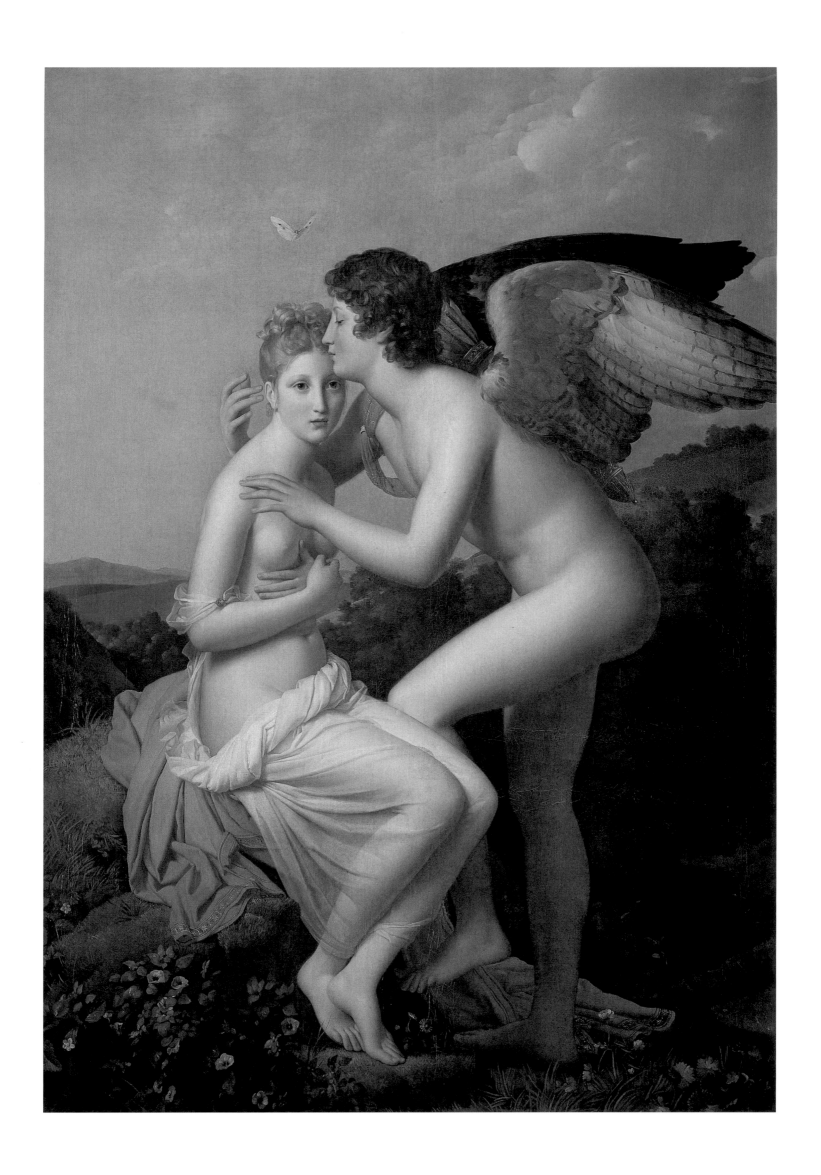

Anne Vallayer-Coster. *Still Life with Coral and Shells.* 1769. Oil on canvas. 51 ¼ x 38 ¼ in. (130 x 97 cm).

Like her father, Vallayer-Coster, who had apartments in the Louvre, designed tapestries for the Gobelins; her still lifes, confident compositions designed for the grand rooms of the aristocracy, displayed great originality, as here. A member of the Académie, she lobbied her colleagues successfully to include more women in the Salons.

ABOVE

Théodore Géricault. *Raft of the Medusa*. 1819. Oil on canvas. 193 ⅜ x 281 ⅞ in. (491 x 716 cm).

The raw emotional effect of this vast, meticulously composed Romantic masterpiece created a sensation at the 1819 Salon. The painting refers to the scandalous aftermath of a shipwreck, when a government-appointed captain abandoned 149 men at sea. Only 15 were still alive when the party was finally saved; reports of cannibalism added to the public's outrage.

OPPOSITE

Théodore Géricault. *The Woman with Gambling Mania*. c. 1822. Oil on canvas. 30 ⅜ x 25 ½ in. (77 x 65 cm).

In 1822 and 1823, the artist, a fashionable gentleman driven to expose social injustice, executed a series of five portraits of women with specific mental illnesses. Although this is a likeness of an individual woman, the sitter's gaze, locked into a perpetual future, makes the image read as an allegory.

Jean-Baptiste Camille Corot. *The Forum Seen from the Farnese Gardens.* 1826. Oil on canvas.
11 x 19 ⅝ in. (28 x 50 cm).

In the spirit of Constable's new art, Corot traveled to Italy to study its light, rather than its classical and Renaissance masterpieces. He approached the city as pure landscape: there is no sign of present life. That absence and a flat light that eliminates detail create a feeling of poised stillness.

John Constable. *View of Salisbury.* c. 1825. Oil on canvas. 14 ⅓ x 20 ½ in. (36 x 52 cm).

One of the most influential painters of any period, Constable rejected conventional landscape painting, whether artful Dutch composites or storm-tossed Romantic countrysides. He chose instead to depict the places of his childhood, with subversive realism and shocking techniques, such as bald white dabs of paint.

Eugène Delacroix. *Death of Sardanapalus.* 1827. Oil on canvas. 154 ⅜ x 195 ¼ in. (392 x 496 cm).

Red flows across the canvas like a river of blood. The luxury-loving Assyrian king of Byron's poem watches as, at his behest, his men slaughter concubines and pages, so that the victorious rebels may not enjoy them. Shown at the 1827–28 Salon, both the public and critics disliked the work for its "confusion."

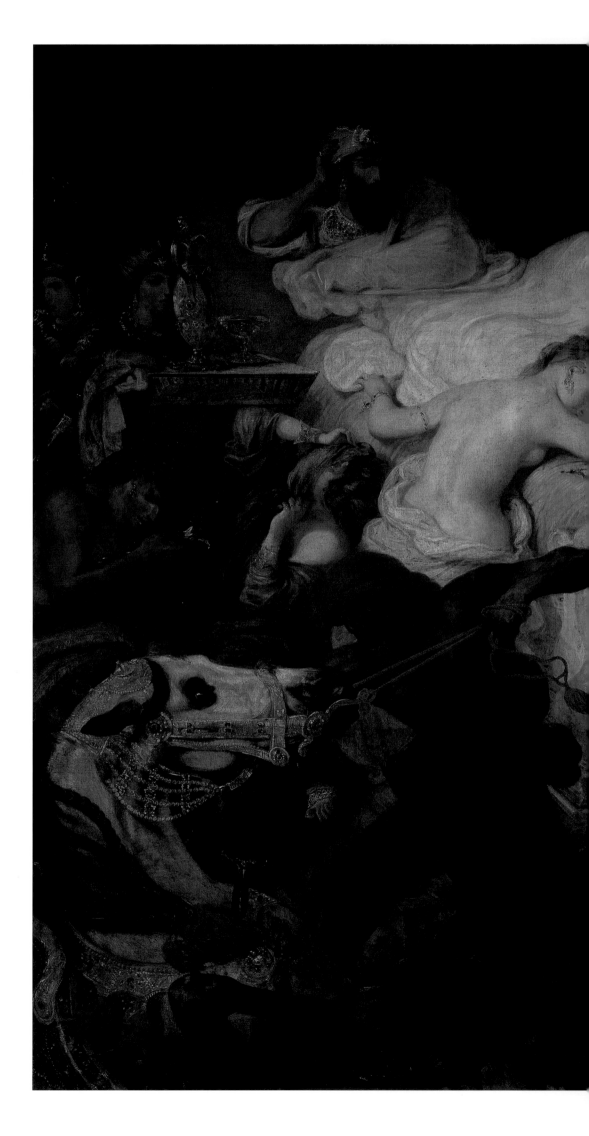

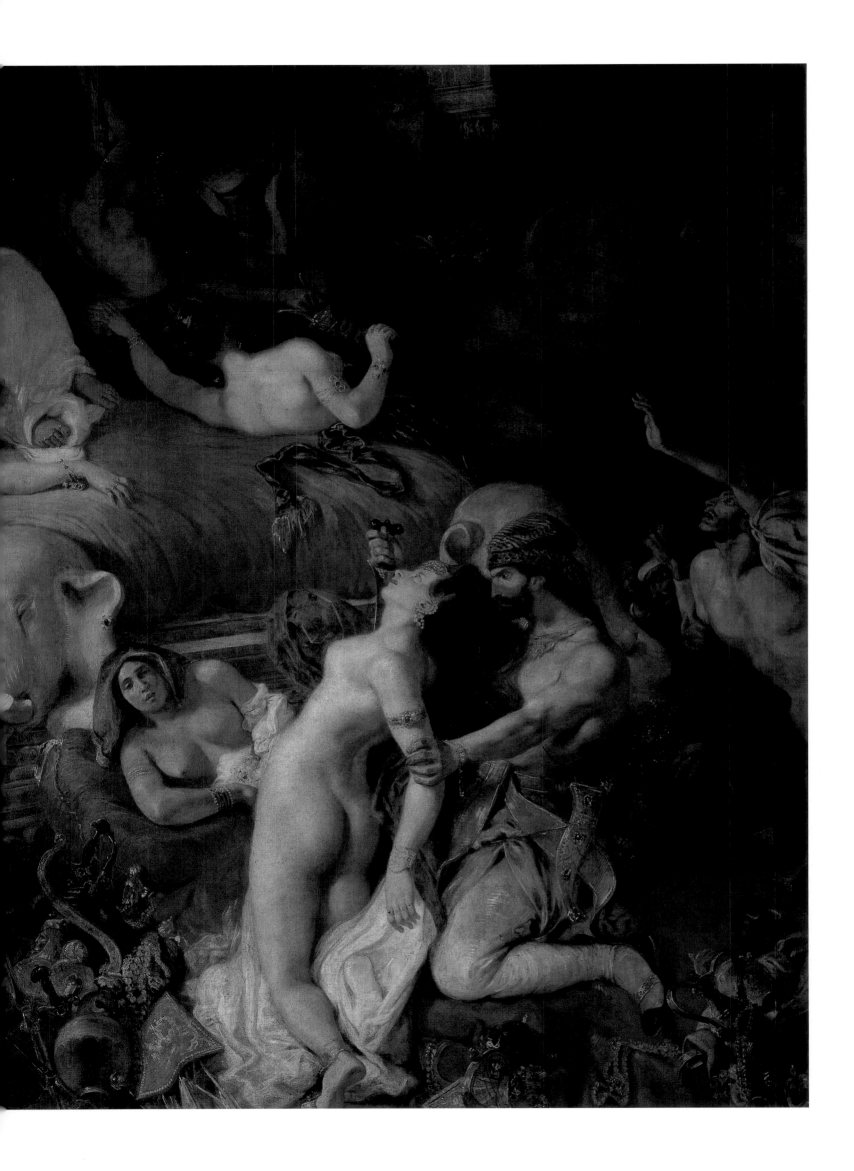

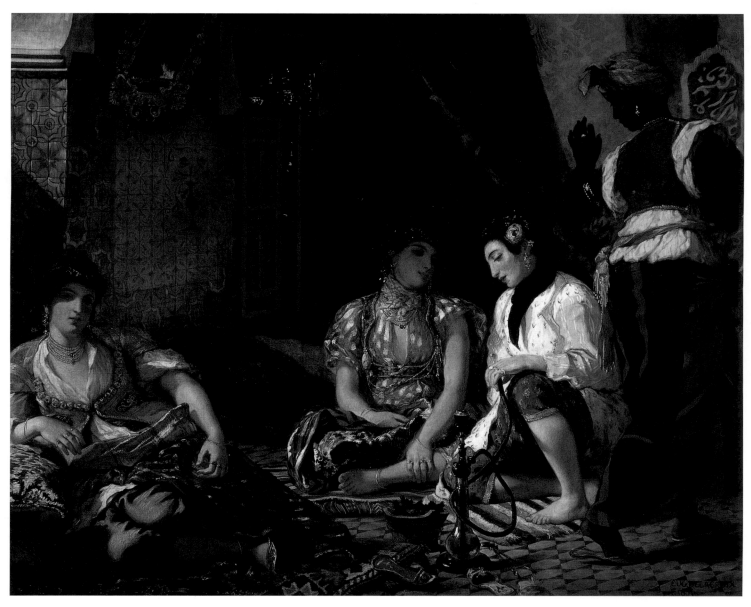

Eugène Delacroix. *Algerian Women in Their Apartment.* 1834. Oil on canvas. 70 ⅞ x 90 ⅛ in. (180 x 229 cm).

The artist was already the most popular Romantic and Orientalist painter of his day when he finally visited the "Orient"—in this case, North Africa—beginning in 1832. Paradoxically, his portrayals of the Muslims and Jews of Morocco and Algeria became almost classically restrained.

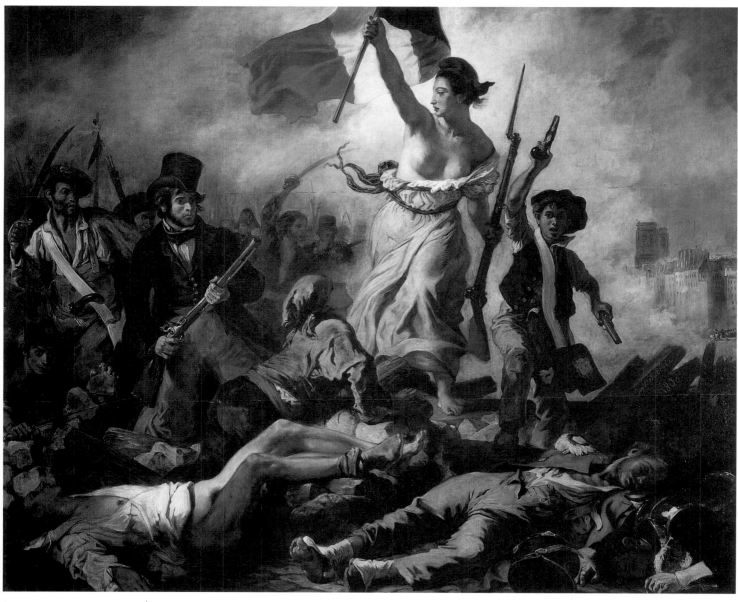

ABOVE

Eugène Delacroix. *Liberty Leading the People*. 1830. Oil on canvas. 102 ⅜ x 128 in. (260 x 325 cm).

Alexandre Dumas reported that the politically cautious Delacroix was thrilled when the Revolutionary tricolor was raised over Notre-Dame, shown on the right. More controversial than the painting's politics, at the 1831 Salon, was the artist's realistic rendering of the female allegorical figure of Liberty.

P. 274

Jean-Auguste-Dominique Ingres. *Louis-François Bertin*. 1832. Oil on canvas. 45 ⅝ x 37 ⅜ in. (116 x 95 cm).

The well-manicured Louis-François Bertin was an influential journalist and press magnate, a member of the economically and politically powerful bourgeoisie. It is intriguing to see how Ingres adapted the palette and brushwork that idealize his Neoclassical figures to an almost photographic portrait.

P. 275

Jean-Louis-Ernest Meissonier. *The Barricade in Rue Mortellerie, Paris, June 1848*. 1850–51. Oil on canvas. 11 ⅜ x 8 ⅝ in. (29 x 22 cm).

Meissonier, a hugely successful artist, recorded several of the violent passages of his century. In 1848, Parisian workers erected barricades in a street war with government troops. In this small, intense work, the artist equated the broken bodies of the demonstrators to the paving stones that were their weapons.

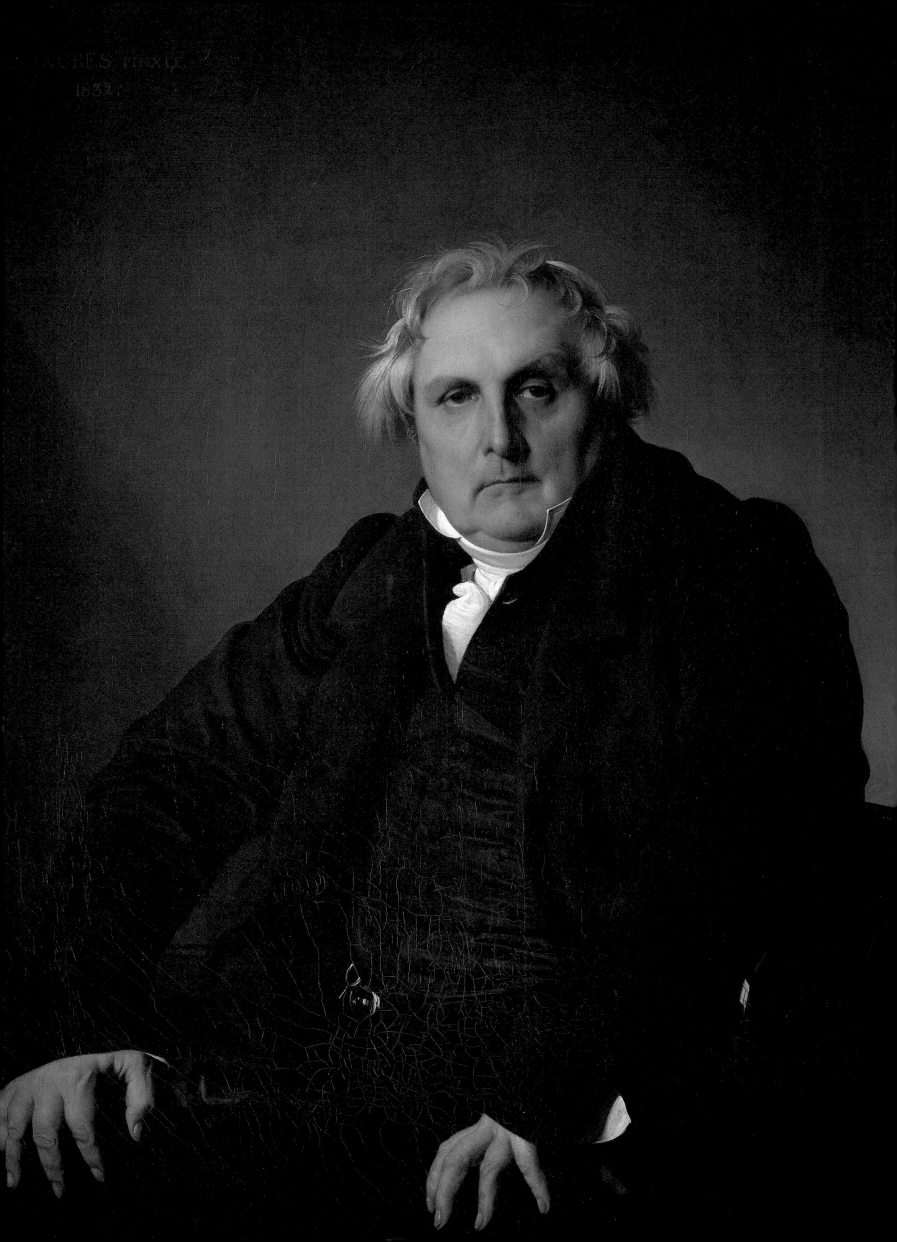

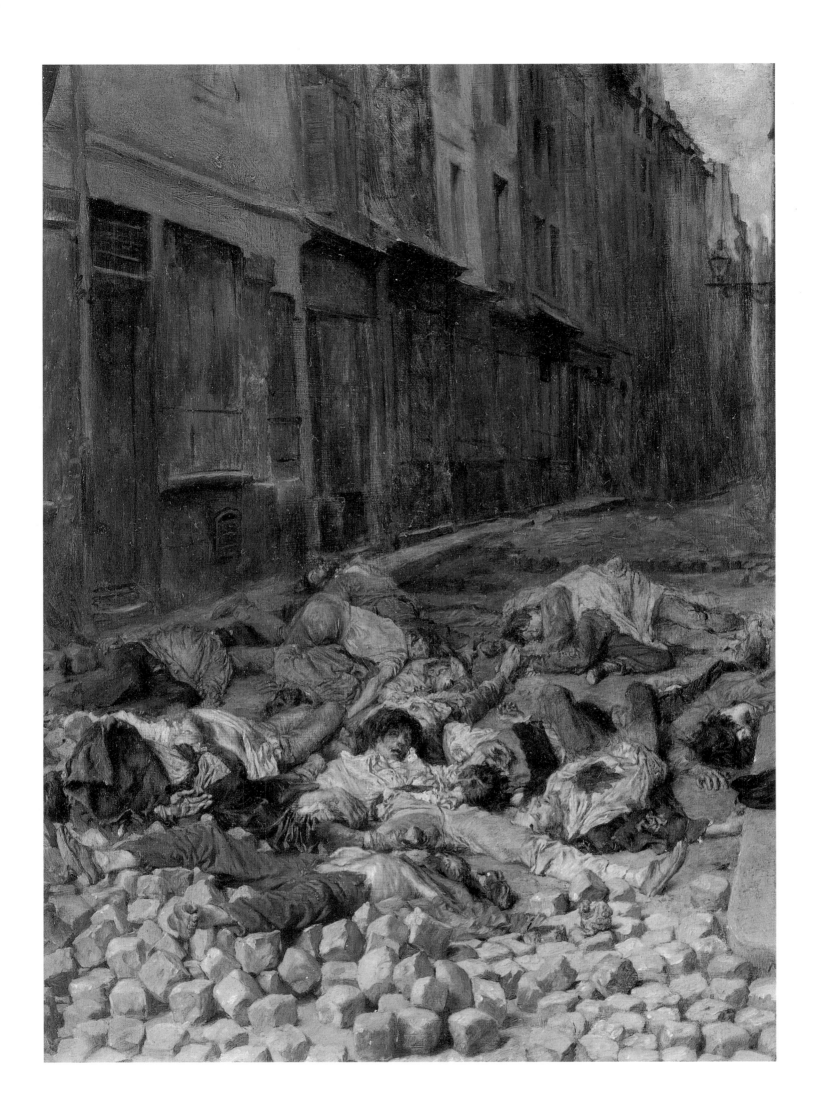

Joseph Mallord William Turner. *Landscape with a River and a Bay in the Distance.* c. 1845. Oil on canvas. 37 x 48 ⅞ in. (94 x 124 cm).

Turner was a phenomenon, a barber's son who attended the Royal Academy schools, and became the Academy's deputy president. First exhibiting while still a teenager, he quickly became successful, despite his continual and radical experimentation.

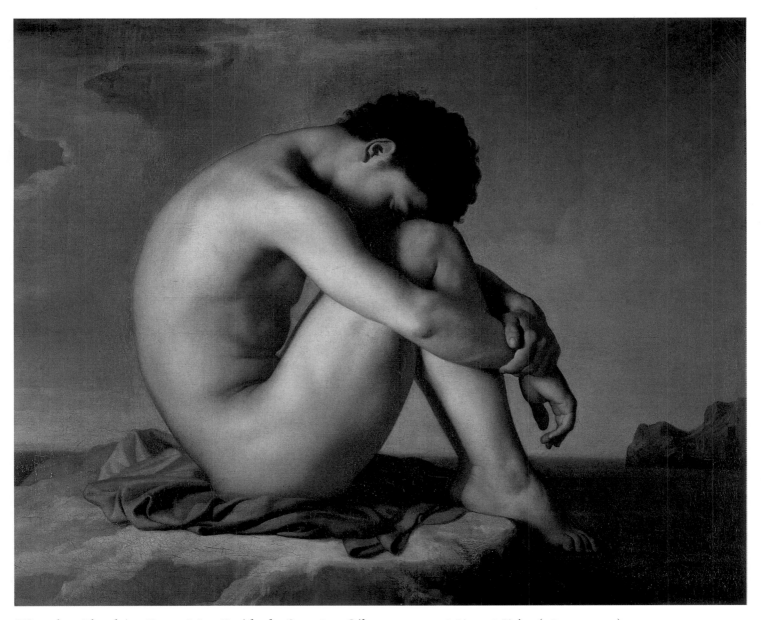

Hippolyte Flandrin. *Young Man Beside the Sea*. 1855. Oil on canvas. 38 ½ x 48 ⅞ in. (98 x 124 cm).

This painting, shown at the 1855 Paris World's Fair, exhibits the clean lines, close brushwork, and rich skin tones of "Ingrism." Flandrin made the pilgrimage to Rome, and the Neoclassical fabric on which the pensive subject sits is enough to suggest that here is the eternal southern Italian boy, resting after a swim.

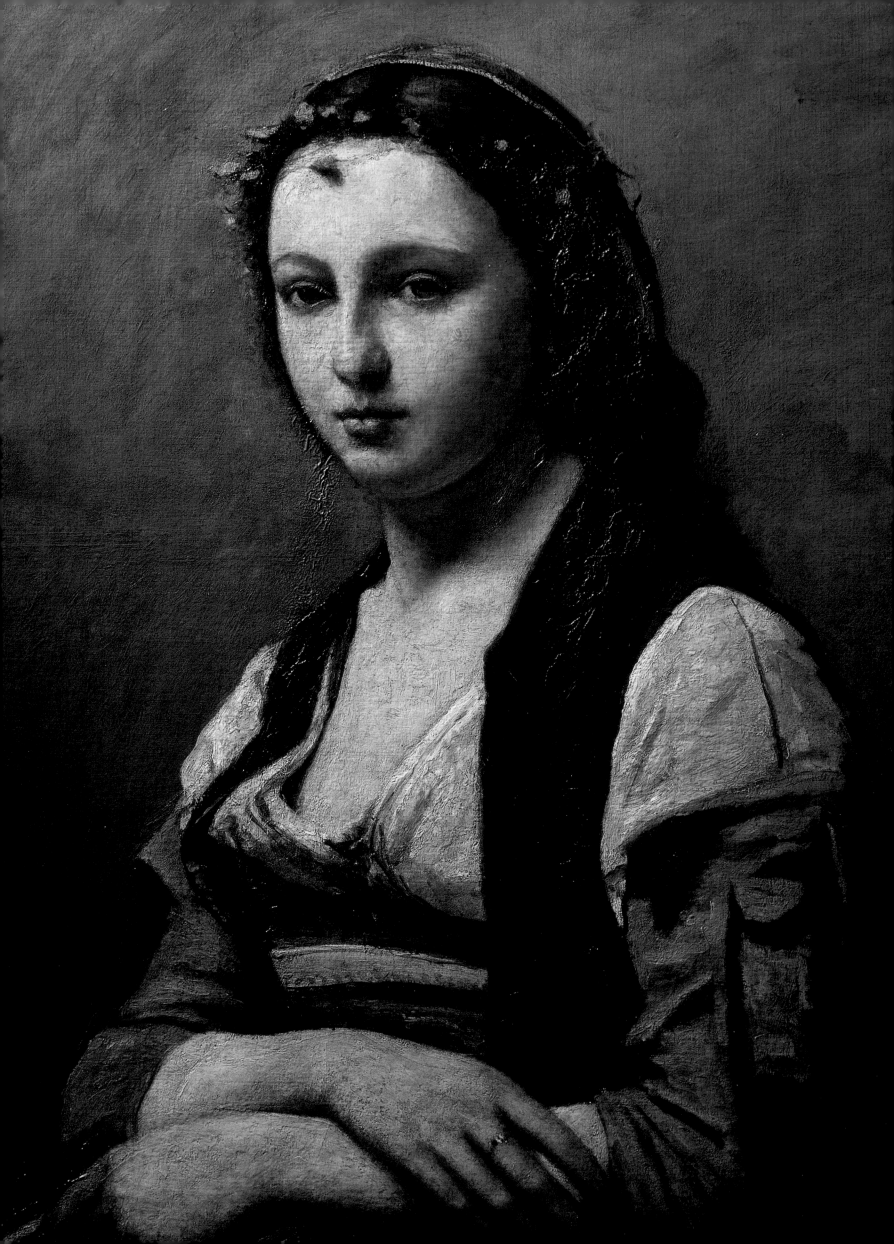

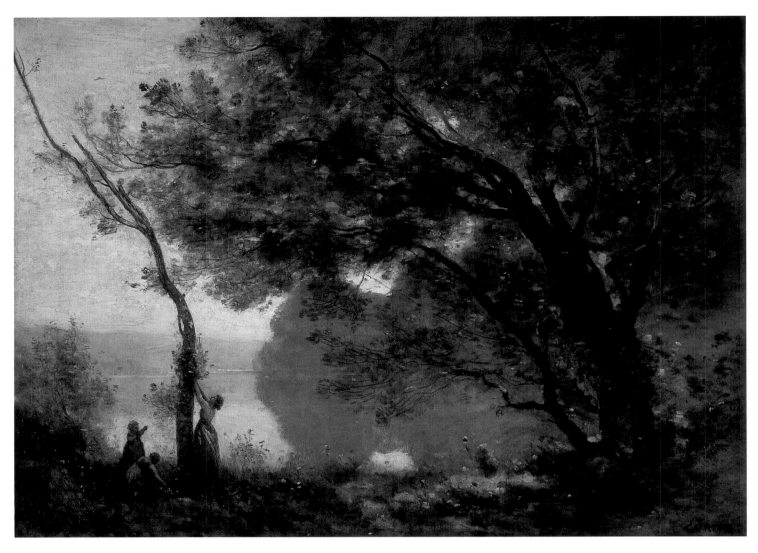

ABOVE

Jean-Baptiste Camille Corot. *Souvenir of Mortefontaine.* 1864. Oil on canvas. 25 ½ x 35 in. (65 x 89 cm).

Although the painting hints at early Impressionism, the elegiac, misty beauty of nature in this recollected landscape distantly recalls the eighteenth century's carefree *fêtes galantes.* The work was shown in the 1864 Salon, where it was purchased by Napoleon III.

OPPOSITE

Jean-Baptiste Camille Corot. *Woman with a Pearl.* c. 1857. Oil on canvas. 27 ½ x 21 ⅔ in. (70 x 55 cm).

In this and other works, Corot experimented with the Classical principles of his early training. The half-figure portrait, which refers to the early Renaissance, especially Leonardo's *Mona Lisa* and *La Belle Ferronnière,* shows a woman in a local costume of central Italy.

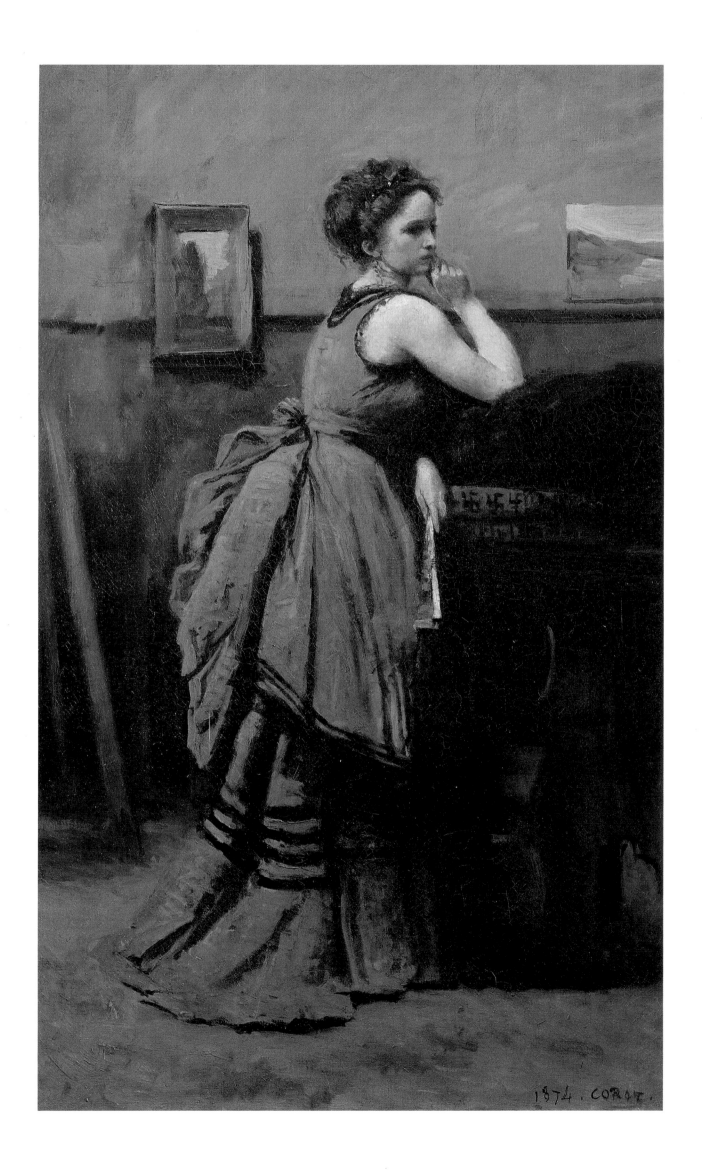

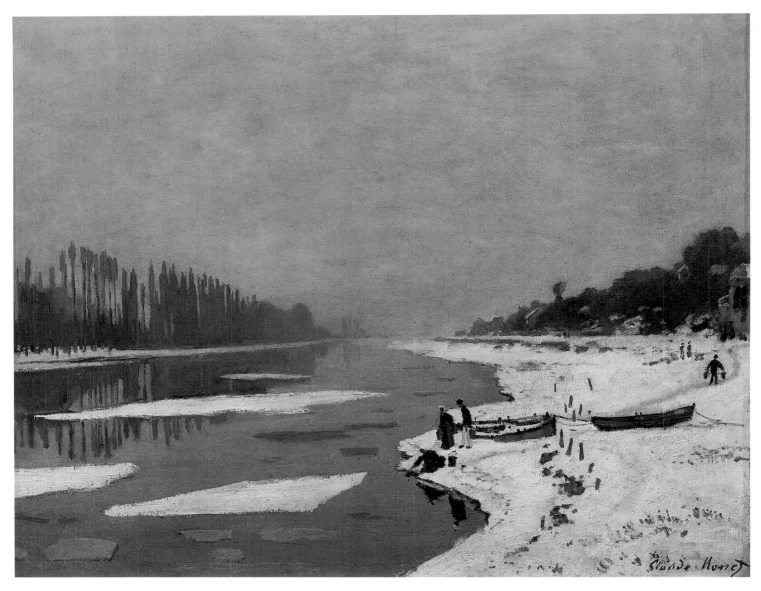

ABOVE

Claude Monet. *Ice Floes on the Seine at Bougival.* c. 1867. Oil on canvas. 25 ½ x 31 ⅞ in. (65 x 81 cm).

Winter presented a particular challenge to the Impressionists, not only because it was frigid work painting outside, but also because of the innumerable gradations of white. Here, a powerfully symmetrical composition points the eye and imagination along the river and all the life it supports.

OPPOSITE

Jean-Baptiste Camille Corot. *Woman in Blue.* 1874. Oil on canvas. 31 ½ x 20 in. (80 x 51 cm).

Although the official watershed between the collections of the Louvre and those of the Musée d'Orsay is 1848, certain gifts uniting later works have been kept together. Corot, became more interested in both female figures and color, such as the rich blue of the subject's dress, whose overtones relate it to the green background.

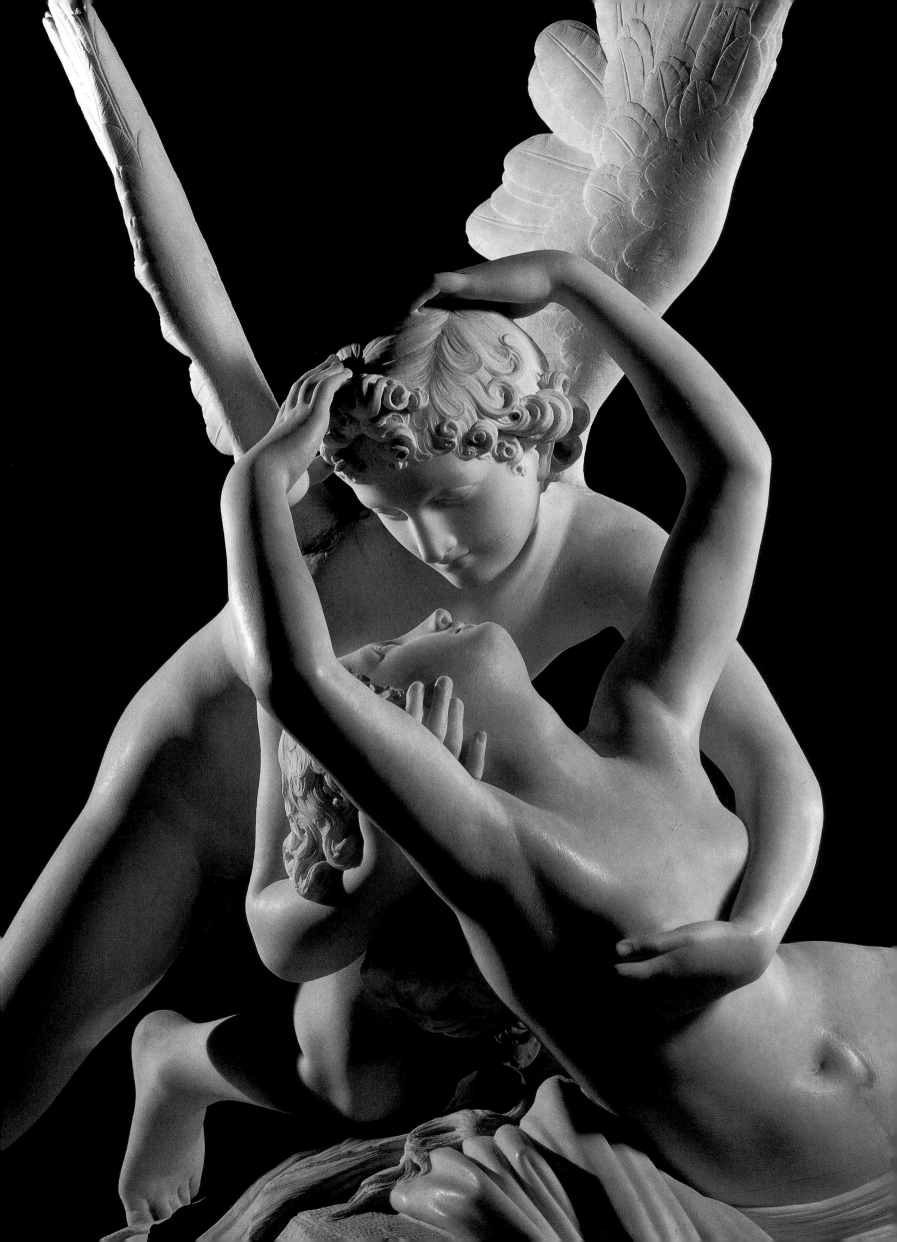

~ EUROPEAN SCULPTURE

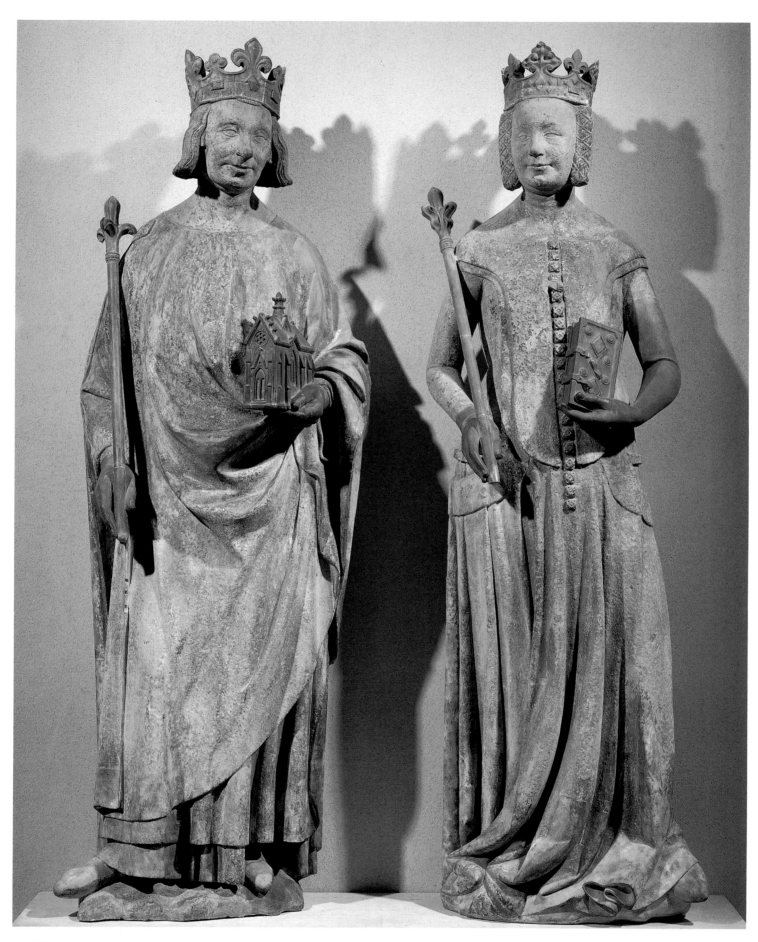

ABOVE
French School. *King Charles V and his Wife Jeanne de Bourbon*. c. 1365–1380. Stone. Each, 76 ¾ inches (195 cm) high.

Charles V transformed the Louvre's Great Tower into one of the most important libraries of his time, although it is Queen Jeanne de Bourbon who holds a book. The devoted couple, expressing benevolent and enlightened rulership, probably stood at the east entrance of the renovated Louvre.

P. 282
Antonio Canova. *Psyche Awakened by Eros* (detail). 1787–93. Marble. 21 ⅝ x 26 ¾ x 39 ¾ in. (55 x 68 x 101 cm).

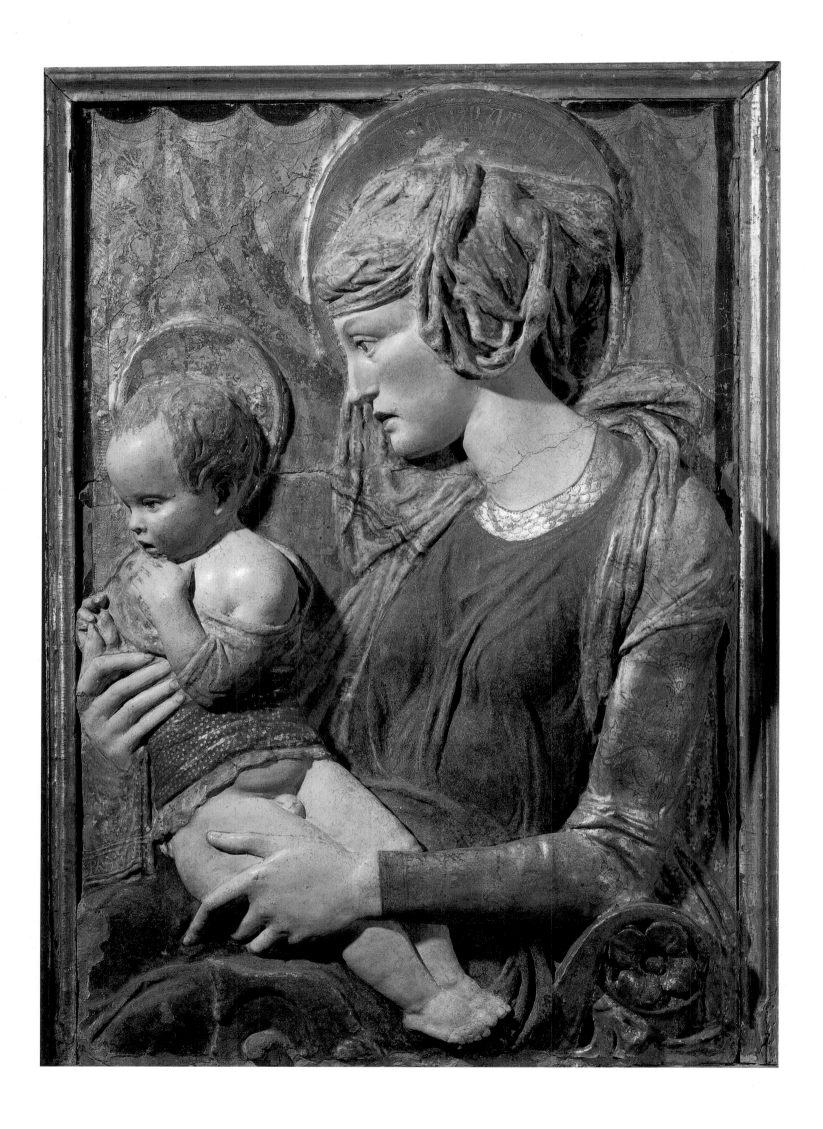

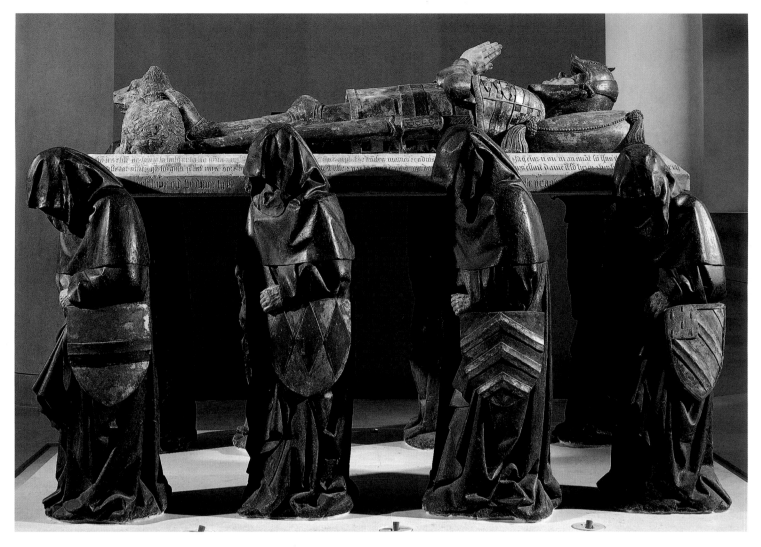

Antoine le Moiturier. *Tomb of Philippe Pot*. Late 15th century. Painted stone. 70 ⅞ x 104 ½ in. (180 x 265 cm).

Piety vies with pride and loses, in an extraordinary sculpture commissioned during his lifetime for his tomb by the Grand Seneschal of the powerful duke of Burgundy. The near-life-size hooded mourners, feats of eloquent realism, carry the coats of arms of Pot's ancestors, while the nobleman rests his feet on a crouching lion.

Michelangelo Buonarroti. *Dying Slave*. 1513–16. Marble. 82 ⅜ inches (209 cm) high.

Michelangelo sculpted this and another figure for the base of the tomb of the great patron of the arts Pope Julius II. Although scholars disagree about the allegorical meaning of these beautiful, tortured, unfinished sculptures—including the monkey at the base of this one—some suggest that this is the soul struggling for eternal perfection.

Donati di Bardi, called Donatello. *Virgin and Child*. 1440. Terracotta, painted and gilded. 40 ¼ x 29 ½ in. (102 x 74 cm).

Donatello, the greatest sculptor of his time, invented a unique and moving interpretation of a common early Renaissance theme. Stripped of symbols, this is an intimate and direct exploration of a human, albeit unique experience: the sorrowful young Virgin contemplates her son, who in turn gazes into the Passion.

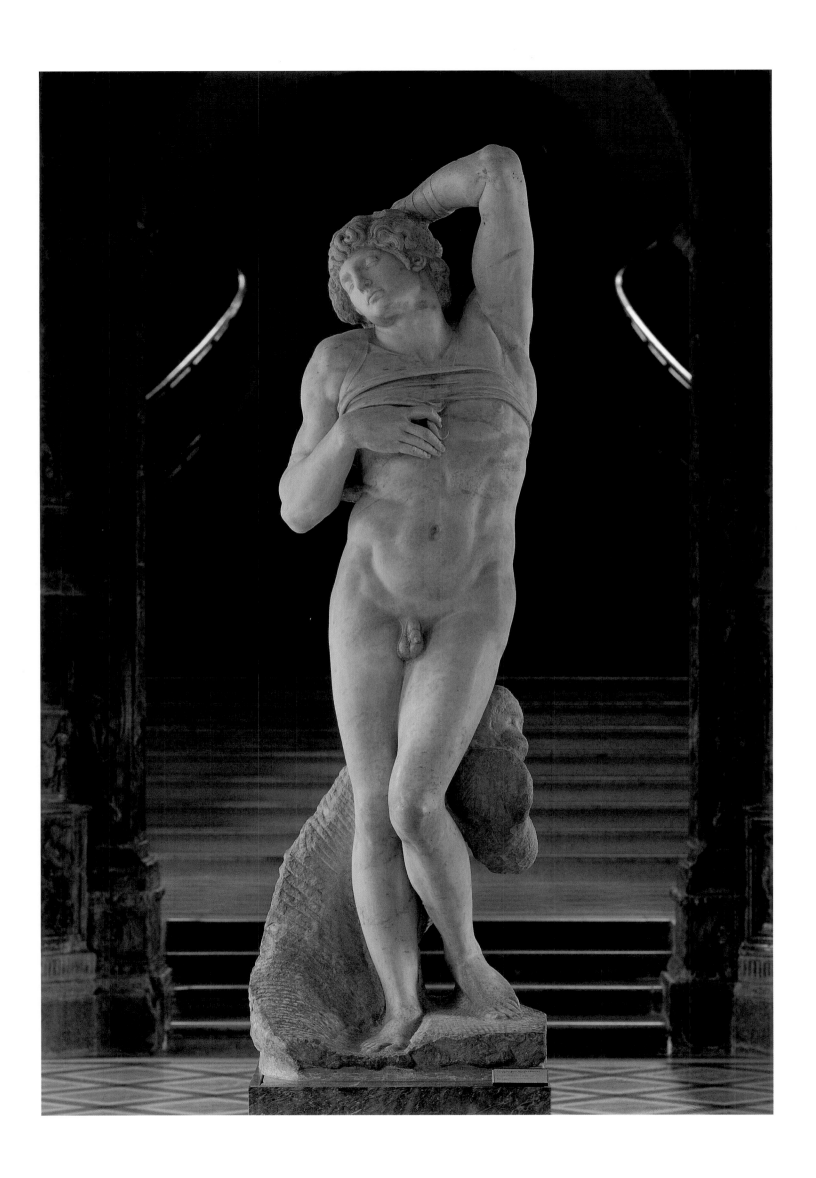

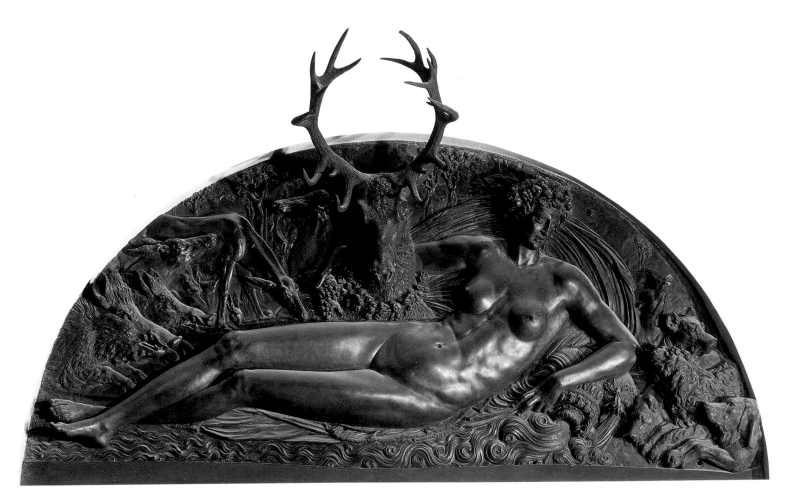

Benvenuto Cellini. *Nymph of Fontainebleau.* 1543–44. Bronze relief. 80 ¾ x 161 in. (207.6 x 409 cm).

Invited by Francis I in 1540, the goldsmith and sculptor Benvenuto Cellini joined his compatriots at the fabled palace. Their common experiment was with the deformation of common forms to decorative ends, visible here in the nymph's elongated shape. The horns protruding above the curve of the relief are a virtuoso touch.

Gianlorenzo Bernini. *Angel Bearing the Crown of Thorns.* c. 1667. Terracotta. 13 x 5 ⅛ x 7 ½ in. (33 x 13 x 19 cm).

To decorate the bridge in Rome leading to Castel Sant'Angelo—the Fortress of the Holy Angel—Bernini, the foremost Italian Baroque sculptor, designed two rows of angels bearing the instruments of the Passion. His students worked in marble from his models, of which this lyrical example, borne by otherworldly winds, is one.

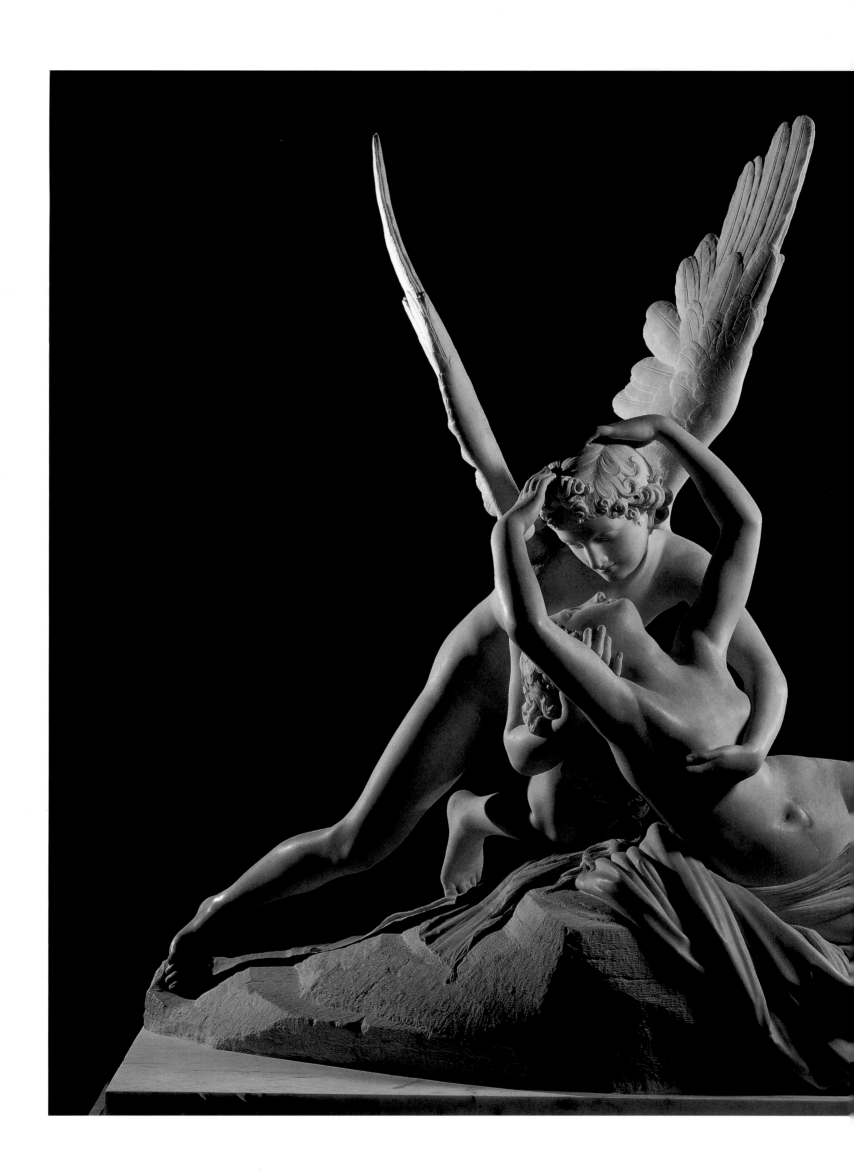

LEFT

Antonio Canova. *Psyche Awakened by Eros.* 1787–93. Marble. 21 ⅝ x 26 ¾ x 39 ¾ in. (55 x 68 x 101 cm).

His colleagues and clients alike acknowledged Canova as the master of graceful and accomplished Neoclassicism. Eros's wings and the enlaced circles of the lovers' arms, coaxed out of moon-white marble, recount not so much the eroticization of Psyche as a poetic exchange between soul and sex.

ABOVE

François Rude. *The Genius of Freedom*, model for *La Marseillaise.* Plaster. 16 ⅛ x 11 ⅜ in. (41 x 29 cm).

Rude was the emblematic Romantic sculptor of the first half of the nineteenth century; today, his work bridges the collections of the Louvre and the Musée d'Orsay. This is a study for his roaring, Revolutionary *Marseillaise*, placed atop the Arc de Triomphe during the reign of the Citizen-King Louis-Philippe.

ABOVE

Antoine-Louis Barye. *Lion Fighting a Serpent.* 1832. Bronze. 53 ⅛ x 70 ⅛ x 37 ¾ in. (135 x 178 x 96 cm).

He created classical allegories in 1854 for Napoleon III's New Louvre, but Barye is best known as a consummately skillful Romantic *animalier,* whose models were in Paris's Jardin des Plantes. Although well received at the Salon of 1833, this group's unallegorical naturalism disconcerted some viewers.

OPPOSITE

Guillaume Coustou. *Horse Restrained by a Groom.* 1739. Marble. 132 ½ x 110 ¾ in. (340 x 284 cm).

Louis XV's favorite hunting lodge was his château at Marly, for which he commissioned several sculpture groups, including this energetic study of equine and human emotion, worked from a single block of marble.

~ Graphic Arts

ABOVE

Leonardo da Vinci. *Seated Figure, Drapery Study*. Before 1481. Gray wash heightened with white on canvas. 10 ½ x 9 ⅛ in. (26.5 x 23.3 cm).

Verrocchio, one of Florence's leading sculptors and painters, took the teenage Leonardo on as an apprentice on the basis of drawings shown him by Leonardo's father. Like the master's other pupils, Leonardo prepared exercises like this one. The sensuous, satiny effect derives from the highlights and from the wash being laid onto primed canvas.

OPPOSITE

Francesco Mazzola, called Parmigianino. *Study of a Head*. Red chalk drawing.

Leonardo was the first important artist to use red chalk, a naturally occurring red ocher. Its tones permit great subtlety, because it can be smudged, as well as mixed with water for lines and wash: this adaptability supported Parmigianino's evolution toward individuality in portraits, and away from Renaissance idealization.

~ DECORATIVE ARTS

Serpentine Paten. 1st century (Court of Charles the Bald) and 9th century. Serpentine, gold, garnet, precious stones. 6 ⅝ inches (17 cm) diameter.

It was not unusual for ancient objects to be enhanced and consecrated centuries later. This first-century C.E. saucer, perhaps made in Alexandria, was richly decorated in the ninth century for the abbey of Saint-Denis, where it was used as a sacramental plate during the mass.

OPPOSITE

Equestrian Statue of Charlemagne. Carolingian. 9th century. Bronze with traces of gilt. 9 ¼ inches (23.5 cm) high.

The oldest medieval bronze in the Louvre, this small equestrian statue, once in the treasury of the Cathedral of Metz, was acquired during the Revolution. The king is traditionally identified as Charlemagne, although it may be his grandson Charles the Bald.

P. 306

Simon Vouet. *Moses Found in the Bulrushes* (detail). c. 1630. Wool and silk. 16 ft. 2 ⅞ in. x 19 ft. 3 ½ in. (4.9 x 5.8 m).

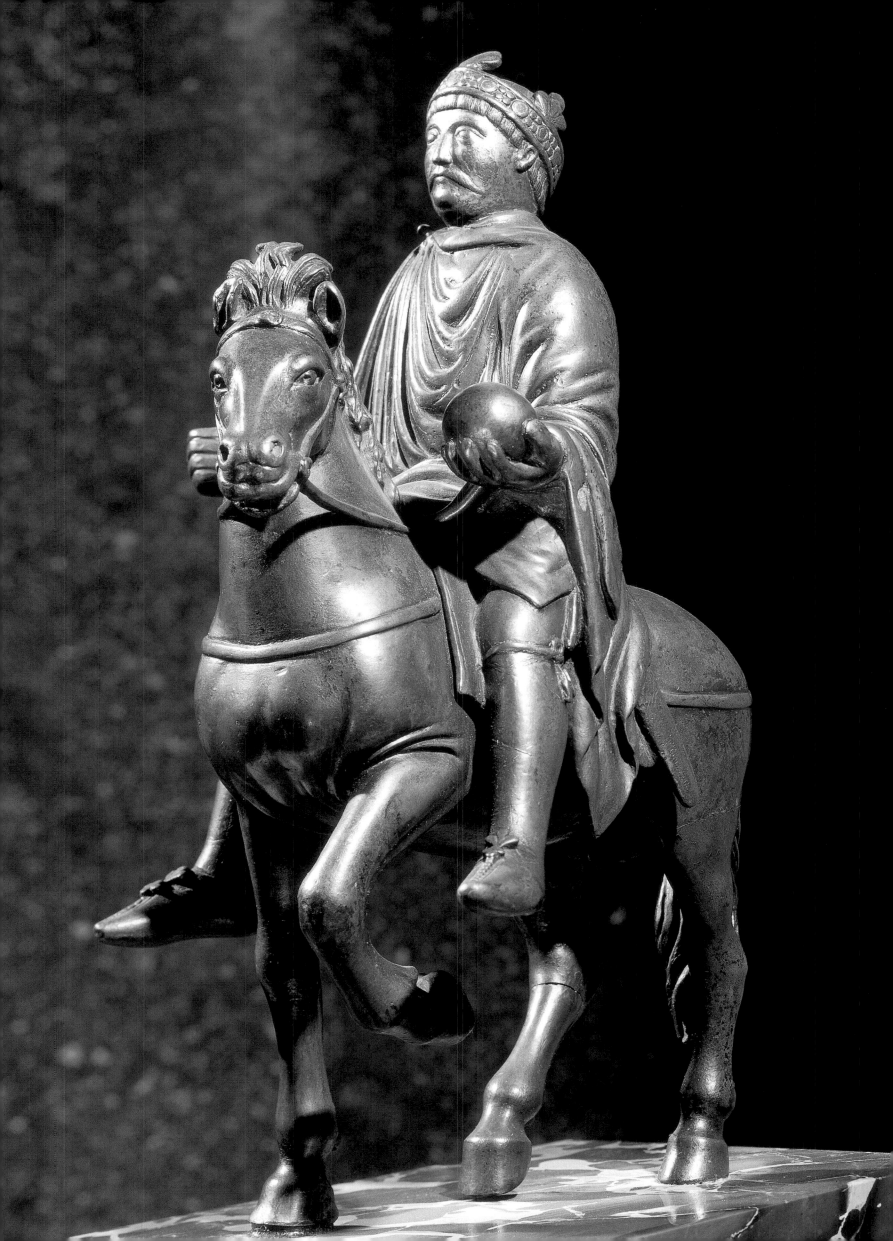

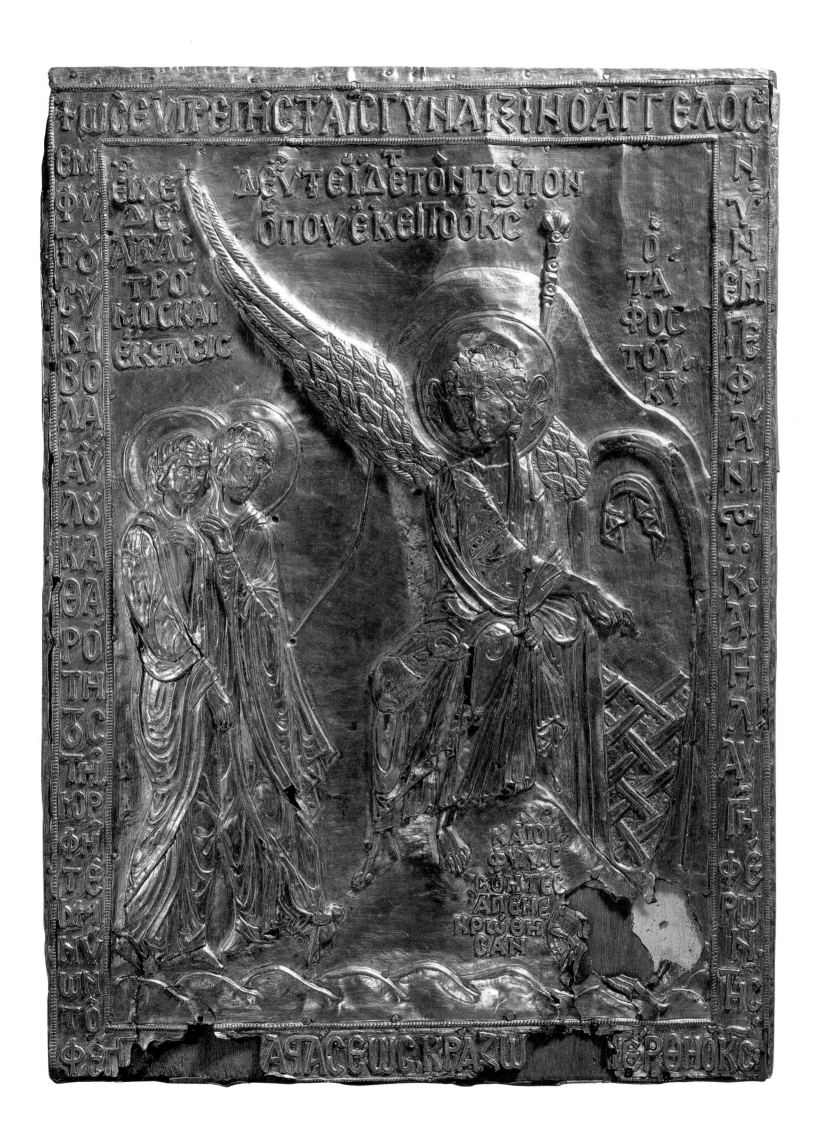

ABOVE

Arm Reliquary of Saint Luke with Coat of Arms of Sancia of Majorca. c. 1337–38. Rock, crystal, gilt silver, and enamel. 18 ⅞ inches (48 cm) high; 10 ¼ inches (26 cm) diameter.

This streamlined piece was crafted in Naples under the Angevin king Robert the Wise, a patron of writers, including Petrarch and Boccaccio. Made to hold a piece of the evangelist's arm bone, its realism encompasses a metal quill poised as if to receive divine inspiration.

OPPOSITE

Lid of Reliquary of the Stone of the Holy Sepulcher. Constantinople. 11th–12th century. Silver, chased and engraved on a wooden base. 16 ¾ x 12 ¼ in. (42.6 x 31 cm).

The Crusader King Saint Louis brought this and other relics back to the Sainte-Chapelle, the jewelbox shrine he built to house them. This lid shows the angel with Mary Magdalene and "the other Mary," at the empty tomb. This was taken to Saint-Denis in 1791, and from there to the Louvre in 1793.

Simon Vouet. *Moses Found in the Bulrushes.* c. 1630. Wool and silk. 16 ft. 2 ⅞ in. x 19 ft. 3 ½ in. (4.9 x 5.8 m).

Louis XIII commissioned Simon Vouet to design a series of tapestries, the History of the Old Testament, to be woven in the Louvre workshops. This episode in particular may have aroused wistful feelings in the king, son of two larger-than-life personalities.

P. 311, BOTTOM

Charles V's Scepter (detail). c. 1380. Gold, formerly enameled (with fleur-de-lys), pearls, and precious stones. 23 ⅝ inches (60 cm) high.

Charlemagne, enthroned, holds a scepter similar to this one, designed to associate the new Valois dynasty with the first kings of France. Charles V, who may have used this in his own consecration ceremony, had it enriched for his son's. It was kept at the Abbey of Saint-Denis until the Revolution.

Martin Carlin. *Commode with Porcelain Panels.* 1774. Wood marquetry and Sèvres porcelain. 34 ⅜ x 47 ¼ x 18 ⅞ in. (87 x 120 x 48 cm).

The Sèvres porcelain factory, founded by Madame de Pompadour, continued the tradition of royal patronage of industry, begun with Henry IV. Vivant Denon, director of the factory for a time, also designed pieces, at times exploiting their propagandistic possibilites.

François-D. Froment-Meurice. *Harvest Cup.* 1844. Agate, pearls, partially gilt and enameled silver, and gold. 13 ¾ inches (35 cm) high.

This cup rings ribald changes on a theme. The figures on the base are Anacreon, a poet of love and wine; Noah, guilty of drunken nakedness; and Lot and one of his daughters. Fearing that they were the last people on earth, the two women inebriated their father in order to have children by him.

Baby Bottle. c. 1500. Silver.

The clean, sweeping lines of this silver bottle are strikingly modern. Made in Rheims, the city where the French kings were crowned until 1830, it was used to feed a high-born baby. The mother, or more likely the nurse, simply poured milk or fine gruel slowly into the infant's mouth.

BIBLIOGRAPHY

Laurie Schneider Adams. *A History of Western Art.* Madison, WI: Brown & Benchmark, 1994.

Bonnie S. Anderson and Judith P. Zinsser. *A History of Their Own.* Vol. 2. New York: Perennial Library/HarperCollins, 1988.

Art Treasures of the Louvre. Translated and adapted from the French of René Huyghe. With a brief history of the Louvre by Milton S. Fox. New York: Harry N. Abrams, Inc., 1951.

Oskar Bätschmann. "Les portraits anonymes." In *Corot, un artiste et son temps*. Actes des colloques organisés au musée du Louvre par le service culturel les 1er et 2 mars 1996 à Paris et par l'Académie de France à Rome, Villa Médicis, le 9 mars 1996 à Rome. Paris: Louis Klincksieck, in association with the musée du Louvre and the Académie de France à Rome, 1998.

Germain Bazin. *Corot.* Paris: Éditions Pierre Tisné, 1942.

Geneviève Bresc-Bautier. "Le Louvre et Ses Fantômes," in *Revue des Deux Mondes* (September 1999), pp. 29–34.

Annie Caubet. "Départements d'Antiques et Aventure de l'Archéologie," in *Revue des Deux Mondes* (September 1999), pp. 51–61.

Keith Christiansen. *Italian Painting.* Southport, CT: Hugh Lauter Levin Associates, Inc., 1992.

Jean Clay and Josette Contreras, in collaboration with the editors of Réalités-Hachette. *The Louvre.* New York: Librairie Hachette, 1980.

"Connus et Inconnus par Qui le Louvre Est Ce Qu'il Est," in *Revue des Deux Mondes* (September 1999), pp. 111–117.

Jean-Pierre Cuzin. "Restaurer: Méthode et Prudence," in *Revue des Deux Mondes* (September 1999), pp. 45–50.

Jean Ehrmann. *Antoine Caron: Peintre des fêtes et des massacres.* Paris: Flammarion, 1986.

Alison Gallup, Gerhard Gruitrooy, and Elizabeth M. Weisberg. *Great Paintings of the Western World.* Southport, CT: Hugh Lauter Levin Associates, Inc., 1998.

Lawrence Gowing. *Paintings in the Louvre.* New York: Stewart, Tabori and Chang, 1987,

Knopf Guides: Paris. New York: Borzoi/Knopf, 1995.

Knopf Guides: The Louvre. New York: Borzoi/Knopf, 1996.

Michel Laclotte. *Treasures of the Louvre.* New York: Abbeville Press, 1993.

Jack Lang. *Francis I, ou le rêve italien.* Paris: Librairie Académique Perrin, 1997.

Paula Young Lee. "The Musaeum of Alexandria and the Formation of the *Muséum* in Eighteenth-Century France," in *Art Bulletin* 79, 3 (September 1997), pp. 385–412.

The Louvre: 7 faces of a museum. Trans. Jean-Marie Clarke. Paris: Éditions de la Réunion des musées nationaux, 1987–89.

André Malraux. *Le Musée Imaginaire.* Paris: Gallimard, 1965.

Andrew McClellan. *Inventing the Louvre: Art, Politics, and the Origins of the Modern Museum in Eighteenth-century Paris.* New York and Cambridge, U.K.: Cambridge University Press, 1994.

Prosper Mérimée. "Restauration du Musée" (originally published in the *Revue des Deux Mondes* of March 1, 1849), in *Revue des Deux Mondes* (September 1999), pp. 103–110.

Alain Pasquier. "Les Voyages de la 'Vénus de Milo,'" in *Revue des Deux Mondes* (September 1999), pp. 35–44.

Pei Ieoh Ming. "Les Métamorphoses du Louvre" (excerpted from a lecture given April 10, 1999, at the auditorium of the Louvre, as part of the Musée-Musées series), in *Revue des Deux Mondes* (September 1999), pp. 90–92.

Carlo Pietrangeli et al. *Paintings in the Vatican*. Boston: Bulfinch Press, 1996.

Pierre Quoniam. *The Louvre*. Paris: Éditions des musées nationaux, 1977.

Roland Recht. "Une Double Révolution Culturelle," in *Revue des Deux Mondes* (September 1999), pp. 84–89.

John Russell. *Paris*. Foreword by Rosamond Bernier. New York: Harry N. Abrams, Inc., 1983.

Gary Schwartz. *Rembrandt: His Life, His Paintings*. New York: Viking, 1985.

Tout l'oeuvre peint de Murillo. Paris: Flammarion, 1980

Barbara W. Tuchman. *A Distant Mirror: The Calamitous 14th Century*. New York: Ballantine Books, 1978.

Jane Turner, ed. *The Dictionary of Art*. New York: Grove's Dictionaries, 1996.

Jacobus de Voragine. *The Golden Legend: Readings on the Saints*. Trans., William Granger Ryan. Princeton: Princeton University Press, 1993.

Marguerite Yourcenar. *Sous bénéfice d'inventaire*. Paris: Éditions Gallimard, 1978.

Video

I.M. Pei: First Person Singular. Peter Rosen Productions for Lives and Legacies Films. Distributed by PBS Home Video, 1997.

Photo Credits

INDEX